ADVANCE P

The Magic Glasses oj Critical Thinking

"While the words 'critical thinking' have become an almost essential part of academic discourse and thinking, it is not always clear what is meant. In *The Magic Glasses of Critical Thinking: Seeing Through Alternative Fact & Fake News*, D. Michael Rivage-Seul offers us a book that deals simply, clearly, and decisively with the subject. From discussions on mainstream mass media to models of socio-economic systems to the way we read history, this book bristles with relevance. Opening the lens wide yet able to zoom in on the details that matter, enlighten and challenge, this book, with its wonderful 'ten rules of critical thinking,' offers the kind of engaged pedagogy that enriches immensely our discourse. It succeeds in finding ways for meaningful conversation between the North and the Global South, and that is not only more important than ever, it might also be the singular underlying strength of this gift of a book."

—Allan Boesak, South African liberation theologian and
Distinguished Professor of Religion and Social Justice, Berea College

"Those with the courage to put on D. Michael Rivage-Seul's Magic Glasses will be given the opportunity to acquire the conditions of possibility for seeing the world with new conceptual lenses. This magical eyewear is not rose-tinted but assists the wearer in penetrating the viscera of social life, whose dank cavities contain the muck of the ages, the bile of political bitterness, and the sinewy tissue that connects all the turpitudinous machinations of everyday life. But if one steadies one's gaze, a glint of light appears, growing brighter the more one becomes accustomed to a more magnified world. And eventually the wearer is able to illuminate possibilities for reimagining the landscape of the ordinary, whose dank and fetid rot can become transformed into the loam of the extraordinary—the foundations for a new and more critical and loving humanity."

—Peter McLaren, Distinguished Professor of Critical Studies,
Chapman University, and author of *Pedagogy of Insurrection*

"[This book is] a compelling story of D. Michael Rivage-Seul's journey in critical thinking as he learns to view the world through the vantage point of the Global South. This creative approach to learning critical thinking recognizes that it is more than learning the rules of logical reasoning. Rather, it is a frame of mind that interrogates reality and the cultural ideas through which we interpret it. Critical thinking challenges us to consciously adopt an interpretive framework based on our stage of personal development and social commitments. Influenced by liberation theology and practicing Paulo Freire's pedagogy of the oppressed, Rivage-Seul is conscientized with the glasses of the Global South. His readers will come away with their eyes opened as well, or at least be left very uncomfortable."

—Cliff DuRand, Center for Global Justice, Editor of
Recreating Democracy in a Globalized State and *Moving Beyond Capitalism*

The Magic Glasses of Critical Thinking

EDUCATION and STRUGGLE

Narrative, Dialogue, and the Political Production of Meaning

Michael Peters & Peter McLaren
Series Editors

Vol. 15

The Education and Struggle series is part of the Peter Lang Education list.
Every volume is peer reviewed and meets
the highest quality standards for content and production.

PETER LANG
New York • Bern • Berlin
Brussels • Vienna • Oxford • Warsaw

D. Michael Rivage-Seul

The Magic Glasses of Critical Thinking

Seeing Through Alternative Fact & Fake News

PETER LANG
New York • Bern • Berlin
Brussels • Vienna • Oxford • Warsaw

Library of Congress Cataloging-in-Publication Data

Names: Rivage-Seul, D. Michael.
Title: The magic glasses of critical thinking: seeing through
alternative fact & fake news / D. Michael Rivage-Seul.
Description: New York: Peter Lang, 2018.
Series: Education and struggle: narrative, dialogue
and the political production of meaning; vol. 15
ISSN 2168-6432 (print) | ISSN 2168-6459 (online)
Includes bibliographical references and index.
Identifiers: LCCN 2017035870 | ISBN 978-1-4331-4951-1 (hardback: alk. paper)
ISBN 978-1-4331-4952-8 (paperback: alk. paper) | ISBN 978-1-4331-4954-2 (ebook pdf)
ISBN 978-1-4331-4955-9 (epub) | ISBN 978-1-4331-4956-6 (mobi)
Subjects: LCSH: Critical thinking—Study and teaching.
Classification: LCC LB1590.3 .R633 2018 | DDC 370.15/2—dc23
LC record available at https://lccn.loc.gov/2017035870
DOI 10.3726/b13184

Bibliographic information published by **Die Deutsche Nationalbibliothek**.
Die Deutsche Nationalbibliothek lists this publication in the "Deutsche
Nationalbibliografie"; detailed bibliographic data are available
on the Internet at http://dnb.d-nb.de/.

The paper in this book meets the guidelines for permanence and durability
of the Committee on Production Guidelines for Book Longevity
of the Council of Library Resources.

Printed in the United States of America

To Peggy who has taught me more about life, love, and what's truly important than she'll ever know.

Contents

Figures

Introduction

Critical Thinking, Magic Glasses, and Film

Critical thinking is my passion.

In various forms, I have guided courses on the topic for each of my 40 years teaching at Berea College in Kentucky. Most of those courses were required of first year students. The offerings typically employed prescribed texts shared across sections taught by an interdisciplinary faculty. For instance, we used a very fine book by Sylvan Barnet, Hugo Bedau, and John O'Hara, *From Critical Thinking to Argument: A Portable Guide*.[1] It helpfully emphasized clear expression and coherent organization of ideas, along with logical consistency and avoidance of common errors in reasoning. In other words, the text (as well as others we've used) stressed reason as the arbiter of truth.

In my early years, I accepted that. For me, our manuals defined and elucidated the very task of critical thinking.

Later, however, reflection on my own experience gradually showed me that reason alone cannot successfully arbitrate between truth and falsehood. Critical thinking is much more relative than that. In fact, it represents a process of personal development. What a person takes as "truth" largely depends on her or his evolutionary stage of development and on one's physical, historical, and social location in the world. In a sense, the world is filled with "alternative facts" whose perceived truth depends on one's physical situation and personal maturity.

Moreover, critical thinking as normally practiced in the academy typically fails to note the very parameters of thought that are culturally defined and that necessarily limit the effectiveness and value of critical thinking aspiring to cultural neutrality. A student (or professor!) can be completely clear in expression, avoid all logical and factual errors in argument, and still remain completely unaware that any other way of thinking even enjoys validity. The thinkers in question are literally wearing "cultural blinders" that prevent critical thought at any deep level.

With all of that in mind, I take the phrase "critical thinking" as a reference to thought processes that remove cultural blinders. To do so, the processes must be (1) world-centric or integral, (2) evidence based, (3) comprehensive, and (4) committed to changing the world. Such thinking is needed more than ever in the post-fact, fake news context characterizing today's American culture.

Book's Organization

Accordingly, this book will be divided into four main parts. Part One will address the questions of alternative facts and fake news as well as presenting a description of the author's personal journey towards critical consciousness. In the light of those stages, the book's second part will introduce the first eight of ten rules for thinking critically about alternative realities and fake information. These chapters are intentionally brief to make them suitable for actually reading in class. Part Three will return to the historical world and attempt to apply those discernment criteria to our contemporary context of alternative facts and fake news where fascist tendencies reminiscent of the 1930s are unmistakable. Chapters in Part Three are more fully developed and not intended for in-class reading. They fill in the historical background required to understand the rules for critical thinking that earlier chapters present so briefly. The book will conclude with Part Four. It will address my final two rules of critical thinking that deal with the practical questions of listening carefully and living critically.

More specifically, the heart of what follows will submit for consideration ten "criteria of discernment" that may prove helpful for those at any stage of development to judge which "facts" deserve credence and which do not. The truth criteria suggested here are: (1) Reflect Systemically, (2) Select Market (as the root of political differences), (3) Reject Neutrality, (4) Suspect Ideology, (5) Respect History, (6) Inspect Scientifically, (7) Quadra-Sect Violence, (8) Connect with Your Deepest Self, (9) Collect Conclusions, and (10) Detect Silences.

Magic Glasses

The hope is that consideration of these rules may tempt readers to try on for size what the late comedian and social activist, Dick Gregory called his magic glasses. In practice, Gregory used the term to refer to the perspective conferred by viewing the world from the standpoint of the world's poor, oppressed, and disenfranchised. Attaining such vision, Gregory said, is like donning special eyewear that enables one to perceive what is invisible or absurd to those without them.[2]

Magic glasses, Gregory warned, are both a blessing and a curse. The blessing is that eyesight through their lenses is fuller, and more evolved—more worthy of human beings. The curse is that those without the glasses will consider their wearers insane or worse. And the hell of it is that glassless folk cannot be persuaded unless their independent growth cycle enables them to do so.

So, Gregory pointed out, the magic glasses come with three inviolable rules: (1) once you put them on, you may never take them off, (2) afterwards, you can never see things as your tribe says they're supposed to be, but only as they truly are, and (3) you can never force anyone else to wear them.

Critical Thinking and Film

The question is, how to help readers see the world from perspectives that can help them develop the critical vision or in-sight Gregory described?

An obvious answer would be travel. As you will see in chapters two and three, that's what expanded my own vision from an originally narrow, deeply religious and ethnocentric conservativism to something much broader. In Chapter Three, I describe that process in detail. It took me across Europe and then to Latin America, Africa, and finally to the Middle East and to Asia—never simply as a tourist, but as one seeking deeper understanding of the world specifically from the viewpoint of the world's poor and disenfranchised.

The quest was inspired by the realization (to be explained in Chapter One) that Frantz Fanon's *Wretched of the Earth* have a much deeper understanding of the way the world works than those of us living in what's commonly referred to as "the developed world."

But what about people unable to travel as I did and study with scholars, saints, revolutionaries, and advocates of the planet's impoverished classes? How help them don Gregory's eyewear? I searched for ways to answer that question. I found them, I think, in film. A friend of mine once observed that if a picture is worth a

thousand words, a good film is worth a million. And it's true: we all love films, and discuss them enthusiastically.

So, in my classes, I employed several classics to illustrate my Ten Rules for Critical Thinking. Movies such as *Romero*, *Wall Street*, *Traffic*, and even comedies like *Bulworth*, and *The Distinguished Gentleman* found their ways, at various times, into my syllabi. So did several documentaries. However, showing the films absorbed so much class time, that I began to question the wisdom of their inclusion. Often two hours or more were taken up to foster a discussion that focused merely on one or two moments in the film.

Then it occurred to me that the computer and YouTube make it possible to excerpt those one or two moments (each usually lasting no more than ten minutes), and to connect the clips directly with the points I wanted them to illustrate. Additionally, if students missed the point, and wanted to see the clip again, I could simply show it again, with nothing lost. In most cases, all that was necessary to get a good discussion going was to ask, "What did you see?"

Student responses and conversations that followed showed that the film clips often reflect back to students what they themselves are thinking, and how they perceive the world.

As a result, films, I concluded, are especially apt for raising consciousness. After all, cinematic writers, producers and directors have done a lot of the preliminary research work necessary for teachers of critical consciousness. Those involved in the film industry are obviously interested in marketing their products. So they must know how their audiences see the world, how they think, and what their problems are. Film producers are usually interested in realism too—accurately reflecting the way people look, speak, and interact with each other. Movies, then, or at least parts of them, raise critical questions that can deepen and sharpen critical understandings of the world.

So film will be centralized in my explanations of critical thinking. I've worked into the text dialogs from most of the classics I've just mentioned. But I've also included more recent releases (like *Sausage Party*, *War Dogs*, and *Avatar*) throughout the book's chapters and analyzed them as they might appear to one wearing the magic glasses.

Notes

1. Sylvan Barnet, Hugo Adam Bedau, and John O'Hara. *From Critical Thinking to Argument: a portable guide.* Boston: Bedford/St. Martins, 2017.
2. "Dick Gregory: Magic Glasses." *YouTube.* YouTube, 05 Aug. 2016. Web. 14 Apr. 2017.

Critical Thinking in Our Post-Fact World of Fake News

Alternative Fact and Fake News Inside Plato's Cave

By many accounts, we're living in a post-fact age, where it's increasingly difficult to tell truth from falsehood. As we'll see below, it's as if we were living in Plato's allegorical Cave, where shadows masquerade as reality. That's why in our culture, contemporary debate rages over terms such as "post-truth," "truthiness," "alternative facts," "fake news," outright "bullshit," and "propaganda."

In fact, according to the *Oxford Dictionary*, the 2016 Word of the Year (WOTY) was "post-truth." That same year, the Australian *Macquarie Dictionary* identified "fake news" as its own WOTY. The trend is unmistakable—signaled as far back as 2006, when "truthiness," a term coined by Stephen Colbert, took the *Oxford Dictionary* honor. The Colbert term synthesized the trend's direction. "Truthiness" was defined as "The quality of seeming or being felt to be true, even if not necessarily true."

That's what the post-truth era centralized: feelings over analysis. "Trust you gut and not your brain" is the way Beppe Grillo put it while urging Italians to vote with his conservative Five Star Party against constitutional reforms.

Shortly after being elected, Donald Trump's team took the trend a step further. Republican strategist Kellyanne Conway, introduced the phrase "alternative facts." She was debating "Meet the Press" host, Chuck Todd, about the size of Trump's 2017 inauguration audience.

Conway defended the position expressed by Sean Spicer, President Trump's Press Secretary. He had described the crowd as the largest in inauguration history. Todd disagreed citing D.C. police estimates that it was four times smaller than the number attending Barack Obama's second inauguration. Conway responded, "… Our press secretary, gave alternative facts to that …" Todd answered, "Look, alternative facts are not facts. They're falsehoods."

Philosopher Harry G. Frankfurt would put Todd's point in even starker terms. Drawing on the title of his best-selling book, Frankfurt would say that alternative facts are simply "B.S."[1] In *On Bullshit* the professor contrasts liars and bullshitters. The Liar, Frankfurt writes, cares about truth and attempts to hide it; bullshitters don't care if what they say is true or false. Their only concern is whether or not their listeners are persuaded.

According to another philosopher, Ken Wilber, polls taken during the 2016 election cycle showed that truthiness was valued more highly by a majority of voters than researched facts. Day after day, Wilber writes, newspapers would keep count of questionable statements made by Donald Trump the previous day. Reporters would write things like, "Our fact checkers have found that Mr. Trump told 17 lies on the campaign trail yesterday."[2] To a lesser extent, they criticized Ms. Clinton's statements. And yet, when asked who was more truthful, Donald Trump or Hillary Clinton? the polls consistently ranked Trump first. This signified, Wilber says, that poll respondents valued persuasiveness more highly than what news reporters called truth.

Fake News

Truthiness, alternative facts, and bullshit have given rise to widespread concern about "fake news." During the 2016 presidential campaign, the phrase received prominence when it was discovered that Eastern European bloggers had concocted from whole cloth wild stories about Hillary Clinton and Barack Obama. The stories were directed towards supporters of Donald Trump, and the concoctions' only purpose was to have the tales go viral—while earning thousands of dollars for their authors. So, readers were treated to headlines such as: "JUST IN: Obama Illegally Transferred DOJ Money to Clinton Campaign!" and "BREAKING: Obama Confirms Refusal to Leave White House, He Will Stay in Power!"

Such headlines might make one laugh. However, Noam Chomsky reminds us that "fake news" is by no means a trivial matter. That's because its principal perpetrators are not Macedonian teenagers trolling for cash. They are the CIA, the NSA, and the White House (under any president). Their messages are

communicated to the rest of us through the mainstream media (MSM) whose function is the dissemination of propaganda. In *Necessary Illusions,* Chomsky puts it this way[3]:

> The mass media serve as a system for communicating messages and symbols to the general populace. It is their function to amuse, entertain, and inform, and to inculcate individuals with the values, beliefs, and codes of behavior that will integrate them into the institutional structures of the larger society. In a world of concentrated wealth and major conflicts of class interest, to fulfill this role requires systematic propaganda.

In other words, at least according to Professor Chomsky, fake news has long been with us. It is the official policy of the country's ruling elites.

Critical Thinking and Truth

All of that represents a challenge to critical thinking. It even raises the question of truth, which the culture I've just described seems to accept as largely relative. One person's truth is another's propaganda. In such a world, critical thinking is either essential or irrelevant. I hold for the former.

I believe that truth is relevant, that facts exist, and that the facts of some are truer than those of others. At the same time, I recognize that my own understanding of "fact" has changed drastically over the course of my life. What I once fervently embraced as truth, I no longer accept. Something similar, I think, is true for all of us. As Paul of Tarsus put it in his letter to friends in Corinth 2000 years ago: "When I was a child, I talked like a child, I thought like a child, I reasoned like a child. When I became a man, I put the ways of childhood behind me."[4]

Paul's insight holds for western culture as well, including the scientific community. It readily admits that facts change. For instance, scientists once universally accepted as absolute fact that the earth was the center of the universe. Galileo changed all of that.

And that brings me to those critical thinking elements of world-centrism, evidence, comprehensiveness, and commitment.

Here the argument begins by noting that truth *is* largely relative. Our perception of it often depends on our stage of personal development—on the degree of evolution we've attained. What's true for children (think Santa Claus and the Tooth Fairy) is not true for adults. This by no means invalidates what children think. Their insights are often more acute than grownups'.

On the other hand, however, there are hierarchies of truth. While honoring children's perceptions, adults cannot generally operate on the basis of what

youngsters believe about the world. Neither do all (even very sincere) adults enjoy the same credibility. Some of them are more mature than others—more highly evolved at least in their chosen fields. Einstein, for instance, enjoyed high credibility in the field of physics. He also played the violin. However, his credibility in the field of music didn't begin to approach that of Jascha Heifetz. It's the same with other endeavors. Expertise matters.

Recognizing such relativity makes us realize that we *do* actually inhabit a world of "alternative facts." But not all fact-claims have the same value. To separate true from less true and truth from falsehood, we must exercise extreme care. Recognizing the previously mentioned truth-hierarchies associated with universal stages of personal development is part of that process.

Truth and Personal Development

Philosopher Ken Wilber identifies four major stages of personal development or evolution.[5] The perceptions of higher stages are superior to their lower-stage counterparts. Children, Wilber notes, tend to be *egocentric*. As such, their world and judgments tend to revolve around themselves, their feelings, needs and naïve beliefs.

In early adolescence or sooner, their scope of concern begins to widen towards group identification or *ethnocentrism*. They identify with their family, church, school, town, teams, and country. Relative to nation, the attitude here can be as narrow as "My country, right or wrong." Many people never move beyond ethnocentrism. And in practice, their tribal superiority complex often leads to what Wilber calls "dominator hierarchies," where control extends beyond the abstract realm of "truth" and "facts" to the politics of imperialism, war, and even slavery.

Those who move beyond ethnocentrism advance to the next evolutionary stage, *world-centrism*. Here allegiance shifts from my tribe and country to the world and human race. At this stage it becomes possible to criticize even habitually one's tribe and country from the viewpoint of outsiders, "foreigners," and independently verifiable data. Dominator hierarchies become less acceptable.

A final (as far as we can tell) stage of development is *cosmic-centrism* or what Wilber terms "integral thinking." The cosmic-centric thinker is a mystic, who realizes the unity of all reality, animate and inanimate. (S)he holds that separation between human beings and their environment is only apparent. As many of them put it, "There is really only one of us here."

The crucial point to note in this context, is that each of these developmental stages has its set of "alternative facts."

Charlottesville and *American History X*[6]
Seen Through Critical Thinking's Magic Glasses

Keeping in mind the controversy around the August, 2017 white supremacist rally and violence in Charlottesville VA, you might want to watch *American History X* again. Some probably remember it well, even though it premiered in 1998—before some reading this book were born. However, the events in Charlottesville make the film more contextually relevant than ever, since it depicts the inner dynamics of a white racist gang, and the psychology of its leaders and members.

Without mentioning the phrase, "X" also says much about critical thinking and how it's dependent on one's stage of personal development and growth beyond the stage of ethnocentrism—in its case, the nationalism reflected in white supremacy.

Recall the narrative. Like the Charlottesville backstory, the plot of "American History X" centers around white supremacists afraid that they're losing control of their neighborhood and what they consider their country.

Derek Vineyard (Edward Norton) is the main character. He becomes a white supremacist after his father, a Los Angeles firefighter, is killed in the line of duty. Crucially for Derek, his father's killers were members of an African-American street gang.

That personal tragedy leads Derek into deep ethnocentrism. He not only joins a skinhead gang, but there he uses his extraordinary leadership charisma and street eloquence to become its legendary head and inspiration.

Here's a speech that Derek gives to gang members before they trash a grocery store owned by an Asian immigrant:

"We need to open our eyes! There are more than two million illegal immigrants bedding down in this state tonight. The state spent three billion dollars last year for services for people who had no right to be here in the first place. Three billion dollars! Four billion just to lock up a bunch of immigrant criminals, who only got into this country, because the fuckin' INS decided it's not worth the effort to screen for convicted felons. Who gives a shit? Our government doesn't give a shit. Our border policy is a joke. So is anybody surprised that south of the border they're laughing at us—laughing at our lives? Every night thousands of these parasites stream across the border like some fuckin' piñata exploded. (Laughter) Don't laugh. There's nothing funny going on here. This is about your life and mine. It's about decent, hard-working Americans falling through the cracks and getting the shaft because their government cares more about the 'constitutional rights' of a bunch of people who aren't even citizens of this country. I mean, on the Statue of Liberty, it says 'Give me your

tired, your hungry, your poor.' Well, it's Americans who are tired and hungry and poor. And I say, until you take care of that, close the fuckin' book, 'cause we're losin'. We're losin' our freedom, so that a bunch of fuckin' foreigners can come in here and exploit our country. And this isn't something that's goin' on far away. It isn't something that's takin' place somewhere we can't do anything about it. It's happening right here—right in our neighborhood—right in that building behind you. Archie Miller ran that grocery store since we were kids here. Dave worked there. Mike worked there. He went under. And now some fuckin' Korean owns it who fired these guys and is making a killin' because he hired 40 fuckin' border jumpers. I see this shit goin' on and I don't see anyone doing anything about it. And it fuckin' pisses me off."

The one chiefly influenced by Derek's example is his younger brother, Danny (Edward Furlong), who idolizes his brother and so becomes roped into the white gang's culture.

After Derek shoots one and brutally stomps to death another of two black men attempting to steal his truck, he's sent to prison for three years. There interactions with other white supremacists whose actions reveal their hypocrisy, along with an unlikely friendship with an African-American inmate open Derek's eyes. He emerges from prison a changed man. He rejects his skinhead ideology, formally leaves his gang, and makes it his mission in life to open the eyes of his younger brother who is already well along the path following in Derek's footsteps.

In other words, Derek moves from a stage of ethnocentrism to something like world (or at least multi-racial) awareness that makes him more understanding and accepting of those he previously despised. What he takes as fact has changed dramatically.

The film's conclusion even hints at a dawning cosmic-centrism on the part of Danny who narrates the film. Just before the credits roll he quotes someone (unnamed) who has said, "We are not enemies, but friends. We must not be enemies. Though passion may have strained, it must not break our bonds of affection. The mystic chords of memory will swell when again touched, as surely they will be, by the better angels of our nature." Put otherwise, Danny realizes that mystical recollection of a Higher Self ("the better angels of our nature") will, despite contrary passions, prevent the severance of kinship's bonds that precede the historical events that tend to divide us one from another. That's cosmic-consciousness.

Take the question of Donald Trump's inauguration audience. According to many observers, Mr. Trump has largely been fixated at the stage of egocentrism (with, no doubt, ethnocentrism rising). Accordingly, he evidently thinks that because

of his exceptionality, brilliance, and importance, his crowd must have been larger than that of President Obama, because the latter isn't nearly as important or smart as Mr. Trump. At Trump's stage of development, his perception constitutes a fact, pure and simple. Those who disagree are disseminating fake news.

For their parts, the dissenters—reporters, for instance—are usually ethnocentric. In the United States, they typically report from an "American" point of view. They regard Mr. Trump's statements about crowd size as lies, since his assertions do not agree with readily available independent data information. As previously noted, the D.C. police, for instance, say that Mr. Obama's crowd was four times larger than Mr. Trump's. Moreover, ethnocentric reporters regard Mr. Trump's lies as particularly egregious, because the falsehoods bring discredit and shame on the United States, which they typically consider the greatest and most virtuous country in the world.

Those with world-centric consciousness subscribe to yet another set of alternative facts. While agreeing that independent data are important for "fact checking," they emphatically disagree with the premise that the United States is exceptional in its greatness or virtue. Simply put, it is *not* the greatest country in the world. Instead, for many (especially in the Global South with its history of United States-supported regime changes, wars, and dictatorships), fact-checked data show that "America" is the cause of most of the world's problems. In the words of world-centric Martin Luther King, it is the planet's "greatest purveyor of violence." That recognition shapes and relativizes every other judgment of fact.

Cosmic-centered thinkers profoundly disagree with the so-called "facts" of all three previous stages of development. Nonetheless, they recognize that all human beings—and they themselves—must pass through the stages of egocentrism, ethnocentrism, and world-centrism before arriving at cosmic-centrism. That is, though most humans do not surpass ethnocentrism, no stage may be skipped. One cannot become world-centric without having previously been ethnocentric. One cannot adopt a cosmic-centered viewpoint, without first having traversed the world-centric stage. So, instead of anger, those with cosmic consciousness experience great compassion, for instance, towards Donald Trump and his critics both patriotic and more cosmopolitan.

Nonetheless, mystics approaching "facts" from their particular altitude insist that antecedent stages of awareness, though true in ways appropriate for those phases, are at best incomplete. All of them are incapable of discerning the Universe's single most important truth that renders all else highly misleading. And that's the fact is that all consciousness of separation is itself an illusion. Hence the size of Donald Trump's inauguration audience is completely irrelevant. But so are questions about "the greatest country in the world." No country is greater than any other. In the end, the only truth is God (or some equivalent term) and divine love.

Nationalist separation, fear, war, hatred, and associated attitudes are all false. They remain without factual support.

Cognizant of Wilber's developmental stages, I intend to illustrate (in chapters three and four) what I mean by using my own growth process as an example. It will suggest that our lives' journeys, our lived experiences, learning foreign languages, achieving critical distance from families and cultures, and our encounters with great teachers and thought leaders, can all help us gain higher levels of consciousness better able to grasp more evolved levels of critical thinking. In my own case, exposure to critical thought as explained, practiced and stimulated in former European colonies like Brazil, Nicaragua, Guatemala, Costa Rica, Mexico, Zimbabwe, South Africa, Israel, and India gradually raised my critical awareness that the Global South's "alternative facts" about economics and history must underpin any critical thought worthy of the name. This is because the Global South and impoverished perspective tends to be fuller than its developed world counterpart.

Poverty and Critical Consciousness

Think about that for a moment. Those of us who are rich and/or comfortable actually have very limited experience and awareness. Our communities are pretty much siloed and gated. As a result, we can live without consciousness of the poor at all. Wall Street executives rarely really see them. The poor are located in other parts of town. Most, even in the middle class, never enter their homes or schools. The comfortable have no immediate experience of hunger, coping with rats, imminent street crime, living on minimum wage, or cashing in Food Stamps. Even if they notice the poor occasionally, the comfortable can quickly dismiss them from their minds. If they never saw the poor again, the rich and middle class might easily think their lives would continue without much change. In sum, they have very little idea of the lived experience of the world's majority.

That becomes more evident still by thinking of the poor outside the confines of the developed world who live on two dollars a day or less. Most in the industrialized West know nothing of such people's languages, cultures, history, or living conditions, whose numbers include designated "enemies" living in Syria, Iraq, Somalia or Yemen. Even though our governments drop bombs on the latter every day, people in those places can remain mere abstractions. Few of us know what it really means to live under threat of *Hellfire* missiles, phosphorous bombs or drones. Similarly, we know little of the actual motives for "their terrorism." Syria could drop off the map tomorrow and nothing for most of us would change.

None of this can be said for the poor and the victims of bombing. They *have to* be aware not only of their own life's circumstances, but of the mostly white people, who employ them, shape their lives, or drop bombs on their homes. The poor serve the rich in restaurants. They clean their houses. They cut their lawns. They beg from them on the streets. The police arrest, beat, torture and murder their children.

If the United States, for example, dropped off the planet tomorrow, the lives of the poor would be drastically altered. In other words, the poor and marginalized must have dual awareness. For survival's sake, they must know what the rich minority values, how it thinks and operates. They must know more about the world than the rich and/or comfortable.

That's why when the poor develop "critical consciousness," their analysis is typically more comprehensive, inclusive, credible, and full. They have vivid awareness not only of life circumstances that "make no difference" to their comfortable counterparts; they also have lived experience of life on the other side of the tracks.

Conclusion: Fake News and Plato's Allegory of the Cave

One might easily argue that fake news separated from the critical consciousness just described predates our modern world altogether. Back in the 5th century BCE, Plato of Athens depicted something like it in his "Allegory of the Cave," which has always played a central part in my own teaching. Since the image is so important and informs this book's general approach, I find it pertinent to conclude this chapter by recalling the story's details and relating them to the project at hand.

To begin with, Plato's allegory[7] has been visually portrayed like this:

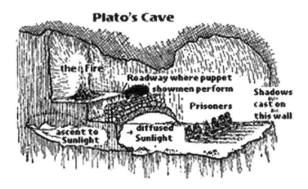

Figure 1.1: Plato's Cave. Source: "The Cave" from GREAT DIALOGUES OF PLATO by Plato, translated by W.H.D. Rouse, translation copyright © 1984 by J.C.G. Rouse. Used by permission of New American Library, an imprint of Penguin Publishing Group, a division of Penguin Random House LLC. All rights reserved.

In his allegory, Plato described the human condition as that of prisoners confined from birth to a cave. Within its confines, they live within a shadow world. Taking liberties with the tale, I've always told it as follows:

Prisoners in the cave pass their entire lives chained alongside one another, unable to move or even turn their heads to see companions seated alongside them similarly constricted. Instead, everyone confined to the cave faces the cavern's back wall. Upon that surface, what the prisoners take for themselves and life itself is imaged before them in the form of shadows.

The shadows appear because behind the prisoners' backs a fire acts like a movie camera in a dark theater, causing the shadows of those before it to be projected on the cave's blank wall. So the prisoners see themselves and those beside them only in specter form. In other words, the prisoners are completely alienated from their true selves.

Behind the prisoner's back, and between them and the fire there stretches what Plato calls a parapet. It's a long elevated pathway that runs the width of the cave. Shielded by the parapet's wall, men walk unseen, each carrying a statue overhead. There are statues of everything you might think of: flowers, trees, animals, buildings, gods and goddesses ... As they pass before the fire, the statues, but not their bearers, appear as shadows on the cave's wall.

The prisoners watching the parade, imagine that life is unfolding before them, even though, in reality, their perception is artificial to say the least.

Then one day, one of the prisoners has his chains struck (we are not told how). Slowly, and with great discomfort, he manages to stand. In the fire's light, he observes the actual bodies of those chained alongside him. He turns and though the fire's light stabs his eyes, his vision gradually adjusts allowing him to see the blaze and the parapet running before it. He sees the statues for what they are and eventually even the ones carrying them.

"And what's that beyond the fire?" he asks himself. Why, it's a pathway leading who knows where. The freed prisoner decides to follow the path. Stumbling and falling, he's swallowed up in the darkness of the cave's elongated entrance tunnel. Finally, however, things brighten as he approaches the cave's entrance.

Then all at once, he's there. He emerges into the real world, blinded by the terrible splendor of the sun. His eyes adjust and the panorama before him is stunning. For the first time, he sees real flowers, real trees, animals, birds, buildings, and people walking freely about. Finally, he's able to look fleetingly at the source enabling such wonderful visions, the sun itself. He has entered the real world and is free at last.

But then he remembers his fellow prisoners left behind in the dark cave. He pities their bereft condition, and resolves to set them free. Back to the cave he goes, this time feeling the cavern's darkness more oppressive than before. He stumbles back to the fire and presents himself before the prisoners with his good news.

"This is not reality!" he exclaims. "There's a whole world outside this cave more wonderful than anything you can imagine. I have only to strike your chains, so you might leave here and enjoy an unimaginably fuller life. Let me set you free!"

Plato asks, how do you suppose the prisoners will receive the escapee's message? Will they welcome him and follow his lead to freedom? Far from it, Plato replies. On the contrary, if they could, they would rise up and kill him for disturbing their comfortable tranquility.

Such is the fate of all great teachers, Plato observes. It's what happened to his beloved Socrates whom the citizens of Athens executed for "corrupting the youth." Socrates' crime was teaching the young to think critically. In fact, Plato's allegory describes the journey of critical thinking—from acceptance of shadow-reality through facing the hard truth of having been tricked, to a thrilling sense of liberation followed in many cases by rejection and hostility from friends, relatives, and strangers content with being duped.

Plato's message suggests that we are all prisoners by choice. We're locked in our cultural cave whose world vision is so profoundly distorted that it deprives us of life itself. In fact, we love the chains that bind us. And that love has created a drab, stultifying reality. Our chains' links are forged from fear of the unknown—of life itself—and of our own freedom and power. We're afraid of what might happen to us if we embrace life without illusion. We're wedded to our comfort with what we've always known. From that perspective, liberation strikes us as threatening and insane. Nonetheless, our prison cell's door stands open before us. We have only to replace fear with courage, love of life, and willingness to change. The reward is new vision—another way of looking at things, and fullness of life itself.

Today such reward is experienced by those who realize their own manipulation at the hands of manufacturers of fake news constructed by ethnocentric dominator hierarchies whose purveyors are not simply mass media, but other (usually good-willed) upholders of the status quo—parents, educators, politicians, priests and ministers …

Because of its comprehensive nature, it is critical consciousness not only "from the underside of history," but from outside our cultural cave that will be exposed and applied in this volume.

For Discussion

1. How would you describe your own stage of personal development? Is it egocentric, ethnocentric, world-centric, or cosmic-centered?
2. Has anyone in your life influenced you the way Derek influenced his brother, Danny in *American History X*?

3. Each element in allegories stands for something else in the real world. Within Plato's allegory, what do the following represent: the cave, the prisoners, their chains, the shadows, the fire, the statues, their bearers, the escapee, the sun?

4. What thoughts and/or insights did Plato's allegory inspire within you?

Notes

1. Harry G. Frankfurt and Michael Bischoff. *On Bullshit*. Frankfurt am Main: Suhrkamp, 2014.
2. Ken Wilber. *Trump and a Post-Truth World: an evolutionary self-correction*. Boulder Colorado: Shambhala, 2017.
3. Noam Chomsky. *Necessary illusions*. Toronto, ON: CBC Enterprises, 1990.
4. I COR 13:4.
5. Ken Wilber. *Integral Spirituality*. Boston: Integral Books, 2006.
6. *American History X*. Dir. Tony Kaye. Perf. Edward Nortorn, Edward Furlong, Faizura Balk. New Line Cinema, 1998.
7. Plato. *The Allegory of the Cave*. Brea, CA: P & L Publication, 2010.

My Own Escape From Our Culture's Cave

From Ego-Centrism to Global Awarensss

Let me put some flesh on the abstractions I've shared so far. I include autobiographical detail in these next two chapters to explain the origins of the conclusions and principles I intend to present later on in this book. They all came to me quite gradually and despite my sometimes fierce resistance.

I also present these segments to raise questions for the reader about issues connected with the Global South and its relationship to the United States and its policies. I'm guessing that questions similar to the ones that arose for me in the course of my travels, may also have occurred to you. Hopefully, the rules for critical thinking elaborated in subsequent parts of the book will suggest answers involving colonialism, capitalism and socialism, poverty, U.S. policy itself, violence, terrorism, and war. In the contemporary world, those, after all, constitute the topics worthiest of critical thought.

The odyssey I'll describe has taken me across five continents—from my hometown, Chicago to Delhi. My journeys had me gathering wisdom from my earliest school teachers, and later from world-renowned philosophers and theologians, as well as from revolutionary fighters, community organizers, gurus, teachers of meditation, and as-yet-to-be-canonized saints. As the story unfolds, I hope you can witness my horizons expand. There is nothing like language study, travel, and challenges from outside one's cultural cave to stimulate critical thinking. Watching my process may make you aware of your own.

Like everyone else's, my horizons were highly constricted at first. To be perfectly honest, I did not start thinking in truly critical ways till perhaps the age of 25. Yet before then, I was extremely concerned with thinking and truth. As a candidate for the Catholic priesthood from the age of 14, I studied Catholic "apologetics" and took it all quite seriously. Apologetics meant rational, logical "defense of the faith." Later as a philosophy major in the Catholic seminary, my whole academic orientation dealt with rational approaches to subjects such as metaphysics, cosmology, and logic itself.

Yet despite such emphasis on rational thought, I was not really thinking critically. Instead, my thought processes remained limited by what philosopher, Ken Wilber and others describe as those early stages of consciousness through which every human being must pass. As previously noted, they begin with egocentrism, pass through ethnocentrism, and finally (for some) arrive at global and possibly even cosmic-centrism.[1]

Reflection has shown how each stage of my own growth along those lines suggested one or more of the ten rules for critical thinking that I mentioned in the introduction.

Egocentrism

I was always a very religious boy. Living on Chicago's northwest side, my working class parents (my father was a truck driver, my mother a homemaker) had sent me to St. Viator's Catholic Grammar School from kindergarten through 8th grade. Every grade there was taught by a Sister of St. Joseph of Carondelet. I have nothing but fond memories of them. They enhanced my spiritual sensitivities. Under their tutelage, I attended Mass every day, went to confession each Saturday, and became a "Knight of the Altar" (altar boy) advancing to the rank of "Vice Supreme Grand Knight." I prided myself in learning the associated and complex Latin prayers perfectly. I loved all of that and wanted to be like Father Burke, the young but strict disciplinarian who was in charge of St. Viator's School.

With that sort of background, it comes as no surprise that my first worries in life were about the salvation of my eternal soul. That's the form my egocentrism took. I needed to secure heaven and avoid hell at all costs. Nothing else mattered.

So seriously did I take the task that I found myself afflicted early on with a case of scruples that recurred for me periodically till my early 20s. Scruples meant that I worried about and feared as sinful what other saner people would not—especially anything that might be associated with sex. So I became obsessed with confessing my "sins," lest I die in mortal sin and lose my eternal soul forever. That

form of obsessive-compulsive behavior was very painful for me. But with help from various spiritual directors, I gradually gained the courage to think for myself (even about God and sin). I remember thinking: "I can't go on like this. If I'm going to hell, I'm going to hell. But I'm trusting that God is not that fearful Being 'up there' looking for the least excuse to condemn me. I'll take my chances."

That in itself was a step away from ego-centrism and a nascent expression of critical thinking, at least in the religious sphere. I was somehow unconsciously employing the principle, "Connect with your deepest self."

Ethnocentrism

My ethnocentrism grew alongside the first stage in personal development just described. It meant that I was fiercely Catholic. For me, that was my primary group identification, my tribe. At that stage, in terms of critical thinking, no other denomination, and certainly no other religion had anything to do with truth that really mattered. All Protestants were simply wrong and destined for hell. For me, that was a fact.

Such conviction stuck with me and grew after I entered St. Columban's Minor Seminary in Silver Creek, New York (40 miles west of Buffalo) at the age of 14. The seminary belonged to the Society of St. Columban—a missionary group founded in Ireland in 1918 as the Maynooth Mission to China. Its calling involved converting Chinese "pagans" who without our ministries, we all believed, would themselves be bound for hell—another fact.

At this stage, my second ethnocentric form of allegiance was to my country. I remember being confused during a "day of recollection" that our entire seminary (about 100 students) attended at a corresponding institution run by the Passionist Fathers in nearby Dunkirk, New York. That was around 1955, only 10 years after the conclusion of World War II. A rather elderly priest from the host seminary gave some kind of keynote talk. In its course, he described the dropping of atomic bombs on Hiroshima and Nagasaki as "the most immoral act in human history." I was shocked and entirely confused. Was this man a communist or what?

My suspicions were aroused by the fact that missionaries on leave from assignments in the "Far East" often regaled us with stories of the evil communists who had by then driven our men and other foreigners from China following Mao Tse-Tung's revolution in 1949. Communist Marxists hated the Blessed Virgin, we were told. That was enough for me. Communists were evil incarnate.

Similarly, those who opposed them at home were correspondingly virtuous. One evening in 1957 during study hall, one of my most admired professors who

was proctoring the session, passed by my desk and whispered, "A great man died today." He was referring to Senator Joseph McCarthy who died on May 2nd of that year.

In 1964, at the age of 24 I cast my first ballot for president. I voted for Barry Goldwater. That shows how ethnocentric I was. In terms of critical thinking, my proud and sincere guideline was "My country right or wrong." My facts were those of Mr. Goldwater, the Catholic Church, Joseph McCarthy, and J. Edgar Hoover.

World Centrism Emerges

My horizons started broadening in 1962. It was then that I began accepting a whole set of facts alternative to what I previously believed. That began to happen soon after Pope John XXIII convened the Second Vatican Council (1962–65) to reform the Church of Rome.

That represented the thin end of a wedge that would gradually change forever what I considered true. The Second Vatican Council seemed to call my most cherished beliefs into question. It recognized that Protestants were "Separated Brethren" rather than enemies surely destined for hell. The notion of priesthood was widened to include their concept of "priesthood of the faithful." Council theologians also problematized conceptions of church as the "perfect society" as well as papal infallibility. That in turn led to conclusions about an "*ecclesia semper reformanda*" (i.e. a church in need of continual reformation). Mandatory celibacy was criticized as an impediment to personal growth among the clergy. Seminary curricula like the one I was following in St. Columban's Major Seminary were disparaged for their narrowness and tendencies to indoctrinate rather than educate.

Initially I resisted all of that in the name of my faith and tradition. But my ethnocentrism was under assault.

Rome

My resistance though couldn't last. Following ordination, I was sent to Rome to secure my doctoral degree in moral theology. So I left the seminary hot house, where I had spent my formative teenage and early adult years. Suddenly, I found myself in an international atmosphere that in every dimension was so much more sophisticated than anything I had previously experienced. Rome's context was still electric in the immediate aftermath of Vatican II. And the Council's spirit was

reflected in the courses I took at the Athenaeum Anselmianum and Academia Alfonsiana. In their light, my secure notions of theological truth underwent continual challenge.

Eventually, I found it all quite liberating.

However, on the political front, it was shocking and embarrassing. Remember, these were the late '60s. The anti-war movement was in full swing, along with the struggle for Civil Rights, the sexual revolution, and women's liberation. It was the era of "Troubles" in Ireland. Martin Luther King and Bobby Kennedy were both assassinated in 1968. My last year in Rome (1972), George Wallace was shot, and the Palestinian group, Black September, terrorized the Olympic games in Munich.

Meanwhile, I was living in the Columban residence on Corso Trieste with about 15 other young priests all pursuing graduate work. Two of us were American. The others came from Ireland, England, Scotland, New Zealand, and Australia. Our conversations over meals revealed to me my narrowness of perspective. All my colleagues were better informed than me. They even had a superior grasp of U.S. history.

I resolved to remedy that and gave myself a crash course in current events courtesy of *Time Magazine*. I even ended up winning our small community's annual political literacy contest. However, that sort of knowledge turned out to be quite superficial.

Gradually, especially because of my theological studies, I was drifting more and more leftward. In the field of theology, what I was learning had me challenging my colleagues' more traditional ideas about the humanity of Jesus, the faults of the church, and the whole idea of trying to convert "pagans" from Buddhism, Hinduism and Islam to Christianity.

None of that sat well with superiors in the Society of St. Columban. Towards the end of my stay in Rome, I was informed that plans had changed. Whereas the whole purpose of sending me to Rome had been to prepare me to teach in our major seminary, I was now considered too "dangerous" for that. I would be sent to Mindanao in the Philippines instead.

For the first time, I considered leaving the priesthood.

Politically, I became similarly alienated. It stemmed from my thought that if what I had been taught about God, the Church and even Jesus were untrue, if I could question the pope, whom I had always considered infallible, why not the U.S. government? Daniel Ellsberg's publication of *The Pentagon Papers* in 1971 sealed the deal. Eventually, I strongly opposed the War in Vietnam. I became a McGovern Democrat.

My journey towards world-centrism advanced.

Appalachia

After returning to the United States, with my doctoral degree in hand, I spent a "year of discernment" to decide whether or not to remain a Columban. Working as a priest for The Christian Appalachian Project in the foothills of Kentucky's Cumberland mountains gave me first-hand experience of the poverty I had read about in Michael Harrington's *The Other America.*[2] It also introduced me to Berea College, where, beginning in 1974, I would spend my next 40 years teaching. Berea had been founded by Christian abolitionists in 1855. It retained its commitment to inter-racial justice, to the Appalachian region, and gradually accepted a revised and remarkably open understanding of Christian faith.

At Berea College, those commitments required me to teach a first-year General Studies course called "Issues and Values." And that meant learning about black history, women's liberation, world religions, the environmental crisis, and the issue of world hunger. Faculty development seminars helped prepare us to teach texts including *The Autobiography of Malcolm X,*[3] "The Seneca Falls Resolutions,"[4] the Club of Rome's *Limits to Growth,*[5] *The World's Religions* by Huston Smith,[6] and *Food First*[7] by Frances Moore Lappe and Joseph Collins. The course was life-changing for my students—and for me.

Even more so was a two semester Great Books course, "Religious and Historical Perspectives" (RH&P) which I began teaching my third year at Berea. Required of all sophomores, the course had a dozen or so sections staffed by professors recruited from across the curriculum. The unspoken rule among them seemed to be "Never admit that you don't know everything." This put me at a considerable disadvantage. For the truth is, though I had taken innumerable courses in (mostly Church) history, I still didn't really understand it. I couldn't see the pattern. To me, history was quite boring; it seemed like one damn thing after another—most of which I couldn't remember.

That all changed with RH&P. Like "Issues and Values," the course centralized faculty development seminars in which colleagues from the fields of history, English, sociology, economics, biology, physics, religion, and political science spent the first three weeks of our summer vacations reading about, studying, and discussing topics like the medieval period, the scientific revolution, Marxism, apocalyptic literature, and evolution. That prepared us to teach our students primary sources including the Bible and authors like Hesiod, Homer, Tacitus, Cicero, Augustine, Luther, Calvin, Dante, Copernicus, Galileo, Newton, Locke, Jefferson, Kant, Adam Smith, Ricardo, Marx, Swift, Mary Shelly, Einstein, and Dietrich Bonhoeffer. It was the best educational experience of my life. For the first time, I found myself understanding history and its patterns. In particular, my study of

Marx and *The Communist Manifesto* made even clearer to me the ethnocentrism of my previous education. I began to realize that I had spent my life studying the rationalizers and defenders of the elite capitalist establishment. I had been taught to despise the philosophers and historians of the working class like Marx himself. My long years in the classroom had given me an understanding of the world alien to my own class roots.

As you can see, I was gaining distance from my ethnocentrism. As I later would put it in my Ten Rules of Critical Thinking, I finally saw the value of respecting history. I was already nearly 30.

Brazil

My insights from R&HP were deepened when in 1983–84 (at the age of 43) I took my first sabbatical and traveled to Brazil. My studies there did wonders for my personal growth and unfolding understanding of facts, truth and critical thinking as essentially relative to one's stage of personal development.

My chosen task in Brazil had been to pursue post-doctoral studies in the field of liberation theology, which had become a central interest of mine. In Rome I had been introduced to the topic. It was part of what had begun broadening my horizons there. I discovered it to be a strain of discourse about God as imagined by impoverished Christians in the former European colonies especially in Latin America, but also in Africa and South Asia. Liberation theology emerged from peasants, factory workers, students and housewives who found in the Bible a reflection of their own lives and an inspiration to work for social change. In the stories of the ancient Hebrews they saw people enslaved and colonized as they had been. They discovered in the Book of Exodus a God whose concern was to liberate such slaves and install them in a land "flowing with milk and honey."

Similarly, in Jesus the exploited found a champion who promised them a place in a this-worldly Kingdom of God, where everything would be turned upside-down. The poor would become solvent, while the rich would be dethroned; the first would be last, while the last would be first. For liberation theologians, the Kingdom of God is what the world would be like if God were king instead of Caesar. Moreover, in Jesus Latin America's beggars, street people, women, peasants, factory workers, and students recognized a kindred spirit. Like them, he was poor and born under a cruel colonizing power. He was the son of an unwed teenage mother, brown-skinned and a friend of prostitutes and sinners. He was homeless at birth and an immigrant in Egypt in his early years. Later he became an enemy of the state. He experienced constant surveillance, and was considered a terrorist.

Jesus finished, like so many of Brazil's poor during the '60s, '70s and '80s, a victim of torture and capital punishment.

My study in Brazil initiated a profound change in my understanding of critical thinking. It led me to see liberation theology itself as a Global South version of that discipline. Its critical dimension was heavily influenced by the work of Paulo Freire, one of the world's preeminent critical thinkers and theoreticians with whom my wife, Peggy, worked our entire time in the country as she completed her doctoral dissertation on Freire himself. As a result, his *Pedagogy of the Oppressed*[8] and *Education for Critical Consciousness*[9] along with frequent conversations with Paulo in his center and home made a tremendous impact on both of us. Freire's work understood critical thinking in terms of *conscientizacao*, or consciousness-raising that helped the oppressed discover the true nature and causes of their oppression.

Freire's version of critical thinking didn't concern itself with abstract dilemmas and logical fallacies. Instead it addressed problems confronted in the very lives of its protagonists—hunger, poverty, dictatorships, imprisonment, torture, police raids, and the reasons for widespread hunger in an extremely rich and rather thinly populated country.

Neither did Freire worry about neutrality and balance or with giving equal time to capitalists and their working class opponents. For him, those problems had long since been settled. After all, in 1964, defenders of capitalism had overthrown Brazil's democratically elected government. In the 1960s that had been the case throughout the region. In Brazil it meant that by 1984 the country had completed its second decade of a military dictatorship fully supported by the United States. Over those years, vast numbers of priests and nuns, union organizers, university professors, social workers, lawyers, and simple peasants had been routinely imprisoned, tortured and often murdered. Their crimes? They had demanded land reform, higher wages, health care, education, freedom of speech, and ability to organize. No: capitalism in Brazil and elsewhere in Latin America had clearly shown itself to be the enemy of the people.

As a theologian, I wanted to know more about the intellectual and spiritual underpinnings of that approach to critical thinking.

To that end, I enrolled in a semester-long seminar taught by liberation theologians, philosophers and scripture scholars I had been reading for years—figures like Argentina's Enrique Dussel, Chile's Pablo Richard, Belgium's Francois Houtart and Brazil's own Frei Gilberto Gorgulho and Ana Flora Anderson. In the course of the experience, I was also introduced to the work of German economist and theologian, Franz Hinkelammert, who would become for me an extremely important mentor. Significantly, Franz was to later found the international *Grupo de Pensamiento Critico* (the Critical Thinking Group).

Again, I wondered, about the analytic key to this sort of thought.

I later found it was the dependency theory of the German-American sociologist and historian, Andre Gunder Frank.[10] Gunder Frank traced everything back to the history and structures of colonialism and neo-colonialism (to be explained here in Chapter 14). I resolved to find out more about that; it seemed essential to this kind of critical thought. I asked for sources. Other than Gunder Frank's works themselves, my seminar colleagues told me to read Eduardo Galeano's *The Open Veins of Latin America.*[11] For perspective on Africa, they recommended Walter Rodney's *How Europe Underdeveloped Africa.*[12] I immediately purchased the books and my education in critical thinking took another giant leap forward.

As one of my Ten Rules would later express it, I was at this point, beginning to suspect that truly critical thought involved rejecting any pretense of neutrality.

Nicaragua

That suspicion was confirmed, when in 1985 I visited Nicaragua for the first time. It had experienced a Marxist revolution in 1979. My purpose in going was two-fold. I wanted to experience life in a revolutionary situation myself and also to learn Spanish, which was increasingly necessary for my work in liberation theology. Languages, by the way, are nearly universally recognized as powerful aids to critical thinking. They stretch the mind by expanding awareness of other cultures, different points of view and ways of expression.

Along those lines, one of the strengths of my training for the priesthood had been language study. In high school it began with Latin my freshman year. Then came French and Greek. All of those studies continued through my sophomore year in college. Next, of course, I had to learn Italian for my years in Rome. Just before that I needed a semester of Hebrew to qualify for theological studies there; so I took a summer course at Harvard. Once in Rome, it became apparent that German would be essential for my doctoral thesis on Jurgen Moltmann and his *Theology of Hope.*[13] That led to two summers' study at the University of Vienna. Then I needed Portuguese for my sabbatical in Brazil. And finally, in '85 it was Spanish in Managua.

For two summers, I studied at *Casa Nicaraguense de Español*. It had students living with Nicaraguan families, leaving for Spanish class every morning and then studying the Revolution every afternoon. We visited prisons, farming co-ops, and offices of both the ruling Sandinista Party and of their political opponents. The experience was difficult, but invaluable in terms of widening my horizons and acquainting me with revolutionary thought and practice. Over the next 20 years

I would return to the country a dozen or more times. In 1990 I would do so as an Official Observer of the election that defeated the Sandinistas, replacing them with a U.S.-supported party. I edited a memoir on the topic.

On that first visit, however, I was amazed by the range of books available in Managua that I would never have otherwise encountered. They covered all aspects of Marxism, socialism, history, education, liberation theology—and critical thinking. It was a treasure trove for me. Reading those books acquainted me with a line of thinking "forbidden" to most Americans. Conversations in Nicaragua about liberation theology and social analysis kept referencing Costa Rica's Franz Hinkelammert.

Costa Rica

That meant that the next stop on my odyssey would be Costa Rica where I finally met Franz, whose Global South approach to critical thinking provided the theory I sought to make everything I had learned in Brazil come together. Recall that I had encountered his latest work while in Brazil.

Franz is a German economist and theologian. After coming to Latin America in 1966, he lived and worked mostly in Chile. But then the 1973 U.S.-sponsored coup removed the democratically-elected Socialist president of the country (Salvador Allende). The subsequent installation of a brutal dictatorship under General Augusto Pinochet, made Chile extremely dangerous for people like Hinkelammert. So he fled to Costa Rica, where he, liberation theologian giant, Hugo Assmann, and biblical scholar, Pablo Richard founded the Department of Ecumenical Investigation (DEI), a liberation theology think tank. The DEI specialized in preparing grassroots organizers to work for social change throughout Latin America. However, its emphasis was not on "training" for activism, but specifically on analysis and critical thought.

My opportunity to study with Franz came with my second sabbatical in 1992. Peggy and I applied and were accepted as the first North American participants in the DEI's annual Workshop for Invited Researchers. The eight-week course hosted about 20 scholars from across Latin America. Each of us had a research project whose goal was publication in the DEI's quarterly, *Pasos*. Not surprisingly, mine was on critical thinking.

During the workshop, Franz, Pablo Richard, and fellow Chilean, Helio Gallardo were the principal presenters and discussion leaders. In his own lectures, Franz emphasized what is for him an enduring key idea about critical thinking. It is expressed most clearly in his *Critique of Utopic Reason*[14] and also in his *Critique*

of Mythic Reason.[15] In both, he highlights the essentially utopian nature of critical thought. Its point, he says, is not simply to analyze arguments for logical fallacies. Instead, it is political. It is essentially utopian—to create a better world by imagining the best possible world. Hinkelammert's defense of utopian reason runs as follows:

1. If politics is the art of the possible,
2. Then a utopian idea of the impossible, but at the same time desirable, is required
3. Not necessarily as a goal to be implemented
4. But as a "North Star"
5. Guiding critical thought and action towards what indeed can be practically accomplished.
6. No such goal can be arrived at without utopian ideas towards which critical thinking gestures.
7. Utopian thought comes naturally to human beings.
8. In fact, critical thought without utopian concepts is itself unconsciously utopian.

Franz develops those ideas by pointing out that utopias are not at all merely the province of starry-eyed idealists. They are essential for any critical thought intent on beneficial social change. In that sense, Franz's own North Star for critical thought is the simple idea later articulated by the Zapatista rebels in Mexico—as a world with room for everyone. Meanwhile, as we'll see in Chapter Four, the capitalist utopian ideal is that of a completely free market governed only by Adam Smith's "Invisible Hand." That is the guiding constellation under whose direction all mainstream economic theory is fabricated.

Hinkelammert's argument illustrates the difference I've been trying to describe between critical thinking as taught in the United States and what I discovered in the Global South. In the Global South, critical thinking is concerned with the big picture—with entire systems, with social analysis of economic and political structures. As explained by Franz and others, it is by no means a matter ferreting out what is now called "alternative facts" or "fake news." Such concern glosses over the lies embedded in the very parameters of perception which act as blinders for both students and their teachers. In that sense, the critical thinking I had become used to had been literally partial in its ignorance and denial of the experience of the world's majority who live in the former colonies. From that viewpoint concentrating on logical inconsistencies or falsehoods in arguments divorced from the unexamined socio-economic matrix of capitalism only serves to normalize what should be completely unacceptable to human beings.

For Hinkelammert, *that* was the insight suggested by Karl Marx. Marx in particular was a humanist who saw critical thought as focusing on human emancipation from the chains imposed by capitalism and the colonialism on which it depended. Critical thinking, in Marx's estimation, involved identifying those chains and the steps necessary to humanize all relationships between persons and with nature itself. In theological terms, the mandate is: "Do what God did; become a human being!" That is the utopian project of the type of critical thinking I was now encountering.

Cuba

My first trip to Cuba took place in 1997. Berea College sent me there as a delegate with The Greater Cincinnati Council of World Affairs. Two years later, I and a Cuban specialist from our college spent a month on the island teaching a January Short Term course for Berea students. It focused on "The African Diaspora in Cuba." Years later, I attended a two-week Conference of Radical Philosophers in Havana. Afterwards, I made three or four trips with a Latin American Studies Program I taught with in Costa Rica during various leaves of absence from Berea College. In 2014, Peggy and I also taught a summer semester course in Cuba just before President Obama began lifting travel restrictions for Americans.

Those experiences gave me the chance to examine a culture and system of political economy attempting mightily to implement the critical theory Franz had attributed to Karl Marx. The efforts have continued for more than 50 years, even in the face of fierce and often terroristic opposition from the most powerful country in the world, located not 100 miles from Cuba's shores. Despite those impediments, and since 1959 Cuba has largely succeeded in providing for itself what human beings care most about.

(And here, I'm sorry to say, my time on the island has made evident the real "fake news" and analysis into which Americans have been indoctrinated for more than 50 years. For I am about to present a series of "alternative facts" that illustrate the need for the "criteria for discernment" centralized in this book, so that any reader might judge the truth of what follows.)

So what do human beings really care about? Most would probably say that they care about their health and that of their families. Education would also be important. They want safety in the streets. They'd even like to have some years of retirement toward the end of their lives. Most also care about the well-being of the planet they'd like to leave to their grandchildren.

In all of those terms—addressing what most humans truly care about—my trips to Cuba show that Marx's critical theory has guided Cuba to provide a way of life that far outstrips even the United States. Consider the following:

- Education in Cuba is free through the university and graduate degree levels
- Health care and medicine are free.
- Cuban agriculture is largely organic.
- 80% of Cubans are home-owners.
- Cuban elections are free of money and negative campaigning. (Yes, there are elections in Cuba—at all levels.)
- Nearly half of government officials are women in what some have called "the most feminist country in Latin America."
- Drug dealing in Cuba has been eliminated.
- Homelessness is absent from Cuban streets.
- Streets are generally safe in Cuba
- Gun violence is non-existent.[16]

Realizations like those helped me appreciate socialism in ways that would have been impossible had I not repeatedly seen it in action within the Cuban context. I thought: any serious approach to critical thinking simply *must* insure that students understand just what socialism is and its relationship to capitalism and other economic systems. We'll broach those issues in Chapter Four. But before that, let me finish my personal story.

Notes

1. It should be noted that I am about to describe my development of intellectual, spiritual, and political awareness. Wilber refers to such dimensions as "lines" of development. Other lines include physical=kinetic, psychological, artistic, emotional, etc. One might be well-developed in some of these lines, and less advanced in others. For example, a person might be quite advanced intellectually, but less so emotionally and artistically.
2. Michael Harrington, and Maurice Isserman. *The Other America: poverty in the United States*. New York: Scribner, 2012.
3. Malcolm X, Alex Haley, M. S. Handler, and Ossie Davis. *The Autobiography of Malcolm X*. New York: Ballantine, 2015.
4. Elizabeth Cady Stanton. *Declaration of Sentiments and Resolutions*. Seneca Fall, 1848.
5. Donella H. Meadows, Dennis L. Meadows, and Jörgen Randers. *The Limits to Growth: a report for the club of Rome's project on the predicament*. New York: Universe, 1982.
6. Huston Smith. *The Religions of Man*. New York: Harper & Row, 1965.
7. Frances Moore Lappé, and Joseph Collins. *Food First: the myth of scarcity*. London: Souvenir Press, 1980.
8. Paulo Freire. *Pedagogy of the Oppressed*. New York: Continuum, 1970.
9. Paulo Freire. *Education for Critical Consciousness*. New York: Continuum, 1994.
10. Andre Gunder Frank. *Crisis in the Third World*. London: Heinemann, 1981.

11. Eduardo Galeano. *Open Veins of Latin America; five centuries of the pillage of a continent*. New York: Monthly Review Press, 1973.

12. Walter Rodney. *How Europe Underdeveloped Africa*. Washington, DC: Howard U Press, 1982.

13. Jürgen Moltmann. *Theology of Hope: on the ground and implications of a Christian eschatology*. New York: Harper & Row, 1965.

14. Franz J. Hinkelammert. *A Critica a La Razon Utopica*. San Jose, Costa Rica: Departamento Ecumenico de Investigaciones, 1984.

15. Franz J. Hinkelammert. *Hacia una Critica de la Razon Mitica: el laberinto de la modernidad*. San Jose, Costa Rica: Departamento Ecumenico de Investigaciones, 2007.

16. But what about Cuba's notoriously low incomes for professional classes? They have doctors and teachers earning significantly less than hotel maids and taxi drivers who have access to tourist dollars. Professionals, it is often said, earn between $20 and $60 per month. Taxi drivers can earn as much in a single day. Of course, there's no denying, the growing income gap is a problem. It's one of the most vexing issues currently under discussion by the Renewal Commission that is now shaping Cuba's future after years of consultation with ordinary Cubans nation-wide. And yet the income gap has to be put into perspective. That's supplied by noting that Cubans do not live in a dollar economy, but in a peso arrangement where prices are much lower than they are for tourists. One also attains perspective by taking the usually cited $20 monthly wage and adding to it the "social wage" all Cubans routinely receive. And here I'm not just talking about the basket of goods insured by the country's (inadequate) ration system. I'm referring to the expenses for which "Americans" must budget, but which Cubans don't have. That is, if we insist on gaging Cuban income by U.S. dollar standards, add to the $20 Cubans receive each month the costs "Americans" incur monthly for such items as

- Health insurance
- Medicines
- Home mortgages or rent
- Electricity and water
- School supplies and uniforms
- College tuition and debt
- Credit card interest
- Insurances: home, auto, life
- Taxes: federal, state, sales
- Unsubsidized food costs

The point is that those and other charges obviated by Cuba's socialist system significantly raise the wages Cubans receive far above the level normally decried by Cuba's critics—far above, I would say, most Global South countries.

Inching Towards Cosmic Consciousness

Zimbabwe

Fresh from my first trip to Cuba, my family and I spent 1997–98 in Zimbabwe—this time accompanying Peggy, who had earned a Fulbright Fellowship to teach in the capital city at the university in Harare. In terms of critical thinking, our experience in Zimbabwe helped me further reflect on the importance of Franz Hinkelammert's observation about the centrality of utopian concepts in the discipline. Zimbabwe embodied a problem that must be faced by any critical thinker in the mold of what this book intends to explore: Which utopia is a better guideline for structuring a just society—a world with room for everyone, or Smith's Invisible Hand governing a market free of government regulation?

That is, if Cuba demonstrated utopian commitment to Hinkelammert's capacious world, Zimbabwe revealed what typically happens when socialism's goals are dropped in favor of capitalism's utopia. Let me share with you my personal experience in the former Rhodesia, for it provides a case study in systemic critical thinking about competing economic systems.

To begin with, the Zimbabwe my family discovered in 1997, had experienced the triumph of its bloody socialist revolution in 1980 under the leadership of ZANU (Zimbabwe African National Union). After its triumph, and unlike Cuba, ZANU was very cautious in the socio-economic reforms it implemented.

True, ZANU established as its goal economic "growth with equity." And towards that end, its policies followed the Cuban model through programs of modest land redistribution, as well as emphasizing education, health care, higher wages, and food subsidies. This required large government programs and expenditures. In those early days, ZANU devoted approximately 50% of its annual budget to such endeavors. The reforms succeeded in significantly raising living standards for the country's overwhelmingly black and poor majority. After years of apartheid, they were finally finding some measure of dignity within their own country.

However, from the outset, ZANU chose not to institute truly comprehensive land reform to aggressively redistribute white-owned acreage to poor black farmers. Instead, it left 70% of the country's productive capacity in the hands of the former Rhodesia's white settler class and under the control of foreign corporations.

Then in 1990, after the fall of the Soviet Union, which had supported socialist revolutions everywhere, Zimbabwe, like Cuba, lost a major source of foreign aid. Socialism seemed entirely discredited. So like other socialist countries, Zimbabwe met a crossroads. Its question was that of every socialist country at the time: Should we continue on the socialist path or admit defeat and surrender to the apparent inevitability of capitalism?

Whereas Cuba, despite overwhelming pressure from its virulently hostile North American neighbor, chose to remain with socialism, Zimbabwe decided otherwise. Acceding to the recommendations of the United States and the International Monetary Fund, the country embraced capitalism and drastically restructured its economy. It lowered taxes on local (usually white) commercial famers as well on foreign investors. It cut back on social programs, lowered wages, and devalued its currency. The idea was to create in Zimbabwe an investment climate attractive to multi-national corporations, whose wealth would finance jobs and trickle down to the country's poor masses.

When our family arrived in Zimbabwe in 1997, the effects of such counter-revolutionary reforms were visible everywhere. On the one hand, downtown Harare and modern shopping centers seemed to exude prosperity. Its streets were broad, clean, jammed with traffic during rush hours, and largely absent of the beggars, homeless, prostitutes and street children we had encountered elsewhere in our travels.

In reality, however, that apparent prosperity never trickled down to the country's black majority. It remained lodged at the top of the socio-economic pyramid. Despite ZANU's belated attempts to radicalize its land reform efforts in the tribal areas, black Zimbabwean city-dwellers continued to live in slums entirely reminiscent of the miserable favelas we had visited with Freire's literacy team in Brazil. As a result of the country's economic "reforms," jobs were lost, wages became stagnant, schools and hospitals shut their doors, and hunger and disease emerged everywhere.

All of that stood in sharp contrast to Cuba. During this same historical period, after losing overnight 70% of its (Soviet) trading partners, the island found itself plunged into a decade-long depression far worse than anything Americans had experienced after the Great Stock Market Crash of 1929. Survivors of the "special period" recalled that the average Cuban adult probably lost about 20 pounds. A sociologist told me "We all looked like those pictures of World War II concentration camp internees." Yet astoundingly in Cuba, not a single school or hospital closed, and unlike European countries after socialism's demise, there were no riots in the street, much less any counter-revolution.

Yes, Cuba was apparently miserable under socialism, while some in Zimbabwe prospered under its new allegiance to capitalism. But who was better off, Zimbabweans or Cubans? Which country made the better choice? Whose utopia is preferable? Answering questions like those reveal the essence of the critical thinking recommended here and elaborated in the chapters to follow.

Israel-Palestine … and Mexico!

The summer of 2006 gave me the opportunity to visit Israel/Palestine for the first time. There I witnessed old-time colonialism and apartheid in action.

The trip to the Middle East was part of a three-week seminar involving a dozen Berea College faculty members. Its purpose was to prepare members of our interdisciplinary group to teach a course required of all Berea College juniors, "Understandings of Christianity." Actually, the seminar took us beyond the biblical "holy land" to Jordan and Egypt as well. Our group explored pre-biblical sites such as the Egyptian pyramids, the ruins of ancient cities like Jerash, Petra, Megido, Jericho, and Beth Shemesh. We spent a week in Jerusalem, visiting holy places there—the ruins of Herod's Second Temple, the Dome of the Rock, the al Aqsa Mosque, and Christian sites such as the Church of the Holy Sepulcher, the Mount of Olives, and the Via Dolorosa.

Realities of more contemporary significance were investigated as well—an ultra-conservative Jewish neighborhood where residents still understandably focused on the terror of the Holocaust, while observing a manner of dressing and way of life reminiscent of 19th century European ghettos.

We also stopped in a Palestinian refugee camp where families reported frequent shootings by Israeli soldiers manning the numerous watchtowers that loomed menacingly over the settlement. At every point we were searched by Jewish security—a sad reminder of continuous and ubiquitous threats from terrifying suicide bombers.

Most appalling were the Palestinian homes and villages destroyed by the Israelis in 1948 during what the Arab world calls the "Catastrophe" (the Jewish invasion of Palestine). That landmark event, we were reminded, represents for Arabs and Muslims their own "9/11." Its continuation is congealed monumentally in that huge concrete wall that snakes its way throughout Palestine-Israel. The wall's presence and the Palestinian graffiti that deface it, proclaim irrefutably Israel's ever-expanding system that daily swallows up Palestinian territory, and increasingly confines Arab non-persons to Bantustans reminiscent of South Africa before the end of the detestable apartheid system.

That parallel with South Africa is exactly the connection made by the Sabeel Ecumenical Center for liberation theology in Jerusalem. (As well, of course, as by President Jimmy Carter in his book, *Peace, Not Apartheid*[1]). Scholars at Sabeel connected the Palestinians' situation with colonialism. They pointed out that ever-expanding Jewish settlements stood in blatant contravention of UN Resolution 242. It was a continuation of the European colonial system that had supposedly been abolished following World War II. In Israel-Palestine, Jewish occupation represented the familiar European settler pattern repeated throughout the former colonies. In Palestine it had (Jewish) invaders from Germany, Russia, Poland, Hungary, Rumania, and elsewhere arriving unexpectedly in lands belonging for millennia to poor unsuspecting peasants, and then taking their homes, fields and resources.

I resolved that on my return to the United States, my speaking engagements would address nothing else but that learning from my own observation and from Palestinian theologians of liberation.

My first opportunity came soon enough in Mexico.

It was still 2006. Peggy and I were working with the Center for Global Justice (CGJ) in San Miguel de Allende. There we directed a summer intern project for students from the U.S., Mexico and Cuba. Out of the blue, one week the program chair of the local Unitarian Universalist (U.U.) meeting invited me to speak at their Sunday gathering. I told them that my talk's title would be "A Report from Israel."

My thesis was clear and unambiguous. "The real terrorists in Israel," I said, "are the Jewish Zionists who run the country." I didn't consider my basically historical argument particularly original or shocking. The Sabeel Center and Noam Chomsky had been making it for years.

What I didn't realize was that many in my audience were Jewish. (I didn't even know about San Miguel's large Jewish population—mostly "snowbirds" from New York City.) Nonetheless, my remarks that Sunday stimulated an engrossing extended discussion. Everyone was respectful, and the enthusiastic conversation even spilled over beyond the allotted time.

Immediately afterwards, during breakfast in the U.U. center, one of the founders of the CGJ said, "That was great, Mike. You really ought to put all of that down on paper. You can publish it as an article in San Miguel's weekly English newspaper, *Atención*. They give us column space there each week."

"Great," I said. (I already had the talk written out.) I sent it into *Atención* and it was published about a month later. By then I was back in the states teaching at Berea.

I'll never forget what followed. All hell broke loose:

- A barrage of angry letters flooded the *Atención* pages for the next two weeks and more.
- As a result, *Atención* threatened to cancel the CGJ's weekly column.
- San Miguel's *Bibliotheca* (library) talked about ending the CGJ's access to meeting space there.
- My article was removed from *Atención's* archives.
- Someone from the AIPAC (American-Israeli Public Affairs Committee) phoned my provost at Berea College reporting me for my inflammatory article, asking whether I really taught there and if my credentials were genuine.
- The CGJ's leadership was forced to do some back-pedaling distancing itself from me and my remarks.
- They lit candles of reconciliation at a subsequent U.U. meeting begging forgiveness from the community and absolution for that mad man from Berea.
- The guiding assumption in all of this was that my argument was patently false.

In other words, an article that should have stimulated critical thinking and discussion (with CGJ activists leading the way as a voice for voiceless Palestinians) was met instead with denial, dismissal, and apology.

An opportunity for stimulating critical world-centric thought was lost.

Cosmic-Centrism South Africa & India

My studies and travel so far had clearly given me world-consciousness. I had pretty much left behind (at least as stages) both egocentrism and ethnocentrism.

Then by 1997 (at the age of 57), I gingerly entered the next phase of Wilber's growth hierarchy, cosmic-centrism. The door opened that Christmas, when Peggy gave me the gift of three books by an Indian teacher of meditation, Eknath Easwaran.

The most important of the three was simply entitled *Meditation*.[2] The book explained how to meditate and outlined Easwaran's "Eight Point Program" for

spiritual transformation. The points included (1) meditation, (2) spiritual reading, (3) repetition of a mantram, (4) slowing down, (5) one-pointed attention, (6) training of the senses, (7) putting the needs of others first, and (8) association with others on the same path.

As a former priest, I was familiar with such spirituality. After being introduced to meditation during my novitiate year in 1960, I meditated every day for the next dozen years or so. But after leaving the priesthood, I stopped doing that and thought I would never go back.

But after reading *Meditation*, I decided to perform the experiment Easwaran recommends there. He challenged his readers to try the eight-point program for a month. He said, if no important changes occur in your life as a result, drop the practice. But if significant personal transformation happens, that's another story.

Suffice it to say that I tried for a month, and now nearly 20 years later, I'm able to report that I've never missed a day of meditation. Soon I was meditating twice a day. In short, I had been re-introduced into spiritual practice, but this time under the guidance of a Hindu. However, Easwaran insisted that his recommended practices had nothing to do with switching one's religion or even with adopting any religion at all.

In other words, meditation had introduced me into the realm of mysticism common to Jews, Christians, Buddhists, Muslim Sufis, and subscribers to other faiths.

Easwaran described mysticism, wherever it appears, as founded on the following convictions: (1) there is a divine spark resident in the heart of every human being, (2) that spark can be realized, i.e. made real in one's life, (3) in fact it is the purpose of life to do so, (4) those who recognize the divine spark within them inevitably see it in every other human being and in all of creation, and (5) they act accordingly.

Those are the principles of cosmic-centrism.

South Africa

In the spirit of those principles, in 2012, during Peggy's sabbatical in Cape Town, South Africa, my eyes started opening to the divine in nature—especially in the ancient rock formations in the southern Cape. As Dean Liprini points out in his *Pathways of the Sun*[3] many of them have been "enhanced" by the Koi-Koi and San people indigenous to this area. The enhancements (for instance, sharpening features in rocks which resemble human faces) serve the same purpose as the completely human fabrications in places like Tikal, Stonehenge, and Easter Island. They position the movement of the sun, moon, stars, and planets to keep track of equinoxes and solstices. All of those heavenly bodies and seasons influence our bodies (70% water) as surely as they do the ocean tides and the seasons. So it was

important to the Koi-Koi and San to mark the precise moments of the annual celestial events for purposes of celebrations, rituals, and feasts.

Close to Cape Town, we lived in Llandudno near the location's great "Mother Rock." Like so many other mountains, rocks, sacred wells and springs in that area, it was said to exude extraordinary cleansing energy. Peggy and I often made our evening meditation before that Rock, and on occasion in a nearby sacred cave.

They say that the human story began in South Africa 300,000 to 500,000 years ago. So in the presence of ocean, sacred caves, and holy rocks, we attempted to reconnect with the roots of it all and with the animals and ancient peoples who in their harmony with nature's processes seem much wiser than we post-moderns are proving to be.

We were entering cosmic space, where the principle of the unity of all creation shapes critical thinking.

India

Perhaps more than anywhere else on earth, India embodies commitment to cosmic-centrism. My family experienced its sacred space in 2014, during the year of Peggy's second Fulbright grant—this time for research at the University of Mysore. (Do you see why the personal development I'm describing is so indebted to my wife?) There I took yoga lessons for the first time. I regularly consulted an Indian guru and did past life regression under his guidance. Then in December of 2014, I participated in a 10 day silent Vipassana Retreat in Karnataka. It was extremely intense—a real immersion experience both in meditation and in Indian culture. Ninety of the hundred or so people attending the retreat were Indians. The living circumstances and diet were Spartan. No talking or even eye contact was allowed for 10 days. No cell phones or computers, newspapers or TV. We meditated for 10 hours each day. It was one of the most unforgettable experiences of my life.

Here's the way my journal described the meditation portion of the experience then:

How to Meditate

Narrow your focus,
The teacher said,
To the triangle
Whose base is your upper lip,
With its apex, the top of your nose.
Now do nothing

But breathe.
Just observe your natural breath
For fifteen hours.
That's step one.
Step two is to spend ten hours
Focusing on sensations
In the same triangular space—
An itch, a pain, a tingling, throbbing—anything.
Work diligently, ardently, patiently.
This was the Buddha's path
To enlightenment and liberation,
The teacher advised.
It can be yours as well
If you follow his technique.
Doing so, you are bound to succeed,
Bound to succeed.
Step three is to narrow focus still further.
The triangle shrinks.
Its base remains your upper lip.
But its apex becomes the bottom of your nostrils.
Focus on that mustache area.
Identify the feelings there,
And contemplate it—for 10 hours.
Now you're ready for Vipassana itself.
The word means seeing things as they are,
Not as you want them to be.
You scan your body
From head to toe
For changing sensations,
For five hours in the morning
And four in the afternoon.

The point is
To experience life's impermanence
Where it cannot be denied
Within the framework of your own body,
And so be liberated
From cravings and aversions.
Which like all bodily sensations
Always pass.
Do that for sixty-five hours.

What does this have to do with critical thinking? The words above about "seeing things as they are and not as you want them to be," give a clue. (Do you sense

echoes here of Dick Gregory and his magic glasses?) So does the phrase, about experiencing the impermanent nature of life "where it cannot be denied, within the framework of your own body." *That* was the Buddha's purpose in meditation: to understand life not according to the testimony of others—philosophers, priests, or gurus—but as it is in one's own experience. Meditation was to enable practitioners to see life clearly and think for themselves.

Of course arriving spiritually at the stage of cosmic-centrism does not guarantee cosmic-centered political consciousness.[4] Nevertheless, such awareness distinguishes itself from world-centric consciousness by its ability to compassionately understand all previous levels. As Wilber notes, earlier stages tend to misunderstand and despise one another. Egocentric children rebel against restraints imposed by parents and teachers. Ethnocentric adults cannot understand their world-centric counterparts. The world-centric tend to regard the ethnocentric with arrogant disdain.

The cosmic-centered, however, realize that they have passed through all previous stages—that they *had* to. They know that those now located at those stages are similarly compelled. This evokes compassion and the *bodhisattva*-like action of the escapee from Plato's cave who returns to enlighten those in the thrall of their shadow worlds of egocentrism and ethnocentrism.

Conclusion

Once again, the purpose of recounting my long odyssey is to put flesh on Ken Wilber's explanation of growth hierarchies. To begin with, my own case at the very least, illustrates one person's growth from egocentricity through ethnocentrism, global-centrism, and his feeble attempts to achieve a more integral cosmic-centrism.

Secondly, my own story traces the gradual dawning of awareness about the prevalence of "alternative facts" as perceived at various stages of Wilber's schema. What I accepted as factual in my teenage years, I grew out of as a young ethnocentric adult. Then, after being exposed to Global South realities and analyses in Brazil, Nicaragua, Costa Rica, Cuba, Zimbabwe, Israel, Mexico, South Africa, and India, I eventually left behind much of my ethnocentrism in favor of world-centrism and even something approaching cosmo-centrism.

Finally, my autobiographical reflections gesture at the principles, rules, or criteria of discernment (critical thinking) that will find exposition in the remainder of this book. The reflections show how I came to realize that foundational to critical thinking is clarity about notions of capitalism and its alternatives on the one hand, and of their history on the other. Without that foundation, truly critical thought about the contemporary world and its problems is virtually impossible.

So let's pursue all of that in the next several chapters. They will lay out eight of my promised ten rules for critical thinking.

For Discussion

1. What are your comments about the author's claim about his movement up the growth hierarchy described by Ken Wilber?
2. Where would you locate your own consciousness in terms of Wilber's growth hierarchy? Are you at egocentrism, ethno-centrism, global-centrism, or cosmic-centrism?
3. So far, who and what have influenced you to move ahead in the growth hierarchy.
4. What part does one's stage of consciousness play in critical thinking?
5. Share your thoughts about the most advanced critical thinker you have ever met? Why does she or he merit that classification?

Activity

Using the model presented in this chapter, write a 600-word autobiographical account of your own movement and aspirations connected with Wilber's growth hierarchy.

Notes

1. Jimmy Carter. *Palestine: peace not apartheid*. Bath: Camden, 2008.
2. Eknath Easwaran. *Passage Meditation: bringing the deep wisdom of the heart into daily life*. Tomales, CA: Nilgiri Press, 2012.
3. Dean Liprini. *Pathways of the Sun: unveiling the mysteries of Table Mountain and beyond*. Cape Town: Double Storey, 2006.
4. Ken Wilber makes this same observation about exclusively "spiritual" approaches to understanding and changing the world. In themselves, they remain incomplete. More specifically, Wilber says that spiritual practice (meditation, contemplation, centering prayer, or any other similar "devotion") of itself proves incapable of bringing one outside culturally-fostered pre-conceptions of the world. This is true even though spiritual practice might include "altered states of consciousness" including awareness and experience of the "unity of all creation." Such phenomena however spectacular, might still leave one at an egocentric or ethnocentric level of consciousness. In fact, without change in world vision, spiritual practice has the counterproductive effect (in terms of critical thinking) of solidifying one's uninformed worldview. Wilber illustrates this point by referring to insistence by leaders in Nazi Germany of the importance of meditation and other spiritual practices.

The First Eight Rules of Critical Thinking

Rule One

Reflect Systemically

As indicated in the previous chapters, no one can claim to wear the magic glasses enabling critical thought as described so far without understanding at some level how the world works economically.

So consider this a ground-clearing chapter. Its point is to clarify the vocabulary and concepts without which one will not be able to understand much of what follows in this book or, more importantly, to think critically about the central issues facing our contemporary world. You cannot think about terrorism, poverty, hunger, war, climate change, healthcare, education, or a host of other problems without well-defined understandings of the basic economic concepts presented here.

Then there's our question of shadows, fake news, and alternative facts. Brief reflection should make it apparent that those carrying the statues before our cave's fire don't want us to know much about alternatives to our own economic system, capitalism. That's a point made by Marxist economist, Richard Wolff. He received his education at Yale, Harvard and Stanford. Yet, he ended up with a doctorate in economics without having studied capitalism's principal critic, Karl Marx.

That would be like, Wolff says, accepting Catholicism without knowing anything about Protestantism—an analogy I can relate to, since it was, in fact, what happened to me in my preparation for the Catholic priesthood. I spent all those

years in the seminary without really understanding the Protestant Reformation—much less, Buddhism, Islam, or Hinduism.

Or take the case of terrorism. Terrorists are often called "Islamic-fascists." (Fascism, we'll see, is primarily an economic term.) Their opponents proudly identify themselves as "capitalists." However, during the Obama presidency, the Commander in Chief of the main army fighting terrorism was accused of being a "Marxist," a "socialist," and even a "communist."

Rarely have discussions recognized the universal prevalence of "mixed economies"—i.e. that all contemporary economies combine elements of capitalism and socialism.

Instead, the discourse has illustrated huge divergences of understanding and opinion about the meaning of all the terms just placed in quotation marks. Most debate participants simply do not have accurate ideas about their meaning. Often they are simply convinced that communism is bad, and that capitalism is good. Beyond that however, ideas remain confused. Most are even unaware that all the terms mentioned describe positions adopted towards the free market economic system.

Hence, it is the modest, yet ambitious, purpose of this chapter to clear up confusion by defining terms in a simple easy-to-understand way.

To repeat: doing so is absolutely necessary for any critical thinker to join productive discussions about our days' most prominent issues. So, oversimplifying for purposes of discussion and clarity, what follows will summarize the crucial categories in three points each, beginning with capitalism, and then moving on to Marxism, socialism, mixed economy, communism, and fascism. The chapter will attempt to be purely descriptive, without judging any of the systems presented. It will end with a brief discussion of human rights in relation to economic systems.

Capitalism

Liberal capitalism is an economic system based on (1) private ownership of the means of production (2) free and open markets (places where goods are bought and sold), and (3) unlimited earnings. Those are capitalism's three points.

Private ownership of the means of production dictates that individuals should be empowered to own fields, forests, farms, factories and other sources of products for sale and exchange. Communal ownership is thus excluded.

Free markets permit private owners to produce what they choose to produce, where and when they choose to do so, employing whom they choose, without any power outside of market forces (supply and demand) dictating that production and its circumstances. Here government interference in the market by way, for

instance, of outlawing or controlling some goods (such as liquor or cigarettes) and mandating production of others (such as beans and rice) is rejected. This is what is meant by a free market—absence of governing laws outside supply and demand.

An open market means that anyone at all should be able to enter the process of buying and selling. Open markets admit buyers and sellers regardless of personal attributes such as race, age, gender, nationality, or religion.

In all this emphasis on freedom and openness, we find expressed the "liberal" nature of "liberal capitalism." Liberal in this sense comes from the Latin word for freedom, *libertas*.

Finally, liberal capitalism calls for unlimited earnings. That is, the producer's talent and the quality of her or his product alone should limit attainable income goals. Thus, limits on earnings such as taxes should be kept to the minimum necessary to provide public protection of private property (police, military, the judicial system) and to supply the infrastructure necessary for commerce (roads, bridges, etc.). Redistributive taxes for social programs such as food stamps are considered negative "market distortions," because the interfere with "natural laws" of supply and demand.

According to the principles of free market capitalism, income ceilings are also out of the question. For capitalists, wide disparities between the rich and the poor are not a problem. And some might even admit to greed as a kind of virtue that is responsible for human progress. That idea was captured in the film, *Wall Street*. There entrepreneur, Gordon Gecko (played by Michael Douglas), praises greed in a speech before the stockholders of his enterprise, Teldar Paper Company. He says,

> The point is, Ladies and Gentlemen, that greed, for lack of a better word, is good. Greed is right. Greed works. Greed clarifies, cuts through, and captures the essence of the evolutionary spirit. Greed in all of its forms: greed for life, for money, for love, for knowledge has marked the upward surge of mankind. And greed, mark my words, will not only save Teldar Paper but that other malfunctioning corporation called the USA. Thank you very much.[1]

These words, of course, not only praise greed in business, but in national life. Ignoring the fact that in the past greed was considered by Christians one of the Seven Deadly Sins, Gecko claims that greed will lead to the salvation not only of his business from low returns in the Stock Market, but of the United States from what ails it as well.

Marxism

For its part, Marxism represents the Western tradition's most trenchant critique of capitalism. Marxism's three points are as follows: (1) capitalism *necessarily* exploits

workers and the environment, (2) workers will eventually rise up against such exploitation and replace capitalism with socialism, and (3) socialism will finally evolve into communism. Let's consider those points one-by-one.

Seen Through Dick Gregory's Magic Glasses, *Sausage Party*[2] Becomes a Marxist Critique of Capitalism

What do you call an economic system where:

- Everything is sexualized?
- But sexuality is repressed?
- Products are treated as people?
- People are treated as commodities?
- Theory promises the greatest happiness possible.
- But theory in practice devours those who believe it?

According to the animated comedy, *Sausage Party*, that system is patriarchal capitalism. And it's exactly what's satirized in the film. Its trenchant critique of the system's ideology and practice is comically reminiscent of Marx's own.

Literally (and revealingly) set in a "Market," *Sausage Party* cleverly presents products as people—or is it people as products? Like characters reminiscent of Plato's "Parable of the Cave," hot dogs, buns, honey mustard, a damaged douche container, and every other super market product you can think of, have all been seduced by a theologized theory that promises a marvelous utopia awaiting them in the "real world" outside the realm where market's theory is constantly celebrated as a gift from God.

However, like enthusiastic commodified workers hired by employers, the "chosen" soon realize a reality harshly at odds with the theory they've learned so well. What was supposed to fulfill actually devours them along with people from all over the world. Meanwhile the commodities' all-white directors are stupid, dirty, unconscious, and unthinking materialists with no clue about the havoc they're actually wreaking across the globe.

With all of this in mind, *Sausage Party* becomes a rich satire redolent not only of Marx, but of Plato's Allegory of the Cave along with other classic themes including The Journey, The Quest for Truth and Meaning, and the Supremacy of Love and Hope over Blame and Guilt.

It becomes the story of how commodified people come to the realization that their rulers are restricting, exploiting, and destroying them. They become conscious that the entire market system is necrophilic, because it is based on

death itself. It employs specifically theologized propaganda to induce guilt about perfectly natural impulses (like love and sex) that might otherwise encourage fellow-feeling and awaken rebellious tendencies.

Despite overwhelming obstacles and odds, the conscientized commodified "persons" overcome the divide-and-rule distinctions their keepers have imposed. Males join forces with females, blacks with whites, Hispanics with Anglos, Jews with Arabs, gays with straights, and atheists with believers. They take up arms against their oppressors, overthrow the establishment replacing its chaos with an order based on free love and joy. (Sausage Party's concluding sexual orgy is remarkable.)

In short, *Sausage Party* is about the power of love and natural instincts to destroy an artificial capitalist system based on deception, repression, guilt and tribalism.

First of all, Marxism's critique of capitalism holds that the system *necessarily* exploits workers (and by extension, as we shall see, the environment). The adverb "necessarily" is emphasized here to show that, according to Karl Marx, the destructive nature of capitalism is not dependent on the personal qualities of individual capitalists. Regardless of their personal virtue or lack thereof, capitalists are forced by the market mechanism to exploit workers (and the environment). This is because, for one thing, workers are compelled to enter a labor market whose wage level is set by competition with similar workers seeking the same job. As a result, each prospective employee will bid his competitors down until what economists have called the "natural" wage level is attained. Marx found this "natural" level below what workers and their families need to sustain themselves in ways worthy of human beings. In other words, wage competition represents nothing more than a race to the bottom.

For Marxists, the capitalist system does not merely exploit workers of necessity. It also *necessarily* exploits the environment. That is, the market's reliance on the laws of supply and demand all but eliminates the presence of environmental conscience on the part of producers.

Thus, for example, conscientious entrepreneurs might be moved to put scrubbers on the smokestacks of their factories, and filters on their sewage pipes to purify liquid effluents entering nearby rivers and streams. Doing so will, of course, raise the costs of production. Meanwhile, however, competitors who lack environmental conscience will continue spewing unmitigated smoke into the atmosphere and pouring toxins into the river. Their lowered costs will enable them to undersell the conscientious producers, and eventually drive the latter out of business. In this way, the market rewards absence of environmental conscience.

Marx's second point is that the exploitation necessarily fostered by the capitalist system will cause rebellion on the part of workers. They will rise up against their employers and overthrow the capitalist system. They will replace it with socialism.[3]

Socialism, on Marx's analysis will then evolve into communism. That's the third point of Marxism.

To understand those terms, consider the three points belonging to socialism and communism respectively.

Socialism

Socialism is capitalism's opposite on each of the three points indicated earlier. First of all, whereas capitalism espouses private ownership of the means of production, socialism advocates public ownership, i.e. ownership by the community. According to this theory, the workers themselves take over the factories and fields to administer them, not for the profit of the few, but for the benefit of the workers themselves and their families.

Secondly, whereas capitalism demands free and open markets, socialism mandates controlled markets. Since socialism has the interests of the working majority at center, its pure theory will not allow, for instance, production of luxury crops (such as roses or coffee) if that production deprives workers of the food they need for subsistence. In this sense, socialism controls "free" markets.

Thirdly, where capitalism idealizes unlimited earnings, socialism calls for limitation of income—for instance, through a progressive income tax, by which those who have more pay more. For socialism, greed is definitely not good. So it might also establish ceilings beyond which personal incomes are not permitted to rise. Taxes and surplus earnings are then used for the common good, for example to fund schools, clinics, food subsidies, affordable housing and health care.

Communism

As for Communism, it is a "vision of the future" which some, though not by any means all, socialists entertain as history's end point. That is, while all communists are socialists, not all socialists are communists. This is because some socialists (along with all capitalists, of course) consider the communist vision of the future as unrealistic and unattainable.

That vision, overly idealistic or not, is of a future where there will be (1) abundance for all, (2) no classes, as a result of such plenty, and (3) no need for a state. Those are the three points summarizing communism.

To begin with, the vision of virtually unlimited abundance marks communists such as Marx and Engels as convinced industrialists. They were highly impressed by the unprecedented output of the factory system of the late nineteenth and early twentieth centuries. Shirts, for example, that would take skilled seamstresses days to produce, were turned out in minutes, once an assembly line based on "division of labor" was set in motion. The same became true of automobiles. By 1927 Henry Ford's River Rouge plant in Michigan was turning out a Model T every 49 seconds.

Soon, communists theorized, the world would be filled with consumer goods. And in a context of such abundance "yours" and "mine" would cease to have meaning. Neither would it make sense for some to horde goods to themselves at the expense of others. The result would be the disappearance of classes. There would be no rich and no poor. All would have more than enough of what they need.

With the disappearance of classes would come the gradual "withering away" of the state. This is because "the state," by communist definition is simply the armed administrator of the affairs of society's dominant class. As Marx and Engels put it in their *Manifesto*, "Political power, properly so called, is merely the organized power of one class for oppressing another."[3]

Thus the state's job is to impose the will of a ruling class on others. Under capitalism, the state's function is to oblige the working class to accept conditions profitable to the bourgeoisie (wealthy property owners). In other words, under capitalism, the state imposes the "dictatorship of the bourgeoisie."

Meanwhile, under socialism, the function of the state is to impose the will of the working class on the bourgeoisie. It enforces the "dictatorship of the proletariat."

By way of contrast, under communism, in the absence of classes (eliminated by a condition of abundance) there remains no group whose will needs to be imposed on others. The state's function thus ceases. It gradually disappears.

Mixed Economy

Following the Great Depression of the 1930s, the world as a whole moved away from attempts to implement either pure capitalism or pure socialism. Instead, the trend virtually everywhere has been towards selecting the best elements from each system in a "mixed economy."

As the phrase implies, this involves (1) some private ownership of the means of production and some public ownership, (2) some free and open markets and some controlled markets, and (3) earnings typically limited by a progressive income tax.

Of course what we have in the United States is a highly mixed economy. The U.S. government is, after all, the largest land owner in the nation. (Think of the national park system.)

Drug, alcohol, food, and medical care markets (and many others) are highly regulated. Following World War II, Americans earning more than $400,000 were taxed at a rate of 91%. Since 2009, the top income tax bracket is 35%. None of that would be possible under pure free market capitalism.

Similarly, countries claiming to be "socialist" (like Venezuela) or "communist" (like Cuba) have mixed economies. Private enterprise flourishes in both.

Does this mean that the economic systems of the United States and Cuba for example are the same? Not at all. True, both economies are "mixed." But they differ in terms of whom they are mixed in favor of. The United States economy is mixed in favor of the wealthy and corporations. This is illustrated by consideration of the recipients of government bailouts at the beginning of the 2008 Great Recession. The main recipients were large corporations and Wall Street firms rather than middle or lower class people.

The theory at work here is "trickle down." That is, it is alleged that if the wealthy prosper, they won't hide their money under their mattresses. Instead, they'll invest. Investment will create jobs. Everyone will benefit. So mixing an economy in favor of the wealthy is not sinister; it's done for the benefit of all.

Cuba, for instance, has a different approach. Its theoreticians observe that historically the wealth hasn't trickled down—at least not to people living in the Third World (the former colonies). So, (the theory goes) the economy must be mixed directly in favor of the poor majority. The government must adopt a proactive posture and interfere directly in the market to make sure that everyone has free education (even through the university level), free health care, and retirement pensions. Food is subsidized to insure that everyone eats. And the government is the employer of last resort to provide dignified employment for everyone, so that Cubans are not simply on the dole.

In summary, then, all we have in the world are "mixed economies." Today, most of them are mixed in favor of the wealthy (once again, on the "trickle-down" theory). Some, like Cuba's, prioritize the needs of the poor.

Fascism

What about fascism then? Today the word is thrown around on all sides, and seems to mean "people I disagree with," or "mean people," or "those who force their will on the rest of us." There's talk of Islamic-fascists. President George W. Bush was accused of being a fascist. Recently President Trump has been similarly labeled.

None of those popular meanings or accusations really capture the essence of fascism. Benito Mussolini, who claimed fascism as a badge of honor in the 1930s (along with Adolph Hitler in Germany, Antonio Salazar in Portugal, and Francisco Franco in Spain), called fascism "corporatism." By that he meant an alliance between government and large business concerns or corporations.

In terms of this chapter, then, we might understand fascism as "capitalism in crisis" or "police state capitalism." That is fascism is the form capitalism has historically taken in situations of extreme crisis, as occurred in the 1930s following the Great Stock Market Crash of 1929.

More accurately however (in the light of our previous section on mixed economies), we might call fascism a police state economy mixed in favor of the wealthy. Fascists are always anti-socialist and anti-communist.

The three elements of fascism then include: (1) A police state (2) enforcing an economy mixed in favor of large corporations, (3) characterized by extreme anti-socialism and anti-communism, and by scapegoating "socialists," "communists" and minorities (like Jews, blacks, gypsies, homosexuals ...) for society's problems.

Human Rights

Both economies mixed in favor of the rich and those mixed in favor of the poor claim to respect human rights. They also blame their opponents for not following suit. The truth is, however, that both types of economies both respect and disrespect human rights.

That is, despite having signed the Universal Declaration of Human Rights, no country and no system of political-economy has shown consistent respect for all human rights. Instead all systems prioritize them according to what they consider the most basic. This means that capitalism respects some human rights more than others. So does socialism.

The Universal Declaration of Human Rights[4]

1. **We are all free and equal.** We are all born free. We all have our own thoughts and ideas. We should all be treated in the same way.
2. **Don't discriminate.** These rights belong to everybody, whatever our differences.
3. **The right to life.** We all have the right to life, and to live in freedom and safety.

4. **No slavery—past and present**. Nobody has any right to make us a slave. We cannot make anyone our slave.
5. **No Torture**. Nobody has any right to hurt us or to torture us.
6. **We all have the same right to use the law**. I am a person just like you!
7. **We are all protected by the law**. The law is the same for everyone. It must treat us all fairly.
8. **Fair treatment by fair courts**. We can all ask for the law to help us when we are not treated fairly.
9. **No unfair detainment**. Nobody has the right to put us in prison without a good reason and keep us there, or to send us away from our country.
10. **The right to trial**. If we are put on trial this should be in public. The people who try us should not let anyone tell them what to do.
11. **Innocent until proven guilty**. Nobody should be blamed for doing something until it is proven. When people say we did a bad thing we have the right to show it is not true.
12. **The right to privacy**. Nobody should try to harm our good name. Nobody has the right to come into our home, open our letters or bother us or our family without a good reason.
13. **Freedom to move**. We all have the right to go where we want in our own country and to travel as we wish.
14. **The right to asylum**. If we are frightened of being badly treated in our own country, we all have the right to run away to another country to be safe.
15. **The right to a nationality**. We all have the right to belong to a country.
16. **Marriage and family**. Every grown-up has the right to marry and have a family if they want to. Men and women have the same rights when they are married, and when they are separated.
17. **Your own things**. Everyone has the right to own things or share them. Nobody should take our things from us without a good reason.
18. **Freedom of thought**. We all have the right to believe in what we want to believe, to have a religion, or to change it if we want.
19. **Free to say what you want**. We all have the right to make up our own minds, to think what we like, to say what we think, and to share our ideas with other people.
20. **Meet where you like**. We all have the right to meet our friends and to work together in peace to defend our rights. Nobody can make us join a group if we don't want to.
21. **The right to democracy**. We all have the right to take part in the government of our country. Every grown-up should be allowed to choose their own leaders.

RULE ONE | 51

22. **The right to social security.** We all have the right to affordable housing, medicine, education, and child care, enough money to live on and medical help if we are ill or old.
23. **Workers' rights.** Every grown-up has the right to do a job, to a fair wage for their work, and to join a trade union.
24. **The right to play.** We all have the right to rest from work and to relax.
25. **A bed and some food.** We all have the right to a good life. Mothers and children, people who are old, unemployed or disabled, and all people have the right to be cared for.
26. **The right to education.** Education is a right. Primary school should be free. We should learn about the United Nations and how to get on with others. Our parents can choose what we learn.
27. **Culture and copyright.** Copyright is a special law that protects one's own artistic creations and writings; others cannot make copies without permission. We all have the right to our own way of life and to enjoy the good things that "art," science and learning bring.
28. **A free and fair world.** There must be proper order so we can all enjoy rights and freedoms in our own country and all over the world.
29. **Our responsibilities.** We have a duty to other people, and we should protect their rights and freedoms.
30. **Nobody can take away these rights and freedoms from us.**

Capitalism puts at the top of its list the rights to private property, the right to enter binding contracts and have them fulfilled, as well as the right to maximize earnings. These rights even belong to corporations which under capitalism are considered persons.

On the other hand, capitalism's tendency is to deny the legitimacy of specifically human rights as recognized, for example, by the U.N. Declaration of Human Rights. For this reason, the United States has never ratified key protocols implementing the Declaration, or other key documents asserting rights beyond the corporate.

Moreover, if capitalism's prioritized rights are threatened, all others are subject to disregard, including the rights to free elections, speech, press, assembly, religion, and freedom from torture. Historical references in the chapters which follow this one will support that observation.

Similarly, socialism heads its own list with the rights to food, shelter, clothing, healthcare and education. In the name of those rights, socialism relativizes rights to private ownership and the rights to enter binding contracts, and to maximize

earnings. If the rights socialism considers basic are threatened, history has shown that it too, like capitalism, will disregard all others.

Conclusion

What's the "take-away" from all of this? Simply this: capitalism is both a simple and complicated system; so is socialism. Both can be summarized quite simply, as can mixed economies, Marxism, communism, and fascism.

Critical thinkers should carry those simple three-point summaries around with them in their heads so they might cut through all the misunderstandings that characterize discussion of so many of today's key issues.

Doing so represents the first step in any critical thought process even for those unaware of insight conferred by wearing the magic glasses.

For Discussion

1. Watch Phil Donahue's interview with economist Milton Friedman about capitalism and greed.[5] Discuss Friedman's position. What would Marxists say about it?
2. In your own opinion is greed good? Or is it rightly classified as one of the Seven Deadly Sins? Explain.
3. Why has communism's vision of abundance for all not come true? Can you think of any field where it has, i.e. where so much is produced that it becomes monetarily worthless, and in some cases cannot even be given away?
4. Does trickle-down theory work? Keeping in mind what was described in Chapter Two, what do you think of Cuba's alternative and of Zimbabwe's survival strategy reviewed in Chapter Three?
5. What rights are most important, those prioritized by capitalism or by socialism? Why?

Activity

Research the reasons why the United States has not signed protocols implementing the U.N. Declaration of Human Rights.

Notes

1. *Wall Street*. Dir. Oliver Stone. Perf. Michael Douglas and Charlie Sheen. 20th Century Fox, 1987. Web. 17 Apr. 2017. www.youtube.com/watch?v=PF_iorX_Maw

2. *Sausage Party*. Dir. Conrad Vernon, Greg Tiernan. Perf. Jonah Hill, Seth Rogen, Salma Hayek. Columbia Pictures, 2016.

3. Karl Marx, Frederic L. Bender, and Friedrich Engels. *The Communist Manifesto*. New York, NY: W. W. Norton & Co., 2013.

4. List provided by Youth for Human Rights International, adapted and simplified from the 1948 Universal Declaration of Human Rights. www.un.org/en/documents/udhr/

5. Phil Donahue interview with Milton Friedman. www.bing.com/videos/search?q=youtube+milton+friedman+phil+donahue&FORM=VIRE1#view=detail&mid=1F39A-35F013334AC90861F39A35F013334AC9086

Rule Two

Select Market as the Economic Root of Political Differences

As we have seen, Rule One in our ten rule guide to critical thinking indicated the necessity of a systemic approach. Rule One required clear ideas about capitalism, Marxism, socialism, communism, mixed economy, and fascism. As we also saw, the distinctions between such systems find primary explanation, in their orientation towards a single element of human life. In a word, that element is MARKET.

That's the point of Rule Two as well. It focuses on the political rather than the economic realm. It highlights the importance of political literacy to complement the economic literacy recommended by Rule One. Without clarity about notions of "left" or "right," "liberal" or "conservative," "radical" or "reactionary," Republican or Democrat, the type of critical thinking recommended here cannot go very far.[1]

The argument here is that in politics too, attitudes towards market represent the key element separating political parties one from the other. That is, though ethical and moral concerns remain important for many, behind all the talk about patriotism, democracy, justice, human rights, and morality lurks the question about the degree to which markets should be controlled or free. Answers to that question are what primarily distinguish the spectrum of political positions mentioned earlier. As the Bill Clinton campaign put it in 1992, "It's the economy, stupid." Again, the root of political differences is market.

Seen Through the Magic Glasses
War Dogs Is About an Economy Based on Murder and Theft

"What do you know about war? They'll tell you it's about patriotism, democracy ... You want to know what it's really about? War is an economy."

That's the way director, Todd Phillips' *War Dogs* begins. It's the (mostly true) tale of two twenty-something stoners from Miami Beach who become wealthy arms dealers supplying weapons to the U.S. military and its allies in Iraq and Afghanistan.

In tune with those opening lines, the story line argues that money (or market) is the major reason for the endless wars the U.S has waged across the Muslim world since 9/11. In fact, war *is* the economy—or at least its heart where the military budget consumes 57% of the U.S. budget's annual discretionary spending—$3.8 trillion to be exact. (That's very nearly as much as the rest of the world combined spends on "defense.")

In other words, our economy is dependent on blood sacrifice. Pope Francis said as much when he spoke to members of the U.S. Congress in 2015. He remarked, "Why are deadly weapons being sold to those who plan to inflict untold suffering on individuals and society? Sadly, the answer, as we all know, is simply for money—money that is soaked in blood."

At the conclusion of "War Dogs," Todd Phillips echoes the pope's phrase, "as we all know." For as the credits roll, Leonard Cohen sings his own "Everybody Knows."

At some level, the song suggests, we all know that the military-industrial complex has fundamentally corrupted our society. Our way of life is based on killing. Yet we refuse to stop. We've become so addicted to permanent mayhem that we rarely ponder what it all means for the defenseless poor of the world who (rather than the rich) habitually end up on the wrong end of the guns, bullets, drones, bombs, missiles, air planes, tanks and ships with which our government and U.S. corporations greedily supply the entire world.

In the end however, *War Dogs* only hints at such disaster. It only suggests the profound corruption of the entire war system. That's because its principals, Ephraim Diveroli (played by Jonah Hill) and David Packouz (Miles Teller) are only small-time bottom-feeders in a system that allows the two—virtually without education or knowledge of the world—to secure a $3 million Pentagon contract for 100 million rounds of Ak47 ammunition for use in Afghanistan and the longest-running war in U.S. history.

The system's top-feeders put Diveroli's and Packouz's profits to shame. The big guys are after much, much more. Their corporate names include the

Carlyle Group, Halliburton, Boeing and Motorola. Of course, their lack of concern for human suffering is highly problematic. But so is their indifference to defense-spending waste. In fact, $6.5 trillion (yes, "trillion" with a "T!") has gone entirely missing from the Pentagon budget without any explanation or even a single audit of the Defense Department over the past 20 years.

Can you imagine the outcry if a similar accounting "error" occurred in social welfare programs meant to assist the poor?

But there will be no outcry, because the missing money fills the coffers of the giant defense corporations.

As Diveroli explains to Packouz whose anti-war sentiment makes him initially demur at joining his friend in the gun-running business: This isn't about being pro or anti-war. It's about money. "This is ... pro-money!" It's pro-market.

All of this is illustrated below in Figure 5.1.

As seen in Chapter Four and now illustrated in Figure 5.1, the basic question about economy—about market—is to what degree it should be private, free, and open, as opposed to public and controlled, with profits limited by taxation. The dilemma is whether the economy should be mixed in favor of the elite (following "trickle-down" theory). Or should economies be mixed in favor of poor and middle class people with associated policies of wealth redistribution through taxes used to support maternal health, child nutrition, day care, public schools, job provision, universal healthcare, and worker retirement programs?

Traditional answers to such questions have ranged from one extreme to the other. Figure 5.1 shows that on the extreme "right," Mafia *Dons* brook absolutely no government or police interference in their business of buying and selling. In their "Black Market," *everything* is for sale, anyone can get in, and prices are absolutely determined by "what the market can bear." Do you want to buy a human liver or heart? If so, you can get it on the black market. If the merchants are fresh out of hearts on a particular day, they can probably get you one overnight. The John Goodman character in *The Big Lebowski* knew all about it. "Toe?" he asks. "I can get you a toe."[2] Similarly, you can buy women, children, men, drugs of all kinds in the extreme right wing form of market. The point is, it's totally unregulated and universally considered criminal.

Libertarians (just to the left of the Mafia in Figure 5.1), also advocate mostly unregulated markets, but not of the criminal kind. Considering themselves as strict followers of Adam Smith, the father of free market theory, they recognize the dangers of both illegal and legal monopolies and the consequent need to implement measures to keep them from forming. In the Libertarian version of market, small businesses interact freely on a level playing field where the laws

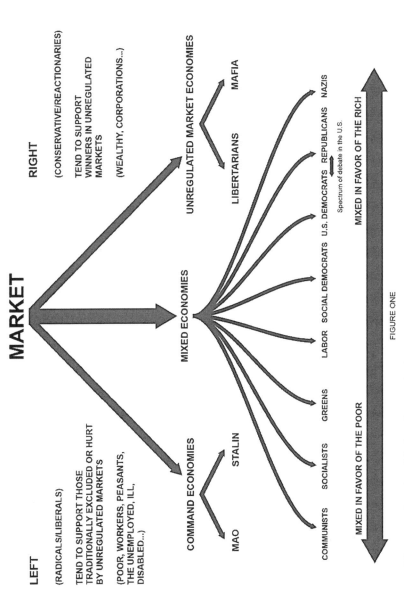

Figure 5.1: Political Spectrum Based on Market. Source: Author.

of supply and demand keep business persons honest, product quality high, and prices low.

As for the extreme left (represented in the diagram by references to China's Mao Tse Tung and Russia's Joseph Stalin), leftists advocate "command economies." These are markets where a central authority is responsible for all decisions involving production, pricing and distribution. Such economies (if indeed they ever existed) fell into disrepute and were abandoned world-wide after the fall of the Soviet Union in 1989.

So much for the extremes. As Figure 5.1 indicates, all other market positions represent variations of "mixed economies." And, again, the key question is, "Mixed in favor of whom?"—the elite or the poor?

In Figure 5.1, the Nazis stand at the right edge of the mixed economy spectrum. As indicated in our previous chapter, like other fascists, Nazis were "corporatists." They interpreted the function of government as allying itself with corporations like the Krupps, Bayer Pharmaceuticals, AIG Insurance, Ford Motor, and IBM, to regulate an economy that would insure the prosperity of blond, blue-eyed Aryans.

Those not falling into that category would be kept in line by exploiting the prejudices of the majority in the body politic. So dysfunctions of the economy were to be blamed on godless communists, socialists, liberals, Jews, non-whites, gypsies, homosexuals, the physically disabled, and those considered mentally incompetent.

Against those who were unpersuaded by such finger-pointing and scapegoating, the police state intervened. The police, army, secret service, and paramilitary Black or Brown Shirts "took care of" dissenters.

Just to the left of such extreme right wing position, Figure 5.1 positions the two party political system of the United States. Here Republicans stand on the right and Democrats just slightly to their left. Both of these are property owners' parties; they are capitalists. Most of their representatives in the U.S. Congress are millionaires. If not, support of millionaires, billionaires and corporations is absolutely necessary for their getting elected. (Of course, unlike most other countries, the United States has no Labor Party directly representing the working classes.)

Traditionally, however, the Democratic Party is more concerned with working class interests than are Republicans. Democrats lean more favorably towards labor unions, minimum wage, workplace safety regulations, consumer rights, and environmental protection.

The Republican tendency is to leave such matters to determination by the interplay of the market forces of supply and demand. However, as seen by the bi-partisan support of huge bailouts for banking and investment firms following the market crash of 2008, both Republicans and Democrats subscribe to "trickle-down" theory.

Both parties agree that during times of economic crisis, Wall Street rather than Main Street—the well-to-do rather than the working classes—should be given priority for receiving government handouts and welfare.

Viewing all of this through the lenses of critical thinking's magic glasses reveals something quite shocking. It shows that the spectrum of permissible political debate in the United States is surprisingly narrow. In fact, anyone to the left of Barack Obama, for example, is considered hopelessly "out in left field," if not "socialist" or even "communist."

A glance at Figure 5.1 reveals the falsity of such perception. On a world scale, Social Democrats, Labor Parties, Green Parties, Socialists, Communists and many others are all far to the left of Mr. Obama. Moreover, they usually find proportional representation in their countries' parliamentary systems.

Consequently, those who support such parties are not left without voice in national assemblies. There the parties in question advocate (and implement) policies such as universal healthcare, free public education through the university level, 35 hour workweeks, high quality universal daycare for working parents, month-long annual vacations for working people, and adequate pensions for everyone in their golden years. In this connection, it might help to watch Michael Moore's *Where to Invade Next* in its entirety.[3]

A Film Illustration

An older classic, *Bulworth* illustrates many of these points.[4] It's the story of a California senator running for re-election. He is very depressed, and decides to end it all—after increasing his life insurance and assigning it to his daughter. Bulworth then hires someone to assassinate him while he is on the campaign trail. Since he has nothing to lose, he begins speaking the truth, instead of the equivocations politicians are accustomed to mouth. He steps outside the parameters of debate allowed by the narrow U.S. political culture. He dresses like a stoner and delivers his speeches in rap.

At one point, Bulworth finds himself in a televised candidates' debate. In the course of answering questions, he makes the following observations about the narrow, highly interested, and exclusive spectrum of political discourse in the United States. He talks about fake news. He alleges that the entire system, including the media serves the rich leaving out the interests of ordinary people.

Moderator: The first question … will be for Senator Bulworth.
Interviewer: Senator Bulworth, the news today requires us to ask you about the sudden change in your campaign style, could you explain it?

Bulworth:	Why are you here? Let's admit you're here because you're making a bundle, right?
Interviewer:	I beg your pardon?
Bulworth:	Oh, you mean you're not here 'cause you're getting paid a bundle of money? Come on: we've got three pretty rich guys here (He points to the interviewers) getting paid by some really rich guys (the debate's sponsors) to ask some other rich guys (the candidates) questions about their campaign. But our campaigns are financed by the same guys that pay you guys your money. I mean, so what are we talking about here?
	I could tell you stories about getting money from these guys that would bend your ears back. Stories about me … Oh, I tell you, we've got a club. Republicans, Democrats, what's the difference? Your guys, my guys, our guys, us guys; it's a club. So why don't we just have a drink. (Bulworth pulls a flask from his hip pocket and offers it to the interviewer and to his opponent.) You, no? (He puts the flask away.)
	You know, Hugh, (He addresses his opponent) if you win this thing you've really got to think about where you're going to put your kids in school. We put our daughter in Sidwell Friends. The Clintons and the Gores really like St. Albans. But a public school anywhere around Washington's a disaster.
Interviewer:	Excuse me, Senator, if you don't mind … At the moment I think we're here to ask about the news."
Bulworth:	The news? The news? Come on! The guys we get our money from— they don't want the people to have the news. They want you to think that corporations are more efficient than government, right? You want to know why the health care industry is the most profitable business in the United States? It's because the insurance companies take twenty-four cents out of every dollar that's spent. You know what it takes the government to do the same thing? Three cents out of every dollar! Now what is all this crap that they hand you about business being more … these pigs need to be regulated. What, you think these guys are going to regulate themselves? What's going on?"
Interviewer:	Gentlemen, if you'll please pardon the interruption. (The debate is interrupted for a commercial)

Bulworth's point is that a two party system like the one in the United States is stacked in favor of the rich. It's all part of a web where politicians and the media serve corporate interests and are highly paid as a result. They can afford Cadillac health insurance and high-quality private schools. Meanwhile the non-rich are left with needlessly high-priced health care and low quality public schools.

Bulworth's remarks suggest the point that a two-party system has only one more party than a one-party system. Meanwhile, in parliamentary arrangements elsewhere, as many as 20 or 30 parties run for office. And many of those parties

end up represented in the countries' legislative assemblies. Unlike the U.S. winner-take-all system, even those who cast their votes for candidates and parties that gain only 10% of the vote typically find themselves represented. Put otherwise, on a world scale that recognizes Labor, Social Democrat, Green, Socialist, Communist and other parties as real players, the limitations of the U.S. system are stunning. So are the limitations of public conversation and awareness.

That's because, Bulworth suggests, corporate media's news is fake. It's sponsored by corporations interested in keeping us in the dark, for instance, about the true costs of privatized healthcare in comparison with government single-payer systems.

Bulworth's insights arguably apply to education as pertinently as to the news. Classrooms normally mirror the narrowness of public discourse that Bulworth references. Even at the university level, it's safe to say that few discussions of "current events" give a sympathetic hearing to viewpoints falling outside the parameters set by the corporate media. Who seriously considers, for instance, the motivations and goals of insurgents in Afghanistan or Iraq or the viewpoints of Palestinians in their conflict with Israel? Similarly, few students or their teachers are familiar with the reasons enumerated by Osama bin Laden for the 9/11 attacks of 2001.

Osama bin Laden's Post-9/11 "Letter to America"[5]

… As for the first question: Why are we fighting and opposing you? The answer is very simple:

(1) Because you attacked us and continue to attack us.
 (a) You attacked us in Palestine;
 (b) You attacked us in Somalia; you supported the Russian atrocities against us in Chechnya, the Indian oppression against us in Kashmir, and the Jewish aggression against us in Lebanon.
 (c) Under your supervision, consent and orders, the governments of our countries which act as your agents, attack us on a daily basis;
 (d) You steal our wealth and oil at paltry prices because of your international influence and military threats. This theft is indeed the biggest theft ever witnessed by mankind in the history of the world.
 (e) Your forces occupy our countries; you spread your military bases throughout them; you corrupt our lands, and you besiege our sanctities, to protect the security of the Jews and to ensure the continuity of your pillage of our treasures.

(f) You have starved the Muslims of Iraq, where children die every day. It is a wonder that more than 1.5 million Iraqi children have died as a result of your sanctions, and you did not show concern. Yet when 3000 of your people died, the entire world rises and has not yet sat down.

(g) You have supported the Jews in their idea that Jerusalem is their eternal capital, and agreed to move your embassy there. With your help and under your protection, the Israelis are planning to destroy the Al-Aqsa mosque. Under the protection of your weapons, Sharon entered the Al-Aqsa mosque, to pollute it as a preparation to capture and destroy it.

(2) These tragedies and calamities are only a few examples of your oppression and aggression against us. It is commanded by our religion and intellect that the oppressed have a right to return the aggression. Do not await anything from us but Jihad, resistance and revenge. Is it in any way rational to expect that after America has attacked us for more than half a century, that we will then leave her to live in security and peace?!!

(3) You may then dispute that all the above does not justify aggression against civilians, for crimes they did not commit and offenses in which they did not partake:

(a) This argument contradicts your continuous repetition that America is the land of freedom, and its leaders in this world. Therefore, the American people are the ones who choose their government by way of their own free will; a choice which stems from their agreement to its policies. Thus the American people have chosen, consented to, and affirmed their support for the Israeli oppression of the Palestinians, the occupation and usurpation of their land, and its continuous killing, torture, punishment and expulsion of the Palestinians. The American people have the ability and choice to refuse the policies of their Government and even to change it if they want.

(b) The American people are the ones who pay the taxes which fund the planes that bomb us in Afghanistan, the tanks that strike and destroy our homes in Palestine, the armies which occupy our lands in the Arabian Gulf, and the fleets which ensure the blockade of Iraq. These tax dollars are given to Israel for it to continue to attack us and penetrate our lands. So the American people are the ones who fund the attacks against us, and they are the ones who oversee the expenditure of these monies in the way they wish, through their elected candidates.

> (c) Also the American army is part of the American people. It is this very same people who are shamelessly helping the Jews fight against us.
>
> (d) The American people are the ones who employ both their men and their women in the American Forces which attack us.
>
> (e) This is why the American people cannot be innocent of all the crimes committed by the Americans and Jews against us.
>
> (f) Allah, the Almighty, legislated the permission and the option to take revenge. Thus, if we are attacked, then we have the right to attack back. Whoever has destroyed our villages and towns, then we have the right to destroy their villages and towns. Whoever has stolen our wealth, then we have the right to destroy their economy. And whoever has killed our civilians, then we have the right to kill theirs ...

Such constriction of perception, thought, and discussion betrays a fundamental purpose of liberal arts education, which is inherently liberal or liberating. That purpose is to expand students' horizons. An important part of doing so entails achieving clarity about politics and the economic roots of political differences.

So that's the second rule of critical thinking: Detect the economic root of political differences. It is MARKET!

For Discussion

1. Have you ever encountered Osama bin Laden's justification of the 9/11 attacks? If so, who exposed you to them? If not, why not?
2. Evaluate Bulworth's comments about Republicans and Democrats, the mainstream media, public schools, and healthcare costs. What does he say? Do you agree?
3. Discuss the pros and cons of parliamentary systems of government in comparison with the U.S. system.

Activity

Research Osama bin Laden's allegations about Palestine, Somalia, Chechnya, Kashmir, Lebanon, or Iraq. Prepare an oral presentation to inform your classmates.

Notes

1. The common political designations, "left" and "right," come from the French Revolution (1789–1799). They refer to the fact that in the French Assembly, the *Estates General*, those who supported the Revolution sat on the left side of the assembly hall, while supporters of the old monarchal order sat on the right side.
2. *The Big Lebowski*. Dir. Ethan Coen. By Ethan Coen and Joel Coen. Perf. Jeff Bridges, John Goodman, and Julianne Moore. Indie film/Stoner film, 1998.
3. *Where to Invade Next*. Dir. Michael Moore. Perf: Michael Moore, Krista Kluru, Tim Walker. Dog Eat Dog Films, 2016.
4. *Bulworth*. Dir. Warren Beatty. Perf. Warren Beatty, Halle Berry, Sean Astin. 20th Century Fox, 1998. Web. https://www.youtube.com/watch?v=Id0cqNWZ50Y
5. Osama bin Laden. "Letter to America." Web.

Rule Three

Reject Neutrality

Our previous two rules for critical thinking have centralized economic understanding as central to deciphering the fake news and alternative facts that have created the shadow world described in Plato's Allegory of the Cave. Without clear ideas about capitalism, Marxism, socialism, communism, mixed economy, and fascism, we have no hope of escaping the shadows that control our lives, or of critically understanding our culture's doxa with its glib slogans about "greatest country in the world" or God being on our side.

Rule Three returns us to the cave and examines the prisoners' attitudes more closely. It addresses Plato's observation that the cave's prisoners love the shadows and strongly resist challenge to their debunking. They are not neutral.

Neither, however, is their would-be liberator. Having escaped the cave's ethnocentrism, his vision became world-centric. Quite possibly (as we'll see) he had achieved cosmic-consciousness. In any case, his broader perspective would never allow him to resume his place among the captives. He is committed to the better world he has discovered. He is committed to the liberation of captives. By definition, those with such commitment cannot be neutral.

Rule Three, then, urges us to reject neutrality, not only because neutrality is undesirable; it is impossible. As the liberation theologians I studied with have noted, it is undesirable, because it ends up supporting the status quo they find so oppressive. That's why rejection of neutrality has consistently characterized

history's great social change activists. Jesus was not neutral, the theologians argue. Neither was Dr. King or Mohandas Gandhi. As Paulo Freire put it, neutrality does nothing to change situations of oppression; it only validates oppression, slavery, xenophobia, sexism, homophobia, etc. He said, "Washing one's hands of the conflict between the powerful and the powerless means to side with the powerful, not to be neutral."[1]

But neutrality is also impossible. That's because cultures make sure its members imbibe world visions favorable to the culture's maintenance. We are prejudiced from the beginning. Parents, teachers, religious leaders, politicians and peers convey fixed understandings of the world before we are able to realize what is happening. So before we know it, well-formed world visions become part of who we are. As I shared earlier, my own case had me staunchly Catholic and unquestioningly patriotic well before my first critical thought.

Later on, of course, I discovered that not everyone was as politically and religiously conservative as I was. Their parents were Democrats, not Republicans like mine. They came from Protestant families, not Catholic like mine. They saw the world quite differently.

All of this means that critical thinking cannot be reduced to a straightforward exercise of logic as if the world were seen in the same way by everyone. Instead, those who would think critically must turn attention to inherited biases which act like blinders limiting what individuals can and cannot see in the world around them. Woven into the fabric of that world are elements like patriarchy, racism, sexism, nationalism and bias towards the economic systems earlier discussed. Neither can we achieve a position of neutrality since our standpoints are also quite well-defined as female or male, black or white, eastern or western, poor or rich.

Such predetermination flies in the face of cherished lessons we learn in school. One of these holds that academic study *requires* neutrality. Students and their teachers are encouraged to suspend their personal judgments about controversial issues, analyze them in detached ways, consider all sides, and render judgments based simply on "the facts" and logic.

The truth contained in such encouragement is its apparent desire for fairness. That's good. For while neutrality might be undesirable and impossible, fairness is neither. Trying to distance oneself from pre-judgment, considering all sides as fully as possible, and rendering judgment on the basis of facts and logic are all part of fairness. They are all part of thinking critically.

The argument of this chapter is that prior to all of that, we must exercise self-criticism. That is, both student and teacher must come to grips with the well-defined and inherited points of view that make neutrality a problem.

Making conscious the elements of one's viewpoint (or world vision) is therefore central to critical-thinking. Of course, there are innumerable world visions. This chapter describes three that appear most common in mainstream U.S. culture.

Functionalism

The most common worldview in U.S. culture is what sociologists term "functionalism." This viewpoint stands behind most classroom presentations of U.S. history, behind most political speeches, and arguably represents what most Americans would like to believe about their world, and the role the United States plays in it.

Functionalism embraces convictions similar to the following:

(1) **Society is basically harmonious.** Butchers, bakers and automobile mechanics all do their part to make the world turn.

(2) **There is a productive place for everyone in society.** Though the work of some might be more important than those of others, we all need one another, and each person contributes according to her or his natural or God-given talents.

(3) **Public institutions are themselves neutral.** The policeman on the beat, our court system, and other government institutions, all represent "fair brokers" in the inevitable disputes that occur among citizens. They have the defense of everyone's interests and rights at heart.

(4) **Government decisions are the result of democratic consensus.** Legislation is proposed. The people's representatives vote their consciences. Decisions are made. If the results prove unacceptable to "the people," they will appeal and/or elect other decision-makers who better serve the electorate's needs.

(5) **Crime is the disruption of society's basic order.** Criminals are those who reject "the old fashioned way" of earning money; they seek short-cuts to wealth and prosperity, and so deserve their punishment.

(6) **Social change begins and ends with personal change, which adjusts people to fit in.** Since society's institutions normally function so efficiently, there is little need for protests and demonstrations, much less for civil disobedience.

(7) **God is neutral.** Like society at large, and its institutions, God favors no one. He (sic) loves rich and poor alike. He allows those who work

harder and smarter to prosper. Those less willing to work suffer the consequences—poverty and what comes with life on the lower rungs on the social ladder.

Film Illustration

President Ronald Reagan's first inaugural speech provides an example of a clear and inspiring expression of functionalism.

> If we look for the answer, as to why for so many years we achieved so much, and prospered as no other people on earth, it was because here in this land, we unleashed the energy and individual genius of man to a greater extent than has ever been done before. Freedom and the dignity of the individual have been more available and assured here, than in any other place on earth.
>
> It is time for us to realize that we're too great a nation, to limit ourselves to small dreams. We have every right to dream heroic dreams.
>
> Those who say that we live in a time when there are no heroes ... they just don't know where to look. You can see heroes every day going in and out of factory gates. Others, a handful in number, produce enough food to feed all of us and then the world beyond.
>
> They're individuals and families who pay taxes and support the government, and whose voluntary gifts support church, charity, culture, art and education. Their patriotism is quiet but deep. Their values sustain our national life.
>
> Now I have used the words "they" and "their," in speaking of these heroes, I could say, "you" and "your," because I am addressing the heroes of whom I speak—you the citizens of this blessed land.
>
> Your dreams, your hopes, your goals, are going to be the dreams, the hopes, the goals, of this administration. So help me God.[2]

Here President Reagan approximates the points listed above as the components of functionalism. The picture he paints of the United States is completely harmonious. The only hint of discord is on the part of those who say ours is a time devoid of heroes. For Mr. Reagan, the U.S. is a place where the freedom and dignity of all are respected and assured. Factory workers, farmers, and families in general, all do their parts in creating unprecedented prosperity.

Everyone is a genius; everyone, a hero. All support the government and willingly pay their taxes. They even go over and above such obligations—sharing their prosperity in the form of voluntary gifts to help the less fortunate, and to spread education, culture and art. The government represents such people, sharing and reflecting in its decisions the people's dreams, hopes and goals. God

blesses all of this—the homeland and its people. God will help the government in its mission too.

Radical Conflict Theory

Radical Conflict Theory represents the antithesis of Mr. Reagan's vision. Inspired most prominently by Karl Marx, this viewpoint comes from the left wing of the political spectrum reviewed in our last chapter. The qualifier "radical" is added to distinguish this world vision from a form of conflict theory that has gained prominence in the United States in recent years. Issuing from the right extreme of political thought, it will be termed "Conservative Conflict Theory," and will be described in the section following this one. Radical Conflict Theory espouses the following convictions:

(1) **Society is basically conflict-ridden**. The root cause of such strife is the capitalist economic system, and its inherent tension between bosses and employees. In the interests of maximizing profit, employers are concerned with employing as few workers as possible. Business owners want to keep wages low, and save money by investing as little as possible in improving working conditions and workers' quality of life. Meanwhile workers want the opposite—full employment, higher wages, better working conditions, and escalating standards of living. Conflict in the workplace is the taproot of conflict in the world.

(2) **Many have no chance for a dignified human life**. Because of the basic conflict just described, many people are left without employment, or are underemployed, and/or underpaid. As a result, there is homelessness, squalor, poor or non-existent medical care, inferior education and a host of other problems for very large numbers of people. The result is a great loss of dignity. Moreover, though a relative handful can, no doubt, escape from such situations, the capitalist system has proven incapable of providing enough good-paying jobs for everyone to rise above poverty and degradation.

(3) **Public institutions favor the most powerful**. In other words, democracy, as described above by President Reagan, is an illusion. Though it's true that every two or four years, citizens can vote for "their favorite millionaire," those who are elected prioritize their relationships with their own kind, and with their financial backers. As a result, most "public servants" do not address the needs of the ordinary people whom Mr. Reagan praised as heroes and geniuses.

(4) **Government decisions are the result of bargains made between the rich and powerful.** Once elected, the decisions of government officials represent "payback" for those who spent huge sums of money on behalf of their protégé's political campaigns.

(5) **Crime is support for the given disorder.** Since the given order of political economy is so biased towards the rich and powerful, it is largely corrupt and deceitful. It represents a huge theft of money from taxpayers who have been led to expect much more. Society's most heinous criminals, therefore, are the ones who deceive the public, and who steal money from those least able to endure the theft. Here the politicians bear great responsibility. But so do the judiciary, the police force and the military.

(6) **Social change begins with personal change enabling people to perceive society's dysfunction, and to work for radical change.** Far from being social misfits, those who protest and demonstrate against government and the business firms underwriting it, are the culture's true heroes. They have taken the trouble to inform themselves, analyze and perceive the way society truly works. They are now expending effort to work for radical change. Here "radical" is used in its etymological sense provided by the Latin word *radix*, meaning "root." Radicals try to get to the root causes of issues rather than dealing simply with their superficial manifestations. For many of them, the root cause is identified as capitalism—a term you now understand in the light of Chapter Four.

(7) **God loves everyone, but is especially committed to the welfare of the poor.** It is true that Marxists among radical conflict theorists might reject belief in God as the people's "narcotic," desensitizing them to the causes of their problems. Still, many radical conflictualists (like the liberation theologians described in Chapter Two) are also believers. They see God as siding with those who are poor and without public power. For instance, Christians in this category would point out that God's first recorded intervention in history was by no means neutral. The biblical God came to the aid of the people of Israel, liberating them from slavery. Jesus, himself was a poor man, illustrating by that very fact, God's preference for the poor. The rich, whom Jesus vilifies (e.g. Lk. 6:24), are invited to sell everything they have and give it to the poor (Mt. 19:21).

Elements of radical conflict theory appear throughout the film, *Bulworth*, which we've sampled earlier. There the main character finds warm reception in the African-American community. Some African-Americans become part of his entourage, and he adopts rap as his style of public communication. At one

especially important political banquet, before the "haves and have-mores," Bulworth sets aside his prepared remarks, and substitutes words which include the following:

> Well it ain't that funny you contribute all my money
> You make your contribution and you get your solution.
> As long as you can pay, I will do it all your way,
> 'Cause money talks and the people walk.
> (Yeah, I wanna hear you say it: 'big money, big money, big money …')
>
> One man one vote; now is that really real?
> The name of our game is "Let's Make a Deal".
> Now the people got the problems: the haves and the have nots;
> But the ones who make me listen pay for thirty second spots.
>
> Yo Bank of America, this table over here,
> Wells Fargo, and Citibank, you're really very dear.
> They loan billions to Mexico and never have to fear,
> Cause taxpayers, the taxpayers, take it in the rear.
>
> Yo over here we got our friends from oil.
> They don't give a shit how much wilderness they spoil.
> They tell us that they're careful; we know that that's a lie.
> As long as we keep driving cars, they let the planet die.
>
> Exxon, Mobile, the Saudis and Kuwait …
> As long as we got the Middle East, the atmosphere can wait.
> The Arabs got the oil; we buy everything they sell,
> But if the brothers raise the price we'll blow them all to hell.
> (Now let me hear you say it: Saddam Hussein; Saddam Hussein.)
>
> Now everyone's gonna get sick someday,
> But no one really knows how they're gonna pay.
> Health Care, Managed Care, HMOs
> Ain't gonna work, no sir, not those.
> 'Cause the thing is controlled across the seven seas
> By these mother-fuckers over here, the insurance companies.
>
> You can call it "single payer" or "the Canadian way,"
> But only socialized medicine will ever save the day
> (Come on now let me hear that dirty word: "Socialism" …)[3]

Bulworth's words are comprehensive, as far as Radical Conflict Theory is concerned. In the struggle between the haves and the have-nots, those who pay for

"thirty-second spots" get the politicians' preference. These include the bankers, oil companies, insurance companies, along with dictators in Saudi Arabia and Kuwait. These are the ones who truly call the shots. Meanwhile, under cover of "one man, one vote" ideology, the taxpayers and a devastated environment foot the bill. To all this, the answer is socialism, including a socialized single-payer medical system. Socialism, as we have seen, is an economic system distinguished by (1) public ownership of the means of production, (2) controlled markets, and (3) limits on income for purposes of wealth redistribution.

Conservative Conflict Theory

Throughout the 1960s and early '70s Radical Conflict Theory threatened to carry the day, as far as mainstream culture was concerned. Everyone seemed to be recognizing the insight that the government was somehow the enemy. Conservatives were put in the position of defending the government according to the tenets of functionalism described above.

Gradually, however, conservatives got on the anti-government bandwagon. But instead of recognizing big business as the power behind the government, conservatives vilified liberals and the groups liberals favored as having hijacked the government.

Thus African-Americans, welfare recipients, women's liberationists, undocumented workers, gay rights activists, anti-war and anti-gun movements, environmentalists, and the like were identified as government favorites. White males, straights, the military, and those claiming the right to drive big cars, live in big houses and to own guns, were the persecuted. In this way, Conservative Conflict Theory took shape: Its tenets are something like the following:

(1) **Though once harmonious, society is now basically conflictual.** The period of our nation's founding was a kind of Golden Age. U.S. founders were especially wise and even holy. Their wisdom and idealism framed a Constitution, which insures the maintenance of the harmonious community the Founders intended. According to the Constitution, the best government is the one that governs least. Most contemporary conflicts are produced by departure from that ideal with the introduction of government "programs" catering to "special interests" represented, for instance by African-Americans, feminists, environmentalists and gays.

(2) **There is a place in society for everyone willing to work and compete.** The problems of unemployment, poverty, homelessness, are due to laziness and other personal faults on the parts of those who are seeking a "free

lunch." The response to such parasitism is "tough love,"—forcing the would-be parasites to fend for themselves, without government aid.

(3) **Public institutions now favor liberals and their clients: foreigners, minorities, women, environmentalists, slackers …** Since Roosevelt's New Deal in 1933, "bleeding heart liberals" have gradually taken control of the Democratic Party, the judiciary, schools, prisons, and the press.

(4) **Government decisions result from bargains struck between these groups and their liberal representatives.** The result of the alliance between government and the "special interest groups" just named has been a gigantic explosion in the size of government, and of government programs favoring those wrongly characterized as "the poor and oppressed."

(5) **Crime results from a breakdown of traditional American morality.** Here liberals are portrayed as excusing crime in terms of rational responses to poverty and rights denied. Meanwhile, Conservative Conflict theorists find explanation instead in rejection of personal responsibility on the part of "professional victims." Above all, conservatives allege, liberals have created a culture where prayer is forbidden in public schools, where abortion is tolerated, and even celebrated, where gay marriages mock a central institution of human community itself, and where freedom of press is misused to foist liberal values on an unsuspecting populace.

(6) **The most essential social change requires a return to "America's" basic traditional morality.** The morality in question is embodied in the values of the Founding Fathers—who were Christians, and espoused strict Christian morality.

(7) **God favors conservatives and the free market system.** Because conservatives are, for instance, "pro-life," advocate the posting of the Ten Commandments in schools and public buildings, espouse prayer in school, and oppose homosexual marriage; and because liberals typically take opposing positions, conservatives represent God's interests, and hence enjoy more favor in God's eyes. Similarly, because advocates of the free market's antithesis (viz. socialism and communism), have traditionally espoused atheism; they cannot be close to God.

In the contemporary United States, examples of Conservative Conflict Theory are found on all sides. The Republican Party, as a group and President Trump himself are sympathetic to its tenets. Rush Limbaugh, the country's most popular radio talk-show host, has been vocal in advancing the theory. So are James Dobson, Pat Robertson and others, in the context of specifically religious leadership.

Conclusion

It would be an interesting exercise to identify which of the world visions just summarized each of us has been taught, who taught it to us, how much we have questioned its elements, or considered its alternatives. Without introspection like that, most of what we believe about the world will remain vague.

Even vaguer for some are the exact elements of and reasons for the world vision they currently espouse and sometimes defend with great emotional vigor. Why do we accept that vision, and what is at the root of the emotion we feel when we discuss and defend? Each of us should answer those questions.

There is also a common response to the question, "Which of the three world visions, functionalism, radical conflict theory, or conservative conflict theory, do you most agree with?" Many answer, "I don't really agree fully with any of them; I'm drawn to elements in all three."

That would be a good answer if the discussion didn't stop there. Usually it does. So the response can be equivalent to "It's all very interesting, I'm sure. But it is also threatening, and I don't want to think about it anymore."

That response is just not appropriate for anyone aspiring to become a critical thinker. Instead, at this point it is appropriate to sit down and list the convictions each of us has about the world, to explain their origins, and the reasons we still find them persuasive.

For Discussion

1. Identify specific lines from President Reagan's inaugural speech that relate to the fundamental ideas of functionalism?
2. Each world vision addressed in this chapter views religion a different way. Explain the role religion plays in your own worldview.
3. With which elements from the three world views do you agree? With which do you disagree?

Activity

1. Using the categories of this chapter (functionalism and conflict theories), write an essay describing your own worldview point by point. Then indicate how your thinking relates to the other worldviews discussed in this chapter.
2. Research the religious convictions of the Founding Fathers? Were they Christian or not?

Notes

1. Freire, Paulo. *The Politics of Education: Culture, Power, and Liberation.* South Hadley, MA: Bergin & Garvey, 1985.
2. Ronald Reagan: "Inaugural Address," January 20, 1981. Online by Gerhard Peters and John T. Woolley, *The American Presidency Project.* www.youtube.com/watch?v=R5cEhtge_BE
3. *Bulworth.* Dir. Warren Beatty. Perf. Warren Beatty, Halle Berry, Sean Astin. 20th Century Fox, 1998. Web. https://www.youtube.com/watch?v=Id0cqNWZ50Y

A Compromise World Vision

Having just observed the wise tendency of students to do so, what follows is an attempt to blend the three positions outlined in the previous chapter in ways aspiring to incorporate the strengths of each. Remember, those positions were functionalism, radical conflict theory, and conservative conflict theory.

Again, in this section most points are illustrated with an example from film, one of the most powerful conveyors of both the dominant and resistant worldviews in the contemporary world.

(1) **Human life is a mixture of harmony and conflict.** Neither personal life nor public and political life is all conflict. Both contain moments of transcendent harmony and peace. Experience teaches as well that even the most conflicted relationships can be transformed into harmonious ones.

At the same time, however, economic and political realities such as systems of slavery, feudalism, capitalism, or communism can override positive and even loving feelings and cause people to act against their better impulses by forcing them into antagonistic roles they might not otherwise choose. To introduce true harmony, those economic, social or political realities as well as accompanying attitudes must be changed.

Ironically, it was Malcolm X, whom whites often associate with unmitigated conflict and intransigence, who described conditions

necessary for overcoming conflict and establishing harmony, especially between the races. In the following passage, he speaks about slavery and its inheritance in the United States.[1]

> "You have to be delivered from slavery to understand this." There were two kinds of Negroes—that old house Negro and the field Negro. And the house Negro always looked out for his master. When the field Negro got too much out of line, he held him back in check; he put him back on the plantation. Black people who talked like me while they were slaves … they didn't kill them; they sent some old house Negro after him to undo what he said.
>
> Because he lived better than the field Negro; he ate better; he dressed better, and he lived in a better house. He lived right up next to his master—in the attic or the basement. He ate the same food his master ate, and wore his same clothes, and he could talk just like his master—good diction. And he loved his master more than his master loved himself. That's why he didn't want his master hurt. If the master got sick, he'd say "What's the matter, boss; we sick?" When the master's house caught on fire, he tried to put the fire out. He didn't want his master's house burnt. He never wanted his master's property threatened. He was more defensive of it than his master was. That was the house Negro.
>
> But then you have the field Negro who lived in huts, had nothing to lose. They wore the worst kind of clothes, ate the worst food, and they all felt the sting of the lash. They hated their master—oh yes they did. If the master got sick, they prayed that the master die. If the master's house caught on fire, they prayed for a strong wind to come along. This is the difference between a house Negro and a field Negro.
>
> And today you still have house Negroes and field Negroes. I am a field Negro. If I can't live in their house as a human being—I'm praying for a wind to come along. If the master's not treating me right and he's sick, I'll tell the doctor to go the other direction. But if all of us are going to live as human beings and brothers and sisters, then we need to be a society of "human beings that can practice brotherhood."

Malcolm's description is vivid and telling. Certainly, he is describing a conflict-ridden situation with elements of harmony. There, despite the institution of slavery, relationships between the slave master and the house negro were cooperative and even loving. But the prerequisite for that concord was that the house negro oppress his field negro counterpart. Meanwhile, the field negro identified the house negro with the plantation boss despite the fact that both house and field workers were slaves. Malcolm's insight is that to achieve harmony, it is necessary that oppressors begin treating their former victims as human beings—as brothers and sisters. Relationships like those are incompatible with any form of slavery or with the system of segregation that characterized Malcolm's own context. Only in a society where everyone's humanity is recognized can the true harmony of brotherhood be

experienced. Only then can a society like the one earlier described by President Reagan emerge.

(2) Many excluded can "make it," but there is limited space for "upward mobil-
ity." It is impossible to deny, of course, that many people can, and indeed
have risen from extreme poverty to achieve prosperity, and even become
millionaires. However, the manner in which income is distributed in the
world, and in the United States, makes it impossible for the majority to
rise from poverty. This is illustrated by the following U.N. graph describing
world income distribution. In this "champagne glass" configuration, each
division in the diagram represents 20% of the world's population.

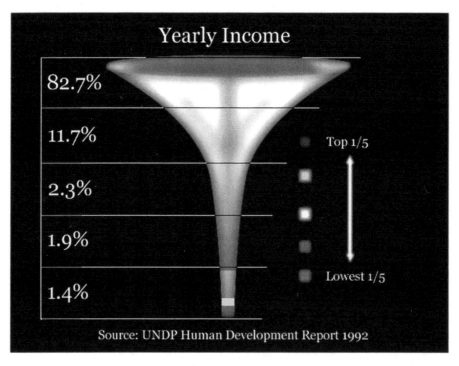

Figure 7.1: Champagne Glass Model of World Income Distribution. Source: UNDP Human Development Report 1992.

This illustration was first published in 1992. It is included here because of its graphic easy-to-grasp quality. Despite the nearly quarter century that has passed since its initial publication, the graph's point remains valid. In fact, today, the situation it describes has markedly deteriorated. Currently the 85 richest people in the

world own as much wealth as the world's poorest 3.5 billion—i.e. half the world's population.

In Figure 7.1, the top 20% receives 82.7% of the world's income. Also, within the top 20%, the uppermost 1% receives 40% of the world's income. The next 20% on the graph receives 11.7% of global income. This leaves something like 6% for the bottom 40% of the world's population. Obviously people at the bottom of the "glass" (mostly children and women) are extremely poor.

(3) **A great many public officials are well-intentioned, but structures force them into harmful actions.** It doesn't take much thought for most U.S. citizens to recall politicians and public servants they admire. George Washington, Abraham Lincoln, Franklin Roosevelt, John Kennedy and Ronald Reagan come immediately to mind.

Many at least began their careers with the kind of idealism expressed in the following dialog, again from *The Distinguished Gentleman*. There, two novice politicians meet in the men's washroom. One, Thomas Jefferson Johnson (Eddie Murphy) finds himself in Washington exclusively to enrich himself. The other, Mike Point, was driven by his experience in Vietnam to seek public office. He brings with him sincere concern for the environment that Johnson finds difficult to understand. In this scene, the two distinguished gentlemen introduce themselves[2]:

Point:	Mike Point, Iowa.
Johnson:	Thomas Johnson, Florida. So how'd you wind up here in D.C. ...? Iowa—you do the crop report on T.V. or something?
Point:	Ah, no. Actually I went all the way to the Vietnamese.
Johnson:	Oh, you're a war hero?
Point:	POW. When I got back to Cedar Rapids I spent so many years telling the Rotary Club what was wrong in Washington, they finally told me either put up or shut up. Hah, so I put up and here I am.
Johnson:	What are you talking about, what's wrong with Washington? Washington's great.
Point:	O, come on. We've got acid rain killing fish and nobody's stopping it. There's top soil being washed away; no erosion programs. Why there's chemicals in the livestock that … Ah, God, I sound like a Boy Scout.
Johnson:	No actually that's kind of nice. This town could use a few geeks like you.

Most of us would agree with Johnson and recognize that the "geeks" he refers to are part of what happens in Washington, along with the other more cynical politicians. Eventually, Johnson himself even adopts Point's idealism.

(4) **Politicians favor the interests of their main contributors.** *The Distinguished Gentleman* provides an example to illustrate this point too. Before his change in consciousness, Thomas Johnson speaks with an advisor (Terry) about his position on various bills before the House. The conversation is completely cynical, and shows how (as Bulworth observed earlier), "money talks and the people walk."[3]

Terry:	I'd like to raise more money for you, but first I've got to get your positions on a few issues. Where are you on sugar price supports?
Thomas:	Sugar price supports ... Where should I be, Terry?
Terry:	Shit, it makes no difference to me. If you're for 'em, I got money for you from sugar producers from Louisiana and Hawaii. And if you're against them, I've got money from the candy manufacturers.
Thomas:	You pick.
Terry:	Let's say, "for."
Thomas:	Yeah, for, for.
Terry:	How about putting limits on malpractice awards?
Thomas:	You tell me.
Terry:	Well if you're for them, I've got money from the doctors and the insurance companies; and if you're against them I've got money from the trial lawyers. Let's put you down as "against."
Thomas:	Yeah, you know what? Put me down for "against."
Terry:	How about pizza?
Thomas:	No, thanks; I've got salad; salad will be enough for me.
Terry:	Not for lunch, old buddy. I'm talking about PAC money.
Thomas:	You thought I was serious; I was fucking with you.
Terry:	If you were, you were.
Thomas:	Fucking with you ... Terry, tell me something. With all this money coming in from both sides, how can anything ever get done?
Terry:	It doesn't. That's the genius of the system.

(5) **Since socio-economic circumstances often give rise to crime, maintenance of such circumstances causes the maintainers to share guilt along with actual perpetrators of crime.** *Bulworth* illustrates this point. The gubernatorial candidate finds himself back in the ghetto, looking for the film's love interest, Nina. His search takes him to the storefront "office" of a local drug dealer. During the conversation, young boys of 8–10 years old are playing video games. These "shorties" are employed by the drug dealer. Each carries a gun. The drug dealer (DD) explains how the children fit into the local economy, and how Bulworth (B) and his fellow politicians

are responsible. DD draws a parallel between his use of the young, and the way other business people use child labor—and the way the government exploits the young to fight questionable wars.

DD: Good work, looking out for the shorties, you know. Ain't every day a white man comes to rescue my little soldiers. I want to tell you I appreciate …"

B: Little soldiers?

DD: Ah … um … what do you know about it? Your ass lives up in Beverly Hills somewhere, right? Am I right … Beverly Hills? I provide for these little brothers right here, these little brothers is my first line of defense. They're my little eyes and ears."

B: Where's Nina?"

DD: I'm giving them entry level positions into the only growth sector occupation that's truly open to them right now. That's the substance supply industry. They gonna run this someday; they're gonna have the whole empire … Man, y' all don't give a fuck about it—you greedy-ass politicians. That's what you tell me every time you vote to cut those school programs, every time you vote to cut those funds to the job program. What the fuck! How's a young man going to take care of his financial responsibilities working at mother fucking Burger King? He ain't! He ain't!

And please don't even start with the school shit. There ain't no education going on up in that mother fucker. 'Cause you all politicians done fucked that shit up. So what are they going to do? What's a young man supposed to do now? Right, what's he going to do? He's going to come to me; that's what he's going to do.

Why? Because I'm a business man, and as a businessman, you've got to limit your liabilities. And that's what these shorties are for me, limited liabilities—because of their limited vulnerabilities to legal sanctions, man. You find an edge, you gotta exploit that shit. That's why you're sending mother fucking teenagers to Iraq …

Here DD presents himself simply as a good businessman providing entry-level work for the youth of his community. He points out that criticism of such provision is entirely hypocritical, especially coming from politicians who cut school funding and job programs. If he is to blame, so are they. Young people in DD's community have little choice themselves. Fast food jobs don't really help. Moreover, DD's employment of "shorties" is a rational response on the part of a businessman seeking the kind of "edge" that all good business people seek. Both he and they use child labor, advancing virtually the same arguments for doing so.

A similar argument about the rationality of the illegal drug trade, closely connected with responsibility on the part of those who support the status quo, appears in *Traffic*. There the teenage daughter of the U.S. "Drug Czar" becomes addicted to cocaine. Her boyfriend and she make regular trips to the ghetto "across the Rhine" in Cincinnati to obtain and shoot drugs. Eventually the Drug Czar father forces the boyfriend to take him to the drug-infested neighborhood. As they wait in the car, the father complains about his daughter's having been brought to such a neighborhood.[4]

Father: I can't believe you brought my daughter to this place.

Boyfriend: Wow! Why don't you just back the fuck up, man. "To this place?" What is *that* shit? Okay, right now all over this great nation of ours, 100,000 white people from the suburbs are cruisin' around downtown asking every black person they see, "You got any drugs—you know where I can score some drugs?"

Think of the effect that has on a psyche of a black person—on their possibilities! God, I guarantee; you bring 100,000 black people in your neighborhood—fuckin' Indian Hills—and they're asking every white person they see "You got any drugs—you know where I can score some drugs?"—within a day, everyone would be selling—your friends, their kids …

Here's why: it's an unbeatable market force. It's a three hundred percent mark-up value. You can walk out on the street and make five hundred dollars and come back and do whatever you want to do for the rest your day. And I am sorry … And you're telling me that white people would still be going to law school?

Once again, drug dealers are presented simply as good capitalists, making rational decisions about most efficiently investing their time in an unregulated market. Will it be law school (instead of Burger King, as in the previous example) or drug dealing? Again, there is only one "rational" choice. Additionally, the racism of segregation, supported by whites who have fled the city center to suburbs like Indian Hills, insures that the ones chiefly incentivized to sell drugs (with corresponding risk) will be impoverished blacks.

Implied in this passage too is the obvious connection between the Drug Czar's work and the price of drugs. Because the substances in question are "controlled," by the half-hearted policies he makes and enforces, their street value skyrockets to 300% profit for the dealer. So as both a protagonist of "white flight" and as a law enforcement officer, the father in the scene shares responsibility for the situation he finds so deplorable.

Again, the point is that law-breakers and law-enforcers share responsibility for "crime."

(6) **Personal change entails recognition and analysis of society's conflicts in order to mitigate them, and to avoid participating in their negative impacts.** The following dialog from *Good Will Hunting* shows the comprehensive nature of analysis necessary to take responsible decisions, for instance, about one's employment. Towards the film's end, the mathematical genius, Will Hunting, is interviewed for a position in the National Security Agency (NSA). He's asked why he shouldn't take the job. Here is his answer:[5]

NSA interviewer: So the way I see it, the question isn't why should you work for the NSA; the question is why shouldn't you?

Will: Why shouldn't I work for the NSA ... that's a tough one. Well, I'll take a shot. Say I'm working at the NSA, and somebody puts a code on my desk—something no one else can break. Maybe I take a shot at it, and maybe I break it. I'm happy with myself, 'cause I did my job well.

But maybe that code was the location of some rebel army in North Africa or the Middle East. And once they have that code, they bomb the village where the rebels are hiding. 1500 people that I never met, never had no problem with, get killed. Now the politicians are saying, "Oh send in the marines to secure the area."

In any case, they don't give a shit. It won't be their kid over there getting shot, just like it wasn't them when their number was called. They were pulling a tour in the National Guard. It'll be some kid from Southie taking shrapnel in the ass.

He gets back to find that the plant he used to work at just got exported to the country he just got back from. And the guy who put the shrapnel in his ass got his old job,' cause he'll work for fifteen cents an hour, and no bathroom breaks.

Meanwhile he realizes the only reason he was over there in the first place was to install a government that would sell us oil at a good price. And of course the oil companies over there use a little skirmish to scare up domestic oil prices—a little ancillary benefit for them, but it ain't helping my buddy at $2.50 a gallon.

They're taking their sweet time bringing the oil back, of course. Maybe they even take the liberty of hiring an alcoholic skipper who likes to drink martinis and fucking play

slalom with the icebergs. It ain't long 'till he hits one, spills all the oil, and kills all the sea life in the North Atlantic.

So now my buddy's out of work; he can't afford to drive; he's walking to the job interviews—which sucks because the shrapnel in his ass is giving him chronic hemorrhoids. And meanwhile he's starving, because when he tries to get a bite to eat, the only Blue Plate Special they're serving is North Atlantic scrod with Quaker State.

So what do I think ... ? I'm holding out for something better. I figure, fuck it, while I'm at it, why not just shoot my buddy, take his job, give it to his sworn enemy, hike up oil prices, bomb a village, club a baby seal, hit the hash pipe, and join the National Guard. I could be elected president.

Will's answer is, of course, ironic. However, his response provides a good example of the kind of analysis that prevents one from participating on the wrong side of the conflicts that undeniably characterize the contemporary world. He traces the effects of an anticipated assignment at the NSA from his desk there, to a war involving senseless carnage, a friend's participation in that war, oil prices, environmental destruction on a massive scale, unemployment problems in the U.S., job loss to cheap Third World labor, and to corrupt politicians, who avoid military service, while somehow managing to get elected to the highest office in the land. In the end, he decides to hold out for something better.

(7) **God loves everyone. But neither the God of the Jewish Testament, nor Jesus is neutral or other-worldly.** As we've seen, this is a central tenet in Global South "liberation theology." It is reiterated again and again in the teachings of the Argentinian, Pope Francis. (See his Apostolic Exhortation, *The Joy of the Gospel*, and his papal encyclical on the environment, *Laudato Si'*.) Both sources refer to God's "preferential option for the poor." This means—especially in political and economic life—choosing to view life from the standpoint of the least among us. It entails choosing as well to read the Bible that point of view. Liberation theologians say that doing so mirrors what believers hold God himself did in the "incarnation" by becoming a poor person in a backwater outpost of the Roman Empire, the biblical land of Israel. As Franz Hinkelammert puts it: "Do what God did: become human."

Noam Chomsky, once described by *The New York Times* as "arguably, the most important intellectual alive" has this to say about liberation theology in a YouTube interview:[6]

Liberation theology grew out an attempt by Pope John XXIII to revive the gospels. During the first three centuries of Christianity, it was a radical pacifist religion, which is why it was persecuted. It was the religion of the poor and suffering. Jesus was a symbol of the poor and suffering. That's what the cross was. In the 4th century it was taken over by the Roman Empire.

The emperor Constantine turned the church into the church of the persecutors, the rich the powerful. The cross went from being the symbol of the suffering of the poor to the shield of the forces of the Roman Empire. And for the rest of its history that's what the church has pretty much been. It's been the church of the rich, the elite, the persecutors, the powerful.

Well, John XXIII tried to reverse that—tried to revive the church of the gospels. This is 1962 with Vatican II. The U.S. responded *immediately* with extreme violence. This was heresy. The church was taking up the message of the gospels. It was called "the preferential option for the poor." You can't have that … Liberation theology was a religious movement based on the gospels.

If that's not religious, I don't know what is. It is, of course, what we would call a radical movement, because the gospels are radical. It was the preferential option for the poor. We're supposed to be in favor of the preferential option for the rich … It was in fact, the message of the gospels.

Conclusion

So students have a point when they say that none of the three positions presented in the previous chapter is worth espousing in its unadorned form. Consequently, there is a distinct case to be made for world vision compromise. After all, life is undeniably a mixture of harmony and conflict. There *are* lazy people in the world. And it *is* possible to improve one's position in life.

However, as the champagne glass figure illustrates, it is not possible under current arrangements for all of those at the bottom of the glass to move up to a decent standard of living—especially since so many of them are children who will die before their first birthday.

Moreover, the largely invisible structures in our world (like congressional rules, school districts, real estate markets, and tax systems) *can* force well-intentioned people to take decisions that might harm large numbers of people.

One of those systems involves congressional lobbying, which differs little from bribery and frequently results in something like the purchase of governmental power by the already rich and influential.

All of that makes the "respectable" political and economic world highly similar to the criminal world of drugs and violence—except that the violence of the "respectable" world is much more widespread and destructive.

Operations like those sponsored by the National Security Agency illustrate the case in point. The example of Jesus show that such policies contradict his life's message, and its concern for God's poor.

Culturally speaking, what makes all of that difficult to perceive is the prevalence of ideology, which also must be uncovered by any critical thinker. Ideology will be addressed in our next chapter.

For Discussion

1. What is your personal reaction to the compromise worldview presented in this chapter?
2. In what ways does this compromise draw upon the worldviews presented in the previous chapter?
3. Judging from this chapter, and the one before it, how does religion influence, or how is it influenced by, these worldviews.
4. If you were in Will Hunting's shoes, would you accept a job with the NSA? Explain.

Activity

Write a short commentary on the compromise worldview presented in this chapter. Give specifics on how it is similar to and different from your own understanding of the world.

Notes

1. Malcolm X. "The Race Problem." African Students Association and NAACP Campus Chapter: Michigan State University, East Lansing, Michigan: 23 January, 1963. www.youtube.com/watch?v=98Jmw5o9ulA
2. *The Distinguished Gentleman*. Dir. Jonathan Lane. Perf. Eddie Murphy, Lane Smith, Victoria Rowell. Hollywood Pictures, 1992. www.youtube.com/watch?v=rHMWHcgRl1o
3. *Bulworth*. Dir. Warren Beatty. Perf. Warren Beatty, Halle Berry, Sean Astin. 20th Century Fox, 1998. www.youtube.com/watch?v=jZtlV8eroS8
4. *Traffic*. Dir. Steven Soderbergh. Perf. Michael Douglas, Benicio del Toro, Catherine Zeta Jones. U.S.A. Films, 2001. www.youtube.com/watch?v=JjRx9IJSTMw
5. *Good Will Hunting*. Dir. Gus VanSant. Perf. Matt Damon, Ben Afleck, Robin Williams. Miramax Films, 1997. www.youtube.com/watch?v=ghpeshRDE8g
6. Noam Chomsky. Liberation Theology. Interview. 2010. www.youtube.com/watch?v=SNDG7ErY-k4

Rule Four

Suspect Ideology

This brief chapter is closely related to the previous two. There we dealt with multiple world visions that can belong to individuals and may or may not be mainstream, i.e. accepted by the majority in a given culture. This chapter, by contrast, focuses on ideology as synonymous with what John McMurtry of Ontario's Guelph University calls "the ruling group mind."[1] As employed here, ideology tends towards consensus and to come from official sources. It is disseminated and fostered by governments, churches, schools, and the mass media. Again, it is the "ruling group mind."

As such, ideology is the official explanation or defense of a given order, rather than its critical analysis. Ideology is marked by positive evaluation of the order in question (and of its defenders), and by negative assessments of any opposing orders (and their defenders). In other words, the concept of sincere self-criticism, and of truthfulness regarding one's opponents or other points of view is most often entirely absent.

A major task of critical thinking is to avoid being taken in by ideology, since it is the antithesis of critical thought. Such avoidance can be negotiated only if ideology is perceived as such—a formidable task for populations everywhere, that are accustomed and educated to unquestioningly accept what most in one's culture take as self-evident.

Thus, for instance, it would never occur to most U.S. citizens to question the assertion that theirs is the freest country in the world, that capitalism is the best possible economic system, that "America" is a true democracy, or that God is on their side. All of these are part of the reigning ideology in the United States. The point here is that such truisms must be questioned. That is, the presence of ideology must be suspected in all statements issuing from official sources—both in one's own country, and in those of designated enemies.

A film script from the period of the Cold War reveals how ideology works. The film was produced by the U.S. government, and appears in the remarkable film collage, *The Atomic Cafe*.[2] The government-sponsored film excerpted there warns of the dangers of communism and the Soviet Union. Though its (lack of) critical thinking is evident now in retrospect, it was not so to most who were subjected to it in 1947:

> Day-by-day news reports in 1947 headlined the global struggle of East versus West, in a clash of ideologies. The ruthless expansionism of the Total State—challenging the basic ideals of individual and national freedoms
>
> In the background was the growing struggle between two great powers to shape the post war world. Soviet Russia was relentlessly stabbing westward, knifing at the nations left empty by war
>
> On orders by the Kremlin, Russia had launched one of history's most drastic political, moral, and economic wars—a Cold War. The United States was obliged to help Europe safeguard its traditional freedoms and the independence of its nations.
>
> Gone was the spirit of wartime unity that reached its peak on that historical afternoon in April of '45 at the Elbe River in Germany. Here two worlds actually met. But the coalition was to be torn asunder. Already an 'iron curtain' had dropped around Poland, Hungary, Yugoslavia.
>
> Ah, but this is Europe you say. Let's see what happens elsewhere—let's say in a small town in Wisconsin. The red truncheon falls, and the chief of police is hustled off to jail. Next public utilities are seized by fifth columnists.
>
> Watch carefully what happens to an editor who operates under free press. He goes to jail too, and his newspaper is confiscated. Exit freedom of thought. (An image appears of people in a soup line.)
>
> Yer this is life under the Soviet's form of government. A little town in Wisconsin made this experiment for twenty-four hours a public service to all America.
>
> And it can't happen here? Well this is what it looks like if it should. (Images follow of the Statue of Liberty exploding, and of the Capital Dome being crushed by a huge fist. The same happens to images of church, and school. A Russian is shown felling pillars marked "human ties," "emotional ties," and "national loyalty." The film ends with the Russian destroyer standing atop the rubble he has produced, holding the Russian flag aloft.)

This excerpt from *The Atomic Café* embodies the characteristics of ideology. There is no self-criticism here. At the same time the criticism of the designated opponent (the Soviet Union) is relentless. The United States is the champion of the basic ideals of individual and national freedoms. In that role, it comes to Europe's aid, protecting the liberties of its citizens, and of their nations.

However, U.S. efforts are met by the Kremlin, which is presented as unilaterally responsible for the Cold War. If the Kremlin's system penetrates to the U.S., the result will be lawlessness, Russian control of public utilities, the end of freedom of thought, press, public schools, and freedom to worship. Symbols of freedom and national identity will be reduced to rubble. People will be fed in soup lines. And life will be impoverished by the destruction of all the human emotions Americans hold dear.

The ideological nature of the propaganda film is clear enough, and sometimes even comical in its self-congratulation.

However, what principles of critical thinking might students use to detect ideological bias when it is better hidden? The suggestion here is that there are four such guidelines:

(1) **Positive statements about one's self or one's own system are generally less reliable**. While it might well be true that the United States is the champion of freedom and justice, as the text of the government film suggests, statements like those made in the film do not carry much weight towards establishing that fact.

(2) **Negative statements about one's enemy or opponent are less reliable**. Of course the text just cited is replete with negative evaluations of the Soviet Union. Again, though such evaluations might well be accurate, the government film in itself does little to confirm that possibility.

(3) **Positive statements about one's enemy or the enemy's system are generally more reliable**. The total lack of any assertions of this nature renders the film's text immediately and highly suspect. If such statements *were* present, they would fall into the category of "reluctant testimony" (see below).

(4) **Negative statements about one's self or one's own system are generally more reliable**. In the film excerpt, such statements are notable for their absence. This is not to say that we are without examples of negative or candid evaluations of this type. Again, debate coaches would call such admissions "reluctant testimony."

Reluctant Testimony

This phrase refers, first of all, to admissions that are at times forced from a speaker by some kind of cross-examination. The image of witnesses breaking down on the witness stand, as a result of the expert questioning of Perry Mason comes to mind.

Alternatively, "reluctant testimony" surfaces in documents which insiders exchange among themselves, but which are not intended for public release. Such exchange is necessary for covert plans to be executed. The resulting documents are consequently highly trustworthy.

Two examples of "reluctant testimony" follow.

The first example of on-camera reluctant testimony is found in a famous "60 Minutes" interview of Secretary of State, Madeleine Albright, by Leslie Stahl.[3] The interviewer asks about reports that half a million Iraqi children had been killed as a result of U.S. sanctions during the 1990s, that were aimed at the removal of Saddam Hussein from office. (Recall that in Chapter Five, Osama bin Laden's "Letter to America" cited those killings as partial justification for the 9/11 attacks.) Here is the exchange:

> Stahl: We have heard that half a million children have died. I mean, that's more children than died in Hiroshima. And … you know … is the price worth it?
>
> Albright: I think this is a very hard choice. The price … but, we think the price is worth it. (www.youtube.com/watch?v=4iFYaeoE3n4)

What is revealing in this exchange, is that the Secretary of State does not dispute Stahl's numbers. The Secretary might easily have done that. Instead, she accepts the numbers, and does not seem in the least fazed by them. Instead she seems quite familiar with the charge. Then Ms. Albright admits, in effect, that she and others have done the calculations, and concluded that forcing the removal from office of Iraq's head of state was worth the sacrifice of half a million innocent children.

The second example of reluctant testimony is documentary, and has no film supporting it. Instead, it issues from an internal paper circulated in 1947 by George Kennan, the National Security Advisor of the Roosevelt and Truman administrations. George Kennan is considered by all, the architect of U.S. Cold War policy. Here is Kennan's recommendation for U.S. goals, policies and conduct in the post-World War II world[4]:

> We have about 50 percent of the world's wealth, but only 6.3 percent of its population. In this situation, we cannot fail to be the object of envy and resentment. Our real task in the coming period is to devise a pattern of relationships which will permit us to

maintain this position of disparity without positive detriment to our national security. To do so we will have to dispense with all sentimentality and day-dreaming and our attention will have to be concentrated everywhere on our immediate national objectives. We need not deceive ourselves that we can afford today the luxury of altruism and world benefaction. We should cease to talk about vague and unreal objectives such as human rights, the raising of living standards and democratization. The day is not far off when we are going to have to deal in straight power concepts. The less we are then hampered by idealistic slogans the better.

This document discloses the nature of revealing "internal documents" under consideration here. This one was obtained under provisions of the Freedom of Information Act. It expresses sentiments, intentions and recommendations that few in the United States are accustomed to hear voiced by architects of national policy. Nonetheless, they reflect the mind-set of a very key player in the formation of that policy.

According to Kennan, the essential purpose of foreign policy is to maintain (not alleviate) the extreme wealth-disparity between the United States and the rest of the world. The United States is not about making life better for others or about acting unselfishly. Rather, human rights, democratization, and improving the living standards of other nations are considered ill-defined and even unreal. Such considerations are not to be factored into decision-making. Slogans to the contrary may be fine, but their content must be ignored in favor of unadulterated power relationships—i.e. in favor of forcing others to conform.

Conclusion

As we have seen, ideology, or the ruling group mind, tends to be completely self-serving. Lacking in self-criticism, its tendency is to idealize its strengths, while focusing relentlessly on the weaknesses of its designated enemies. At the same time, what people say is important. The rationales that individuals, heads of corporations, religious leaders, government officials and others offer for their actions must be heeded. However, the foregoing examples warn that self-praise or self-interested criticism is not worth much. Also, what is said in public must always be checked against what is said in private and with admissions that are accidentally disclosed.

Even more importantly, words must be checked against facts. What public officials and others actually do is more important than what they say. So words must be checked against history.

Nevertheless, history too can be falsified. And, of course, the problem is that most of the time the histories that are read are the "official" histories written by the winners of wars, and by those who have the resources to publish in the first place.

To combat that bias, it is important for critical thinkers to consult records left behind by the casualties of history—the colonized, enslaved, workers, those without university credentials, and all of those who have been injured by political and economic systems considered "normal."

Exposition of stories that compete with the "official story" is the task of the next chapter of this study as well as of Part Three of this book. In both we enter the revelatory realm of historical narrative.

For Discussion

1. What methods does *The Atomic Café* excerpt use to advance the convictions of its authors? Where have you seen these tactics before?
2. Why is "reluctant testimony" a valuable source in assessing positions and arguments?
3. Referencing the "60 Minutes" interview with Madeleine Albright, and the George Kennan statement, evaluate the kind of "testimony" offered in each instance.

Activity

Research *WikiLeaks*. Explain its function and operation. Show in detail how it is related to ideology and the critical principles discussed in this chapter.

Notes

1. Here's how Professor McMurtry defines the ruling group mind (RGM): "… the RGM is recognized and defined by an always distinguishing set of generic properties: (i) *life-blind and destructive behaviors* at micro or macro levels on the basis of (ii) a ruling set of *group presuppositions* which (iii) *frame social ideation and communication* to (iv) *select only for what confirms them* and (v) *invalidate what does not* to (vi) *generate stereotypes and myths as replacement standards* which (vii) reinforce and confer *claims of the group's superiority in virtue of its inherent moral order* which is conceived as (viii) *equivalent to laws of Nature, God or Reason* which (ix) only *malicious or less-than-human enemies reject* who (x) are therefore warred upon in *with-us-or-against us campaigns to impose the group's ruling value program*. While this set of characteristics is diversely expressed and admits of degrees of rigidity and extreme, the RGM is a unitary mechanism whose interlocking operations constitute (xi) a *ruling mind-set of the mutual understanding of members and self-identity*. While RGM formations are invariably confused with beneficial social order, these locked and life-destructive regulators mark it as pathological."

John McMurtry. "The Regulating Group-Mind." Sage Encyclopedia of Case Study Research. bsahely.com/2016/09/22/the-regulating-group%E2%80%91mind-by-prof-john-mcmurtry-sage-encyclopedia-of-case-study-

2. *The Atomic Café*. Dir. Kevin Rafferty, Jayne Loader, Pierce Rafferty. Perf. Kevin Rafferty. Libra Films, 1982.

3. Tclim988. "Is the price worth it." *YouTube*. YouTube, 19 Apr. 2013. Web. 20 Apr. 2017.

4. *Memorandum by the Director of the Policy Planning Staff (Kennan) to the Secretary of State and the Under Secretary of State (Lovett)*. WASHINGTON, February 24, 1948. en.wikisource.org/wiki/Memo_PPS23_by_George_Kennan

Rule Five

Respect History

How does one escape captivity to inherited patterns of thought and false perceptions of reality shaped by ideologies of right and left? Doing so is essential to achieve at least relative autonomy of thought.

"Respecting History" can move critical thinkers in the right direction. This criterion's claim is that what individuals, groups, and nations do and have actually done (as opposed to what they say) is a powerful arbiter of truth. Once again, actions, in fact, *do* speak louder than words.

The problem is however that there is no single agreed-upon version of history—not of world history, of U.S. history, nor of contemporary events. Everything is slanted or spun by historians' biases and politics. In that sense, we're all victims of fake history. This complicates the problem of determining, for instance, whether the United States has been and/or is on the whole a force for good or not in the world—a key question for the kind of critical thinking we've been considering here.

So, relative to "respecting history," the first task is to separate out conflicting stories. Then (as will be seen in the following chapter) our assignment becomes "thinking scientifically" about those stories to determine which of them more closely approximates "the truth." This will entail applying to competing stories the standard scientific criteria of internal coherence, external coherence and explanatory value.

But that's getting ahead of ourselves. For this chapter let's simply separate out the relevant competing stories—first of the U.S. history we all studied in school. Secondly we'll look at U.S. history since World War II, and finally at contemporary patterns of U.S. policy in today's world.

We'll call the more familiar version "the official story." Again, it's the one we usually get in our schools. It is so familiar, there's no need to document it. We'll call the less familiar story (more widely known, for instance, in the Global South or former colonies) "the competing story." It is readily available in sources like Howard Zinn's *A People's History of the United States*, and in Oliver Stone's and Peter Kuznick's *The Untold History of the United States*. The latter is also accessible in video form. The competing story of U.S. international relationships is found as well in Eduardo Galeano's *The Open Veins of Latin America*, and in Walter Rodney's *How Europe Underdeveloped Africa*.[1] For ease of comparison and in the spirit of our chapter on economic systems, both the official and competing stories will be laid out below in bullet-point outline fashion.

However, before you read them, please take some time to get out pen and paper to write down your own version of U.S. history. (I'm just talking about a page or so.) Such writing will remind you of what you've actually been taught or learned on your own—the basic tale you carry around in your head. Comparing that base line with what follows will enable you to determine what you need to research and perhaps revise to arrive at a corrected version of our country's origins and role it plays in the world. To repeat: this determination is extremely important to escape any destructive fakery around beliefs that might be excessively ethnocentric.

U.S. National History

The Official Story

- Fleeing religious persecution, "pilgrims" from England migrated to the New World.
- Aboard the *Mayflower*, they signed a Compact, exercising the God-given power to set up a government that would serve the people.
- Settling into this new Promised Land, the pilgrims endured great hardships that first winter.
- They were aided by friendly Indians who shared food and agricultural know-how with them.
- Miraculously, the pilgrims prospered.

- But the King of England siphoned off their prosperity by taxing them heavily, without giving them representation in the British Parliament.
- Under the banner "Taxation without representation is tyranny," the colonists rebelled.
- Having thrown off the British yoke, they set up their own independent government, establishing a democracy where the rights to life, liberty and the pursuit of happiness were recognized.
- Gradually, democracy was extended to former slaves and women as the implications of the Founders' brave words were better understood.
- Before that could happen, however, it was necessary to fight a bloody Civil War to end slavery and incorporate former slaves into the great American Experiment.
- That project experienced the wonderful blessings of God as the cornucopia of an incredibly rich continent was discovered and developed into a fruited plain stretching from sea to shining sea.
- America prospered and became the richest and most powerful nation in the world.
- Its people experienced a great sense of responsibility to extend democracy where it is absent in the world and to defend it when threatened by tyrants.
- So repeatedly, American youth has been sent to far off places to fight for freedom and hallow foreign soil with their blood.
- Most significantly, this happened in World Wars I and II, in the Korean and Vietnam Wars in the Persian Gulf's Desert Storm, and currently in Iraq and Afghanistan.
- Today America remains the envy of the world.
- However, its people often question the wisdom of doing good for others when there remains so much still to accomplish here at home.

A Competing Narrative

- The European conquest of the Americas' very Old World represents the bloodiest holocaust in human history.
- The Spanish, Portuguese, French, Dutch, British and others all tried their hands at plundering the ancient, rich and very highly developed cultures of the Mayan, Aztec, Inca and other Original Peoples who inhabited the land they called Abya Yala.
- All of these were devastated by the genocidal (religiously motivated) practices of the invaders, including those who fancied themselves Pilgrims on a mission from God.

- Rich males among those who descended from British settlers eventually tired of sharing with their counterparts across the sea the wealth the new-comers had seized.
- They broke off from England and set up their own nation based on political arrangements that insured that they and not the common people (Native Americans, the propertyless, slaves, non Anglo-Saxons, and women) would control the wealth of the vast American continent.
- Eventually, the rich fell to fighting among themselves about who would control the nation's wealth, and the government that administered it.
- (Especially the millions of acres newly stolen from Native Americans and won in a war provoked with Mexico about the middle of the 19th century).
- Rising northern industrialists—Vanderbilts, Rockefellers, Goulds, Carne-gies, and Mellons—challenged the old aristocracy who owned the South's huge cotton plantations.
- The industrialists wanted the lands recently annexed from Mexico (i.e. Texas, California, New Mexico, Nevada, Arizona, Colorado) for railroads, mining, cattle and other endeavors.
- The old southern aristocracy wanted western lands for their agricultural slave system.
- The industrialists persuaded small farmers that the northern rich and the nation's poor shared common interests in the development of the West.
- Following the slogan "Vote yourself a farm," the farmers joined the rich in electing the industrialists' candidate, Abraham Lincoln.
- He favored free markets, free movement of labor and free land to those willing to develop it.
- Lincoln was ambiguous about slavery.
- He was willing to keep it in the South, but insisted on its exclusion from the new West.
- Southern States responded to Lincoln's election by withdrawing from the Union.
- A Civil War between the elite of the North and South followed from 1861–1865, costing the lives of more than 600,000 mostly non-elites.
- After the war, poor white settlers were given forty acres and a mule.
- Rich railroad entrepreneurs were given ten square miles of land and $48,000 in taxpayers' money for every mile of railroad track they laid.
- The rail lines hauled out gold, and silver, timber, coal, copper, iron ore, bauxite, uranium, etc.
- Thus already huge fortunes were multiplied, and an incredibly rich conti-nent was systematically devastated by an economy built on waste.

- When natural resources in the U.S. dwindled or became too expensive to exploit, the elite turned their eyes abroad.
- With the aid of the Marines, they plundered Latin America, Africa and South Asia.
- When citizens there sought control of their own resources, they were branded communists and killed by the dictators the U.S. supported everywhere to make the world safe for its own industrial system.
- Education in the United States indoctrinates students into the official story outlined above thus preventing ordinary people from recognizing the true story unfolding around them.
- So does a system of white supremacy that leads ordinary people to misidentify their friends and enemies.
- Thus instead of struggling against the rich, the powerless have been taught that their real enemies are—one another: the non-rich, non-white, non-male, and non-straight.
- The few times that the self-serving project of the rich has been unmasked (e.g. at the turn of the century, during the Great Depression or the 1960s), the elite have prevented rebellion by buying off the non-elite with government programs.
- These placate by sharing crumbs (social security, food stamps, etc.) with those deemed undeserving.
- Such crumbs however, are to be removed once crises pass.
- In particular, ordinary Americans have been schooled to die on behalf of the rich as the wealthy fight vicariously for resources and markets world-wide, in wars such as WWI, WWII, Korea, Vietnam, the Persian Gulf, Iraq and Afghanistan.
- These overwhelmingly cost the lives of the non-elite while insuring abundant profits for the rich.

A Film Illustration

Here's an illustration of a competing version of U.S. history as it appeared in Michael Moore's seminal film, *Bowling for Columbine*.[2] The medium here is cartoon in the style of "South Park." It understands American history as fundamentally related to guns and racism. It features a narrator taking the form of a talking bullet:

Bullet: Now it's time for a brief history of the United States of America. Hi, boys and girls, ready to get started? Once upon a time there were these people in Europe called Pilgrims and they were afraid of being

persecuted. So they all got in a boat and sailed to the New World where they wouldn't have to be scared ever again.

Pilgrim 1: I feel so relaxed.

Pilgrim 2: I feel so much safer.

Bullet: But as soon as they arrived they were greeted by savages and they got scared all over again. So they killed them all. Now you'd think wiping out a race of people would calm them down but instead they started fighting with each other.

Pilgrims: Witch.

Bullet: So they burned witches. In 1775 they started killing the British so they could be free, and it worked. But they still didn't feel safe, so they passed a Second Amendment so every white man could keep his gun.

White: I loves my gun, loves my gun.

Bullet: Which brings us to Virginia's idea of slavery. You see, boys and girls, the white people back then were also afraid of doing any work. So they went to Africa, kidnapped thousands of black people, brought them back to America and forced them to work very hard for no money. And I don't mean like …

White: I work at Wal-Mart and I make no money.

Bullet: I mean zero dollars, nothing, nada, zip. And doing it that way made the USA the richest country in the world. So did having all that money and freedom calm the white people down? No way! They got ever more afraid. That's because after 200 years of slavery the black people now outnumbered the white people in many parts of the South. Well you can pretty much guess what came next. The slaves started rebelling, there were uprisings and old masters' heads got chopped off. And when white people heard this they were freaking out. They were going …

Master: I wanna live, don't kill me, big black man.

Bullet: Well just in the nick of time came Samuel Colt, who in 1836 invented the first weapon ever that could be fired over and over without having to reload. And all the southern Whites were like …

Whites: Yee-ha.

Bullet: But it was too late. The North soon won the Civil War and all the Blacks were free. Free to go chop all the old masters' heads off. Then everybody was like …

Whites: Oh no, we're gonna die.

Bullet: But the freed slaves took no revenge, they just wanted to live in peace. But you couldn't convince the white people of this; so they formed the Ku Klux Klan. And in 1871, the same year the Klan became an illegal terrorist organization, another group was founded, the National Rifle Association. Soon politicians passed one of the first gun laws, making it illegal for any black person to own one. It was a great year for

America, the KKK and the NRA. Of course they had nothing to do with each other and this was just a coincidence. One group legally promoted responsible gun ownership and the other shot and hung black people. And that's the way it was all the way until 1955 when a black woman broke the law by not moving to the back of the bus. And white people just couldn't believe it.

White 1: Why won't she move?

White 2: What's going on?

Bullet: Then all hell broke loose. Black people everywhere started demanding their rights and white people had a major problem on their hands.

White: Run away, run away!

Bullet: And they did, they all fled into the suburbs where it was all white and safe and clean. And they put locks on their doors and alarms on their houses and gates around their neighborhood. And finally they were all safe and secure and snug as a bug. And everyone lived happily ever after.

So there you have them—the official and competing accounts of U.S. history. What do you think? Which story seems truer? Despite the playfulness of the South Park cartoon, the question is not trivial. As mentioned earlier, subsequent chapters will help us all think further about that.

While you're thinking that over, here are competing versions of U.S. history since World War II. They describe American relations with the former colonies. These accounts too illustrate how sharply the stories we've interiorized diverge from one another, and how such divergence influences possibilities for critical thinking by blocking alternatives to our guiding historical visions.[3]

U.S. International History Since World War II

The Official Story

- A previously isolationist USA reluctantly inherited governance of the post-colonial world.
- Despite attempts to introduce freedom and democracy,
- The U.S. was thwarted
- By disastrous and repressive communist expansionism
- And by ethnic divisions and conflicts,
- That emerged in the former colonies.
- These surfaced in the absence of an ordering European presence.
- As a fair broker,
- Despite some regrettable errors and naivety,

- The U.S. has tried to persuade uncooperative third world leaders and their populations to change their ways.
- Dictators, rogue states and terrorists impede this noble purpose.

A Competing Story

- A basically expansionist U.S. enthusiastically sought to establish its dominance throughout the post-colonial world, by maintaining a "neo-colonial" system
- To continue extracting wealth from the former colonies, by a system of unequal trades.
- Despite attempts by the liberated colonies' new indigenous leaders to establish political and economic democracy, the U.S. thwarted those efforts by establishing and maintaining repressive authoritarian regimes, and by exacerbating ethnic and tribal divisions, to "divide and rule."
- In this way, it kept the former colonies compliant, by preventing them from achieving economic independence, maintaining them instead as privileged locations for capital accumulation.
- All of this is hidden from mainstream North Americans by an education system, which exclusively passes on the "social control" Official Story.

Contemporary U.S. History

Quite a difference, no? The "competing story" is the one I invariably met during those study excursions mentioned early in this book. Third world scholars are quite clear about historical patterns that lay behind the competing story. They would claim that the U.S. consistently acts towards the Global South according to the following pattern:

- Any country attempting to establish an economy mixed in favor of the poor majority
- Will be accused of being "communist" by the United States
- And will be overthrown either by U.S. invasion
- Or by right wing (often terrorist) elements within the local population
- To keep said country within the capitalist system:
- So that the U.S. might continue to use the country's resources for its own enrichment
- And for that of the local elite.

Now a pattern like that is testable. You could, for instance check it out (as I've had my students repeatedly do) by studying the histories of countries throughout the world—in Latin America, the Caribbean, Africa, Asia and the Middle East such as Iran, Tanzania, Angola, Iraq, Nicaragua, Honduras, Guatemala, South Africa, the Republic of Congo, El Salvador, the Philippines, Indonesia, Brazil, Argentina, Korea, Cuba, the Dominican Republic, Panama, Jamaica, Haiti, Colombia, Vietnam …

When John Stockwell, the former CIA station chief in Angola, did his investigation of the countries just mentioned, he came up with the following description of what he calls the "Third World War against the Poor." The verbatim of his speech is worth quoting at length:[4]

> My expertise, as you know, is CIA, Marine Corps … three CIA secret wars. I had a position in the National Security Council, and 1975, as chief of the Angola task force, and was running the secret war in Angola. It was the third secret CIA war I was a part of …
>
> I think it was in the mid 1980s I coined this phrase, 'Third World War.' Because in my research I realized we were not attacking the Soviet Union in the CIA's activities; we were attacking people in the Third World.
>
> And I'm going to give just quickly, in the interest of time, a little sense of what that means, this 'Third World War.' Basically it's the third—I believe, in loss of human life and human destruction—the third bloodiest war in all of history. They undertake and run operations in every corner of the globe. They also undertook the license of operating above and just totally beyond U.S. laws. They had a license, if you will, to kill. But also they took that to a license to smuggle drugs, a license to do all kinds of things to other people in other societies in violation of international … our law and any principle of nations working together for a healthier and more peaceful world.
>
> Meanwhile they battled to convert the US legal system in order that it would give them control of our society. Now we have massive documentation of what they call the 'Secret Wars of the CIA.' We don't have to guess or speculate. We had the Church Committee investigate them in 1975, and that gave us our first powerful in-depth look at what was inside this structure. Senator Church said that in the 14 years before he did his investigation, he found they had run 900 major operations and 3,000 minor operations. And if you extrapolate that over the 40 odd years we've had a CIA, you come up with 3,000 major CIA operations and over 10,000 minor operations—every one of them illegal, every one of them disruptive of the lives of societies of other peoples, and many of them bloody and gory and beyond comprehension almost.
>
> Extensively we manipulated and organized the overthrow of functioning constitutional democracies in other countries. We organized secret armies and directed them to fight in just about every continent in the world. We encouraged ethnic minorities to rise up and fight. People like the Mosquito Indians in Nicaragua, the Kurds in the Middle East, the Hmongs in Southeast Asia. And of course, we organize and fund death squads in countries around the world, like the Treasury police in El Salvador,

which are responsible for most of the killing of the 50,000 people just in the '80s, and there were 70,000 before that.

Orchestrating CIA secret teams and propaganda led us directly into the Korean War. We were attacking China from the Islands Kimoi and Matsu, (and from) Thailand, Tibet—a lot of drug trafficking involved in this, by the way. Until eventually we convinced ourselves to fight the Chinese in Korea, and we had the Korean War, and a million people were killed. Same thing for the Vietnam War ... We have extensive documentation of how the CIA was involved at every level, and the National Security Complex was very cooperative in manipulating the Nation into the Vietnam War.

We wound up creating the Golden Triangle in which the CIA, Air America airplanes were flying in arms to our allies and flying back out with heroin. We launched the largest—this is something that Jimmy Carter did; Admiral Turner brags about it—operation in Afghanistan. (It was) the biggest operation in the CIA secret wars; and sure enough we very quickly produced the Golden Crescent, which is still the largest source of heroin in perhaps the world today.

I'm trying to summarize this 'Third World War' that the CIA, National Security Complex, the military, interwoven in it in many different ways, has been waging. Let me just put it this way: the best heads that I coordinate with studying these things, count at least—minimum figure—six million people who have been killed in this long forty-year war that we waged against the people of the Third World. These are not Soviets. We have not been parachuting teams into Soviet Union to hurt, kill, and maim people, especially not since 1954, when they developed actual capability of dropping atomic weapons on the United States.

They aren't British, French, Swedes, Swiss, and Belgians. We don't do bloody, gory operations in the countries of Europe. These are all people of the Third World. They are people of countries like the Congo, Vietnam, Kampuchea, Indonesia, Nicaragua, where conspicuously they nor their governments do not have the capability of doing any physical hurt to the United States. They don't have ICBMs; they don't have armies or navies. They could not hurt us if they wanted to. There has rarely been any evidence that they really wanted to. And that, in fact, is perhaps the whole point. If they did have ICBMs, we probably wouldn't have done those things to them for fear of retaliation. Cheap shots, if you will, killing people of other countries of the world who cannot defend themselves, under the guise of secrecy and under the rubric of national security.

Stockwell's testimony is a confession to what he sees as a generalized policy of world terrorism on the part of the United States. Its veracity is supported by the fact that he was awarded the Medal of Merit before his retirement. His confession also agrees with those offered by Philip Agee, Victor Marchetti and many other ex-CIA officials who have made similar revelations.[5]

In any case, such revelations can be independently verified or disproven by anyone with access to the internet. Questions to research about the countries I listed earlier include: (1) Did a government ever arise professing to reorient its

mixed economy to benefit the poor rather than the wealthy? (2) When and under whose leadership? (3) What were the specific elements of the government's proposed program? (4) What was the response of the local elite and of the United States? (5) What happened as a result of that response?

Entertaining questions like those will move us far down the critical thinking path. It remains, however, for us to establish specific criteria for separating truer historical accounts from their less accurate counterparts. That will be the focus of Chapter Ten.

For Discussion

1. In what ways does the "Official Story" of U.S. national history differ from the "Competing Narrative" presented in this chapter? Are there any ideologies at work here?
2. Apply the first question to U.S. international history since World War II.
3. What leads people to formulate these narratives and how and why do people come to hold these views?
4. Discuss the nature of the version of U.S. history you wrote before reading this chapter. Did it more resemble the official or competing story? What questions do you now have about it?

Activity

The conclusion to this chapter mentions testing a pattern of the United States' interaction with the Third World. Pick one of the countries listed and prepare a short report on how this example relates to the pattern in question.

Notes

1. Here are the bibliographic references for the competing story sources just mentioned:
 a. Howard Zinn. *A People's History of the United States*. New York: Harper perennial, 2001.
 b. Eduardo Galeano. *The Open Veins of Latin America*. New York: NYU Press, 1997.
 c. Walter Rodney. *How Europe Underdeveloped Africa*. Boston: Harvard University Press, 1981.
 d. Oliver Stone and Peter Kuznick. *The Untold History of the United States*. New York: Gallery Books, 2012.
2. *Bowling for Columbine*. Dir. Michael Moore. Prod. Michael Moore. Perf. Michael Moore. Dog Eat Dog Films, 2002. www.youtube.com/watch?v=Zqh6Ap9ldTs

3. For exposition of this historical pattern see:
 a. J. W. Smith. *Economic Democracy: a grand strategy for world peace and prosperity: green economics for sustainable development.* Fayetteville, PA: Institute for Economic Democracy Press, 2010.
 b. J. W. Smith. *Why?: the deeper history behind the September 11th terrorist attack on America.* Radford, VA: Institute for Economic Democracy in cooperation with the Institute on World Problems, 2005.
4. The video of Stockwell's speech is found here: www.youtube.com/watch?v=m3ioJGMCr-Y&t=15s
5. See Victor Marchetti and John Marks. *The CIA and the Cult of Intelligence. Introd. by Melvin L. Wulf.* New York: Knopf, 1974. See also Philip Agee. *Inside the Company: CIA diary.* New York: Bantam, 1989, as well as John Perkins. *Confessions of an Economic Hitman.* San Francisco: Berret-Koehler Publishers, 2004.

Rule Six

Inspect Scientifically

The previous chapter focused on what is really the central problem of this entire book. It raised the question of distinguishing between truth and falsehood when experts (in this case, historians) disagree. What do you do when historians insist (as many do) that the official story is correct, when vision provided by critical thinking's magic glasses tells you that the competing story has more merit than official historians are willing to admit?

The answer is that you try to think like a scientist. You think outside the box of what's culturally acceptable. This is what scientists have done since the Scientific Revolution at the beginning of the 17th century. They have routinely gone against accepted axioms and theories. Instead, these cutting-edge thinkers have been drawn to explanations of the world that were rejected out of hand as preposterous and contrary to everything people held as sacred.

Think of Galileo, for instance, and what he suffered because he dared to endorse Copernicus' vision of heliocentrism, and to deny that the universe was earth-centered. He was condemned outright and forbidden to teach because his theory was "absurd and contrary to the teachings of the Bible." Similar rejection was experienced by those who advanced other theories that scientists now take for granted—the theory of gravity, the germ theory of disease, atomic theory, the theory of evolution ...

Rather than simply obeying orders from above to abandon their thinking, Galileo, Newton, Darwin, Einstein and others insisted that their new thought

as well as the theories their own threatened to displace be judged according to criteria scientists still invoke and apply to every new theory however outlandish it might at first seem. Does the theory (new or old) have internal coherence, they ask? Does it have external coherence, does it have explanatory value, and can it be falsified?

What's suggested in this chapter is that those same questions and criteria should be applied to official and competing stories of U.S. history, to the functionalist and conflict-based social theories explored earlier, and to statements politicians, scientists or anyone else make about the world.

Internal Coherence and Falsifiability

Internal coherence means that a theory or statement does not contradict itself or contain elements that cannot be reconciled. Falsifiability means that the theory can be proven wrong. If contradictory evidence is offered, the theory will have to be abandoned. If a theory cannot be falsified, it belongs more to the realm of religion and faith than to that of science and critical thinking.

For instance, Mr. Trump's earlier cited claims about the size of his inauguration audience seems, in his mind, unfalsifiable. Even though the Washington Park Police and photographic evidence contradict his position, he maintains the truth of his assertion that his audience was the largest in the history of presidential inaugurations.

A filmed example of a more consequential statement arguably violating both the principle of internal coherence and falsifiability surfaced during the "Iran-Contra Affair," which nearly brought down the Reagan administration in the mid-1980s.[1]

After first denying in the strongest possible terms that weapons had been exchanged for hostages held by Iranians (a violation of U.S. law), President Reagan was forced to retract his earlier statement, in the light of evidence discovered by the press and other investigators. But he did so in a strange way apparently inconsistent with internal coherence and falsifiability. See if you agree:

> **President Reagan**: (Nov. 13, 1986): "Our government has a firm policy not to capitulate to terrorist demands. That no-concessions policy remains in force. In spite of the wildly speculative and false stories about arms for hostages, and alleged ransom payments, we did not (repeat: did not) trade weapons or anything else for hostages. Nor will we."

Despite Reagan's denials investigations soon revealed that arms had indeed been traded for hostages in the Middle East. So a few months later, the president was forced into the following retraction[2]:

President Reagan: (Mar. 4, 1987): "A few months ago I told the American people I did not trade arms for hostages. My heart and my best intentions still tell me that's true, but the facts and the evidence tell me it is not."

The denial and retraction in President Reagan's statements are clear and dramatic. In the context of the discussion here, the retracting statement is noteworthy first of all for its attempt to save face and maintain a presidential appearance of sincerity and good will. In it, one might detect elements which also make the candor of the retraction itself questionable from the scientific point of view.

George Orwell's term for what we're calling lack of "internal coherence" was "double-speak"—an expression of "double-think," in which the audience is invited to participate. In his novel *1984*, Orwell defined double-think as "The ability to think two contradictory thoughts while giving assent to both."

Whether or not President Reagan's words, "My heart and my best intentions still tell me that's true, but the facts and the evidence tell me it is not" constitute insincere "double-speak" might generate a good and revealing discussion. Is it possible to "still" assent to the truth of something that has been disproved by "the facts and the evidence?"

What is the expected reaction of the audience that hears such a statement? If it's thinking scientifically, the audience will be suspicious and disbelieving not only because the statement seems to contradict itself, but because it fails the test of falsifiability. It seems that no matter what the "facts and evidence" might say, the President would still believe what his heart and best intentions tell him. No scientist could endorse that.

Neither should any critical thinker.

External Coherence

External coherence is the second scientific criterion to keep in mind for the purposes of critical thinking addressed here. Remember, internal coherence sought consistency within a theory or statement itself. External coherence addresses the agreement or lack of agreement between a theory or statement and what is known about the world apart from such theorizing or assertion.

Michael Moore's film, *Bowling for Columbine* contains an illustrative example of the implied application of this principle precisely to official and competing stories of U.S. history reviewed in our previous chapter.

It just so happens that the town of Columbine is home not only to the tragic school massacre we all know about, but to a nuclear missile plant. At one point Moore interviews a spokesperson for the plant standing in front of missiles

decorated with the U.S. flag. The man had evidently been asked about the school shootings. His response gives a concise version of the official story of U.S. history and policy. He says, "We don't get irritated with somebody and just because we're mad at them, drop a bomb or shoot at them, or fire a missile at them."

But notice how that theory not only contradicts the historical patterns described by competing stories in our previous chapter, it also seems incoherent with the very work the interviewee is doing (manufacturing missiles) and with the physical context where he's standing with its prominently displayed missiles in the background.

Apart from that, however, the spokesperson's words offer a theory about the U.S. in the world, namely: Unlike the Columbine shooters, we are a basically peaceful people. We are rational and never shoot or bomb people simply because we are angry with them.

Moore's film immediately tests this theory for external coherence—that is, for what we know about the world and U.S. policy apart from the theory. For immediately following the statement above, Moore unreels his competing story while Louis Armstrong sings "What A Wonderful World" for background. The story takes the form of a timeline implicitly claiming to illustrate the way the United States does in fact routinely "get irritated with somebody and just because we're mad at them, drop(s) a bomb or shoot(s) at them, or fire(s) a missile at them." The timeline follows[3]:

1953:	U.S. overthrows democratically-elected Prime Minister Mossadeq of Iran. U.S. installs Shah as dictator.
1954:	U.S. overthrows democratically-elected President Arbenz of Guatemala. 200,000 civilians killed.
1963:	U.S. backs assassination of South Vietnamese President Diem.
1963–1975:	American military kills 4 million people in Southeast Asia.
Sept. 11, 1973:	U.S. stages coup in Chile. Democratically-elected President Salvador Allende assassinated. Dictator Augusto Pinochet installed. 5,000 Chileans murdered.
1977:	U.S. backs military rulers of El Salvador. 70,000 Salvadorans and four American nuns killed.
1980s:	U.S. trains Osama bin Laden and fellow terrorists to kill Soviets. CIA gives them $3 billion.
1981:	Reagan administration trains and funds "Contras." 30,000 Nicaraguans die.
1982:	U.S. provides billions in aid to Saddam Hussein for weapons to kill Iranians.
1983:	White House secretly gives Iran weapons to kill Iraqis.
1989:	CIA agent Manuel Noriega (also serving as President of Panama) disobeys orders from Washington. U.S. invades Panama and removes Noriega. 3,000 Panamanian civilian casualties.

1990:	Iraq invades Kuwait with weapons from U.S.
1991:	U.S. enters Iraq. Bush reinstates dictator of Kuwait.
1998:	Clinton bombs "weapons factory" in Sudan. Factory turns out to be making aspirin.
1991 to present:	American planes bomb Iraq on a weekly basis. U.N. estimates 500,000 Iraqi children die from bombing and sanctions.
2000–01:	U.S. gives Taliban-ruled Afghanistan $245 million in "aid."
Sept. 11, 2001:	Osama bin Laden uses his expert CIA training to murder 3,000 people.
9/11 observer:	(screaming) "Oh my God, Oh my God! Oh my goodness, Oh my goodness!

This sequence from *Bowling for Columbine* is useful for our purposes not only because it offers an illustration of "official" vs. "competing" story as well as a test for "external coherence;" it also implicitly invokes the scientific principle of "explanatory value."

Explanatory Value

Explanatory value means that a theory or statement offers a pleasing, satisfactory and or comprehensive explanation of phenomena in question. Does the theory "cover all the bases," or does it leave significant factors unexplained. Is it basically believable?

Take, for instance, the "official story" about the 9/11, 2001 attacks on New York's Twin Towers and Washington's Pentagon. The official explanation is that the attacks were entirely unprovoked, came out of the blue, and were due to "evil." The attackers hate American freedom and its way of life. They themselves were evil, enjoy killing (even, apparently, themselves). That's it.

Moore's explanation is different. By ending the sequence we're considering with the image of planes flying into the Twin Towers, he implies causal factors connecting events between 1953 and 9/11/01 especially as they impact the Middle East. Remember the sequence ends as follows:

1991 to present:	American planes bomb Iraq on a weekly basis. U.N. estimates 500,000 Iraqi children die from bombing and sanctions.
2000-01:	U.S. gives Taliban-ruled Afghanistan $245 million in "aid."
Sept. 11, 2001:	Osama bin Laden uses his expert CIA training to murder 3,000 people.
9/11 observer:	(screaming) "Oh my God, Oh my God! Oh my goodness, Oh my goodness!

Does Moore's explanation have more explanatory value than the official story? Do you think so? Why? Is your position falsifiable? What would it take for you to abandon your theory?

Answering those questions in this and other contexts as well as questions about internal and external coherence will make you a better critical thinker.

For Discussion

1. Explain what it means to think like a scientist.
2. In terms of "double speak" and "double think," assess President Reagan's words "My heart and my best intentions still tell me that's true, but the facts and evidence tell me it's not." Is it fair to use "double speak" and " double think" in relation to this statement?
3. Define internal coherence and external coherence. How do these two elements relate to critical thinking?

Notes

1. The Iran-Contra affair (also termed the Iran-Contra scandal, Contragate and Irangate) became a central focus of the Reagan administration during its second term in office. The affair involved contravention by the administration of a congressional law that prohibited funding a counter-revolutionary movement (the Contras) in Nicaragua, where in 1979 a long-time ally of the United States (the Somoza family) had been overthrown by Marxist forces (the Sandinistas). The illegal funding of the Contras was made possible by selling arms to Iran, which the Congress had placed under an arms embargo, and secretly negotiating with Iran's leaders for the release of a group of U.S. hostages kidnapped in Lebanon.
2. The first few minutes of this video juxtaposes President Reagan's denial of U.S. involvement in any arms for hostages deal with his later admission of involvement: www.youtube.com/watch?v=RAMn-xmJ_tA&t=20s
3. *Bowling for Columbine*. Dir. Michael Moore. Prod. Michael Moore. Perf. Michael Moore. Dog Eat Dog Films, 2002. www.youtube.com/watch?v=om4NJoZaPac

Rule Seven

Quadra-Sect Violence

As we saw earlier, immediately following the tragic and despicable events of 9/11/01, Osama bin Laden, made explicit the connections Michael Moore implied in the *Bowling for Columbine* sequence reviewed in our previous chapter. In effect, bin Laden said, "Now you know what it's felt like in the Arab world for the last 80 years." This was an apparent reference to the European occupation of the former Ottoman Empire following the latter's disintegration after World War I.

Additionally, bin Laden alleged the attacks occurred in response to the stationing of U.S. troops in Islamic holy lands desecrating, he said, the sacred sites of Mecca and Medina following the first Gulf War. The 9/11 attacks were evoked as well, he said, by sanctions on Iraq all during the 1990s (with the resulting deaths of 500,000 children, not to mention adults), and especially because of the U.S. support of Israel in its illegal occupation of Palestine. According to bin Laden, the Arab world hates the United States because of this list of perceived atrocities. In commentary, many Arabs agreed. They said that solving the Palestinian dilemma would go a long way towards solving the problem of international terrorism.

In a word, according to bin Laden's explanation of 9/11, it was "blowback"— an act of retaliatory violence.

With that in mind, it becomes imperative for would-be critical thinkers attempting to make sense of the contemporary world and the "war on terrorism"

to think clearly about violence. It also becomes necessary to understand what bin Laden and the Arab world in general claim is the central cause of Islamic terrorism, viz. the situation in Israel/Palestine.

It is the purpose of this chapter to address both problems. They are intimately related in terms of critical thinking. On the one hand, the situation in Israel/Palestine offers another example of "competing stories" inviting application of the scientific principles reviewed in our previous chapter. And on the other hand, the two accounts open the door to application of yet another criterion for critical thinking: Quadra-sect violence.

Violence Quadra-Sected

Quadra-secting violence means that critical thinkers must take account of the fact that there is more to violence than is commonly understood. In fact, there are actually four levels of violence that characterize armed conflict. This distinction recognizes violence as (1) institutionalized, (2) self-defensive, (3) reactionary, and (4) terroristic.

Dom Hélder Câmara on Four Levels of Violence

In his 1971 book, *The Spiral of Violence*, Dom Hélder Camara, the Roman Catholic bishop of Recife in Brazil, and a champion of liberation theology, distinguished between four levels of violence. He called them established violence, the violence of revolt, the violence connected with suppressing revolt, and the violence of state torture designed to discourage revolt. These are the levels we are calling institutional, self-defensive, reactionary, and terroristic.

In his own words, here is the heart of Dom Helder's argument that violence only begets violence:

> "Look closely at the injustices in the underdeveloped countries, in the relations between the developed world and the underdeveloped world. You will find that everywhere the injustices are a form of violence. One can and must say that they are everywhere the basic violence, violence No. 1. ...
>
> "This established violence, this violence No. 1, attracts violence No. 2, revolt, either of the oppressed themselves or of youth, firmly resolved to battle for a more just and human world. ...
>
> "When conflict comes out into the streets, when violence No. 2 tries to resist violence No. 1, the authorities consider themselves obliged to preserve or re-establish public order, even if this means using force; this is violence No. 3.

> "Sometimes they go even further, and this is becoming increasingly common: in order to obtain information, which may indeed be important to public security, the logic of violence leads them to use moral and physical torture—as though any information extracted through torture deserved the slightest attention! ...

Institutionalized Violence

Institutionalized violence refers to negative social, political, and economic "structures" that shape all of our actions. The reference here is to laws, customs, and ways of doing business, to the "rules of the game" that force people to do things they might not otherwise choose. Sometimes what people are forced to do is terribly destructive.

But for a moment, set aside destruction and just consider "structures" themselves. Every college student knows about the "structures" of school life. There are rules and customs. You have to attend class, achieve a certain grade point average, take exams at scheduled times, pay your term bill, and generally adopt certain ways of speaking and behaving to stay in school.

No particular student has chosen those elements; they simply are. Similarly, all teachers, however subversive they might imagine themselves, need to show up for class, keep records, submit grades, and observe other regulations and customs necessary to retain their jobs.

The very layout of campus with its buildings and classrooms located in particular places changes behavior. To make it from your dorm to your first class at 8:00 means you have to get up at a certain time, leave your residence hall on schedule, and maybe even get to bed by 12:00 the night before.

Those are the structures of academic life.

Larger societal life at community, national, and international levels has its structures too. First of all, there are the structures of capitalism reviewed earlier in this book—markets, laws of supply and demand, income taxes, and so on. In addition, everyone has to deal with City Hall. You have to pay your bills.

National life has its Constitution. Then there are international organizations such as the U.N., the International Monetary Fund, the World Bank, and the U.S. Army. All of these are institutions. All of them represent "structures." We are born under their sway; we didn't choose them. To get along in the world, we must conform our lives to the behavior they mandate or suffer sometimes highly negative consequences.

Occasionally at least, social structures can come in the way of doing the right thing. For instance, an opponent of a particular national war might nevertheless end up paying taxes to fund the conflict in question. Or a student might accept a scholarship provided by university investments whose morality she considers questionable.

The difficulties of overcoming structural obstacles to doing the right thing in terms of government policy are illustrated once again in *The Distinguished Gentleman*. After his conversion, Thomas Johnson tries to do something about remedying the link between power lines and cancer. He calls for hearings on the subject. But his meeting with the House leadership demonstrates how structures—investigating committees, construction costs, school districting, utility fees, property values, real estate markets, insurance concerns, citizen resistance to tax increases (not to mention outright bribery)—prevent even the best-willed politicians from introducing needed reform. Each of these elements appears in the dialog below. The chairman of the relevant House committee introduces the conversation:[1]

Dick:	Thomas and I were just talking about power lines.
Thomas:	Man, I think we ought to have those hearings.
Dick:	Well now look, Thomas, why don't we get Olaf's opinion on this.
Olaf:	Well it's tragic, I mean, cancer is a terrible thing. But there's no way you can link it to power lines. Now the truth is …
Thomas:	Now, wait a minute, there have been studies that show …
Lobbyist:	For every study that shows one thing, I'll show you a study saying another. We've studied this ourselves … Nada.
Thomas:	Well, what if you guys are wrong?
Dick:	Thomas, do you want us to move the power lines? I mean, do you know how much it would cost to bury those things in Florida alone? I mean, we're talking five billion dollars.
Lobbyist:	Not counting the liability claims.
Terry:	Now how would you like the people in your district to think of you as the man who tripled their electric bill?
Thomas:	I just thought … if we had the hearings …
Terry:	Think for a moment, chum, if you had those hearings, overnight, everyone who lives near a substation will find the value of their homes in the toilet. You'll kill the real estate market.
Olaf:	You'll kill the insurance companies.
Terry:	You'll kill the school district.
Olaf:	You'll kill the local economy.
Dick:	Son, the system ain't perfect. But the fleas come with the dog.
Thomas:	Maybe I should think about it, huh?
Dick:	Atta boy. (Looking intently at Olaf) Ahem …

Olaf:	Oh, Thomas, on a completely different subject here, you haven't set up a state PAC yet, have you? Cause I'd be happy to start one off, with a contribution of say … oh, two hundred thousand.
Lobbyist:	No strings attached.
Thomas:	Natch.
	(Thomas leaves the room.)
Dick:	You were beautiful, Olaf.
Olaf:	No, you were beautiful, Dick.
Lobbyist:	No, you were beautiful, Terry.
Terry:	To the mutual aid society.
	(They all drink a toast.)

Structures and Violence

Even the conversation just quoted shows that not all structures are as benign as they might at first appear. The normal way society is set up often makes change difficult or nearly impossible. Other structures don't even appear to be benign; they are positively murderous. Think of the structures colonialism and their requirements and effects, for instance, on the indigenous of the New World after 1492. (These will be discussed at length in Chapter 14.) Think of German life under the Nazis in the 1930s and the effects of its laws, customs, and institutions (e.g. its death camps) not only on Jews, but on the world. Think of apartheid in South Africa before it formally ended in 1991, or of Jim Crow laws here in the United States. All of these involved "rules of the game" that were, for example, responsible for the deaths of six million Jews under the Nazis alone, and of untold numbers of African-Americans through the custom of lynching in the U.S. South.

The point here is that all of these (colonialism, Nazism, Apartheid, and Jim Crow) were instances of violence. They were a first level of violence that could easily be overlooked, since the laws and customs in question seemed as natural to most as the air they breathed. Yet those who rebelled against such structures, like Nelson Mandela and Martin Luther King, are now generally considered heroes.

Even more, after our Founding Fathers took up arms against the unjust structures that bound them to England, their violence came to be considered praiseworthy and patriotic by most of us. In fact, the U.S. Declaration of Independence claims that when any government fails to represent the wishes of the people, citizens have a duty to follow the example of their revolutionary forebears and overthrow it even if that entails killing and wholesale destruction of property.

All of us understand that. Yet we don't usually make such understanding part of our thinking about "violence." We overlook the fact that institutions can kill, often massively. When that's the case, resisting their murderous nature can be

considered virtuous even if resistance entails violence like that exercised by the founders of our nation.

Self-Defensive Violence

That brings us to the second level of violence addressed here. Let's call it "the violence of self-defense." This second level of violence is a response to the first level, and is usually practiced outside the law which by definition is part of institutionalized or structural violence.

As a result, it is easy for the powers that be to classify rebels (like Washington, Jefferson, Franklin, Jay, and the other signers of the Declaration of Independence) as "outlaws," "bandits," or "terrorists." And that's exactly what the British did.

Such classifications by those our educational and cultural structures teach us to honor and obey fog the picture for most of us thinking about violence today. For instance, when we read of Iraqis planting roadside bombs that kill American soldiers, it's easy to think of the "insurgents" simply as evil terrorists.

American Sniper[2] and the Violence of Self-Defense
What the Magic Glasses Reveal

Who are the terrorists in *American Sniper*? Or in the film's terms, who are the bullies and who are the sheepdogs? For the sake of critical thinking, consider the question from the Iraqi viewpoint. It is intimately related to this section on the violence of self-defense.

The theme was announced in one of the film's opening scenes. There an adolescent Chris Kyle is instructed by his father about three ways of being in the world. Kyle, of course, is the film's central character—the most lethal sniper in the history of the American military. He is believed to have killed 255 Iraqis in his 4 tours of duty. Many, it is certain, had their heads blown right off.

"You can be a wolf, a sheep, or a sheepdog" Kyle's father tells him (in my paraphrase). "Wolves are bullies; they are cowards preying on the weak. Sheep are the naïve who simply go along, following the herd; they do nothing about bullies. They too are cowards. The way to deal with bullies" says Kyle's father," is to be a sheepdog and protect those the bully preys upon.

"I want you to be sheepdogs!" the elder Kyle shouts at his sons, "Don't let the bullies have their way."

Ironically, the rest of *American Sniper* might be seen as how Chris Kyle entirely rejected his father's advice. It might also present examples of how Iraqi patriots unconsciously heeded it. They emerge in the film as the sheepdogs Kyle's father admired. (Remember: this is what, I'm guessing, Iraqis might say.)

For his part, Kyle joins a gang that specifically preys upon the weak for no good reason—simply because it can and because (as Kyle writes) it's fun. Chris Kyle became a gangster bully.

No, he didn't join the "Crips" or "Bloods," "Sharks" or "Jets." He joined the "Seals." And their destructive power was beyond belief. To begin with, their gang attire was fearful including matching helmets and boots, flak jackets, camouflage, wrap-around sunglasses, and night vision goggles. They had guns of all types, unlimited supplies of bullets, grenades, missile launchers, armored vehicles, helicopters, planes, and sophisticated communication devices. They prowled in menacing groups along the streets of Bagdad pointing guns at open windows and doors, pedestrians and drivers.

But it wasn't easy for aspiring bullies to become Seals; doing so required absolute submission and humiliation. So as with all gangs, they had their initiation rites. These included merciless hazing and demeaning tests of endurance. Such rites of passage were accompanied by constant indoctrination that left initiates exhausted and absolutely malleable.

As a result, and with no knowledge whatever of their intended victims, Seals became convinced that anyone their superiors identified as "targets" were savages. They knew that because their indoctrinators told them so. They knew nothing else about Iraq, Iraqis or their culture. And so, like their Indian Fighter predecessors, Seals hated "savages" and wanted them all dead.

In other words, gang aspirants became servile and submissive sheep. They obeyed orders without question or understanding of context. Seals stood ready to kill women, children, the elderly and disabled—anyone identified by their superiors or who threatened their mafia-like ethos of "family." Protecting one's "brothers" in crime became the justification of any slaughter. As a result of that brainwashing, Seals were entirely unable to see their "enemies" human beings.

Iraqis, on the other hand, were perfect targets for bullies. They had no army, no sophisticated weapons, no helicopters, planes or armored vehicles. They wore no uniforms or protective clothing. Apart from unemployed members of Iraq's Republican Guard, almost none had formal military training.

Instead they were simple peasants, merchants, teachers, barbers and taxi drivers. They were fathers and mothers, children barely able to lift a grenade launcher, grandparents, friends and neighbors banding together as best they

could to protect their homes, families from the ignorant, marauding invaders who proudly called themselves "The Seals." Unable to show weapons in public (like their menacing occupiers), Iraqis hid them by day under floor boards in their homes.

Some were so desperate that they were willing to sacrifice themselves and their children to resist the Seal home-invaders. So they became suicide bombers. Others experimented with non-violent resistance. They were willing to share their tables with the barbarians from abroad, offering them food and shelter in hopes that kindness might win them over.

But no such luck.

So the majority resorted to defending themselves and each other with weapons—mostly captured or left over from previous Seal-like invasions (there had been many). What else were these brave patriots to do?

One of them became particularly admired. He had been a national hero, called Mustafa. In the story, this fictional character was an Olympic gold medal marksman, a champion like the Americans' Michael Phelps. But instead of resting on his laurels or using his status to protect himself from harm, he employed his skills as a sharp shooter to defend his people.

We can only imagine the pride that swelled the hearts of Iraqis when they heard how he inspired fear in the American bullies who constantly kicked in their doors, destroyed and looted their property, belittled their culture and faith, intimidated their children, frightened their elders, and demeaned their women.

In the end, Mustafa became a glorious martyr.

Again ironically, he was gunned down by his ignorant American counterpart. He was killed by the bully without a thought in his head who was in the game for fun, for the rush of battle, and to protect his relatively invulnerable "brothers" from the harm they deserved at the hands of the civilian victims they tormented.

In what could be described as an act of self-loathing, that counterpart, Chris Kyle, takes careful aim and from a great and safe distance shoots a patriot he considers "savage," perhaps because the latter mirrors so well Kyle's own bloody work.

It might be easy to vilify Chris Kyle. But he's not to blame; he evidences not a shred of critical awareness that was apparently drilled out of him in boot camp. In that, was he any different from drone "pilots" striking targets from their air-conditioned "theaters" in Nevada or New Mexico? Certainly not all of them are bullies or gangsters. But are they brainwashed sheep? What about the rest of us?

In response, however, Iraqi resisters might ask us, "What would George do? That is, if in 1775 your country were invaded by the British the way ours has been by Americans, what would Washington, Jefferson, and the others have done? What *did* they do? What would *you* do today if Iraqis invaded America? If in response you took up arms (in an act of second-level violence) would you consider yourself a terrorist or a patriot?"

These are matters worth discussing. But the point here is simply to understand the nature of second-level violence. That's the level most of us have no trouble identifying as violence—and usually negatively. Once again, we don't generally even recognize first-level violence. Neither do we identify third-level violence as such, nor at least with the same negativity accorded to the second kind.

Reactionary Violence

Reactionary violence refers to the response of the defenders of structures (the government, police, army and the institutions that usually support them, such as schools, churches, and the media) to second-level violence. That response is routinely overwhelming and shocking in its disproportionality.

For example, the attacks of 9/11 (regardless of what we think of the "self-defensive" justification accorded them by bin Laden) evoked a response on the part of the United States that has already claimed more than one million victims, most of them innocent civilians. (The 9/11 attacks themselves took nearly 3000 lives.)

Despite such disproportional response, most Americans, it seems, consider it justified, and therefore not really "violence" in the negative sense.

The same has been true of textbook portrayals of U.S. Cavalry response to the scalping of women and children at the hands of American "Indians," and in general to Israeli response to suicide bombers in Israel/Palestine. Most seem to think that the so-called rebels or insurgents have gotten or are getting what's coming to them.

However, even the most superficial thought (especially if we put ourselves in the place of the "outlaws," "rebels," "insurgents," "bandits," or "terrorists") reveals that such judgments are not without their problems. Again, all of that is worth discussion.

Terroristic Violence

Let's call the fourth level of violence "terroristic." Even our considerations so far should have made it clear that, as they say, one person's terrorist is another person's

patriot or hero. Terrorism is complicated. Take the F.B.I.'s definition. It defines terrorism as:

> The unlawful use of force and violence against persons or property to intimidate or coerce a government, the civilian population, or any segment thereof, in furtherance of political or social objectives.[3]

First off, note the emphasis on law (or legal *structures*). The assumption here is that legal structures are inviolable.

That's what the Nazis thought too, and the upholders of apartheid and Jim Crow. That is, under this definition and in terms of violence, unjust and violent legal structures are totally invisible and ruled out of consideration.

Also no provision is made in this definition for even recognizing the possibility that a government itself might be terroristic and if so should be opposed even with (second level) violence. On the contrary, by definition any attempt to intimidate or coerce a government in furtherance of political or social objectives is classified as terrorism. By this definition the founders of the United States were justifiably classified as terrorists.

Yet from our previous considerations it is clear that governments themselves (the British in colonial America, the Nazis in the 1930s, the Afrikaners in South Africa, state governments in the Jim Crow South) can intimidate or coerce entire "civilian populations or segments thereof, in furtherance of political or social objectives." In other words, state terrorism is not only possible, but has arguably been far more destructive than non-state terrorism. This is why some have referred to state terrorism as "wholesale" and non-state terrorism (even like that exercised on 9/11/01) as "retail."[4]

Application

All of this means that critical analysts must move beyond the Ruling Group Mind in analyzing what counts as "violence." The call is to transcend our 9/11 thinking on the subject which starts and ends with the attacks on the Twin Towers and Pentagon and ignores their alleged causes and the violence and terror associated with responding to the attacks.

Now we are equipped to entertain the possibility that structural responses to second level self-defense might not only merit the name "violence," but even "terrorism." The same is true in the context of Israel/Palestine. There while we still might be appalled by suicide bombers who sometimes kill dozens of presumably

innocent people as well as themselves, the door opens to considering the Israeli response in terms of violence actually comparable to that of the suicide bomber.

In other words, with the conceptual background provided by this chapter, we're now equipped to apply its distinctions to "competing stories" about Israel/Palestine, the alleged main cause of the Islamic terrorism and Western response that has shaped our contemporary world.

The Jewish/Israeli Story

Here is a summary of the story Jewish Israelis typically tell to justify their occupation of Israel/Palestine and their classification of Palestinian insurgents as "terrorists."[5]

- Jewish Israelis are inheritors of Abraham's "Promised Land."
- They were unjustly expelled from their God-given homeland in 135 C.E. and dispersed throughout the world.
- After Christianity became the Roman Empire's official Religion in 381 C.E., Jews were routinely persecuted by Christians, who tended to be anti-Semitic, identifying Jews as "God-killers."
- Anti-Semitism eventually led to the birth of the Zionist movement in 1887.
- It sought return for Jews to their ancient homeland, now thought of as "a land without people for a people without land."
- The Jewish people suffered their worst persecution under Christians from 1939–1945, in the Great Holocaust, which slaughtered six million Jews, and which evoked great sympathy for the Jewish people worldwide.
- So in 1947 the UN (UNSCOP) gave 55% of Palestine to Jewish settlers.
- The returnees were immediately attacked by Palestinians, and by the whole Arab world in 1948, 1967 (Six Day War), and 1973 (Yom Kippur War).
- The goal of the Arabs was to drive Jewish settlers into the sea.
- Beginning in 1995, Palestinian terrorists even used suicide bombers against innocent civilians.
- Despite such outrages, Israeli Jews have generously offered peace plan after peace plan to the Arab terrorists.
- Most notably, this happened in 2000 at a Camp David meeting (moderated by Bill Clinton) between Israeli Prime Minister, Ehud Barak, and Palestinian Liberation Organization (PLO) leader Yasser Arafat.
- Arafat refused a very generous offer, thus continuing the Palestinian tradition of refusing to recognize Israel's right to existence.

- Instead Palestinians have continued mercilessly terrorizing Jewish Israelis—especially with suicide bombers.
- Naturally, in self-defense, Jewish Israelis have (1) established security zones that penetrate into Palestinian territory, (2) built a road system from which Palestinians are excluded or restricted, (3) set up checkpoints throughout the country, and (4) built a security fence to further control the terrorists.
- It is true that U.N. resolutions (most notably 242) have ordered Jewish "occupiers" out of territories captured in the 1967 war.
- However, such orders come from an "international community" which history has taught the Jewish people not to trust.
- They are forced to rely only on themselves.

Once again, that's the Jewish-Israeli story. It should be familiar to most Americans, since, as we'll see below, the "competing story" is generally not publicized, at least in the United States. In terms of this chapter, it is important to note several elements of this story. Note to begin with the references to structures. Among them are belief systems (religious beliefs about ownership of Palestine and specifically Christian anti-Semitism), organization of the world (Christendom after the fall of the Roman Empire), laws (U.N. resolutions and German laws against Jews), as well as geographical arrangements (security zones, road systems and a security fence). To repeat: all of these are examples of the "structures" referenced earlier in this chapter.

Finally, understand that the Jewish story sees the structures Jews have imposed in terms of security against unjustified Palestinian terrorism. As we'll see immediately below, the Palestinians experience those same structures as instances of institutionalized violence. They see their own actions against such violence not as terrorism, but as patriotism and justified war. They see their actions as self-defense.

The Palestinian Story

Here is the story of the conflict in the Middle East as told by Palestinians. To anticipate our final truth criterion, "detect silences" (to be explained in Chapter Twenty) this story has been "silenced" in the United States. That is, it is almost never seriously entertained or sympathetically explained in the mainstream media.[6] But here it is:

- Like the Jewish Israelis, the Palestinians are descendants of Abraham.
- From the beginning Palestinians shared the "Promised Land," which never belonged exclusively to the Hebrew or Jewish people, but (as described in the

Bible) was shared by many other tribes (e.g. Canaanites, Hittites, Amorites, Perizzites, Hivites, Jebusites, Geshurites, Maacaathites, and Philistines).

- Jewish people were unjustly expelled from their homeland in 135 C.E. and dispersed throughout the world.
- However, Palestinians had nothing to do with that.
- Instead they lived peacefully for centuries with the few Jews who remained in Palestine over the next 1700 years.
- During this time, Jews thought of themselves not as a nation-state, but as a religion, the way Christians, Muslims, Hindus, Buddhists and others do.
- In the face of relentless persecution by European Christians, European Jews sought a homeland where they might live together in peace.
- They were encouraged to do so by the British, who thought of Jews in Palestine as a European colonial presence that would maintain a "beachhead" in a strategically important area of the world, which contained the "most stupendous prize" of all—a virtual sea of oil.
- With such encouragement, the "Zionist" movement was officially launched in 1887.
- It was an explicitly secular movement completely without religious pretensions.
- In fact, besides Israel, Zionists had considered colonizing Argentina, Uganda, Cyprus or the Northern Sinai region rather than Palestine.
- Palestinians resisted Zionism from the beginning with peaceful demonstrations, local and general strikes, and sometimes with violence.
- Nonetheless, in 1947 the United Nations awarded Jewish settlers 55% of Palestine, even though they represented only 30% of the population, and even though Palestinians had nothing to do with the Holocaust.
- Outraged Palestinians protested so strongly that the UN suspended its "Partition Plan."
- In response, Jewish settlers inaugurated a terror campaign directed both against the British and Palestinians.
- The Jewish Haganah, Irgun and Stern Gang terrorists (under the leadership of future Prime Minister Menachem Begin) blew up British headquarters in Jerusalem's King David Hotel killing scores of British, Palestinians and others.
- Jewish terrorists evicted Palestinians from their homes, and drove them into refugee camps, often simply murdering even hundreds of Palestinians at a time.
- In response the Arab world came to the defense of their brothers and sisters in Palestine.

- They were militarily weak however (having just escaped colonialism themselves).
- So they were easily defeated in the Six Day War.
- In that conquest, Jewish Israelis took over more Palestinian territory—in the Gaza Strip, on the West Bank, in the Golan Heights, and in East Jerusalem.
- The U.N. subsequently ordered Israel to abandon these "occupied territories" (in Resolution 242).
- But the Israelis (unconditionally supported by the United States) have refused to obey.
- In another attempt to expel the illegal occupiers, the Arab world attacked again in 1973 (the Yom Kippur War).
- With U.S. aid, the Jewish Israelis repulsed the attack, annexing further Palestinian territory in the process.
- Recognizing military defeat, the Palestinians since 1976 have been willing to settle for the arrangements recognized in the original U.N. partition plan—two states in Palestine, secure borders, and Jewish Israeli withdrawal from the occupied territories.
- Alone in the world, the Jewish Israelis and their U.S. patrons have refused such settlement.
- In fact, far from obeying repeated U.N. resolutions, Israeli occupiers have continually encroached further into Palestinian territory, building extensive illegal settlements, and a huge wall (far higher, more impenetrable and extensive than the Berlin Wall) separating Palestinians from their families, work, and vital resources.
- When Palestinian children and young people have resisted in two uprisings (*Intifadas* in 1982 and 2000) by throwing stones at soldiers in the illegally occupied territories, they have been shot by the occupiers.
- When in 2006 Palestinians overwhelmingly elected their leaders (Hamas) in a democratic election, Jewish Israelis (with the support of the United States) refused to recognize the election results. They have instead engaged in "collective punishment" cutting off an entire people from vital resources.
- It's no wonder, then, that many desperate Palestinians have immolated themselves as suicide bombers, against an occupying army that is supported by the United States not only with sophisticated armaments, but with $10 million per day in "foreign aid."

Here too there is much to note relative to our discussion of violence and its levels.[7] To begin with, the Palestinian story references many of the elements from the Jewish/Israeli story. The difference is that the Palestinian competing story sees

Jewish settlement of Palestine as a violent theft of land. The robbery was imposed by world structures (including the United Nations and the U.S. government) on a people who had nothing to do with the crime of the Great Holocaust for which the land of Palestine was given the Jews as a form of reparation. Implied in the story's disavowals of responsibility for that crime is the question, why were the Jews not given all or part of Germany to make up for the Holocaust for which Germans *were* responsible?

Noteworthy too in the Palestinian story is its justification of self-immolation by suicide bombers. What is the difference, the story implicitly asks, between such tactics and the ones used by Israelis in response (the third level of violence), when again and again that Israeli response takes on average 10 times the number of Palestinian civilian lives as any original attack? In any case Palestinians argue, the suicide bombing was not "original," but merely a response to first-level violence and its gradual imposition of structures that greatly resemble the apartheid system abolished in South Africa in 1991.[8]

Conclusion

To reiterate: discussions of these issues of violence with all their distinctions should enhance the ability of critical thinkers to understand their world and overcome simplistic thinking about violence and terrorism. It's much more complicated than we've been led to believe. Do you agree?

For Discussion

1. What is your response to the way Iraqis might interpret *American Sniper*?
2. Does such interpretation help critical thinking? Explain.
3. This chapter claims that first and third level violence (structural and reactionary) are usually not identified as violence, while second level violence (self-defensive) is. Do you think that claim is true? If so, why?
4. How do the insights of Chapter 10 ("Inspect Scientifically") help you assess the competing Jewish-Israeli and Palestinian stories? What about their internal coherence, external coherence and explanatory value?
5. Evaluate each story in terms of violence, as detailed in this chapter. What does each side claim about its own acts of violence? What do they claim about the other side's acts of violence?
6. Do you agree with the conclusion of this chapter which claims that the situation in Israel-Palestine is much more complicated than we have been led to believe? In what ways is the situation complicated? In what ways is it not?

Activity

Use resources from the library and on the internet to research the Palestinian/ Israeli conflict. Starting from the competing stories found in this chapter, develop your own informed and researched story.

Notes

1. *The Distinguished Gentleman*. Dir. Jonathan Lane. Perf. Eddie Murphy, Lane Smith, Victoria Rowell. Hollywood Pictures, 1992.
2. *American Sniper*. Dir. Clint Eastwood. Perf. Bradley Cooper, Sienna Miller. Village Roadshow Pictures, 2014.
3. U.S. Department of Justice, Federal Bureau of Investigation. "Terrorism in the United States." Washington, D.C., 1998. P1.
4. Edward S. Herman. *The Real Terror Network: terrorism in fact and propaganda*. Montréal: Black Rose, 1985.
5. Alan Dershowitz. *The Case for Israel*. New York: John Wiley & Sons, Inc., 2011.
6. Noam Chomsky. *Fateful Triangle: The United States, Israel, and the Palestinians* (Updated Edition). S. l.: Haymarket , 2015.
7. For a debate between Alan Dershowitz and Noam Chomsky see www.youtube.com/ watch?v=3ux4JU_sbB0
8. Jimmy Carter. *Palestine: peace not apartheid*. Bath: Camden, 2008.

Rule Eight

Connect With Your Deepest Self

From the outset, the argument here has been that critical thought worthy of the name demands expanding perceptions beyond what Plato identified as "doxa," the cultural limits of perception or the Ruling Group Mind. Gaining such distance facilitates the task of putting on Dick Gregory's magic glasses which confer sight beyond those cultural boundaries.

Some perceptual limits are more difficult to overcome than others. According to many, those set by religion represent the mother of them all. Karl Marx said as much.[1] For the fundamental convictions expressed in religious language claim to have the authority of God behind them. To question them is to question God—something many of us are reluctant to do. My own story (Chapters Two and Three) shows how that was true for me early on in life.

Nonetheless, this is precisely why it has been said that all critical analysis must begin courageously with critique of religion—a very powerful force which often divides people, but which also has potential for uniting them like none other. In this age of terrorism, with religious conflicts heightened in unprecedented ways, such critique seems more necessary than ever. In some ways, religion exercises more power than ever in our world. Even atheists neglect that power and its analysis at their own peril. For ignoring it limits one's capacity for effective critical thought in the world as it is.

As we'll see below, James Cameron's *Avatar* recognized that fact and presented an epic tale that validates and illustrates everything about the primacy of religion's critique that this chapter is about to expose. But first, the exposition.

The Mountain of Spiritual Awareness

To begin with, it might help to recognize the simple fact that on the one hand there is a great variety of religious beliefs in the world among very sincere people. On the other hand, at a certain high level of religious conviction, beliefs among the religious seem to converge. Arguably, the Buddha, Jesus, Muhammed, Teresa of Avila, Gandhi, Mother Teresa and other spiritual giants share much in common and would recognize each other as brothers and sisters.

Aware of such differences and convergence points, we might think of religion as a steep mountain many feel called to climb. The image points up the fact that once attracted to the spiritual—once drawn inward—advance in that field depends a lot on the effort and expenditure of energy on the part of "the climber."

Some (like the giants just mentioned) find enormous energy to continue the climb. They adopt rigorous spiritual practices, and seem to care about little else. Others, while not neglecting spiritual disciplines, readily connect their spiritual path with issues of justice and peace. Still others are content to remain where they came in or reject religion entirely, often because their childhood understanding does not match the challenges of adult life. Those who continue the climb progress to stages so inaccessible to those left behind that the plateaus encountered are literally inconceivable. Some lower down might even consider the "cliffs" above as unspiritual. However, those lofty heights are intimately related to our considerations of alternative facts, fake reality, Plato's cave and its distinctions between illusion and reality.

Consider Figure 12.1. It is meant to illustrate that there are actually at least four major plateaus up the mountain of spiritual awareness. Each has its alternative facts.

Let's call the first three "mind-based," "practice-based," and "consciousness-based." A fourth level unites consciousness with practice. Let's examine each of those levels. And let's continue the discussion in terms of Christianity, since that is the most familiar religion to most readers of this book. James Cameron's *Avatar* will widen the conversation to include Hinduism and the faith of indigenous people everywhere.

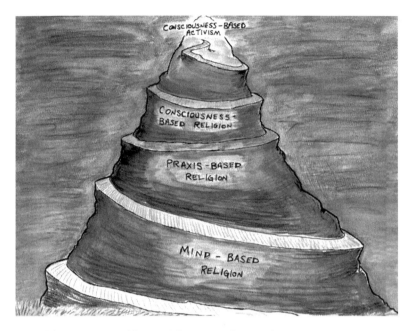

Figure 12.1: The Mountain of Spiritual Awareness. Source: Author.

Mind-Based Christianity

Christian orthodoxy represents a kind of entry-level faith that primarily amounts to a way of thinking. It focuses on correct doctrine and on heresy as incorrect belief. This doesn't deny that correct action (or morality) is also important. But according to the orthodox view, doing the right thing for the wrong reason is practically valueless as far as God is concerned. That is, orthodoxy more than anything else identifies faith with correct ideas. So, one must believe "in God," and "accept Jesus as personal Savior" for actions to be truly valuable in God's eyes. As you recall, this is the faith I personally accepted until my mid-twenties.

The connection between orthodoxy and the issues centralized in this book— of critical thought and understanding the world—is clear. By their nature, the thought bundles in question are exclusive. Believers are correct; all others are wrong. In fact, it is their wrong thinking, their mistaken concepts that make those "others" enemies of God. So God will punish the erroneous for the inaccuracy of their thought-bundles with a fate worse than death—unspeakable eternal torture in unimaginably hideous circumstances (hell).

With that future assured for infidels, mind-based believers often find no difficulty in anticipating and imitating God's inevitable punishments by torturing, killing and waging holy wars against "unbelievers." This indeed is the origin of many forms of terrorism, crusades, holy wars, inquisitions, and witch-burnings.

In its specifically U.S. and highly politicized version, mind-based Christianity sometimes has apparently little to do with the Bible or with Jesus himself. Instead it is more connected with "the Ruling Group Mind" described earlier by John McMurtry. As already indicated, that phrase refers to intellectual boundaries beyond which most "Americans" simply find themselves unable to think even as people of faith. The limits are powerful. They are set by parents, schools, politicians, teachers, priests and ministers. Here are the essential (mind-based) elements of American religion as described by McMurtry:[2]

- An all-powerful, all-knowing and jealous Supreme Power rules the world to realize America's goal—the liberation of humankind through the spread of the free market.
- By virtue of such divine support, America is the world's leading force for good.
- God's power is especially manifest in the U.S. military whose ability to kill and destroy represents proof of divine favor.
- To oppose America is evil.
- America's armed forces are necessary to subdue such evil opposition.
- In principle, those armed forces are incapable of committing crimes as they pursue their goal of fostering freedom, justice and peace.
- "The President of the United States" is the military's 'commander in chief,' and the embodiment of 'America's leadership of the free world.'
- He occupies 'the highest office on earth,' is God's vicar there, and is identical with 'America.'
- The project of God, America and its president is achieved by incorporating everything that exists into the free market system.
- It is achieved by spreading 'democracy' understood as responding to the consumption preferences which the ruling group-mind shapes by advertising and determines by continuous opinion polls.
- Any other concept of democracy and any other economic system are by definition evil.

Several years ago, David D. Kirkpatrick described the type of Sunday service which powerfully illustrated the union of Christian beliefs and American patriotism.

Later, as a choir in stars-and-stripes neckties and scarves belted out 'Stars and Stripes Forever,' a cluster of men in olive military fatigues took the stage carrying a flag. They lifted the pole to a 45-degree angle and froze in place around it: a re-enactment of the famous photograph of the American triumph at Iwo Jima. The narrator of a preceding video montage had already set the stage by comparing the Iwo Jima flag raising to another long-ago turning point in a 'fierce battle for the hearts of men'—the day 2,000 years ago when 'a heavy cross was lifted up on top of the mount called Golgotha'. A battle flag as the crucifixion: the church rose to a standing ovation.[3]

Practice-Based Christianity

Practice-based Christianity is highly critical of the type of Christianity just described. Practice-based faith understands "correct action" to be more important than "correct belief." Here faith's essence is embodied in what people do, rather than in what they think. Specifically, it is about seeking justice rather than merely offering an intellectual "yes" to a collection of correct ideas. If one had to choose between correct belief and action on behalf of social justice and peace, the latter carries the day; the former is completely insufficient.

The great Catholic theologian, Karl Rahner, introduced this idea to many Catholics in the 1960s. He wrote eloquently of "anonymous Christians."[4] It was a reference to those who act like Jesus, despite knowing little or nothing about him. Anonymous Christians might even have specifically rejected belief in Jesus or God. Yet they were somehow "following Jesus" without even knowing it. In orthodox terms, they were "saved."

On the other hand, according to this approach, it would also be quite possible for contemporary mind-based believers to say all the right words, to "believe in God," and to have accepted "Jesus as their personal Savior," and yet to be far removed from God. Even kings, emperors, presidents and popes could embody such alienation.

Given what the historical Jesus himself said and did, this would be especially true if would-be believers supported war or imperial oppression of the poor. That is, according to this understanding of Christianity, it was to the poor that Jesus understood himself as sent. In solidarity with the poor, he frequently disobeyed the laws seen as inviolable by his religion's orthodox leadership. He found his best friends among those the establishment considered lost and unclean. He even seemed to favor those completely outside the Jewish faith. In other words, Jesus' was not a mind-based faith, but one based in practice.

In my own case, this type of faith was mirrored in the liberation theology I studied in Brazil.

Consciousness-Based Christianity

Still ascending the mountain of spiritual awareness, we encounter a third type of Christian faith. This one is based on consciousness. Consciousness-based religion is located somewhere above mind-based and practice-based approaches to faith. This level of spiritual awareness has been previously described as cosmic-centered.[5]

Far from understanding thoughts and concepts as the litmus tests of faith, consciousness religion regards them as obstacles on the spiritual journey. They are problems not only because they can be manipulated so easily for political and venal purposes, but because by their very nature, concept and thought are inadequate to the job mind-based religion assigns them. Finite thought and concept can never adequately express the boundless reality towards which they gesture.

Nonetheless consciousness religion doesn't reject thought and concept entirely. It does after all "gesture." For that reason, consciousness religion tends to see the bundles of thought so important to mind-based faith in terms of "signposts." They are indicators pointing in the general direction of thoughtless awareness of a single truth. That truth is that ALL CREATION IN ALL OF ITS ASPECTS IS ONE—a manifestation of a single Essence or Being that underlies everything. That being can be variously described as God, Being Itself, or even as Nature with a capital "N."

This underlying unity applies to religion as well as everything else. At their highest summit, at their deepest core, all religions represent a drive to understand and more importantly to participate in a single unified reality. Once again, words and concepts are mere fingers pointing to the moon representing this basic truth. They are not the moon, and so should not be taken too seriously.

In Buddhist terms, religion is a raft conveying passengers to another shore. They lead to a way of being in the world based on the unity of everything that is. Just as the pointing finger is not the moon, so the raft of religious conviction is not the shore. It too should not be taken with too much seriousness.

In this view, all religion is quite simple and accessible to everyone. It needs no complicated formulas, doctrines or theologies. Once again, its fundamental conviction might be expressed in just four words: ALL REALITY IS ONE.

Even more simply, a single vowel-sound says it all, "Ah." That thoughtless sound means "clear your mind of concepts."

Only such "clarification" will put one in touch with the consciousness that is prior to all thought and idea. "Ah" connects more surely than words or doctrine with the primordial Mind that says "I am," and which precedes and is obscured by the mind that says "I think."

The point here is that consciousness-based faith properly understood is a source of unity rather than of division often encouraged by its mind-based counterpart. Consciousness-based faith leads to interdenominational and interfaith peacemaking efforts rather than to supposedly inevitable wars and support of empires.

Neither is such faith based on consciousness foreign to Christianity. To some extent, it is the reason Christians can embrace the ecumenical movement, not only as it stretches across Christianity's various denominations, but also across distinct religions. Consciousness-based Christianity finds its greatest adherents among Christianity's most prominent saints and heroes—figures such as Francis of Assisi, Thomas a Kempis, Teresa of Avila, John of the Cross, John Woolman, Meister Eckhart, Thomas Merton, Pope John XXIII, Teilhard de Chardin, Catherine of Siena, Thérèse de Lisieux, and many others.

Religion of Conscious Praxis

The fourth plateau up the mountain of spiritual awareness might be termed "religion of conscious practice." It unites religion based on practice with religion based on consciousness. It is found in the faith of those giants mentioned earlier—like Jesus the Nazarene, identified as "God's anointed" or Christ. It is the faith embraced and practiced by Mohandas K. Gandhi, sometimes referenced as the Buddha of the 20th century.

According to this approach, these extraordinary avatars not only changed the world. They were also seers who exhibited a deep consciousness of the divine residing at the core of their own persons, of all reality, including each and every human being. On the one hand, both Jesus and Gandhi were "spirit persons" of vastly expanded consciousness that went far beyond their apparent selves characterized by body, mind, and personal story. Instead their consciousness reached out to the utter limits of the universe to the divine "Sun" mind that permeates all of reality.

On the other hand, since they took the unity of all creation with the utmost seriousness, they regarded themselves as trustees of all creation. This led them to embrace a deep kinship with and responsibility for all of creation and for brothers and sisters at the bottom rungs of the social ladder.

The Principle of Universality

Realization of the ultimate unity of everything is the basis for a key moral impera-
tive that might guide critical thinkers hoping to escape from the kind of ethnocen-
trism that convinces people that they, their country, their race, their religion, their
gender are somehow exceptional and not subject to the same moral expectations
they apply to others. We might call the imperative in question "the principle of
universality."[6] It's fundamental to critical thought. It means that what I demand
from you, I must also demand from myself. What I consider wrong for you, I must
consider wrong for me too.

This is a principle so elementary that all children, not just the spiritually
enlightened, recognize it. And so they object when parents who smoke, use bad
language, drink, use pornography, or take drugs tell them not to engage in similar
behavior.

Applied to public life and international politics, the principle of universality
suggests that if it's wrong for Iran, for instance, to have nuclear weapons, it should
be wrong for Israel or the United States to have them too. If it's wrong for suicide
bombers to kill indiscriminately, it should also be wrong for those bombing from
30,000 feet with no danger to the pilots involved. If it's wrong to torture U.S.
soldiers in captivity, it should also be wrong for U.S. soldiers to torture those they
themselves hold in prison.

Jesus expressed the principle of universality himself when he said in effect,
"Why do you worry about the speck in your brother's eye, while ignoring the log
in your own?" (LK 6:42)

Grapes of Wrath

Once again, it's not necessary to be specifically "religious" to embrace the unity of
all creation and its implied "principle of universality." In the film version of John
Steinbeck's *Grapes of Wrath*, Tom Joad expresses what we're calling the principle of
universality from a completely non-religious standpoint.[7] He articulates a secular
working class mysticism (awareness of shared unity with everyone and everything)
in the following dialog with his mother just before he finally leaves her:

Ma:	How am I gonna know about you, Tommy? Why they could kill you and I'd never know. They could hurt you, how am I gonna know?
Tom:	Well, maybe it's like Casey says. A fellow ain't got a soul of his own, but a little piece of a big soul, the one big soul that belongs to everybody. Then …

Ma:	Then what, Tom?
Tom:	Then it don't matter. I'll be all around in the dark. I'll be everywhere. Wherever you can look, wherever there's a fight so hungry people can eat, I'll be there. Wherever there's a cop beating up a guy, I'll be there. I'll be there in the way a guy yells when they're mad. I'll be in the way kids laugh when they're hungry and they know supper's ready. And when people are eating the stuff they raised or living in the house they built, I'll be there too. (www.youtube.com/watch?v=i2JR3FmvVAw)

Here Tom Joad expresses an awareness of solidarity with all the world's suffering. That unity is based on a Great Soul of which each person's is an incarnation. The soul is especially apparent, Tom says, in the world's hungry, in those victimized by the law, and in those who are angry about hunger and police brutality. It's apparent too when poor are happy because hunger is finally satisfied because people own land to grow food on, and finally have a home of their own.

Did Jesus have something similar in mind when he called the poor happy or blessed and promised that the gentle and humble would have the earth for their possession?

Conclusion: *Avatar* and Spiritual Combat

Is such realization central to critical thinking? Should it be? The problem is that most of us will never know. That's because, according to teachers in all the world's great spiritual traditions, getting in touch with the shared Self is not a matter of thinking or knowing in the usual way.

Instead, it can be accessed only directly through processes variously described in terms such as "meditation," "yoga," and "contemplation." And few in the post-modern world are willing to engage in the grueling spiritual combat required to know in that way.

The Spiritual Challenge of *Avatar*
(Seen Through the Magic Glasses)

James Cameron's *Avatar* recognized and re-presented the challenge involved in confronting the Self.[8] And millions (at least subconsciously) responded. *Avatar* became the world's highest grossing film of all time.

In tune with liberation theology and the spirituality of conscious praxis, *Avatar*'s message asserts that human beings, and particularly the poor and victims of resource wars, represent God in human form. When tribal peoples

are slaughtered, God is somehow murdered. The only way to avoid deicide is not merely to campaign against genocide, but to co-create a world with room for everyone. More basically, it involves sublimating and redirecting militaristic impulses to confront the violent false God residing deep within our own psyches. That God is driving us to suicide writ large. Consequently, the fundamental battle must take place in our own hearts and souls.

Is that reading too much into the film? Judge for yourself. *Avatar's* very title invites such reading. It's about divine incarnation. In the language of religious studies, avatars represent the descent of God to earth, and the presence of divine consciousness in human beings. Jesus the Christ was an avatar; the Buddha was. Krishna was. Some would even identify Mahatma Gandhi as an avatar.

And then there's the story itself—so reminiscent of *The Bhagavad Gita*. The genius of Cameron's film is that it didn't alienate audiences with "God become man" language that would be too reminiscent of a Christianity irreversibly hijacked, as we saw above, by the militaristic religious right. Instead, Cameron's story taps into the spiritual power of the *Gita*. Ironically, the *Gita's* saving grace is that it remains largely unknown to westerners. They haven't domesticated it.

The *Gita*, of course, is the timeless tale of a great warrior, Arjuna, instructed by the blue-skinned avatar, Krishna, to engage in battle and kill his false self. The *Gita* imagines that self appearing in the form of all the great warriors Arjuna has been taught to admire. Only by fearlessly killing those warriors within, Krishna instructs, can Arjuna's true divine Self—his own avatar center—emerge.

The parallels in *Avatar* are unmistakable. Blue-skinned Neytiri introduces her "Arjuna" (Jake Sully) to his deeper Self of which she is a manifestation. Her instruction brings Jake not merely to the "insight" that he and Neytiri are one (He "sees" her). She leads him to realize as well his unity with the Na'vi people and all of creation. Neytiri's teachings cause Jake to understand that "being all you can be" entails engagement in an internal battle that mercilessly kills everything within him, all that obscures his divinely incarnate Nature.

So Jake joins battle. Again and again he dives deep within to discover the electric exhilarating beauty residing there. But to appropriate it, he must first conquer his greatest enemy, himself. In the language of mysticism, he must die before he dies. So repeatedly Jake squeezes himself into a machine that looks exactly like a coffin. There *Avatar's* real story unfolds.

Jake's false self is personified in Colonel Miles Quaritch, Jake's commanding officer. As indicated by his first name, Miles (the Latin for "soldier"), is generic.

He represents everything Sully had aspired to be—tough, heartless, supremely confident, and a literal fighting machine. In battle, Quaritch represents a kind of Anti-Avatar, as he sits in the heart of a huge seemingly invincible robot. The final showdown pits that robot against Jake Sully's new Krishna consciousness centered at the heart of his new gigantic blue body.

The final confrontation is epic and dramatic as it must be for everyone who aspires to enlightenment. Quaritch attacks and counter-attacks. He absorbs and shrugs off blows that would have killed ordinary humans. In the end however, it is Jake's androgynous Krishna consciousness, Neytiri who slays his old self, and allows his new divine Self to survive and flourish. Incongruously, she does the job with primitive tribal arrows.

As for the *Avatar's* outer world, the invaders are, of course, defeated in the story. But it is neither the Na'vi nor their puny armaments nor self-defensive "violence" that defeats the Marine fighting machines. Much less is Jake Sully's white "leadership" responsible for bringing the aggressors to their knees. Instead it is the Great Mother God Herself, Eywa, who intervenes to destroy the mercenary thugs. They have no understanding of the interconnectedness of absolutely everything. So Nature herself reacts in the name of restoring balance. Before her mighty powers, invincible machines become as children's toys thrown about by hurricane winds and earthquake force. In this way, the film portends the inevitable defeat of pretentious and arrogant military might, and the ultimate victory of the divine.

Liberal critics watching this three-dimensional film, have been hesitant to recognize and embrace *Avatar's* fourth (spiritual) dimension. It may be because they are simply blind—incapable of understanding anything beyond the scientific and technological. They might be embarrassed to recognize the need to acknowledge the truth that God has become human—and can again incarnate the God-self within each of us.

Their blindness makes them like *Avatar's* genius scientist, Grace Augustine—the one responsible for creating the technology the story centralizes. True, she had sympathy for the Na'vi. But still she reluctantly cooperated in their destruction. After all, they were primitives without scientific understanding. Their mythic worldview was incompatible with science and stood in the way of progress. As Grace might put it, "It's sad, but without science there simply is no salvation." No other worldview is allowed much less honored, embraced, and permitted to flourish.

That's like the 5th century Church father, Augustine, and his understanding of grace. He divided the world into saved and unsaved—those with grace,

and those without it. Those without grace were condemned (like the Na'vi) to eternal damnation.

Lionizing science and rejecting pre-scientific grace turns the skeptical into the mirror image of the religious right that post-moderns too often ridicule. The right's exclusivist understanding of "God made man" theology has divided the world into insiders and outsiders. The typical liberal worldview has done something similar.

In the end, though, Grace Augustine shows the way. Embraced by the tendrils of the Tree of Souls, she finally "sees." She realizes that science and faith are not contradictory but entirely compatible and complementary. All reality is indeed one. We are the Na'vi. We are the Palestinians and the Zapatistas. But we are also the Israelis, Taliban, al-Qaeda, the religious right, and members of the Pentagon Clan. There are battles to be fought. But not principally "out there."

Implicitly and largely unconsciously, it seems, audiences loved and embraced that message. At root they are not only anti-war, feminist, and pro-environment. They are spiritually hungry and can recognize truth when they see it.

Once again, critical thinkers ignore at their own peril the hunger and insight portrayed in art works such as *Avatar* and *Grapes of Wrath*. Rule Eight, "Connect with your Deepest Self," suggests that we put on our magic glasses to discern our own avatar identity and lose all fear of expressing that ownership in public and politically. Are you willing to engage in the spiritual combat required to do so?

For Discussion

1. How might mind-based religion be an expression of the "Ruling Group Mind"? What about the other levels of faith?
2. How do religious ideas relate to worldview, ideology, and economics, as discussed in previous chapters?
3. What does it mean to be an "anonymous Christian"? Can someone be a Christian without knowing it?
4. How do Tom Joad's statements in *The Grapes of Wrath* relate to the ideas of religion that have been presented in this chapter?
5. Do you agree that *Avatar* is really about the struggle between our true and false selves?
6. In terms of critical consciousness, how is *Avatar's* soldier, Jake Sully, different from *American Sniper's* Chris Kyle?

Activities

1. As a group, view James Cameron's *Avatar* together. Discuss it in the light of this chapter.
2. Review John McMurtry's elements of American religion. Then, write a reflection on how Christian orthodoxy, mind-based religion, and the "Ruling Group Mind" are found in McMurtry's points.
3. Read Eknath Easwaran's book, *Meditation*. Then for a period of one month, spend one half hour each day in silent meditation. Keep a journal recording your inner experiences, and how the practice influenced your daily life and critical perceptions of the world.

Notes

1. Karl Marx. *A Contribution to the Critique of Hegel's Philosophy of Right*. First published in *Deutsch-Französische Jahrbücher*. Paris, 1844.
2. John McMurtry. "Understanding 9/11 and the 9/11 Wars." scienceforpeace.ca/0409-understanding-9-11. Science for Peace, 21 Sept. 2004. Web. 24 Apr. 2017. Also see "The Moral Decoding of 9-11: Beyond the U.S. Criminal State", http://www.journalof911 studies.com/resources/2013McMurtryVol35Feb.pdf, and "Fake News: The Unravelling of US Empire From Within": http://www.globalresearch.ca/fake-news-the-unravelling-of-us-empire-from-within/5581878.
3. David D. Kirkpatrick. "The Evangelical Crackup." *The New York Times*, Oct. 28, 2007. www.nytimes.com/2007/10/28/magazine/28Evangelicals-t.html?_r=1&oref=slogin. (Accessed 10/28/07)
4. Joseph H. P. Wong. *Anonymous Christians: Karl Rahner's Pneuma-Christocentrism and an East-West dialogue*. Baltimore: Theological Studies, 1994.
5. Richard Maurice Bucke. *Cosmic Consciousness: A Study in the Evolution of the Human Mind*. Secaucus, NJ: Citadel Press, 1993.
6. Listen to Noam Chomsky's brief exposition of the principle of universality here: www.youtube.com/watch?v=t0bRJ3jlBfM
7. *Grapes of Wrath*. Dir. John Ford. Perf. Henry Fonda, Jane Darwell, John Carradine. 20th Century Fox, 1940.
8. *Avatar*. Dir. James Cameron. Perf. Sam Worthington, Zoe Saldana, Sigourney Weaver. 20th Century Fox, 2009.

Reviewing History Through the Magic Glasses

How the Wealthy Privatized the Commons

How does one escape captivity to inherited patterns of thought and false perceptions of reality shaped by Plato's shadows, fake news and unevolved "leaders?" Doing so is essential for truly critical thought as understood in the Global South.

Unfortunately, there is no easy answer to the question just posed. As already indicated, the final section of this book will provide occasion for applying the criteria that I have found essential for answering it. At this point, however it is important to note that one criterion is supremely important—"Respect History."

Just to remind you: the criterion's claim is that what individuals, groups, and nations do and have actually done (as opposed to what they say) is a powerful arbiter of truth. Actions, in fact, *do* speak louder than words—especially as remembered by those who, we have argued, have more comprehensive knowledge of the world, the victims of colonialism and other forms of oppression.

As we shall see, those historical realities have gradually robbed the world's majority of their rightful inheritance as inhabitants of a planet which by nature belongs to everyone. Especially over the last five hundred years, the world's commons has become increasingly privatized.

To clarify this critical insight, which is vilified or simply ignored in mainstream education, the next three chapters will examine a major taproot of international and class conflict, viz. private property—or to be more accurate, the gradual process of privatization of the earth's productive resources (fields, forests, rivers,

oceans, mines, factories …) by a distinct minority—white men of European and European-influenced origin. This appropriation involved processes and structures called colonialism and neo-colonialism. So the second of these historical inclusions (Chapter Fourteen) will explain those phenomena in very simple terms. Then Chapter Fifteen will review the unbroken resistance to such privatization and its colonial forms on the parts of the world's majorities. Their untold story makes it clear that they have not surrendered their common wealth without resistance.

The narrative that will unfold stands in sharp contrast to western official stories which glorify privatization as civilization's advance at the hands of intrepid explorers, adventurers, warriors, generals, statesmen, missionaries and the intellectuals who supplied such "men of action" with "enlightened" theory. Instead, we'll see, their rationale was far more self-interested.

Through the Magic Glasses
Hamilton[1] Celebrates Those Who Oppressed Its Actors' Ancestors

Ironically, the much-celebrated musical, *Hamilton*, by Lin-Manuel Miranda, demonstrates how even extremely talented artists often participate in the celebration of questionable "official stories" in need of serious deconstruction.

The musical has black and Hispanic actors echoing the patriotic tale familiar to us all. As a result, the production's predominantly white and well-heeled audiences (including presidents and vice presidents) invariably give standing ovations to blacks and browns presenting a play about the era of slavery and extermination of Native Americans that decimated the actors' own ancestors.

In critical perspective then, *Hamilton* can be seen as a demeaning "reverse" minstrel show without the grease paint. There an unwitting cast of what Malcolm X called "house negroes" pretend to be heroic whites and thus normalize a process that should be horrendous to descendants of slaves and Native Americans whose forebears experienced the privatization of their homeland and very bodies

Instead, in *Hamilton*, mostly black and Hispanic actors cavort and grin through performances redolent of Stepin Fetchit. Without a hint of conscious irony, they domesticate their communities' hip-hop resistance medium to honor the slave merchant, Alexander Hamilton and the Indian Exterminator, George Washington.

And white people love it. That's because *Hamilton* is the Horatio Alger story our culture adores and uses against the poor, especially people of color.

Hamilton is about a lowly illegitimate Scotsman from the Caribbean who at the age of 19 comes to New York City bent on making a fortune and achieving immortality. An unabashed social-climber, young Alexander sees himself as the embodiment of his newly adopted country. As he puts it, he is "young, scrappy, and hungry." He has plenty of brains but no polish—a real diamond in the rough.

So he joins the revolution, marries into the rich slave-owning Schuyler family, rises to prominence in the Continental Army, fathers a son, authors most of *The Federalist Papers*, has an affair, becomes Secretary of the Treasury and is killed in a duel with Aaron Burr.

Actually, Hamilton turns out to be a real buffoon. A typical colonizer, he's self-centered and arrogant. Though a criminal in the eyes of the slaves and Indians, he and his kind are obsessed about honor and are willing to kill and be killed for the sake of that virtue. In fact, three honor duels mark the play. One eventually causes Hamilton's own death; another takes the life of his son. Hypocrisy, you say? That's only the beginning. Hamilton was one of the Founding Fathers, who routinely crushed slave and Indian uprisings without mercy, but then self-righteously took up arms against England. Their issue (as the play expresses it): taxes on tea and whisky!

The play overflows with comatose irony.

Lin-Manuel Miranda who produced *Hamilton's* music, lyrics and book, is himself Puerto Rican. Though his people know plenty about the horrors of colonialism, he presents his work as an instance of post-racial patriotism. He has said "We're telling the story of old, dead white men but we're using actors of color, and that makes the story more immediate and more accessible to a contemporary audience."

Apparently, the actors are just as uncritical. Unconsciously, it seems, they're doing a minstrel show for the descendants of the Massa. What follows in this chapter will indicate that they shouldn't.

Along with rudimentary forms of money and credit, private property first emerged in the 8th century B.C.E.[2] However, in its earliest forms, among the Greeks for instance, the point of its accumulation was neither the provision of personal pleasure nor the amassing of wealth for its own sake. Rather, property attained for its owner the prestige and enhanced reputation issuing from community service (e.g. emergency relief), and from the organization of cultic and religious events for the edification of local communities.[3]

This changed somewhat during the later Hellenistic period and even more so with the Romans. Among the latter, the idea of dominion or absolute ownership

took hold. Romans could use, abuse or even destroy what they owned, regardless of the impact their arbitrary choices wreaked on their communities.[4] Such imperial thinking was adopted by European planters and merchants with the emergence of capitalism.

The adoption, however, found it imperative to distort the biblical tradition, which subsequently provided an indispensable tool for justifying the process of privatization. The distortion was necessary because both the Jewish Testament and its Christian counterpart were highly suspicious of private property, wealth accumulation and their economic derivatives. Private property inevitably brought with it the confiscation of land belonging to the poor, along with crippling debt and a resulting slavery.[5] This flew in the face of the Ten Commandments' injunctions against stealing and coveting the property of one's neighbor, which were directed primarily at the rich and their designs on the farms of their poor neighbors.[6] Biblical prophets equated rejection of Israel's God with repudiating justice by trampling the rights of the poor. For prophets like Micah, purely economic events connected with executing credit contracts were called "theft" for the first time.[7] Tithing obligations, along with the provisions of the Jubilee year (with the key requirement of periodic debt forgiveness) represented the world's first social tax.[8] In short, the Jewish Testament embodies an emphatic rejection of the Roman concept of absolute dominion over one's property.

This rejection was further emphasized by Jesus of Nazareth as recalled by the first written accounts of the Jesus Movement and as embodied in its early church. Thus Ulrich Duchrow and Franz Hinkelammert, rightly observe that the Nazarene's words to the "rich young ruler" ["One thing is lacking to you. Go and sell what you have, give it to the poor, and come follow me."[9]] are trivialized when understood as a simple call to "Christian charity." Rather, the author of the Gospel of Mark intended Jesus' words to correct the ignorance of the rich concerning the fact that keeping the Mosaic Law required them to make restitution for property *stolen* through market dynamics unwittingly associated with property, money and credit.[10]

Initially, the Desert Fathers and the early church believed themselves bound by Jesus' words and example. Members of the 1st century Jesus Movement held all goods in common, and distributed excess according to a variant of the principle, from each according to his or her ability, to each according to her or his need.[11] This primitive "communism" represented a practical ratification of the prophetic insights Micah and Isaiah, who saw accumulation of land and houses as necessarily causing poverty among Israel's peasants.[12] Additionally, until the dawn of the modern era, Christians forbade, under pain of sin, money lending for profit. Money itself was looked on with suspicion, as the root of the world's evil, as inert, sterile and unproductive.

Such attitudes took deeper root with the fall of Rome to Germanic invaders at the beginning of the 5th century CE. The Church of Rome stepped into the resulting power vacuum, as the glue holding together a culture cobbled from elements of Jewish, Greek, Roman, Christian, and now Germanic origin. In doing so, the Church adopted (for itself) Roman attitudes towards private property, and became the most extensive landowner in Europe. However, in opposition to Roman patterns, the Germanic tribes brought with them attitudes towards private property typical of people united by familial bonds. They insisted on the priority of communal rights to essential resources. This insistence tempered the enduring influence of Roman traditions, which eventually allowed the feudal system to take shape across Europe.

Claims to private property, however, strengthened with the passage of time, beginning with the emergence of a money economy, and the monetization of public life in the 14th century. As we'll see in Chapter Fifteen, so-called commoners consistently resisted such changes often violently.

To cope with the aggressive demands of free peasants for access to land, desperate landlords enclosed their property, erecting fences, hedges and ditches to mark boundaries. This violent act of privatization even affected commons, along with forests, streams, and wells that had previously been considered community property. Peasants had long since depended on these communal resources for drinking water, for grazing and watering their flocks, and for the provision of firewood and building material. As will be seen below, enclosures evoked further rebellion from below, always repressed ruthlessly by slaughter and massacre.

Relief from such mayhem came when the voyages of Columbus and other conquistadors "discovered" and invaded the New World. There followed the most extensive act of privatization in recorded history. Over a period of 400 years, refugees from European enclosure themselves enclosed tribal lands that had always been communally held. They also "privatized" the bodies of millions of indigenous across North and South America, through a process of slavery. Soon those labor resources were exhausted by murder, overwork and disease. So the conquistadors turned to Africa to privatize and enclose the communal lands and bodies of innumerable tribes there.

Privatization's Ideology

In view of the Christian tradition just recapped, the emergence of capitalism and the colonization of North America demanded a new theory to justify the appropriation of the continent's vast commons. With that need in mind, the great

philosopher of the bourgeois class, John Locke, stepped to the fore. Locke, of course, elucidated that concept enshrined in Thomas Jefferson's hallowed words, "all men are created equal." However, critical analysis reveals that neither Locke nor Jefferson was concerned with protecting anyone's rights but those of their own class of conquistadors, planters, bankers, merchants and slaveholders.

That is, Locke's thinking does not merely supply the ideological basis for property rights articulated in all Western constitutions.[13] It also provides what Franz Hinkelammert recognizes as a *Nineteen Eighty-Four* rationale for the theft-by- privatization represented by colonialism and slavery. In fact, according to Hinkelammert, Locke's task was to explain something like "slavery is freedom."[14] Referring to England's 17th century historical context, Hinkelammert writes,

> The legitimacy problem surfacing at the time was unmistakable. Habeas corpus and the Bill of Rights had posited human rights that the bourgeoisie were not able or willing to forgo. It was their answer to the divine right of kings, and there could be no going back on that. These rights guaranteed the physical integrity of persons and property in the face of political authority and transformed the latter into a means of protecting those rights. Taking such rights literally, however, meant excluding forced labor through slavery and the violent appropriation of the indigenous territories in North America. Consequently, these rights, indispensable for the bourgeoisie, came into conflict with important, central goals of the colonial expansion of this same bourgeoisie.[15]

In other words, if all humans were truly equal, those invading the New World could hardly enslave or steal land from the people already living there. It was important for Locke to think his way around that problem. After all, he had gained his fortune from the international slave trade. It was the most lucrative source of capital accumulation in the 17th century. Jefferson, of course, was also a slave owner. In addition, both the philosopher and the politician were centrally interested in privatizing the land of unsuspecting "savages" in the New World.

Locke is particularly explicit about the difficulty of justifying such land theft and slavery. In Chapter 5 of his *Second Treatise of Government*, Book II, published in England in 1690, he refers frequently to the "Indians," to their communal lands, and to the theological problems involved in enclosing the property they held in common. Here is his own phrasing of the dilemma he faces, and his intention to resolve it:

> … (I)t seems to some a very great difficulty how anyone should ever come to have a property in anything … upon a supposition that God gave the world to Adam and his posterity in common … but I shall endeavor to show how men might come to have a property in several parts of that which God gave to mankind in common, and that without any express compact of all the commoners.

Locke's purpose, then, is to justify the transformation of commons into private property without the consent of commoners and despite the Bible's apparent counter-claim that the whole earth belongs only to "one universal monarch" in the person of "Adam and his heirs in succession."

Accordingly, Locke proceeds to the task at hand, viz. to establish the right to expropriate land from the New World's indigenous, and from the inhabitants of Asia's Indian subcontinent. He also argues that Europeans may legitimately enslave Africans. To those ends, Locke's landmark reasoning encompassed the following dozen points:

(1) **In theory, the earth does indeed belong to everyone**: In the "state of nature," all humans are indeed created equal and free. The playing field is level. There are no classes. No one owns anything. Nothing is fenced in (or "privatized"). No one has advantage over anyone else. This was Locke's understanding of the status quo in the Americas.

> … (I)t is very clear that God, as King David says (Psalm 115:16), 'has given the earth to the children of men,' given it to mankind in common.[16]

(2) **However, God's original generosity is overridden by natural law which demands that human beings own the land they till productively**: That is, in Locke's view, humans in order to survive, must have private property; otherwise they would not be able to feed and provision themselves (pars. 25–30).[17] Efforts to do so are represented by land's productive use by means of European-style agriculture which for Locke constitutes the only valid way to appropriate land.

> As for the earth itself, human beings may lay proprietary claim to it in virtue of the labor they expend on making it fruitful. As much land as a man tills, plants, improves, cultivates, and can use the product of, so much is his property. He by his labour does, as it were, enclose it from the common.

(3) **Since all men are created equal, land used unproductively, e.g. for hunting and gathering, is there for the taking.** This is Locke's crucial point!

> God gave the world to men in common, but since He gave it them for their benefit and the greatest conveniences of life they were capable to draw from it, it cannot be supposed He meant it should always remain common and uncultivated.

(4) **After all, the claims of hunters and gatherers call for unreasonably vast stretches of land that deprive farmers of their more modest requirements.**

The measure of property Nature well set, by the extent of men's labour and the conveniency of life. No man's labour could subdue or appropriate all, nor could his enjoyment consume more than a small part; so that it was impossible for any man, this way, to entrench upon the right of another or acquire to himself a property to the prejudice of his neighbour ...[18]

(5) **To protect the rights of settlers, European-style representative governments have been instituted and invalidate every other governmental system.** The only freedom worthy of the name is that provided by a published law, administered even-handedly by a European-style legislative power. By way of contrast, tribal peoples are governed by chiefs and kings whose decrees are "inconstant, uncertain, unknown, and arbitrary."

> The liberty of man in society is to be under no other legislative power but that established by consent in the commonwealth, nor under the dominion of any will, or restraint of any law, but what that legislative shall enact according to the trust put in it. Freedom then is ... freedom of men under government ... to have a standing rule to live by, common to every one of that society, and made by the legislative power erected in it. A liberty to follow my own will in all things where that rule prescribes not, not to be subject to the inconstant, uncertain, unknown, arbitrary will of another man, as freedom of nature is to be under no other restraint but the law of Nature.[20]

(6) **However, in the colonies, the bourgeois form of government finds itself opposed by savages who have in effect declared war on their equals.** They have done so by insisting not only on the retention of their traditional chiefs and kings, but of their communal claims to forests and plains for purposes of hunting and gathering. Their war represents unjust aggression against productive European planters, and against civilized society itself. Notice that at this point, Locke places the entire non-bourgeois world at war with Europe's property owning classes who, as representatives of humankind, have, as recently as England's Glorious Revolution (1688), installed what he claims is the only type of legitimate government possible. More specifically, British settlers in the New World are here presented as the victims of aggression by the natives there.

(7) **Such aggression amounts to an attempt to enslave the Europeans and rob them of everything they own.**

> ... He who attempts to get another man into his absolute power does thereby put himself into a state of war with him ... For I have reason to conclude that he who would get me into his power without my consent

would ... make me a slave ... (H)e who makes an attempt to enslave me thereby puts himself into a state of war with me. He that in the state of Nature would take away the freedom that belongs to any one in that state must necessarily be supposed to have a design to take away everything else, that freedom being the foundation of all the rest ... and so be looked on as in a state of war. [21]

(8) **Aggression of this type reduces the aggressor to the level of an animal who may justly be killed as such.**

> ... (O)ne may destroy a man who makes war upon him, or has discovered an enmity to his being, for the same reason that he may kill a wolf or a lion, because they are not under the ties of the common law of reason, have no other rule than that of force and violence, and so may be treated as a beast of prey, those dangerous and noxious creatures that will be sure to destroy him whenever he falls into their power."[22]

(9) **Alternatively, the aggressor's death may be postponed in favor of his enslavement**: For, though slavery is forbidden by the law of nature (par. 21), those who commit crimes worthy of death, forfeit that natural freedom (par. 22). They may therefore be enslaved:

> Indeed, having by his own fault forfeited his own life by some act that deserves death, he to whom he has forfeited it may, when he has him in his power, delay to take it, and make use of him to his own service; and he does him no injury by it. For, whenever he finds the hardship of his slavery outweigh the value of his life, it is in his power, by resisting the will of his master, to draw on himself the death he desires.[23]

(10) **Not only may the uncivilized be killed or enslaved without guilt, their property may also be seized. (See point 12, below.)**

(11) **This seizure is not at all a denial of sacred property rights.** (See point 12 below.)

(12) **Rather, it represents indemnification of losses on the parts of those who have defended themselves from the implicit attacks of the uncivilized.**

> For it is the brutal force the aggressor has used that gives his adversary a right to take away his life and destroy him, if he pleases, as a noxious creature; but it is damage sustained that alone gives him title to another man's goods ... The right, then, of conquest extends only to the lives of those who joined in

the war, but not to their estates, but only in order to make reparation for the damages received and the charges of the war ...[24]

Conclusion

So there you have it: a brief history of private property claims and an account of their philosophical justification at the hands of the great British philosopher, John Locke. His thinking, remember, formed the basis of Jefferson's famous statement in the Declaration of Independence that "all men are created equal." As demonstrated above, that claim was not originally formulated to facilitate democracy, but to justify theft of land from Indians, both in America and on the Asian subcontinent.

The wars of conquest justified by such theory predictably resulted in the genocide of 90% of Native Americans who once roamed North America. Locke's theory allowed them to be shot like wolves. Worldwide, Lockean reasoning also justified transferal of huge amounts of wealth directly from the colonized to their colonizers throughout the 18th and 19th centuries—right up to the end of the Second Inter-Capitalist War. In terms of our study, the communal wealth of the colonized was "privatized."

To repeat, the idea here is that rejecting neutrality, respecting history, suspecting ideology, thinking scientifically, checking for structural violence, and creatively examining our dearest religious traditions can yield whole new understandings that call into question even something as sacred as the thought and actions of our Founding Fathers.

Do you see how such study is like putting on Dick Gregory's magic glasses? And once we see through fake history's lionization of colonialist thieves, we can never be the same in polite company. We'll find ourselves unable to take our glasses off. We'll even wear them to apparently innocuous theater productions like *Hamilton*, and be disturbed accordingly.

For Discussion

1. What connections do you see between this chapter and our ten rules for critical thinking?
2. In your own words, recap John Locke's ideological rationale for confiscating the tribal lands of Native Americans. Do you agree with his justification?
3. Does this chapter's criticism of *Hamilton* seem unfair to you? Explain.

Activities

1. Listen to *Hamilton*'s music. Evaluate its lyrics in terms of critical thinking as understood in this book.
2. Research reviews of *Hamilton*. See if you can find any that criticize it in ways similar to the review in this chapter. What do you make of your findings?

Notes

1. *Hamilton*. By Lin-Manuel Miranda. New York, 2016. Performance.
2. Ulrich Duchrow and Franz Hinkelammert. *Property for People, Not for Profit: alternatives to the global tyranny of capital*. London: Zed Books, 2004. 5.
3. *Ibid.* 10.
4. *Ibid.* 13
5. *Ibid.* 14–15.
6. *Ibid.* 24.
7. *Ibid.* 16.
8. *Ibid.* 19
9. MK. 10:17–22.
10. Duchrow and Hinkelammert 24.
11. ACTS 4: 32–35
12. Duchrow and Hinkelammert 26.
13. *Ibid.* 49.
14. *Ibid.* 47
15. *Ibid.* 46
16. John Locke. *Second Treatise of Government*. Salt Lake City, UT: Project Gutenberg, 2015: par. 24.
17. *Ibid.* pars. 25–30.
18. *Ibid.* par. 35.
19. *Ibid.* par. 21.
20. *Ibid.* par. 21.
21. *Ibid.* par. 17.
22. *Ibid.* par. 16.
23. *Ibid.* par. 22.
24. Maryse Brisson. "La Globalicazion capitalista … una exigencia de las ganancias." *El Huracan de la Globalizacion*. Ed. Franz Hinkelammert. Costa Rica: Departamento Ecumenico de Investigaciones, 1999: 55–104.

Colonialism and Its Structures

Chapter Thirteen sketched the origins of private property and the ideology that later ended up justifying the colonization of the New World as well as the enslavement of Africans. Both colonialism and the slave trade might well be described in terms of globalization in service of capitalism.

The modern phase of globalization began in 1492. Its second phase occurred between 1830 and 1870, during the period Henry Mora calls "Manchesterian Globalization."[1] The name makes the point that the colonies were there to feed the hungry bestial machines of Manchester, London, Newcastle, Liverpool and other manufacturing centers. During this period, Great Britain extended its empire across the globe, so that the sun never set upon it. To repeat, the colonial period lasted till just after the end of the Second Inter-Capitalist World War. However, colonial struggles continued in some parts of the world all the way up to 1974, and the end of the "American War" (as the Vietnamese refer to it).

Other colonizers, besides Great Britain, took part in the colonial movement. By 1878, 67% of the planet had been colonized by Europeans. By 1914, the figure had reached 84.4%.[2] Most prominently, colonizers included Spain, Portugal, England, France, Italy, Germany and the Netherlands. During this phase of the colonial process, armies of occupation insured wealth transfer by force of arms.

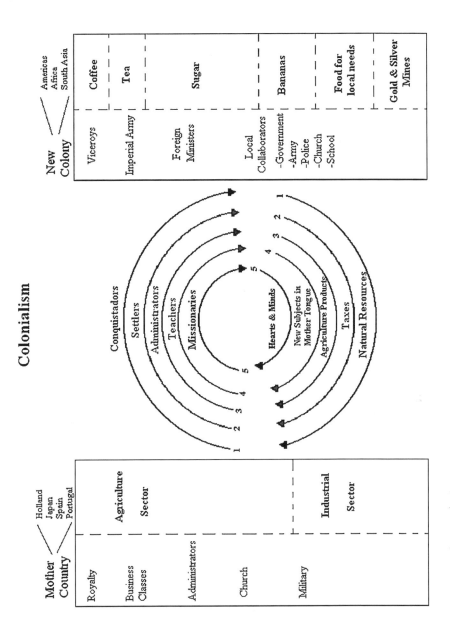

Figure 14.1: Colonialism. Source: Author.

As indicated earlier, the colonization of the Americas, Africa and South Asia represents the most extensive project of privatization in the history of the world. Invariably colonial powers have rationalized their enterprise in terms of civilizing, modernizing, and/or bringing to infidels "the true faith." Without doubt, occupation authorities did bring some accouterments of the modern world. They supplied paved roads, harbors and railways. But the main purpose of such benefits was to facilitate the transport of the colonies' wealth and patrimony to the "Mother Country." Railways were essential too for military "rapid response" strategies aimed at quelling frequent insurrections, on the parts of local patriots who resented foreign domination.

The figure above assumes all of that. However, while not denying the trappings of modernization introduced by Europeans, the diagram's thesis is that colonization is first and foremost about privatization and resource transfer. The colony envisaged is nothing if not privatized. It is something like a mirror image of the Mother Country portrayed on the left side of the illustration. The apparatus of administration is highly similar in both cases. A "royal majesty" (king or queen) is in charge of the colonizing nation; a "viceroy" (or vice-king) directs the colony. The colony also has its analogues for the rest of the bureaucratic offices necessary for efficient operation, including courts, militaries, police, churches, and schools. Under the colonial system, most of the colonial offices are filled by nationals of the Mother Country. However, over time, they become increasingly filled by "natives" who have proved their trustworthiness.

In the classic colonial system, the colony exists almost entirely for the Mother Country. Hence nearly all of its agricultural produce and its harvested raw materials are sent abroad. Much is also used to support the exotic lifestyles of the colonist occupiers. This leaves only a small portion of the country to meet local needs. As a result, hunger and poverty are widespread among the local population.

According to the diagram, the first movement in the colonial process is the invasion of conquistadors. In both the 16th century phase and its 19th century counterpart, firearms of ever-increasing sophistication overwhelmed tribal peoples who in some cases had not advanced technologically beyond the Stone Age. This made, for instance, the capture of Indians and forcing them to mine gold and silver relatively easy for Europeans bent on securing for their patrons "free samples" of potential slaves and booty to justify future voyages of "discovery." Concerns such as these are revealingly reflected in Columbus' infamous log,

> They ... brought us parrots and balls of cotton and spears and many other things, which they exchanged for the glass beads and hawks' bells. They willingly traded everything they owned ... They were well-built, with good bodies and handsome

features ... They do not bear arms, and do not know them, for I showed them a sword, they took it by the edge and cut themselves out of ignorance. They have no iron. Their spears are made of cane ... They would make fine servants ... With fifty men we could subjugate them all and make them do whatever we want.[3]

As indicated in Figure 14.1, the second phase of the colonial process has waves of "settlers," or "pilgrims" (as some fancied themselves), accompanying their families and possessions to a far off virgin territory understood as the embodiment of Locke's "state of nature." Not all colonial enterprises were settler societies. Great Britain, for instance did not attempt to settle its colony, in India nor its holdings in China. These were used simply to supply raw material to England, and to provide markets for British products. By way of contrast, the British did, of course, settle on the eastern seaboard of North America, and in Australia. The Dutch (Boers), settled in South Africa, and so did the Zionists in Israel. "Settler Societies" of these sorts were not content with simply supplying agricultural products and raw materials to the Mother Country. They insisted on industrializing themselves. As a result, the United States, Australia, South Africa and Israel eventually became integrated into the developed world.

It should be noted, however, that it was the *colonizers*, not the colonized who overwhelmingly benefited from such development. Their independence movements were not indigenous, but exotic. In stark terms, they represented a power struggle within a single gang of thieves. One faction of the gang (the settlers) got tired of sharing the "loot" with the Mafia "Don" (in the Mother Country), and so made a Declaration of Independence. This, however, had no positive effect on the *colonized*. More specifically, in each of the cases already mentioned, Native Americans, the Maori, black South Africans and Palestinians continue to find themselves in highly similar situations of unemployment, underemployment, hunger and poverty as experienced by their counterparts in the Third World.

Settlers moved to the colonies for various reasons. As every U.S. school child knows, some of these came motivated by a search for religious freedom. Less well-known is the fact that even more were the dregs of European society, as jails were opened and as vagabonds, town drunks, and prostitutes were deported to far off places with quaint names such as "New England," "New France," and "Australia." Applying Locke's theories of property ownership, war, and enslavement, the newcomers "enclosed" the "commons" they found, and proceeded to exterminate those whom they perceived as waging unjust war against beneficent civilized and civilizing European "settlers." Once in place, however, the planters began producing crops, and sending portions of their harvests, along with raw materials such as timber, gold and silver back to the motherland.

To insure that the flow of goods would continue unabated, officials in the Mother Country sent army units and administrative personnel. These are depicted in Figure 14.1 as the third wave of invaders. The soldiers (usually cavalry) made sure "Indian uprisings" were promptly squashed. They also kept the settlers in line, especially in case they might forget where they came from, and refuse to share the fruits of their stolen booty and labor with those who sent them in the first place. The administrators functioned as direct representatives of the relevant "crown" in Europe. They oversaw the formation of local government, making sure that those filling important posts could be trusted to continue colonial wealth transfer. Administrators also levied taxes on behalf of "majesties" abroad. They taxed settlers and indigenous alike; they taxed imports and exports. Additionally, the administrators forged alliances with cooperative (i.e. bribable) members of indigenous communities with whom treaties were negotiated, as well as other agreements to continue giving the foreigners access to land and raw materials.

Through the Magic Glasses
Captain Phillips Repeats the Colonial Theme "Cavalry to the Rescue"[4]

The film, *Captain Phillips* shows how the cavalry still comes to the rescue of capitalist marauders plundering the resources of the former colonies. Think of it in terms of Prairie Schooners transporting goods across the plains and attacked by savage Indians. The cavalry comes to the rescue and slaughters the "tribals." We all go home feeling safe and proud of our armed forces.

Mutatis mutandis, that's the basic story of *Captain Phillips* starring Tom Hanks and Somali actor, Barkhad Abdl. Though familiar in basic plot-structure, the film spins an account of the 2009 piracy of the container ship, *Maersk Alabama*, on the open seas. The ship is waylaid by four Somali ex-fishermen turned pirates. The captain, Rich Phillips, is abducted by the bandits. The Navy Seals are called in. They kill the pirates, rescue the captain. And normalcy returns.

The story, based on actual events occurring in 2009, has much to tell about colonialism, globalization, national sovereignty, and the spiral of violence as explained in Chapter 11.

Begin with globalization.

The back story of *Captain Phillips* demonstrates that we're living through an era of buccaneer business, where multinational corporations act like lawless pirates. They roam the globe and operate where they will, regardless of international law, territorial waters, national boundaries, environmental impact, and the noxious effects their investments might have on local populations.

Somalia provides a case in point. There, overfishing by factory ships from Europe and the United States has left tribal fishermen without income. What fish escape the nets of the giant sea trawlers have been poisoned by toxic waste flushed from container ships off Somalia's coast. Along with loss of income by local fishermen, plummeting living standards, and otherwise avoidable deaths from poverty and starvation are the predictable results.

This is where national sovereignty and the spiral of violence come in.

In the absence of an effective national coastguard, such practices have forced locals to form citizens' defense groups like the National Volunteer Coastguard. Initially, these attacked the offending ships to drive them from Somalia's territorial waters. Though characterized as "pirates" by western media, such groups enjoyed the support of Somalia's affected population. According to a survey by Wardheer News, about 70% in Somalia's coastal communities "strongly support[ed] the piracy as a form of national defense of the country's territorial waters."

Eventually, such "pirates" discovered that responding in kind to buccaneer businesses (represented by container ships) could itself replace lost revenue from fishing. Whether understood as such or not, "reparations" could in effect be seized by attacking ships on the open seas. (In terms of our Chapter Eleven, this could be understood as an instance of second-level, self-defensive violence.) At sea, goods could be confiscated and hostages taken in return for large ransoms. Ensuing battles amounted to one highly financed buccaneer business competing against another more primitive, poorly financed counterpart.

Never mind limiting concepts such as open seas, territorial waters, international boundaries, or other legal considerations. From viewpoint of the impoverished "pirates," if such limitations did not apply to their competitors, neither did they apply to them. It's all "free enterprise" at its rawest—the law of the jungle, the Wild West, or of Cowboys vs. Indians. As Muse, the "captain" of the pirates attacking the *Maersk Alabama* put it, "No al-Qaeda here. This is just business."

But then comes the overwhelming response from the military-industrial complex. Giving the lie to right-wing claims of independence from government, Maersk Shipping demonstrates the ability to call in the Navy Seals to protect its private enterprise operations. As portrayed in *Captain Phillips*, the White House itself is involved. After all, if private firms are threatened, "America's" credibility is on the line.

Two cruiser ships, their crews of hundreds, several helicopters, and parachuting Seals are all employed to enforce the Law of the Sea on four impoverished "pirates." This is a law whose rejection by the big-time pirates and their protectors was the root cause of the Somalis' small-time piracy in the first place.

What to take away from all of this? Myths are powerful. And we should beware of their ability to blind us. Though Hollywood can no longer get away with enforcing such archetypes by portraying Indians as savages, it's still free to do so with Muslim tribals. After all the West has already been won; there is no longer need to vilify "Indians."

Muslim tribals are another story. Their resources are still up for grabs.

The fourth and fifth waves of invaders are chronologically out-of-sequence in our illustration. It is not as though missionaries, for instance, came either by themselves or late in the day. Rather, clergy like Bartolome de las Casas and Junipero Serra came with the first waves of merchants, adventurers, pirates and explorers. They also were the first teachers to arrive from Europe. Instead, Figure 14.1 singles out missionaries and teachers, only because their contributions incarnate the indispensable ideological dimensions of the colonial enterprise. The teachers schooled many Indians to think like the colonizers. Native Americans learned the lessons Paulo Freire encapsulated in the phrases, "to be is to be under the oppressor," and eventually, "to be is to be like the oppressor." Winning minds in this way represented a conquest indeed "mightier than the sword." Schooled Indians were thus "westernized," making them more pliant and controllable. The missionaries' conquest went even deeper. For those who would accept the foreigners' gospel, indigenous Gods, formerly revered and worshipped, were reduced to mere "idols." With the acceptance of the European God, Jesus, Mary, and the saints, indigenous converts surrendered their souls. The Conquest was complete.

Neo-Colonialism

Though traditional colonialism may have ended shortly after the Second Inter-Capitalist World War (1939-1945), the former colonies were by no means abandoned as privileged sites for capital accumulation by way of wealth transfer from the poor to the rich. As evidenced in the vast literature on Dependency Theory, the former colonizers lost no time in establishing highly efficient means to insure that raw materials, cheap labor and markets would continue to be provided by the Third World.[5] Those means are indicated in Figure 14.2.

As the arrows in the diagram suggest, markets were especially important. Though the Second Inter-Capitalist World War had pulled the world out of its Great Depression, the bitter memories lingered on. Rebuilding Europe following the devastating conflict insured industrial production and jobs in Europe and

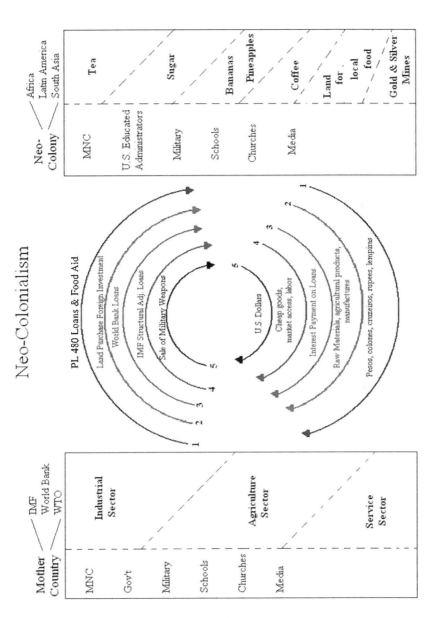

Figure 14.2: Neo-Colonialism. Source: Author.

the United States, at least for a while. Especially under the Marshall Plan, post-war food needs in Europe also absorbed the legendary U.S. agricultural surplus. However, planners in the industrialized world could easily foresee the day when capitalism's surplus production would again produce too many goods, too few jobs, rock-bottom prices, and depression.

To head off that eventuality, U.S. President Harry S. Truman, in 1947, declared two-thirds of the world "underdeveloped," and in urgent need of U.S. assistance to help those countries modernize, eat more healthily, and eventually enjoy a lifestyle like that of the United States and Western Europe. So the United States and the rest of the industrialized world became the standard of development, and began programs of "foreign aid" and subsidized transfer of agricultural over-production to the former colonies.

As pictured in the first movement of the figure above, monetary "foreign aid" took the form of loans of U.S. dollars and of food aid. (First arrow, top of figure). Typically, such loans came with the stipulation that the money be used to purchase U.S. manufactured goods. So African countries, for instance, would have to purchase John Deer tractors. In this way, the dollar loans quickly returned to to the Mother Country. Meanwhile, Africans still owed the banks the money loaned—with interest, of course. So the developed world's banking industry was stimulated as well as the manufacturing sector.

Repeated again and again throughout the vast Third World, relative to a whole range of U.S. manufactures, this arrangement had the effect of complicating the former colonies' efforts to develop their own industries which might otherwise compete with those of the U.S. and the rest of the industrialized world. That is, since the U.S. goods were often sold at below-market prices, Third World producers found it impossible to match the imports' prices. Something similar happened with agricultural produce.

Food aid to the former colonies was called "P.L. 480 Food for Peace." However, its original title was the Agricultural Surplus Disposal Act (P.L. 480).[6] The name was brutally honest in its first christening. For the primary purpose of this "foreign aid" subsidy program was to benefit U.S. agriculture in the same way the loan program just described benefited U.S. industry. More specifically, P.L. 480 was to secure ever-expanding markets for United States farmers, who routinely produced far more than could be absorbed by the U.S. internal market.

But how sell to countries already well-provisioned by their own farmers? In the most direct terms, the answer is "dumping." That this was its original intention was strongly suggested by the program's original title. Whatever the intention, however, Third World farmers experienced P.L. 480 as the death knell of their

livelihoods. They found that food given away or sold below market value makes it impossible to compete. Inevitably they were driven out of business. Once that occurred, U.S. agricultural prices returned to market levels. Thus "foreign aid" exorcised the specter of the Great Depression's return to the U.S. farm belt, just as it had done so for United States industry.

According to concessionary stipulations of Food for Peace, food purchased under the program's rules, might be paid for in a country's local currency. So U.S. banks, along with General Foods, Ralston Purina, Cargill and other food giants began accumulating colones, pesos, cordobas, lempiras, cruzeiros, and other forms of currency not classified as "foreign exchange." This meant that unlike "foreign exchange" [U.S. dollars, but also Deutsch Marks, and (today) Euros], the money could be spent only in the country of its origin; it was not directly usable for purchases elsewhere. These concessions are reflected in the first arrow in the bottom portion of Figure 14.2 , "pesos, colones, lempiras."

This local currency was then used by U.S. multinational firms (MNCs) to purchase or rent land in the country of the currency's origin. (See second arrow, top, "land purchase and foreign investment.") Foreign currency was also used to build U.S. factories there, and to pay workers employed in those facilities. Typically, these multinational firms exported their Third World products to the U.S. and other countries. This is indicated in the second arrow, in the bottom portion of the neo-colonial diagram, "raw materials, agricultural goods, manufactures." However, the multinationals in question also produced for the local market. In this way, they gained even more pesos, colones and lempiras.

As multinationals, though, the firms in question had to pay dividends to their stockholders. They needed dollars to do so. The MNCs also wished to use profits gained from the Third World holdings for investment outside those locations. They needed dollars for that too. For both stockholder payment and investment purposes, then, the multinationals went to the relevant Third World Central Bank to seek conversion of their pesos, colones or lempiras into dollars. To oblige, the Central Bank had to borrow such "foreign exchange" from abroad. In doing so, the Central Bank added to its country's national debt, already high because of the initial "loan of U.S. dollars" indicated earlier. According to Franz Hinkelammert, up to 80% of the Third World's crippling debt is attributable to money-changing transactions of this type, which confer no direct benefit on ordinary people who are ultimately made responsible for repaying debt incurred by private firms (indicated in the illustration by the third arrow from the bottom, "interest payments").[7] Ironically, this is the opposite of privatization. It is the socialization of private liabilities. In the classic formulation, it is the epitome of "capitalism for the poor," and "socialism for the rich."

When poor countries are unable to pay their overwhelming debts, the terms of those obligations are typically renegotiated through the International Financial Institutions which increasingly function as a world government. These include the World Bank, an international lending agency; the World Trade Organization (WTO), a judge of the fairness of trade agreements, and the International Monetary Fund (IMF), the international debt auditing agency.

The IMF is the agent for renegotiating the loans of debtor nations. Renegotiations however, are premised upon the indebted country's acceptance of "structural adjustment" programs. For purposes of this study, suffice it here to say they entail most prominently (1) further orientation of the country's economy towards export; (2) devaluation of its currency; (3) downsizing of government services; and (4) selling off (privatizing) state assets such as schools, telephone, transportation, postal services, prisons, utilities, and even water. As indicated in the fourth arrow from the bottom of the neo-colonial diagram, the results of such measures are "cheap products, cheap labor, and market access" for the lending country. For the indebted country, structural adjustment provisions earn "foreign exchange." The dollars gained are then used to repay the renegotiated debt.

Structural adjustment programs are not well-received by many in the indebted country's impoverished population. Government jobs are lost. Typically wages elsewhere are reduced. But even if they remain steady, currency devaluation makes local money worth less than previously. Additionally, social services are reduced. The cost of bus fares, electricity, garbage removal, and water usually rises. Street crime generally increases. Feelings of lost national sovereignty spread. Protest demonstrations mount. In extreme cases, demonstrations meet with heavy-handed repression. Some may even take up arms to bring about change. All of this threatens the state and the stability necessary for MNCs to do business. Judgments are made within the local government, and from abroad that security measures must be intensified. This entails the purchase of weapons for police and military (the final arrow in the top half of the figure), and the return of yet more U.S. dollars to their country of origin (fifth arrow from bottom of diagram).

Even before the advent of structural adjustment programs—during the 1960s, '70s and '80s—the threat of armed rebellion against neo-colonialism spread throughout the Third World. This was especially true in Latin America, where the success of the Cuban revolution in 1959 encouraged peasants, workers, and other disaffected sectors that they too might seize power in their own countries. The spirit of the Cuban revolution, described, as I said, in 1984 by Enrique Dussel as "the envy of the Third World," inspired the poor in Africa and Asia as well. In response to this "threat of good example," the United States stepped in again and

again to install dictators who would prevent the socialization (or re-communalization) of land that had been so arduously privatized over a period of close to 500 years. To repeat: a short list of dictators (referenced in the diagram as "puppet-dictators") put in place in this way includes: Diem (Vietnam), the Duvaliers—Papa Doc and Baby Doc (Haiti), Fujimori (Peru), Banzer (Bolivia), Mobutu (Zaire), Montt (Guatemala), Noriega (Panama), Pinochet (Chile), Resa Palavi (Iran), Saddam Hussein (Iraq), three Somozas (Nicaragua), Strossner (Paraguay), and Suharto (Indonesia).

As the power of the Soviet Union declined during the 1980s, and then definitively after the highly symbolic fall of the Berlin Wall in 1989, government by puppet dictators became less necessary in what became a unipolar world governed by the world's lone superpower, the United States of America. In fact, it became the world's dictator. In a world of high speed transportation, computers, fax machines and portable phones, it could turn over day-to-day governance of an increasingly privatized world to the financial institutions earlier described. In case of rebellion, the unparalleled U.S. military could respond quickly and overwhelmingly. Global stability (with 40% of the world receiving more than 90% of its income) seemed assured.

Contemporary Privatization

A closer look at the stabilized situation in a "typical country" in the "Two-Thirds" World is depicted in another diagram immediately below. Examining it briefly will reveal the face of privatization schemes within the context of modern commercial globalization. It will also connect that face with problems in the former colonies stemming from multinational investment, population, debt and military policy.

Figure 14.3 presents a schematic rendering of Third World economies structured according to David Ricardo's principle of comparative advantage. The amount of land devoted to export production is striking. People in this country are hungry, not because there are too many people or because the land is infertile, but because the land is being used to produce products for the already well fed, e.g. in the United States and Europe, instead of supporting the local population first. The small amount of land set aside to feed the country's inhabitants is easily comparable to similar allocations in the colonial and neo-colonial diagrams—i.e. under earlier forms of commercial globalization.

When most tourists visit venues like this, they never get the picture represented in the figure above. The reason is that, for instance, in Jamaica, the Bahamas

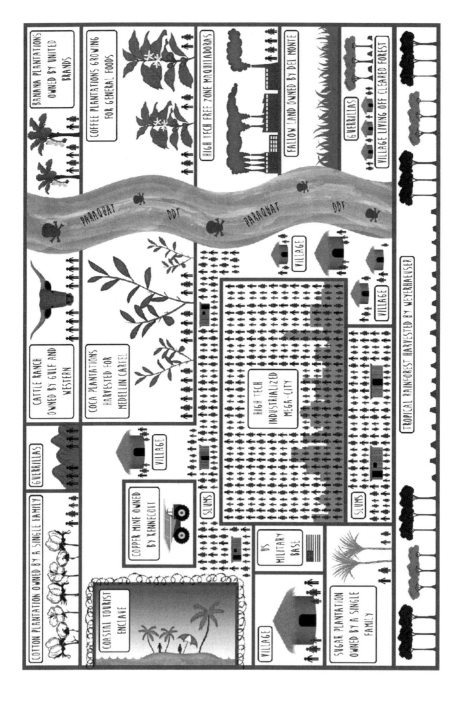

Figure 14.3: Economic Organization in the Two-Thirds World. Source: Author.

or Seychelles, tourists are practically confined to what is called a tourist enclave, at the left edge of the illustration. It is sunny and beautiful, and has wonderful hotels, nice beaches. People on the beach and in the hotels spend their vacation hours pool-side drinking their cocktails with nice little umbrellas in them. The food and the drink are often served by people in colorful native dress.

Tourists hardly notice that the enclave is surrounded by barbed wire and razor wire. The purpose is not to keep the tourists inside, but to keep the local population out. The purpose is to block the expropriation efforts on the part of desperate local people who recognize that each of the tourists is carrying on their persons about $500 on any given day in cash or in cameras or other luxury items. So the sad fact is that many who visit such locales never venture beyond the tourist enclave. On their return, they tell their friends that they have seen Jamaica. In reality, though, they have not visited much more than a movie set pretending to be Jamaica.

Meanwhile the rest of the country is organized in a way entirely reminiscent of earlier colonial patterns. These are structures of poverty. A cotton plantation in the northwest is owned by a single family. Then there is the cattle ranch belonging to Gulf and Western, a banana plantation run by United Brands, and a Kennicott copper mine. Almost in the very center, we find a coca plantation harvested for the Medellin Cartel. Of course, the Cartel is a multinational corporation too. Its profits are the most astronomical of all. Its outlets are found on the streets of all big cities in the developed world. The illustration also depicts a coffee plantation growing coffee for General Foods. Then there is the fallow land owned by Del Monte. Nothing is being grown there; still though, it is fenced in to keep land-less farmers out. The large sugar plantation owned by a single family takes up a huge space in the southwest part of the illustration. The Weyerhaeuser Lumber Corporation is harvesting trees from the tropical rain forest along the illustration's bottom edge. On the forest's borders, villagers have cleared off sections to create farmland. The jungle also provides a safe haven for guerrillas. So do the mountains located up in the central northern section. The guerrillas have recognized the counter productivity of this kind of economic configuration, and are waging armed struggle against it. To help head off the possibility of subversion, the U.S. has installed a military base down in the southwest.

Worthy of special note in this illustration is the allocation of population. Most of the country's inhabitants are located around the highly industrialized mega-city. Adjacent to it is a high tech Free Zone where foreign-owned *maquiladoras* or assembly plants are located. A Free Zone amounts to a country within a country. In the free-trade zone pictured here, national laws regarding minimum wage, union organization, working hours, and the employment of child labor do not apply. Such zones represent a big reason why so many multinational companies

have uprooted their factories and transplanted them in places like Mexico, Taiwan, Vietnam, and other low-wage venues. There wages often run around $1.50 a day, and in some cases even less.

Wages are connected with the population pressures this country is evidently experiencing. Despite population concentration around the high-tech mega-city, this country is not overpopulated technically speaking. Overpopulation means too many people for the amount of land available. There is, in fact, plenty of land here to accommodate the country's population. If the population were spread throughout the nation, there would be room for everyone. The space in the figure above is not overpopulated then. Instead, it is experiencing "surplus population." Surplus population means too many people for the economic organization in place. Population-wise this country is also characterized by rapid population growth. Rapid population growth means that couples are having more children than is needed to replace their parents. Each pair is averaging more than two or three children.

There are of course sound economic reasons for their reproductive behavior. Reasons include the fact that this country is basically agrarian. The inhabitants of the mega-city are typically displaced farmers. As such, they have brought with them their practice of having many children, who on a farm amount to a reduction in cost rather than expenses. Children there represent free labor. There is also high unemployment in this country and the fact is that under this economic arrangement, children are more employable than their parents. For one thing, youngsters can be paid less than adults. For another, children are more easily intimidated and controlled. That represents an advantage for factory supervisors.

Add to all this, the lack of social security in the modeled country, and one finds other reasons for having many children. Without social security, parents are forced to rely on their children for support in the parents' senior years. Similarly, the model's system offers no compensation for injuries sustained on the job. This means that people, for instance, who lose an arm in the production process, also lose their jobs. The injured person then has to depend on children for income. And in order for children to survive in a country where there is high infant mortality, it is necessary to have many.

These are just some of the reasons for "the overpopulation problem" in the former colonies. To reiterate, the model shows that the countries in question are typically not overpopulated. Instead, they are experiencing surplus population and a very understandable and economically justifiable rapid population growth.

Another kind of economic sense makes such venues attractive to multinational corporations (MNCs) and their privatization programs. To begin with, globalization as depicted here offers a captive work force. In this new economic order, while capital is free to move wherever it wants in the world, the other key part in the economic equation, labor, is not allowed to do so. Labor's immobility enables

the imposition of extremely low wages on workers who end up in competition with each other for the relatively few jobs provided in the high-tech industrialized mega-city. The double standard about capital's mobility and labor's captivity is illustrated by the huge wall that the United States is currently building along the border that separates it from Mexico.

Capitalists are also enticed to locate in our model by tax holidays that are promised by the governments of the countries to bring them here. In some cases, MNCs do not have to pay taxes for periods of twenty years or more—often followed by generous extensions of the initial favor. The working class here enjoys few or no benefits, and as a direct result, costs are lower for their employers. Similarly, and surprisingly, there are also tax breaks in the US tax code that make it profitable for multinational corporations to locate outside the country. Profits gained outside the country can be manipulated in such a way that no taxes are paid on them.

Another factor that entices capitalists to locate their production in Third World countries are what might be called "pollution rights." The pollution laws in the model are extremely weak. So United Brands and Del Monte can fill the river with DDT, Paraquat and other chemicals that are banned in the United States, and that end up in the ground water. The air is also extremely polluted in the modeled country, because the clean air laws in this country are either lax or nonexistent. Additionally, there are weak unions, or unions are outlawed completely. Strike prohibitions may also be in place. The prohibitions apply especially to free trade zones. All such provisions make it very enticing for multinational corporations to locate in countries like the one pictured.

A system of this nature is, of course, unsustainable. The guerrilla presence, already noted, shows that the local population will not tolerate it. For that reason, a US military base is located here, and the US government maintains strong police and military forces in the country, as already explained in relation to neo-colonialism. Thus, law enforcement controls the working class whose members want to eat, to feed their children, to have housing, education, and health care. Under conditions of neo-colonialism, rebels in this situation were once called communists. Now they are either identified as "narco-guerrillas" or simply as "terrorists."

Conclusion

Until quite recently, discussions of globalization, privatization and structural adjustment purveyed by protagonists of the Washington Consensus have typically ignored or denied (without much specific refutation) the contextualization of their policies, which has been offered here.[8] As a result, discussion has often remained at a highly abstract, technical and relatively incomprehensible level—at least for

the uninitiated. For their part, antagonists of the policies in question have often assumed knowledge of the contexts just described. As a result, their arguments have often been perceived as ill-founded. This chapter has attempted to supply that missing context in a schematic way—even to the point of oversimplification. Now we'll pass on to address popular grassroots resistance to enclosure and other forms of privatization schemes.

For Discussion

1. Explain the distinction between colonialism and neo-colonialism.
2. Explain the origins of Global South debt.
3. How does this chapter's position on population problems differ from that generally accepted in the United States?
4. What is the difference between overpopulation, surplus population, and rapid population growth?

Notes

1. Henry Mora Jiménez. "La Globalización después de Iraq: De Los Aujustes Estructurales a La Privatizacion de la vida por El Asalto al Poder Mundial." *Pasos*: No. 107, Mayo, Junio, 2003: 12–16.
2. Maryse Brisson. "La Globalicazion capitalista … una exigencia de las ganancias." *El Huracan de la Globalizacion*. Ed. Franz Hinkelammert. Costa Rica: Departamento Ecumenico de Investigaciones, 1999: 55–104.
3. Howard Zinn. *A People's History of the United States*. New York: Harper Collins Publishers, 1995.
4. *Captain Phillips*. Dir. Paul Greengrass. Perf. Tom Hanks, Barkhad Abdi. Columbia Pictures, 2013.
5. "Dependency theory is the notion that resources flow from a 'periphery' of poor and underdeveloped states to a 'core' of wealthy states, enriching the latter at the expense of the former." en.wikipedia.org/wiki/Dependency_theory
6. Francis Moore Lappe and Joseph Collins. *Food First*: beyond the myth of scarcity. New York: Ballantine, 1991.
7. Franz Hinkelammert. "Reflections on the External Debt of Latin America." www. pensamientocritico.info/index.php/articulos-1/franz-hinkelammert1/reflexiones-sobre-la-deuda-externa-de-america-latina
8. "The Washington Consensus is a set of 10 economic policy prescriptions considered to constitute the 'standard' reform package promoted for crisis-wracked developing countries by Washington, D.C.-based institutions such as the International Monetary Fund (IMF), World Bank, and the US Treasury Department." en.wikipedia.org/wiki/Washington_Consensus

Commoners Resist Privatization

The subtext of what's been said so far about privatization runs contrary to received wisdom on the topic. That wisdom describes a relatively smooth historical trajectory towards private ownership of productive forces—the result of a predictable dialectical process. Instead, the so-far largely implicit argument here has been that the historical emergence of private ownership and capitalism has been a counter-revolutionary tactic or device. Or more accurately, it represented the reaction of European elite to the constant efforts of peasants, workers, and indigenous tribes to reassert their traditional control over resources considered public and common, especially since the overthrow of the feudal order. As Sylvia Federici has put it:

> Capitalism was the response of the feudal lords, the patrician merchants, the bishops and popes, to a centuries-long social conflict that, in the end, shook their power and gave (in Thomas Muntzer's words) "all the world a big jolt." Capitalism was the counter-revolution that destroyed the possibilities that had emerged from the anti-feudal struggle—possibilities which, if realized might have spared us the immense destruction of lives and the natural environment that has marked the advance of capitalist relations worldwide. This much must be stressed, for the belief that capitalism "evolved" from feudalism and represents a higher form of social life has not yet been dispelled.[1]

Put otherwise, privatization and capitalism were not the only possible responses to the crisis of feudalism. As will be seen below, from the 12th century on, widespread

social movements based on common ownership of essential goods and on social equality and cooperation had spread across the continent. It required frequent and violent massacres on part of the beneficiaries of the defunct feudal order to prevent those movements from coming to power.

From the dawn of the middle ages, the counter-revolutionary character of the capitalist order that eventually prevailed has assumed many forms. It crushed the frequent uprisings of peasants against their feudal landlords and the urban elites. It produced the women's holocaust which massacred hundreds of thousands of women over a period of less than 200 years.[2] The colonial process was also part of the counter-revolution. The rise of the United States to a position of hegemony in the capitalist world marked yet another phase of the counter-revolution. "The American Century" was marked by the Cold War, and the relentless promotion of commercial globalization in the face of wide-spread resistance by the majority which has experienced the system's overwhelming negativity for more than 500 years.

Peasant Resistance to Feudalism

The introduction of serfdom following the fall of the Roman Empire, between the 5th and 7th centuries, was a counter-revolutionary measure on the part of the surviving Roman rural aristocracy to regain control of peasant labor. After the empire's collapse, these elite found themselves without the slaves who had made their lives so comfortable. The now free farmers, or peasants, were suddenly disobedient, refusing to submit to the accustomed hierarchies and to authoritarian rule. Many took up arms to protect themselves, or to expropriate those who had formerly abused them. Others took to the hills, and formed free maroon communities outside the reach of their former masters.[3]

In order to quell the rebellions, and to persuade the marooned to return, landlords offered peasants plots of land to work "on shares." This transformed the former slaves into sharecroppers or serfs, a status somewhat above slavery in terms of improved living conditions and autonomy. The landlords' package of concessions included continued recognition on their parts of large "commons"—resources traditionally considered as belonging to no individual, but to the entire community. As already indicated, these embraced meadows, forests, lakes, and wild pastures that provided wood for fuel, timber for building, fishponds, and grazing grounds for livestock.[4]

In this emerging feudal arrangement, even beyond the commons, collective forms of ownership prevailed over private, and even familial ones.[5] Nonetheless,

landowners made sure that the serfs remained bonded to their betters, and that a stable labor force was provided. So oaths of fealty were exacted in exchange for the security this feudal system offered the peasants. Serfs swore to perform military service for their landlords. Additionally, the very persons of the serfs, as well as their property belonged to lord of the manor. Virtually all aspects of the serfs' lives were controlled from the feudal big house.

Such constricting arrangements did not long subjugate those chafing under their burden. This was especially true in situations where landlords were themselves churchmen, as was often the case. At this time, the Roman Church was Europe's largest landowner. At the very least, churchmen routinely supplied the religious ideology which made social control possible. Serfs frequently rebelled. With good reason, they viewed landowning bishops and priests as unfaithful to the gospel, as corrupt and oftentimes ignorant. In response, landlords increasingly "freed" their serfs, replacing feudal bonds with wage relationships. In the process the landed classes now claimed *all* the produce from their fields, instead of having to share it with their peasant subjects. Thus the rural workforce began to be proletarianized. Besides increasing the landlord's wealth, such arrangements had the advantage of relieving their social responsibilities for serfs and their families. Those responsibilities had become costly and onerous.

In their search for alternatives to the older feudal relationships, and to the newly monetized ones, and in their quest for more extensive democratization of their lives, rural proletarians began interpreting the Christian tradition for themselves. Thus, as Richard Shaull points out, they developed a kind of liberation theology—or reflection on the following of Christ from the viewpoint of the poor. From the 12th to the 14th centuries, such popular interpretations took the form of "heresies" or unorthodox religious beliefs unacknowledged as acceptable by church officials—largely because of their social implications. So unacceptable were the new interpretations that church authorities instituted Inquisitional crusades against anti-feudal "heretical" rebels.

The main heretical sects were well organized and informed both by a theological and social vision. Typically, the theological convictions anticipated those of later reformers. Heretics held that God no longer spoke through the clergy, whose members had been discredited by their ignorance, avarice, and corrupt behavior. Taking the lead from the New Testament, the heretics observed that Christ possessed no property and that if the Church wanted to regain its spiritual power it too should divest itself of all its possessions. Heretics also taught that the sacraments were not valid when administered by sinful priests, that the exterior forms of worship—buildings, images, symbols—should be discarded because only inner belief mattered. They also exhorted people not to pay the tithes, and denied the

existence of Purgatory, whose invention had been for the clergy a source of illegit-imate income through paid Masses and the sales of indulgences.[6]

Socially, heretics were a mixed lot. They drew adherents from all walks of life, including artisans, peasantry, the lesser clergy, burghers, and the lower ranks of the nobility. Typically, they tolerated non-Christian religions—especially Judaism, providing safe haven for Jews in a time of mounting European anti-Semitism.[7] Heretics also opposed all forms of authority, and held strongly anti-commercial sentiments. As the most influential of the heretics, Cathars were vegetarians, refusing to kill animals.

They rejected marriage and procreation, since (like the similar peasant move-ments of Paulicians and Bogomils) they refused to bring children as "new slaves" into this "land of tribulations." Their rejection of marriage was probably linked to a refusal to live in the mere survival state to which serfs and free peasants had been reduced. Cathars also resisted war, and especially the Crusades. They opposed cap-ital punishment. Other heretical groups included Waldensians, who according to Inquisition records, were pledged to avoid all forms of commerce, as well as lies, frauds and oaths. The Poor of Lyon rebelled against forced labor by refusing to work at all; as imposed by the feudal elite, the Poor considered work degrading, and lived entirely on charitable donations.

In sum, heretics represented the Middle Ages' most important resistance movements against clericalism and feudalism. As will be seen below, the rebellion also represented self-defense on the part of peasants against acts of aggression by armies of the landlords themselves, as well as against gangs organized by emerging urban industrialists. Beginning in the 12th century, these regularly roamed the countryside to vandalize and destroy peasant productive capacity. In the words of J. W. Smith, it was "plunder by raid" to prevent the peasants from exploiting their "comparative advantage" of proximity to resources in the production of crafts.[8] By decree of Guilds and landlords, craft manufacture was to be the province of the resource-poor Walled Cities. Whatever the motivation, Rome's Office of the Holy Inquisition burned rebels by the thousands. In 1215 a genuine Crusade was waged against the Albigensians—again accompanied by wholesale slaughter.

Such carnage against heretics, by no means spelled the end of peasant rebel-lion before the institutionalized counter-revolutionary measures just described. Instead, an unforeseen "act of God" beyond the control of both the ruling classes and their subjects intervened to reverse the tide, and to introduce what has been described as the "golden age" of prosperity for European peasantry. Before its lib-erating aspects could be felt, however, the act of God in question exacted further tribute from its eventual beneficiaries. The reference here is to the Black Death (1347-1352). This plague came on the heels of the Great Famine of 1315-22,

and wiped out 30–40% of Europe's population—mostly the poor. Nonetheless, it represents a turning point in the medieval struggles over control of resources. The plague leveled social differences between clergy, nobles, and common people. It decisively turned the labor market in favor of the lower classes. One noble put it this way:

> The peasants are too rich ... and do not know what obedience means; they don't take law into any account, they wish there were no nobles ... and they would like to decide what rent we should get for our lands.[9]

As a result of this shift in power, peasant uprisings took place in Flanders in 1323, in France in 1358, in England in 1381, in Florence, Ghent and Paris in 1370 and 1380. Only then came that "golden age of the European proletariat."[10] During this time, wages increased by 100%, prices fell by 33%, the working day was shortened, and local self-sufficiency was fostered.[11] At no time, in England for instance, were wages so high and food so inexpensive. All of this finally brought the end of the age of serfdom.

The golden age, however, was short-lived. Already by the end of the 15th century, a new counter-revolutionary response was underway. First of all, the land-owners and emerging business classes took steps to restrict the mobility of the workers upon whom they depended. They passed and applied "Bloody Laws," against vagabonds and migrant workers, effectively imprisoning would-be mobile laborers in work houses and correction centers. So widespread were such measures that historians have referred to their results as the "Great Confinement."[12] Significantly for this study, the strategies of the ruling class also took the form of even more aggressive and widespread privatization measures (enclosures) than had been implemented in response to earlier peasant rebellions. The means for imposing such unpopular projects were twofold.[13]

The first means was war. Peasants, of course, objected to the privatization of their communal holdings. So, in 1486, another whole series of peasant uprisings took place throughout Germany. In response, the bourgeois, nobility and church joined forces to reassert control over peasants who demanded that "every man should have as much as another."[14]

The second means for imposing privatization in the form of enclosures was religious reform. However, in the related conflicts, the Reformation of the 16th century proved to be a two-edged sword. On the one hand, it supported the newly "converted" princes in their project of expanding and consolidating their land control. That is, the Reformation accorded the landed classes the ideology they required to escape domination by the Church of Rome, their inveterate rival in the business of property accumulation. Princes could now not only escape the payment

of taxes to "the Romanists;" better still, as self-appointed heads of their respective Protestant churches, the princes could now expropriate the extensive land holdings of the Catholic Church. Such appropriation represented yet another form of privatization, as individuals confiscated land belonging to a (church) community.

On the other hand, though, the Reformation promised peasants newly expropriated of their commons, that they too could enjoy God's blessings in rebelling against established authority, just as Luther and the princes themselves had done. In this way, the Reformation inspired a lower class struggle to regain control of communal holdings largely lost to the wave of privatization following the ruling classes' "labor crisis" of the 15th century. Thus began the Peasant Wars in the century that followed. First came the German "Peasant War" in 1525. Known as the "Revolution of the Common Man," the rebellion was widespread, extending from Frankfurt to Cologne, and to other towns in Northern Germany.[15] This uprising ended with the massacre of more than 100,000 peasants, and with the encouragement of Martin Luther himself. Luther was appalled that the princes, who had supported him against Rome, would be so rudely treated by their inferiors. He accordingly instructed his patrons to "stab, burn and kill" the ungrateful insurgents.

Ten years later, Thomas Muntzer's Anabaptists invoked Reformation principles to introduce God's kingdom on earth in the town of Munster. Generally regarded as adherents of the last great heretical movement, Anabaptists rejected economic individualism and competition. They aspired to a Christian form of communalism based on the sharing of goods.[16] Like the peasant uprising of 1525, the "New Jerusalem" movement was crushed mercilessly in 1535.

Even these egregious bloodbaths, however, did not spell the end of rebellions against privatization of communal holdings. Others occurred in England in 1549, 1607, 1628, and 1631. During these uprisings poor farmers, women as well as men, uprooted fences and destroyed hedges, meanwhile proclaiming that "from now on we needn't work anymore." In France between 1593 and 1595, the impoverished took up arms against taxes, tithes and the high price of bread. All of this was carried out against the energetic and bitter opposition of the conservative wing of the Reformation.

The reformers' support for counter-revolutionary violence against peasants highlights the important theological differences between the conservative and popular interpretations of the Judeo-Christian tradition, both during the Reformation, and in our own times relative to contemporary forms of liberation theology. As Weber has famously explained, conservatives emphasized character traits such as work, self-denial and saving. Meanwhile, populist reformers, like the heretical sects before them, stressed equality, sharing of goods, and community spirit.[17]

Recollection of these Anabaptist tendencies, which run so counter to typically Protestant support for capitalism and privatization, has virtually disappeared from mainstream religious memory. This is largely because the details of the Anabaptist story have been mostly erased from mainstream history. When Anabaptists are included, their story is almost invariably told from the viewpoint of their enemies. As a result, all during the 17th and 18th centuries, rebellions of any kind were linked to the "Anabaptists," just as deviances during the 1950s were connected to "communists," or today, to "terrorists."

Women's Holocaust and Colonial Slaughter

According to Sylvia Federici, the across-the-board murder of women during what is commonly referred to as the "witch craze," is another often-neglected episode inseparably related to the reassertion of ruling class dominion over rebellious peasants and urban workers during their "golden age." As Federici and others argue, this "craze" is more accurately termed a "holocaust," since it took the lives of *hundreds of thousands* from 1550 to 1650.

This slaughter was intimately connected with restricting worker mobility, but more especially with controlling women's reproductive capacities to make them subservient to the emerging capitalist labor market. Additionally, witch hunts countered women's perceived threat to the "work ethic" so necessary for capitalism's success. The persecution was also part of the effort by the ruling class to suppress the surviving "old religions," which women tended to champion more than men.[18] The old ways opposed the counter-revolutionary economic order which privileged work, competition and the clock over the rhythms of nature and communal values such as commons, subsistence farming, leisure, family, neighborliness, feasts, and sexual freedom. In this connection, it is no coincidence that the women's holocaust unfolded contemporaneously with similar wars against indigenous peoples in both the Americas and in Africa. Tribal religionists there too were demonized under accusations of witchcraft and commerce with demons. Like women in Europe, the demon-possessed in North America and Africa were slaughtered mercilessly.

The connection between European peasant wars and colonial slaughter is easy to understand. Both were provoked by an extension of the already-referenced tradition of "plunder by raid," carried out by European urban elites since at least the 11th or 12th century. The tradition, with the changes actually reflected in Figures 14.1 and 14.2 of our previous chapter, reaches all the way to our own day. Its current form called "globalization," and "privatization" is a key element of the strategy. Here is how.

In Europe, plunder by raid began as the counter-revolutionary response of urban elites to efforts by peasants seeking greater autonomy and economic prosperity. Rich urbanites resided in Walled Cities (Free Cities), which were able to coalesce, because the agricultural overproduction of the countryside enabled merchants, churchmen, lawyers, craftsmen, and increasingly, police and military personnel, to subsist and prosper without working the land. In the cities, craftspeople in particular set up their looms, fulling vats, leather making tools, forges, etc.

The problem for the urban elite, however, was that the cities were resource-poor. The wealth they needed, in the form of forests, fields for the production of wool, and mines lay in the countryside. In other words, the country people, represented by the peasants in rebellion enjoyed a "comparative advantage" over their urban competitors. So, for nearly a millennium, the urbanites used raiding parties to destroy the productive capacities of their rural counterparts and either stole or forced them to sell their products to town-dwellers.

When the Free Cities grew into nations, they remained relatively resource poor. England and Japan offer good examples. Geographically, they are both quite small, and by comparison, for instance, with Brazil or Mexico, have very few resources. Consequently, such nations turned to plundering-by-raid the resource-rich countries of the south to supply the needs of the factories which had replaced the primitive industrial installations of medieval craftspeople. This explains the colonialism of the 16th and 19th centuries. However, it also explains the innumerable insurrections and wars throughout the colonies, which became known as the Third World. Even further this dynamic explains how after these colonies achieved independence in the 1950s, and attempted to imitate the industrial path to "development" adopted by their colonizers, the latter intervened again and again to stop the development of industry in places enjoying the "comparative advantage" of proximity to natural wealth. It was all a repetition of the plunder by raid syndrome.

The Cold War

In 1848, Karl Marx and Friedrich Engels used the term "class struggle" to describe the story recounted in this chapter so far. When they published *The Communist Manifesto*, these vilified scholars of the working class (just as Locke and others are the celebrated scholars of the bourgeoisie), supplied learned and practical theory to the peasant and worker movements for liberation which had begun, not in the 19th century, as is often supposed, but, as we have seen, in the 5th. Though considering the bourgeois "revolution" more progressive than portrayed here, Marx

and Engels described in detail the exploitation of peasants, workers, women and the colonized as experiencing unremitting and violent reaction on the part of the ruling classes. They called on workers everywhere to throw off their chains.

In terms of our argument, this call to reclaim the expropriated commons indeed caused the industrialist classes and their allies to yet again tremble before the specter of lower class insurrection. Hence from the mid-19th century on, socialists were identified as the ruling classes' main enemy. Socialism offered (to the working classes) higher wages, shorter working days, a five-day workweek, paid vacations, social security, free education, free health care, subsidized food and housing, retirement plans, workers' compensation for injuries sustained on the job …

Antagonism to socialism, however, did not stop the capitalist elite from combating one another for supremacy. Accordingly, the First Inter-Capitalist World War pitted capitalists in Germany (the most prominent European capitalist state), against Great Britain which till 1870, had been most prominent in Europe. The Germans wanted colonies comparable to Britain's.

However, even in the midst of that war, the specter of socialism reared its ugly (to capitalists) head. Before the war's conclusion, Russian soldiers left the warfront to overthrow the mercantilist elite who had sent them there to kill fellow workers and be killed by them—by the hundreds of thousands. Thus Russian workers and peasants reasserted claim to their commons, and instituted a socialist system in 1917. Capitalists everywhere were frightened. Communist socialists predicted that socialism would come to power everywhere, once workers came to their senses and overthrew the capitalist system.

The communist prediction seemed on the verge of coming true after the Great Crash of 1929 and with the ensuing Great Depression. Angry workers, who were suffering from high unemployment, fallen wages, and hard times in general, demanded radical change in the capitalist system; socialist parties became popular throughout the capitalist world. In short, the Soviet system looked attractive to the working class.

To stave off the socialist threat, capitalists decided to give workers the elements of socialism they were demanding, as long as they left capitalism's most important element, private ownership of the means of production (and the ancillary huge profits), largely unchecked. Thus the New Deal came to the United States, and the Welfare State to Europe. For Josef Stalin, this was the onset of socialism. In 1934, in Vienna, he called a Congress of Victory to celebrate the victory of socialism over capitalism, and to declare the "end of history." Still, the Great Depression hung on.

So (as will be seen in the chapter following this one) when anti-socialist, Adolph Hitler, aspired to achieve political power in Germany, he had the backing of the capitalist classes. British Prime Minister, Neville Chamberlain, gave Hitler

the "go ahead" for *der Fuhrer's* project of subduing socialist threats on the continent. Pope Pius XII called Germany's leader "an indispensable bulwark against the Russians." However, Hitler "went too far," when he attempted to establish Germany's hegemony (rather than Great Britain's or France's) over European capitalism, and when by declaring war on the United States (in December of 1941), he attempted to subordinate U.S. capitalism as well. The Second Inter-Capitalist World War ensued.

Following the defeat of the "Axis Powers" in that conflict, Germany and Japan rejoined Britain and France in their counter-revolutionary fight against the real enemy, socialism—this time under the leadership of the United States, which assumed the hegemonic position among capitalists to which Hitler had aspired. For the next 45 years, the reunited capitalist powers fought a "Cold War" against that enemy. The prize in that war remained the resources of the Third World (the former colonies), which the capitalist Powers coveted for themselves (to fuel their industrial machines), and which socialists wanted under the local control of the former colonies.

In 1949 capitalist efforts to contain their enemy received a huge set-back, when in one swoop one-fifth of the world "went communist." That is, under the leadership of Mao Tse Tung, peasants in China definitively reclaimed their commons after a centuries-long battle against landlords similar to the one just described in Europe. To prevent the "contagion's" spread to nearby Korea and Vietnam, the United States intervened directly—in Korea from 1950-1953, and in Vietnam from 1962-1974. Elsewhere in the former colonies, the interventions were typically indirect.

Seen Through Magic Glasses
The Interview's[19] Logic Justifies Terrorist Attacks on the United States

The Sony Pictures' film, *The Interview,* is pertinent to this section on U.S. interventionism in the former colonial world. It also relates to what Noam Chomsky calls the Principle of Universality. It holds that if an action is right or wrong for others, it is right or wrong for us.

In December of 2014, *The Interview* nearly caused an international crisis with North Korea. A North Korean spokesperson even called the film an "act of terrorism" that would evoke "merciless retaliation" if released.

In the end, though, the North Korean government's concern was probably misplaced. That's because *The Interview* turned out to be more a send-up of U.S. culture, politics and the CIA than an indictment of North Korea's buffoonish "Dear Leader." The film's basic take-away is that U.S. foreign policy

is run by provincials who have no understanding of the regimes they routinely attempt to change. Much less do they grasp those regimes' historical and political contexts.

The Interview's plot involves two young tabloid TV show personalities who land an exclusive interview with North Korea's Supreme Leader, Kim Jong-Un. Before leaving for Pyongyang, the pair is recruited by the CIA to assassinate their interviewee. They accept, and the story of this Dumb and Dumber team goes on from there.

In fact, the political understanding of the film's protagonists, Seth Rogen and James Franco, is summarized in a single slogan repeated throughout *The Interview*: "They hate us 'cause they ain't us." That's it—a completely ignorant and self-congratulatory level of analysis whose depth reflects common American understandings of politics, like George W. Bush's explanation of 9/11, "They hate our freedom."

However, contrary to their expectations, Rogen and Franco discover in Kim Jong-Un someone totally like them. He's a frat boy, shallow, insensitive and entirely obsessed with sex, drugs, and American celebrity culture.

More to the point: Jong-Un's alleged crimes mirror those of the CIA itself. That is, according to Langley, the North Korean president's policies are reprehensible because they starve his people, keep them under constant surveillance, torture his enemies, and threaten the world with nuclear weapons. He therefore deserves to die.

But as North Korea's Dear Leader himself points out in the film's climactic interview, those are the very crimes of which the United States itself is guilty— but on a much larger scale. The Americans, he observes, are not just responsible for starting the Korean War. Their decades-long sanctions on the country along with their unrelenting policy of regime change have attempted to create famine throughout the northern part of the peninsula.

Jong-Un might have added that the U.S. is one of the world's most egregious actors when it comes to cyber-warfare and that NSA surveillance hacks into private communications across the globe, not just in a single place. The U.S. also maintains torture sites world-wide; it has more prisoners per capita than any other country (including North Korea). It is the only nation to have used nuclear weapons, and is in the process of modernizing its entire nuclear arsenal.

This means that the decision to kill Kim Jong-Un represents a subconscious act of self-destruction. Its logic actually justifies attacks on the United States, whose crimes (once again) mirror and dwarf those of the "international

criminal" destroyed at the film's conclusion. This makes the assassination a kind of suicide by proxy—an expression of a death-wish.

The suggestion here is that the film's easily overlooked message is this: They don't hate us 'cause they ain't us; they hate us because we *are* us—because of what history shows us to be. It might even suggest that (according to the Principle of Universality) North Korea's possibly attacking the United States is far more justifiable than any U.S. attack on North Korea. What do *you* think?

Thus when Cuba adopted a socialist form of government after 1959, the U.S. sponsored disaffected exiles to invade the country. They were defeated soundly by an insurgent population which rallied to protect their newly recovered commons. Cubans and their leader, Fidel Castro, immediately became heroic in the eyes of the expropriated majority in the former colonies. Peasant and worker armies formed all over Latin America to imitate a population and leader who had become, as already noted, "the envy of the Third World." The U.S. responded in a counter-revolutionary manner by installing military dictatorships across South and Central America, and by mounting a huge propaganda campaign to discredit Castro and other leaders of peasant insurgency.

The Soviet Union came to Cuba's defense. It protected the revolution not only with military aid (including at one point, nuclear missiles), but by implementing on Cuba's behalf the provisions of the 1971 New International Economic Order (N.I.E.O). Formulated within the United Nations by the former colonies' "Group of 70," the N.I.E.O. embodied the underdeveloped world's formula for repairing the economic and political damage inflicted by nearly 500 years of colonial domination. In the spirit of "restorative justice," its principal demands included (1) massive transfer of monetary wealth, (2) equally massive transfer of technology, so that the Third World might industrialize, and (3) indexing the prices of Third World agricultural and raw material exports to the prices of finished goods produced by the industrialized north. The U.S.S.R implemented all of these measures for Cuba. More specifically, it guaranteed stable prices for Cuban sugar for periods of five years at a time, with those prices adjusted to make purchase of Soviet tractors, cars, refrigerators, and other industrial products affordable. The island nation prospered as a result, thus affording for the rest of the Third World the "bad example" the capitalist nations feared.

In 1973 former colonies within the now defunct Ottoman Empire decided to force something like the N.I.E.O. on the industrialized world. They were uniquely situated to do so, since the "raw material" they offered the former colonizers was oil, the very life's blood of the modern system of production, distribution and

transportation. Together these middle easterners, along with other oil producers across the globe formed the Organization of Petroleum Exporting Countries (OPEC). They doubled the price of oil in 1973, then raised them again in 1976, and yet again in 1978. This act by former colonials raised the prices of every product in the world made from oil (including plastics and fertilizers), as well as every product transported using oil derivatives for fuel. Skyrocketing prices plunged the capitalist system into a crisis unparalleled since the Great Depression.

All of this happened while the privatized order was losing ground in Asia as well. There in 1974, following more than a decade of intense struggle which took the lives of more than two million from their population, Ho Chi Minh's peasant army finally prevailed against the much better-equipped Americans intent on restoring the hated privatized order in Vietnam.

And so, despite overwhelming odds, counter-revolutions and intense propaganda, the contagion of peasant and worker, student and female resistance to those who would use national territories to benefit foreigners spread. It affected most of the countries of Africa, most notably Angola, Mozambique, Tanzania, and eventually South Africa. Whenever this occurred, the United States was quick to intervene in the cruelest and harshest of manners. No tactic, however brutal, was left unemployed to keep workers, peasants and uncontrolled local industrialists and merchants from depriving the elite and their foreign sponsors of private ownership of natural resources and industrial facilities in the resource-rich south.

John Stockwell, the former CIA station chief in Angola, and the highest CIA official to go public, spoke of it all as the "Third World War against the Poor." His words have already been quoted at length in Chapter Nine.

After the Fall

The situation just described as "plunder by raid" changed after 1989, when Cold War arms expenditures became too much for the Soviet Union to sustain. With an economy half the size of the United States, it could no longer match that much bigger economy dollar for dollar. The fall of the Berlin Wall was taken as a sign of the Cold War's end. With that development, the United States declared the death of "historic socialism," the victory of capitalism, and the end of history. It was time, then, to roll back the New Deal in the United States (President Reagan called it a "fifty-year mistake") and to dismantle the Welfare State in Europe, since these were remnants of a historic compromise between capitalism and a now discredited socialism.

Similarly, "foreign aid" now took the form of "free trade." With this change, "plunder by raid" was replaced by "plunder by trade." The new order centralized

the establishment of U.S., European and Japanese businesses in the former colonies, which were now expected to become "export platforms" for those businesses, to cease attempting to develop their own industries, and to exploit their "comparative advantage" as suppliers of raw materials and "competitive" labor. Plunder by trade facilitated a new round of "primitive accumulation" for the neo-colonialists. The bedrock foundation of the system was a wage differential that enabled the "developed" competitor to outstrip the underdeveloped one in exponential as opposed to arithmetical proportions.[20]

The problem with "plunder by trade" policies has been that they are immensely unpopular with the majority of the people within the Global South countries involved. There such programs have regularly incited rebellion in the form of insurgencies against local governments, and terrorism against foreign entities. Keeping down such rebellion has required vast military expenditures on the part of the United States—in order to facilitate fighting several wars at once. But absent the Cold War rationale for such expenditures, "selling" such wars to the American public proved difficult.

Additionally, the post-Cold War business class agenda of rolling back the "New Deal" (in the United States) and the much more elaborate Welfare State (in Europe), had its own problems. The institutions and programs involved [legalized unions, social security, minimum wage, paid vacations, public schools, universal health care (in Europe, not the United States)] were immensely popular.

The political right's monopolization of the media went a long way towards undermining public support for such achievements by propagandizing against them as "socialist" or "communist" and therefore discredited. In addition to being remnants of a failed system, such elements were characterized as "lavish" and "spendthrift"—products of "Big Government" that was inefficient, and could no longer be afforded. As a result, union membership declined, and right wing governments took office in many countries, most notably in the United States and Great Britain.

Further rollbacks in the working classes' historic gains were prevented by workers' legal and human achievements. These included Bills of Rights guaranteeing, for example, privacy, the right to organize, to petition government, to assemble freely, to speak and publish without restriction. The problem for the right became how to annul these rights, in order to take back what workers had achieved in response to the Great Depression. What was required was some crisis—an equivalent of war—that would enable bourgeois (business class) governments to implement measures which would otherwise be unpopular with citizens.

All of these concerns, both domestic and foreign, are reflected in the turn-of-the-century documents of the Washington think tank, the Project for a New

American Century (PNAC).[21] The crisis required to implement the agenda outlined there (imposition of American Empire on the world and further roll-backs in working class economic, civil and social gains) arrived on September 11th 2001 in the form of an apparently sudden and unprovoked attack on the World Trade Center, and on the Pentagon.

Now the business class could dramatically increase military spending, and create a budget deficit which would necessitate further shrinking of social programs serving the poor. Heightened security concerns were reflected in Patriot Acts I and II, and in the Military Commissions Act of 2006. All of these dramatically restricted citizens' rights in the name of national security. Pre-emptive wars could now be fought to secure regime-changes throughout the world—to at last rid the world of worker-friendly governments, and install those uniformly subservient to the interests of big business.

Conclusion

The foregoing has been the sketchiest of accounts of a centuries long process of resistance by peasants and workers to violence mostly on the part of European elites who have insisted on imposing on the world's majority various "enclosures" and privatizations. The point is that resistance to privatization is not new. Neither does it begin with the Industrial Revolution. Nor did it end with the fall of the Soviet Union. What has been recounted here highlights and puts into perspective contemporary resistances to globalization's latest efforts to privatize the planet's commons.

Consider, for example the Zapatista revolt against the North American Free Trade Agreement which began on January 1, 1994. Then in November of 1999 huge demonstrations took place in Seattle against the World Bank and IMF. That was followed by similar events in Washington, Genoa, Geneva, and elsewhere, as well as gigantic world-wide demonstrations against the war in Iraq in February of 2003. Add to that the World Social Forums begun in Porto Alegre in 2001 and continued annually across the globe, and you have the incarnation of what *The New York Times* has called "The Second Superpower"—people in the streets resisting the globalization juggernaut. All these events have been expressions of a globalized and enduring understanding on the part of the working class that the new world order and the triumph of capitalism are not in their own best interests. All over the world, ordinary people especially students have come together to recognize and denounce the destructive effects of the new globalized economy.

Such movements have once again put capitalism in crisis mode. As we saw in Chapter Four, crisis typically evokes from capitalists a form of political economy called fascism. It was described in that early chapter as (1) A police state (2) enforcing an economy mixed in favor of large corporations, (3) characterized by extreme anti-socialism and anti-communism, and by scapegoating "socialists," "communists" and minorities (like Jews, blacks, gypsies, homosexuals ...) for society's problems.

Chapter Sixteen will review fascism's development from Hitler to the present day.

For Discussion

1. What historical patterns have you seen in the last two chapters about privatization and resistance to it?
2. Have you found anything new in the history you've been reading here?
3. What do you understand by the phrases "plunder by raid" and "plunder by trade?"
4. Do you agree that the logic of U.S. policy against reprehensible heads of state like Kim Jong-Un suggests merited assassination of *our* leaders and justifies acts of terror against America? Explain.

Notes

1. Silvia Federici. *Caliban and the Witch: women, the body and primitive accumulation.* Brooklyn: Autonomedia, 2004: 21–22.
2. *Ibid.* 164.
3. *Ibid.* 23.
4. *Ibid.* 24.
5. *Ibid.* 25.
6. Richard Shaull. *The Reformation and Liberation Theology: Insights for the Challenges of Today.* Louisville: John Knox Press, 1991. 34.
7. *Ibid.* 37.
8. J. W. Smith. *Why?: The Deeper History behind the September 11, 2001 Terrorist Attack on America.* New York: First Books, 2002.
9. Silvia Federici. *Op. Cit.* 45.
10. *Ibid.* 46.
11. *Ibid.* 62.
12. *Ibid.* 165.
13. *Ibid.* 68.
14. *Ibid.* 49.

15. *Ibid.* 116.

16. *Ibid.* 116.

17. *Ibid.* 121.

18. *Ibid.* 213.

19. *The Interview.* Dir. Seth Rogen and Evan Goldberg. Culver City: Columbia Pictures, 2014.

20. In his book, *Democratic Capitalism: The Political Struggle of the 21st Century,* J. W. Smith explains the exponential progression. Suppose, he says, a worker in the developed world and one in the underdeveloped world each produces a widget equally attractive to their counterparts, and each bearing a cost equivalent to that of the labor invested in its production. Suppose that the worker in the underdeveloped world is earning $1.00 per hour for his work, while the one in the developed world is making $2.00 per hour. According to this arithmetic, it would seem that the developed world worker is earning twice as much as the one in the underdeveloped world. Actually, Smith explains, the worker earning $2.00 and hour is earning 4 times as much, in terms of purchasing power. This is because it will take the first worker 2 hours of work to earn enough to buy the widget of the second worker. Meanwhile, the developed world worker can buy 4 widgets from the worker in the underdeveloped world. So the wealth accumulation differential of the developed world producer is 4 to 1. If the developed world worker earns $3.00 per hour, while his competitor earns $1.00, the wealth accumulation differential is 9 to 1. At $4.00 per hour compared with $1.00, the differential is 16 to 1. At $20 per hour, the differential is 400 to one.

21. Project for the New American Century. *Rebuilding America's Defenses: Strategy, Forces and Resources for a New Century.* September, 2000. www.informationclearinghouse.info/pdf/RebuildingAmericasDefenses.pdf

Hitler and Fascism's Defense of Privatization

The argument of Part Three of this book has been that capitalism is the chameleon strategy employed by Western elite classes to stifle rebellion on the parts of the non-elite in the latter's quest for autonomy, dignified human life and the means to attain it. In particular, the non-elite have resisted the capitalist strategy of "privatization," whose goal has been to expropriate "commoners" of their traditional access to "the human patrimony"—otherwise known as the commons. For commoners, this patrimony embraces everything that is not the product of human labor. Its logic demands that no one should be allowed to "own" the "four sacred things"—not earth, not air, not fire, not water. For though such elements might be rented, and though income for making them accessible to others might subsequently be earned, no one may deny access to such resources to those who depend on them for the maintenance of life itself. A fortiori, no one may destroy or use up such resources without making adequate restitution to the human family.

The same holds true for "the fifth sacred thing," viz. life itself, and the products of the human spirit. These too are parts of human patrimony. Clearly, then, establishing ownership rights over the genetic code of plants and animals—not to mention human beings—offends truths as self-evident as those claimed by the Founding Fathers of the United States in their Declaration of Independence.

Similarly, no one can own thoughts. These are produced and exchanged freely by human minds simply and inevitably as part of community life. As a result, insights are shared, minds are enriched, and "discoveries" are made. The final formulation of a discovery, as well as intermediate expressions, might well be so valuable that "royalties" for them might be justly claimed for limited periods. But the thought itself remains community property—part of the commons. This is the underlying perspective of critical thought as I've encountered it in my work with Global South scholars and activists.

Part Three has also shown that the counter-revolutionary classes (landowners, industrialists, merchants, and their ideological supporters in government, churches, schools, and the media) have been willing to sacrifice other elements of their system in order to preserve what they consider the most important one, private ownership. Thus, especially when lower class challenges have threatened to replace capitalism with socialism, capitalists have been willing, at least partially and temporarily, to accept controlled markets, endure high taxes, and to allow public ownership of electricity, telephones, railroads, post offices, forests, meadows, and even banks. In addition, implicitly acknowledging the greater efficiency of socialist control, capitalists, during time of war, have adopted other basic socialist policies. Under measures commonly referred to as "war socialism," capitalists have rationed key products, controlled prices and wages, and have replaced the ideology of individual competition with propaganda about community responsibility and putting others first.[1]

Compromises like these between capitalism and socialism became necessary in order to "save the system" following the Great Stock Market Crash of 1929. Franklin D. Roosevelt compromised with his New Deal. Governments throughout Western Europe followed suit with the introduction of the Welfare State. So did Adolph Hitler with "National Socialism"—also referred to as fascism and Nazism. Whatever its name, Hitler's system like Roosevelt's and the Welfare State, represented the attempt by industrialists, landowners, and church people, to save as much of the system as possible in a moment of grave crisis that otherwise would have spelled the system's end. Their adversary here, as always, was comprised of the peasants, trade unionists and others, who were attracted to Marx's defense of "the commons," and by the Soviet example of "communism."

Join me in considering that crisis in detail and then see how it presents itself today when capitalism's death throes suggest unprecedented alternatives. For according to economist, Richard Wolff, capitalism today is in the deepest crisis he has seen in his lifetime of more than 75 years. So if we define fascism as "capitalism in crisis," it makes sense that we are witnessing today a rebirth of fascism across the planet, including, some would say, in our own country.

Hitler as Capitalism's Champion

As far as other capitalists were concerned, Hitler was their champion against the Soviets and those who admired Soviet accomplishments. After his coming to power in 1933, Hitler's international sponsors quickly rescinded the harshly punitive clauses of the Treaty of Versailles. They forgave Germany's debt. British prime minister, Neville Chamberlain hastened to align Great Britain with Hitler. Pius XII referred to *der Fuhrer* as "an indispensable bulwark against the Russians." Henry Ford loved the man. The admiration was mutual; Ford accepted a medal of honor from Hitler's hands, as did the founder of IBM. Trans-Atlantic aviator, Charles Lindbergh and movie actor Errol Flynn were prominent among Hitler's devotees.

With such backing, the Western Powers allowed Hitler's Germany to rearm. But in the end, *der Fuhrer* lost the support of his capitalist backers, because he went too far. His crime, however, was not gassing Jews. The West proved remarkably compliant with anti-Semitism. Rather, Hitler's crime was his attempt to establish control of the world economy—over such capitalist competitors as Great Britain, France, and the United States. He proposed a New World Order, which, he promised, would bring prosperity to all. Nonetheless, Hitler's attempts to impose his order ultimately met with stiff resistance from his opponents' Allied Forces. The Second Inter-Capitalist War ensued.

Afterwards, the United States emerged relatively unscathed from the conflict, and proceeded to establish its own dominance of the world capitalist system, in ways not extremely different from those employed by Adolph Hitler. That dominance of the capitalist world turned to imperial global dominance following the disappearance of the Soviet Union as the lone super-power adversary of the U.S. at the beginning of the 1990s. In other words, there is surprising continuity between Hitler's New World Order and the New World Order embodied in the contemporary system of globalization. To understand this perhaps shocking claim, it is necessary to (1) clear up some common misconceptions about fascism, (2) describe the connections between Hitler and capitalism, and (3) indicate how fascism triumphed in World War II and its aftermath. Chapter 17 will show how Hitler's system is continued today in globalization and the War on Terrorism. It will suggest remedies for capitalism's contemporary crisis.

Fascism

To see privatized globalization as a continuation of Hitler's system, it is first of all necessary to elaborate on the sketchy description of fascism offered in Chapter Four.

Not surprisingly, misunderstandings abound concerning fascism's nature. Most correctly identify it with a police state, with institutionalized racism, anti-Semitism, and totalitarianism (though they typically remain unclear about the term's meaning). Most too are familiar with concentration camps, the Holocaust, and, of course, with Adolph Hitler himself. Some can even associate the Nazi form of fascism with homophobia and persecution of Gypsies. However, rarely, if ever will anyone connect fascism with capitalism. For instance, here is Jackson Spielvogel's (Western Civilization) textbook description of Hitler's thought:

> In Vienna, then, Hitler established the basic ideas of an ideology from which he never deviated for the rest of his life. At the core of Hitler's ideas was racism, especially anti-Semitism. His hatred of the Jews lasted to the very end of his life. Hitler had also become an extreme German nationalist who had learned from the mass politics of Vienna how political parties could effectively use propaganda and terror. Finally, in his Viennese years, Hitler also came to a firm belief in the need for struggle, which he saw as the "granite foundation of the world." Hitler emphasized a crude Social Darwinism; the world was a brutal place filled with constant struggle in which only the fit survived.[2]

Here it is interesting to note that racism, especially anti-Semitism, nationalism, propaganda, terror and Darwinian struggle are signaled as defining attributes of the Hitlerian system. Capitalism is not mentioned, though "struggle" is. Perhaps, had the term "competition" been used instead of "struggle," the basically capitalist nature of "Social Darwinism," and fascism might have been at least suggested.

Fascism and Communism

Textbooks typically add to the confusion by closely connecting fascist Nazism and Communism. For instance, Spielvogel's *Western Civilization* deals with Hitler's fascism and Josef Stalin's socialism back-to-back, linking the two with the term "totalitarianism." Spielvogel's transition from one to the other illustrates how the merely mildly interested (i.e. most students) might come away confused. He writes, "Yet another example of totalitarianism was to be found in Soviet Russia" . Spielvogel defines totalitarianism in the following terms:

> Totalitarianism is an abstract term, and no state followed all its theoretical implications. The fascist states—Italy and Nazi Germany—as well as Stalin's Communist Russia have all been labeled totalitarian, although their regimes exhibited significant differences and met with varying degrees of success. Totalitarianism transcended traditional political labels. Fascism in Italy and Nazism in Germany grew out of extreme

rightist preoccupations with nationalism and, in the case of Germany, with racism. Communism in Soviet Russia emerged out of Marxian socialism, a radical leftist program. Thus, totalitarianism could and did exist in what were perceived as extreme right-wing and left-wing regimes. This fact helped bring about a new concept of the political spectrum in which the extremes were no longer seen as opposites on a linear scale, but came to be viewed as being similar to each other in at least some respects.[3]

Spielvogel correctly points out "significant differences" between fascism and communism. One is radically right, the other radically left. (Recall Figure 5.1.) Nazism is identified with nationalism and racism (not, it should be noted, with capitalism). Communism is associated with Marxism and socialism. In the end, however, the two are viewed as "similar to each other in at least some respects." Thus, clarity of distinction given with one hand seems to be erased with the other. Confusion is the typical result. Such fogginess might have been cleared had Spielvogel employed greater parallelism in his expression—i.e. had he identified Stalinist communism with police-state socialism and Hitler's Nazism with police-state capitalism.

National Socialism

Nonetheless, history books and teachers are not solely at fault for student confusion. There are other understandable reasons for the distancing of fascism from capitalism. For one, Hitler's Party called itself the National *Socialist* German Workers' Party (NSDAP). As a result, it is quite natural for students who reflect on the question at all, to conclude that Hitler and his party were "socialist," or even "communist," since the two terms are almost synonymous for most Americans. After all, well-indoctrinated students would be justified in reasoning, Hitler did such terrible things, he must have been a communist.

Lost in such analysis is the historical realization that during the 1930s, all sorts of approaches to political-economy called themselves "socialist." This is because they supported state intervention to save the market system that was in crisis during the Great Depression. Thus, there were socialisms of the left as found in Soviet Russia. But there were also socialisms of the right, such as Hitler's in Germany, Mussolini's in Italy, Franco's in Spain, and Salazar's in Portugal. In other words, interventionist economies easily adopted the "socialist" identification to distinguish themselves from laissez-faire capitalism, which in the aftermath of the Great Stock Market Crash of 1929, had been completely discredited. As we shall see below, in such context (were it politically possible) Franklin Roosevelt's interventionist program to save capitalism could easily have been called National Socialism instead of the "New Deal."

However, analysis of fascism's approach to socialism must recognize the *national* character of the socialism advocated.[4] The critical adjective was intended precisely to distinguish the right wing brand of socialism from its left wing *international* antagonist. In this connection Schulze writes:

> The catch-phrase 'national socialism' itself had been created before the First World War as a means to unite a variety of nationalistic organizations in the battle against "international socialism." The term was designated to appeal to the working class, but it also proved attractive to young people from the middle and upper classes with romantic notions of *Volksgemeinschaft*, a "popular" or "national" community.[5]

The implication here is that right wing zealots "co-opted" a popular term to confuse the young—a strategy employed to this day with great success.

Fascism as Mixed Economy

Yet another reason disjoining fascism from capitalism is that fascism was not capitalism pure and simple. The same might be said of Roosevelt's New Deal. As seen in Chapter Four, both systems were "mixed economies." That is, if capitalism's essential components are private ownership of the means of production, free and open markets and unlimited earnings, socialism's corresponding elements are public ownership of the means of production, controlled markets and restricted earnings. Both Roosevelt and Hitler combined the two approaches to economy. Once again, in a period when free market capitalism had been widely discredited, both Hitler and Roosevelt performed a kind of "*perestroika*." Soviet Premier, Mikhail Gorbachev would later use the term to refer to the restructuring of socialism, in order to save it by incorporating elements of capitalism. The suggestion here is that more than a half-century earlier, Roosevelt and Hitler had done the opposite; they had incorporated elements of socialism into the capitalist system in order to resurrect it. So, while the means of production most often remained in private hands, others (such as the railroads, the postal system, telephones and highways) were nationalized. Similarly, while the free market was allowed to continue in many ways, its freedom was restricted by measures socialists had long advocated (e.g. rationing, legalized unions, social security, wage and price controls). Finally, high income taxes were used to restrict earnings and garner income for the state to finance its interventionist programs.[6]

None of this is to say that Roosevelt's and Hitler's interventionist economies were the same. As we have seen, mixed economies, after all, are not identical. The key question for distinguishing between them is, "Mixed in favor of whom?" Some

mixed economies are mixed in favor of the working class, others, in favor of their employers. As the product of a liberal capitalist, Roosevelt's mixture successfully sold itself as the former. That is, while keeping most means of production securely in the hands of capitalists, Roosevelt gained the support of the working classes through his populist programs aimed at modestly redistributing income downward towards those otherwise unable to fend for themselves. In other words, Roosevelt's "mixed economy" was blended so as to facilitate its defense in populist terms—that is, as mixed in favor of the working class. And the defense found plausibility with the American people. Despite objections from more overtly pro-business Republicans, Roosevelt was elected four times in succession. His party remained in control of the U.S. Congress for nearly a half-century.

Hitler had another approach. Influenced by Herbert Spencer and (indirectly) by Friedrich Nietzsche (see below), der Fuhrer was an extreme social Darwinist whose programs unabashedly favored elite Aryans and despised "the others," particularly socialists, Jews, trade unionists, non-whites, Gypsies, homosexuals, the disabled and other "deviants." On the other hand, Hitler despised "liberal" politicians like Roosevelt, with their programs of social welfare. On those grounds, he vilified the Weimar government which preceded his own. During the early years of the Great Depression, Weimar politicians had attempted to gain the favor of the working class, and to sidestep civil war by implementing wealth distribution programs.[7] Funding the programs necessitated tax increases, unpopular with middle and upper classes. It meant strengthening unions along with socialists and communists.[8]

The point here is that for good reason few make the connection between fascism and capitalism. A student of Spielvogel, for instance, would have to be quasi-heroic to do so. After all, he or she would be not only resisting the confusion fostered by the text itself, but would also be swimming against the stream of American propaganda that treats Hitler's system as the idiosyncratic product of an evil individual, and unconnected with any specific economic system (other than, mistakenly, socialism or communism). Despite such ambiguity, what follows will attempt to demonstrate more specifically that even a closer reading of a text like Spielvogel's makes unmistakable the connection between fascism and capitalism.

Hitler and Capitalism

To understand Adolph Hitler's connection to capitalism, it helps to distinguish common perceptions from what textbooks like Spielvogel actually say. Common perceptions are that the German economy was devastated following World War I.

The impositions of the Treaty of Versailles are well-known. Images of Germans marshalling wheelbarrows full of *Deutsch* Marks to pay their grocery tabs are fixed in everyone's mind. After the Great War, inflation was rampant. In such context, Hitler's rise to power is typically explained as the reaction of a humiliated German people to the Allies' shortsighted demands for war reparations and border concessions inherent in their Treaty. Germans were so desperate, the story goes that they turned to a madman, Adolph Hitler, to restore their national pride.

Of course, there is truth to such understanding. Germany's economy *was* in a shambles after World War I. Inflation *had* reached unprecedented levels. Ordinary Germans saw their earnings and pensions disappear. They were humiliated, desperate and in search of an alternative to the Weimar Republic which was under fire from factions on both the left and the right.

However, two key realities, relevant to the argument at hand, are often overlooked about Germany's post-World War I situation. The first reality is that by the time Hitler emerged as a serious factor in the German political scene, the country's economy had long since been intensively and triumphantly capitalist. Already by 1870, Germany had become Europe's undisputed industrial leader, replacing Great Britain in that role.[9] By the 1920s, the country's real reins of power were firmly in the hands of capitalist giants. Germany's most effective leadership came no longer from the aristocrats of William II's Empire. Much less was it provided by Paul von Hindenburg, the backward-looking monarchist who succeeded Friedrich Ebert and Gustav Stresemann to head the country in the mid-twenties. Instead, leadership and power found location in the private enterprises today being sued for compensation by those they employed as slave labor during Hitler's *Reich*. That is, leadership resided in banking industry giants such as Deutsche Bank and Dresdner Bank; in auto-makers, Volkswagen and BMW; in chemical and pharmaceutical companies Bayer, Hoechst, and BASF; in industrial firms Degussa-Huels, Friedrich Krupp and Siemens; and in the Allianz Insurance Company.

Secondly, Spielvogel makes it clear that Germany's economy had largely rebounded from the devastation inflicted by the Treaty of Versailles. In fact, from 1924-1929, the country actually participated in "the Roaring Twenties."

> "The late 1920s were … years of relative prosperity for Germany, and, as Hitler perceived, they were not conducive to the growth of extremist parties. He declared, however, that the prosperity would not last and that his time would come."[10]

Hitler, of course, was correct that his party's time had not yet come. During the '20s, Hitler's Nazis remained a minor right-wing faction. For example, in the elections of 1928, the Nazis gained only 2.6 percent of the vote and only twelve seats in the German Parliament.[11]

Hitler was also correct that his time *would* come. It arrived with the onset of the Great Depression.[12] The collapse of market economies throughout the industrialized world had their leaders scrambling to save a system that seemed moribund. Socialists and communists were gleeful and ascendant. Indeed, as already noted, in 1934, Josef Stalin convoked a "Congress of Victory," to celebrate socialism's apparent triumph over capitalism and what he called "the end of history."

As Spielvogel reports, such threats from the left forced German capitalists to turn to Hitler as their Messiah. Industrialists and large landowners provided the firm base of support he needed. More specifically, the elite were fearful, because the Depression's economic hard times had given heart (and popular appeal) to socialists and communists who in Russia had seized power in the Bolshevik Revolution of 1917. Spielvogel writes:

> Increasingly, the right-wing elites of Germany, the industrial magnates, landed aristocrats, military establishment, and higher bureaucrats, came to see Hitler as the man who had the mass support to establish a right-wing, authoritarian regime that would save Germany and their privileged positions from a Communist takeover.[13]

The capitalist nature of Hitler's system stands clear in this description—though it is fogged by circumlocutions. The attentive reader should note that, along with the military hierarchy and government administrators, the powers behind Hitler's takeover of Europe's leading capitalist nation are the captains of industry and large landowners, not, it should be noticed, "capitalists." One can surmise that such unadulterated reference would be "politically incorrect" in a textbook intended for educational institutions whose mission is to enculturate rather than to raise critical consciousness.

Capitalist Support for Hitler

Capitalists supported Hitler because he would not threaten the most important element of their system (private property), because he would keep their working class antagonists under control, and because his anti-Semitism promised to eliminate a major source of commitment to the victims of social Darwinism. Consider the first two points here. The reasons for Hitler's anti-Semitism will be discussed later.

To begin with, the most important component of the capitalist system is private ownership of the means of production. To save that, capitalists during the 1930s generally agreed that it would be necessary to tinker with the system's two other defining elements, viz. free and open markets, and unlimited earnings. That

is, to save the system, the German government would have to intervene in markets and modestly limit and redistribute some income. Despite pressure from some in his party, Hitler assured his powerful backers that he would not generally nationalize German industry. Once again, Spielvogel makes this clear:

> In the economic sphere, Hitler and the Nazis also established control, but industry was not nationalized as the left wing of the Nazi Party wanted. Hitler felt that it was irrelevant who owned the means of production so long as the owners recognized their master. Although the regime pursued the use of public works projects and "pump-priming" grants to private construction firms to foster employment and end the depression, there is little doubt that rearmament was a far more important contributor to solving the unemployment problem.[14]

Again, as we shall see below, Hitler's approach to Depression economics was not far removed from Franklin Roosevelt's. Consciously or unconsciously, it was classic Keynesianism with its refusal to nationalize extensively, and with its public works and "pump-priming" grants aimed at ending widespread unemployment. John Kenneth Galbraith, Roosevelt's chief economic advisor, makes this point.

> The Nazis were not given to books. Their reaction was to circumstance, and this served them better than the sound economists served Britain and the United States. From 1933, Hitler borrowed money and spent—and he did it liberally as Keynes would have advised. It seemed the obvious thing to do, given the unemployment. At first, the spending was mostly for civilian works—railroads, canals, public buildings, the *Autobahnen*. Exchange control then kept frightened Germans from sending their money abroad and those with rising incomes from spending too much of it on imports. The results were all a Keynesian could have wished. By late 1935, unemployment was at an end in Germany. By 1936, high income was pulling up prices or making it possible to raise them. Likewise, wages were beginning to rise. So a ceiling was put over both prices and wages, and this too worked. Germany, by the late thirties, had full employment at stable prices. It was, in the industrial world, an absolutely unique achievement.[15]

Galbraith's words concretize the basic elements of John Maynard Keynes' interventionist approach to economic reform, which Hitler unwittingly adopted. The key was borrowing and spending with abandon. Railroads, canals and superhighways renovated Germany's economic infrastructure for capitalists, while putting the unemployed to work. Public buildings were given new faces when administration centers, court houses, libraries and post offices were renovated or rebuilt. Meanwhile, local industry was protected by way of exchange controls preventing the well-to-do from not "buying German." And, as Galbraith says, it all worked. Unemployment plummeted; wages, prices and profits rose. Hitler then applied

wage and price controls, all with such great success that by 1935 Germany had already largely emerged from its depression. Capitalism had been saved. Socialists and communists had largely lost the grounds for their critique of the system.

Besides his reassuring approach to private ownership of the means of production, Hitler attracted capitalist support because of his labor policy. For one thing, he eliminated labor unions independent of the state. Thus employers were relieved of the threat of strikes and of the necessity of protracted collective bargaining sessions. For their part, workers were impressed by Hitler's spectacular job-creation programs. They also saw their benefits packages improve, along with free time activities.[16] The key concept here was that of control. Secretary of Labor, Robert Ley, made sure mollified workers would not prove threatening to their employers.

> The German Labor Front under Robert Ley regulated the world of labor. The Labor Front was a single, state-controlled union. To control all laborers, it used the work-book. Every salaried worker had to have one in order to hold a job. Only by submitting to the policies of the Nazi controlled Labor Front could a worker obtain and retain a workbook. The Labor Front also sponsored activities to keep the workers happy.[17]

The Triumph of Hitler's System in World War II and Its Aftermath

There are several senses in which Hitler's system of Nazism and the forces of the alliance between Germany, Japan and Italy won the Second World War. To begin with, the larger economic system Adolph Hitler represented was bound to win World War II. This is because the conflict was essentially "inter-capitalist." In other words, no matter which side won, capitalists would prove triumphant. Thus, the war was not fought over human rights. Disdain for them was as virulent on the part of the allies as it was by the Nazis. Dresden, Hiroshima and Nagasaki are evidence enough.[18] So was the U.S. internment of Japanese citizens in concentration camps during the war, along with the confiscation of their property. Nor was World War II fought to somehow defeat the forces of racism or anti-Semitism or to free victims of concentration camps. In the 1940s, U.S. culture was itself still profoundly, systemically and legally racist. Until the end of the war, the U.S. Army itself was segregated. At best, the U.S. Civil Rights Movement was still more than a decade away. Anti-Semitism was rampant too both in the U.S. and throughout Western Europe, often with religious justification.[19] In fact, the allies arguably delayed their response to Hitler's concentration camps till the last possible

moment—until such recognition became useful as a war measure to transform capitalism's internecine struggle into a moral crusade.

Inter-Capitalist Competition

Rather, the origins of the conflict were in capitalist competition for control of Europe's political economy and the colonial world, including its markets, cheap raw materials and cheap labor. This too had been the driving force behind World War I. Already by the end of the 19th century, Germany had recognized that its earlier mentioned superior economic strength entitled it to the empires controlled by Great Britain, France and Russia. Schulze points this out.

> As their country's economic and political potential increased rapidly, many Germans began to see central Europe as too small a stage, as a cramped and confining theater. Without overseas territories, Germany was limited to modest economic development, within its own borders and an already saturated market. This was felt as humiliating by middle-class Germans, and—in comparison with their European neighbors—as discriminatory.[20]

Thus, the formation of the German Colonial Society and the Pan-German League in 1887 and 1891 respectively, made the establishment of German colonies in Africa and Oceania a major goal of German foreign policy.[21] Schulze identifies the forces behind such movements as the "liberal, property-owning middle class, the inheritors of the national movement, who now wanted to use their growing economic might to expand their influence and acquire a say in world affairs."[22] To say it directly, the forces behind World War I were capitalists, and World War I may be seen in terms of the First Inter-Capitalist War.

Having lost that conflict, Germany found the ambitions of its ruling class not only unmet, but further constrained. More specifically, the Treaty of Versailles deprived Germany of 20 percent of the territory it held before the conflict, including 10 percent of its population, more than 30 percent of its anthracite coal production, a quarter of its grain and potato harvest, 80 percent of its iron ore reserves, and 100 percent of its colonies and commercial fleet.[23] In this context, Adolph Hitler's famous call for *lebensraum* (living space) took on an urgent economic tone that would evidently connect not only with the patriotic sentiments of ordinary Germans for restoration of *das Vaterland*, but especially with the ambitions of the country's capitalist ruling class. They still wanted their colonies; they still wanted to dominate markets and set policy for the rest of the capitalist world.

Germany's Recovery From the Great Depression

It is at this point that Hitler's previously described economic policies connect directly with World War II and the salvation of capitalism in its darkest hour. While the German economy had revived under Hitler's "Keynesian" remedies, the United States and the rest of the capitalist world languished in economic hard times. In the U.S. case, this was largely because political obstacles prevented Roosevelt from applying Keynes with the same vigor Hitler had demonstrated. Roosevelt, after all, was not the "strongman" Hitler was. He did not have the same free hand the leader of the Third Reich (and other emerging fascist "strongmen") had in applying economic remedies for the Depression. Galbraith comments.

> Although the recession of 1937 made Keynes's ideas respectable in Washington, action to lift the level of employment remained half-hearted. In 1939, the year war came to Europe, nine and a half million Americans were unemployed. That was 17 percent of the labor force. Almost as many (14.6 percent) were still unemployed the following year. The war then brought the Keynesian remedy with a rush. Expenditures doubled and redoubled. So did the deficit. Before the end of 1942, unemployment was minimal. In many places labor was scarce.[24]

Here the thrust of Galbraith's words is to point out that the onset of World War II removed all caution about Keynesian remedies in the United States. So federal borrowing skyrocketed there to finance the war effort. Public spending on ordnance, planes, tanks, ships, rifles, howitzers, and uniforms performed the miracle. The United States workforce was fully employed. In other words, Hitler had forced Roosevelt's hand and (again unwittingly) had saved capitalism. Galbraith says as much.

> There is another way of looking at this history. Hitler, having ended unemployment in Germany, had gone on to end it for his enemies. He was the true protagonist of the Keynesian ideas.[25]

Nazi Elements Prevail

Besides arguing that Keynesian Hitler's example saved capitalism and emerged triumphant in the Second Inter-Capitalist war, there is a third reason for holding that Hitler's fascism prevailed in the end. That argument points out that those who served Hitler's Reich across Europe fared far better than their leftist opponents who had bravely resisted Nazi rule.[26] As a result, the advocates

of fascism (i.e. Nazi collaborators) became the policy-makers during the post-war period.

That is, the great fear of the victorious allies was that if democratic processes were allowed to function, socialists and communists would come to power, relativizing in the process the hegemony of the white supremacist, capitalist patriarchy represented by the United States, the main victor of the inter-capitalist struggle. For the U.S. (as they had been for Hitler), representatives of the left were the real threat. At the conclusion of the war, their menace had intensified, since they had gained great prestige in resisting Nazi occupation.[27] So, as Chomsky points out, the apparent victors made sure that Nazi friends assumed places at the helm of government leadership in Europe and elsewhere.[28]

> One aspect of this postwar project was the recruitment of Nazi war criminals such as Reinhad Gehlen, who had headed Nazi military intelligence on the Eastern Front and was given the same duties under the new West German state with close CIA supervision, or Klaus Barbie, responsible for many crimes in France and duly placed in charge of spying on the French for U.S. intelligence. The reasons were cogently explained by Barbie's superior, Col. Eugene Kolb, who noted that "his 'skills' were badly needed. To our knowledge, his activities had been directed against the underground French Communist Party and Resistance, just as we in the postwar era were concerned with the German Communist Party and activities inimical to American policies in Germany." Kolb's comment is apt. The U.S. was picking up where the Nazis had left off, and it was therefore entirely natural that they should employ specialists as anti-resistance activity.
>
> Later, when it became impossible to protect them from retribution in Europe, many of these useful folk were spirited to the United States or to Latin America, with the help of the Vatican and fascist priests. Many of them have since been engaged in terrorism, coups, the drug and armaments trade, training the apparatus of the U.S.-backed National Security States in methods of torture devised by the Gestapo, and so on. Some of their students have found their way to Central America, establishing a direct link between the Death Camps and the Death Squads, via the U.S.-SS postwar alliance.[29]

These words once again emphasize continuity between Hitler's fascism and the system enforced by the victors of the Second Inter-Capitalist War. Gehlen and Barbie were to continue precisely what they had done under Hitler, i.e. directing anti-communist operations in West Germany and France respectively.

Chomsky's words should be noted: "The U.S. was picking up where the Nazis had left off." Not only that, the activities were to be expanded—beyond post-war Europe into the colonies that so concerned Germans during Inter-Capitalist Wars One and Two. In Central America and other U.S.-sponsored National Security

202 | THE MAGIC GLASSES OF CRITICAL THINKING

States, particularly in Latin America, ex-Gestapo agents linked Death Camps and Death Squads re-employing identical methods.

Conclusion

Attentive readers have, no doubt, noticed that Part Three of our study has illustrated point-by-point the application of this book's ten rules for critical thinking. That, in truth, has been its purpose—to put flesh on the principles of Part Two by applying them to the system of capitalism whose emergence and development has been traced over the last four chapters.

And so those segments have:

1. **Reflected Systemically**, reviewing the emergence of capitalism in western history as a coping strategy of the elite to keep commoners at bay as the latter attempted to defend the deeply traditional position that the earth belongs to everyone.

2. **Selected Market** as providing the key to unlocking the mysteries of the resulting conflicts between capitalism and socialism, between colonizers and the colonized, and even between versions of "capitalist" economies mixed in favor of the rich on the one hand or the poor on the other.

3. **Rejected Neutrality** by attempting to lend a truly sympathetic hearing to viewpoints largely emanating from the world's majority residing in the Global South who have proven to be more open to philosophers of the working class, such as Karl Marx, than to philosophers of the ruling class like John Locke.

4. **Suspected Ideology**. The guiding image of Plato's Allegory led to the methodological suspicion that McMurtry's "ruling group mind" may have been at work in the fabrication of more congratulatory accounts of capitalism's emergence, colonialism's beneficence, and of the idiosyncratic nature of Hitler's fascism. Whether that suspicion has proven fruitful or not is, of course, left to the reader's own judgment.

5. **Respected History** by recognizing and giving greater prominence to the competing story of capitalism's emergence, colonialism's oppression, and Hitler's normalcy than to the less unified official accounts of those phenomena.

6. **Inspected Scientifically** by implying that the competing story has more internal coherence, external coherence, and explanatory value than the official story. Again, it is up to the reader to decide if that's true.

7. **Quadra-Sected Violence** by (1) exposing capitalism's structural oppression especially as exemplified in slavery, colonialism, and neo-colonialism,

(2) recounting the consistent resistance to such violence by peasants, workers, and heretics throughout western history, (3) portraying capitalism itself with its supporting police and militaries as reactionary responses to the self-defensive strategies of the working classes, and (4) identifying witch burnings, death camps, death squads, holocausts, carpet bombings, and the use of nuclear weapons as wholesale state terrorism dwarfing undeniable instances of its retail counterpart from below.

8. **Connected with Our Deepest Selves** by (1) implicitly distinguishing between the oppressive mind-based nature of the religion supportive of colonialism, neo-colonialism and even Hitler's Third Reich, and (2) re-evaluating medieval "heretics" as forerunners of liberation theology's revolutionary and practice-based activists joined in their struggles by "anonymous Christians" including atheistic communists.

9. **Collected Conclusions** by doing so in this very section of this chapter.

10. **Detected Silences** and given voice to history's silenced majority—to heretics, slaves, the colonized, rebellious workers, their philosophers, and to those exploited by neo-colonialism.

For Discussion

1. What new thoughts about Hitler and Fascism did you encounter in this chapter?
2. What was the chapter's basic argument?
3. Did you agree with that argument? Explain.
4. Do you agree that earth, air, fire, and water represent human patrimony, and should not be owned by anyone, nor denied to others simply because they do not have money to pay for them? Explain.
5. Do you agree that thoughts can never be owned as "intellectual property?" Explain.
6. Explain why you think Hitler was or was not a capitalist?
7. Why was Hitler so popular among capitalists and among workers?
8. Do you see any connections between Hitler and contemporary politicians?

Notes

1. For instance, a World War II ration book distributed in the United States provides the following rationale:

> A Fair Share for All: We cannot afford to waste food or give some any more than their fair share … That is why canned fruits and vegetables are rationed. That is why meat is going to be rationed. [Sharing] of some foods is the best and fairest way to be sure that every American gets enough to eat.

2. Jackson J. Spielvogel. *Western Civilization, Vol. 2*. 4th ed. Connecticut: Wadsworth Thomas Learning, 1999. 3 Vols. 794.

3. *Ibid.* 789.

4. Yet even here, according to Spielvogel, Hitler's program had a distinctly international dimension eerily evocative of promises associated with the current global economy. Spielvogel recalls, "After the German victories between 1939 and 1941, Nazi propagandists painted glowing images of a new European order based on 'equal chances' for all nations and an integrated economic community" (829).

5. Hagen Schulze. *Germany: A New History*. Trans. Deborah Lucas Schneider. Cambridge: Harvard University Press, 1998. 231.

6. Howard Zinn. *A People's History of the United States*. New York: Harper Collins Publishers, 1995. 567–568. Zinn points out that few recall, for instance, that during the 1940s, U.S. federal income tax rates assessed incomes over $400,000 at a rate of 91%. Government revenue collected in this way paid for populist programs that modestly redistributed income to the American working class and unemployed. Such redistribution found its way into workers' pay envelopes, but also took the form of "social wage."

7. Schulze. *Op. Cit.* 233.

8. Hitler's own rhetoric was pro-worker. However, the Spencerian foundation of his approach deprived workers of any entitlement to the wealth the Weimar leadership and left wing parties had been anxious to redistribute. Spencer's own words make this approach clear.

> Pervading all Nature we may see at work a stern discipline which is a little cruel that it may be very kind … Meanwhile, the well-being of existing humanity and the unfolding of it into this ultimate perfection, are both secured by the same beneficial though severe discipline to which the animate creation at large is subject. It seems hard that an unskillfulness, which with all his efforts he cannot overcome, should entail hunger upon the artisan. It seems hard that a laborer, incapacitated by sickness from competing with his stronger fellows, should have to bear the resulting privations. It seems hard that widows and orphans should be left to struggle for life or death. Nevertheless, when regarded not separately but in connection with the interests of universal humanity, these harsh fatalities are seen to be full of beneficence—the same which brings to early graves the children of diseased parents, and singles out the intemperate and debilitated as the victims of an epidemic. (qtd. in Spielvogel 714–715)

Such vision is not working-class friendly. In Spencer's world, the artisan suffers hunger. The laborer works hard, but experiences privations as a result of competition with stronger

fellow workers. Widows and orphans are left alone in their struggle for survival. Parents are ill. Infant mortality is high. The physically weak and improvident are victims of disease. Nonetheless, Spencer (and by extension Hitler and free market capitalism) pronounces all of this good and full of benefit for "universal humanity." None of this should sound strange and unfamiliar to contemporary participants in the New World Order.

9. Spielvogel. *Op. Cit.* 796.
10. *Ibid.* 796.
11. *Ibid.* 796.
12. Ibid. 796.
13. Ibid. 799.
14. Ibid. 800.
15. John K. Galbraith, John K. *The Age of Uncertainty.* Boston: Houghton Mifflin Co., 1977. 213–214.
16. Schulze. *Op. Cit.* 256.
17. Schulze. *Op. Cit.* 239.
18. Spielvogel indicates the terroristic intent of the allies in openly attempting to inflict civilian casualties, "American planes flew daytime missions aimed at the precision bombing of transportation facilities and war industries, while the British Bomber Command continued nighttime saturation bombing of all German cities with populations over 100,000. Bombing raids added an element of terror to circumstances already made difficult by growing shortages of food, clothing, and fuel" (838).

 Schulze even more clearly emphasizes the civilian nature of allied bombing targets, "German propaganda spoke of 'terror attacks,' a term that accurately reflected the intentions of the Allied strategists, for the primary aim of the bombing raids was not to reduce Germany's military potential but to strike terror into the population and leave it demoralized. They had limited success in this, but the material consequences of the bombing were devastating. More than half a million civilians lost their lives in the attacks, approximately four million houses and apartments were destroyed, and the civilian populations of the major cities had to be evacuated" (278).
19. For instance a 1930 Catholic encyclopedia published in Germany held that "political anti-Semitism" was allowed, provided it used morally acceptable means (Johnson 490).
20. Schulze. *Op. Cit.* 184.
21. *Ibid.* 185.
22. *Ibid.* 184.
23. *Ibid.* 203.
24. Galbraith. *Op. Cit.* 221.
25. *Ibid.* 221.
26. Spielvogel says that "After the invasion of the Soviet Union in 1941, Communists throughout Europe assumed leadership roles in the underground resistance movements. This sometimes led to conflict with other local resistance groups who feared the postwar consequences of Communist power. Charles de Gaulle's Free French movement, for example,

thwarted the attempt of French Communists to dominate the major French resistance groups" (831).

27. Again, Spielvogel supports this point, "The important role that Communists had played in the resistance movement against the Nazis gained them a new respectability and strength once the war was over. Communist parties did well in elections in Italy and France in 1946 and 1947 and even showed strength in some countries, such as Belgium and the Netherlands, where they had not been much of a political factor before the war." (862)

28. Schulze makes a similar observation. He refers to the early post-war German Republic "which allowed many officials, judges and diplomats from the Nazi era to continue their careers untouched" (319).

29. Noam Chomsky. *On Power and Ideology: the Managua lectures.* Boston: South End Press, 1987. 31.

Fascism Today, Drawing Conclusions, and Breaking Silence

Continuation of Hitler's System in Globalization and the War on Terrorism

We've arrived at our final section, hopefully having broadened our understandings of critical thinking.

Escape the Cave, has been our study's unifying injunction. Develop world-centric perspective. Take sides. Understand the system. See the structural violence pervading it all. Recognize its hidden and destructive coercive character as experienced by the world's impoverished and silenced majority. Unlearn official history distorted by the rich minority's alternative facts and fake tales about heroic kings, presidents, generals, and CEOs. Judge the ideological lies that defend system's destructive ways by unmasking their incoherence and contradictions. Draw conclusions and live accordingly. Risk wearing Baba Dick Gregory's magic glasses for the rest of your life.

That's what critical thinking—critical living—is about.

Understood in this way, the discipline tells us that, despite the obfuscations we've learned so well from fake education, fake history and economics, fake religion and politics, what needs understanding is pretty simple. The earth that originally belonged to everyone has been the object of privatization efforts tending to benefit only a tiny minority of the rich and powerful. Nonetheless, the world's impoverished majority continues to resist. They have typically been inspired by the ideals of democracy and a world with room for everyone.

As we'll see, Hitler and his ilk consistently referred to those ideals as "Jewish madness." That's because, at a deeper level, the visions evolved from a biblical tradition founded (in terms of liberation theology) by former slaves expressing overriding concern for the poor, widows, orphans, and immigrants. They, of course, are also the concerns of socialism and communism as earlier described.

In Germany's context and in their conviction about the earth's public ownership, the Jews were joined by Marxist atheists and others who shared the same ideals. Tragically, along with homosexuals, gypsies, blacks, and other "misfits," the latter also joined with their Hebrew sisters and brothers in the gas chambers and ovens of Buchenwald, Auschwitz and elsewhere in which Hitler slaughtered more than six million.

Hitler apparently lost the war. However, as argued in Chapter 16, his system prevailed, as the United States assumed the role to which *der Fuhrer* aspired. In the face of opposition to its new Reich, as CIA analyst John Stockwell testified in Chapter Nine, America too committed its ongoing holocaust. When he shared his testimony in 1987, Stockwell estimated that America's "Third World War" against the planet's poor had, like Hitler's gas chambers and ovens, claimed at least six million lives. Since then, the count has risen dramatically every day. And there is no end in sight.

But, as we'll see presently, the resistance has also continued with many taking their inspiration from the same source that so frightened Adolph Hitler. Again, it's the Bible with its prophetic tradition on the side of those poor, widows, orphans, and immigrants. It inspires resistance not only in Christians influenced by liberation theology, but in Muslims who are also "People of the Book."

With all of this in mind, the chapter that follows will detail the shape of overt U.S. fascism as it has played out in the Global South since the end of the Second Inter-Capitalist War. It will suggest that the chickens have come home to roost in the neo-fascism emerging in our own day in response to capitalism's overwhelming crisis. Chapter 18 will describe that crisis and suggest remedies.

So let's begin. Consider first, the fascism sponsored by the U.S. in the Third World, especially in its "backyard," Latin America.

Third World Yankee Fascism

Once again, John Stockwell already reviewed the broad sweep.

Start by donning your magic glasses and specifically recognizing the extension of Hitler's neo-fascist system into the Third World. There are at least four points of continuity between Hitler's fascism and what has been accurately described as the neo-fascism of the contemporary system of globalization.[1] Once again, these

coincidences support the thesis that Hitler's policies have ultimately proven triumphant in the present global arrangement. The coincidences include, first of all, an arrangement of economy mixed in favor of the world's white elite. Secondly, Nazism and globalism share a very evident Darwinian and totalitarian character along with an attendant, comprehensive information control. Thirdly, Hitler's fascism and the process of globalization come together in their identification of scapegoats and use of state terror against them with utter disrespect for human rights. Lastly, Hitler's fascism and its new form share a virulent streak of religious antagonism that the globalist process expresses in its persecution of Muslims and of liberation theology, whose spirit, we saw earlier in the cases of medieval heretics, has always been connected with peasant defense of the commons.

White Supremacy and Racism

Like Hitler's and the other interventionist economies of the 1930s, today's globalized version represents an arrangement mixed in favor of the predominantly white elite of the world. To begin with, despite rhetoric to the contrary, the contemporary "free market" is highly regulated and subject to intervention. Accordingly, forces such as the U.S. Federal Reserve Board, the International Monetary Fund, World Trade Organization, World Bank, and G20 exercise potent regulatory options. These determine important factors such as interest rates, terms of trade, and loan rescheduling premised on policies such as mandated currency devaluation. Such regulation highly complicates agreements such as the North American Free Trade Agreement (NAFTA), a centerpiece of the new global economy. Thus, the actual NAFTA text runs to some 750 pages of highly technical, arcane and often impenetrable language.[2] The purpose of such regulation is to make sure that it favors the world's wealthy who comprise about 25 percent of the world's population, with most of them white and of European extraction.[3] This "stacking of the deck" in favor of the elite is indicated in a Brookings Institution defense of globalization against its critics. The authors take pains to assure their readers that the NAFTA, for example, is tilted in favor of the United States.[4] Similarly, the Brookings report reassures its readers that the bailout of the Mexican Peso in 1994 actually benefited America.[5]

Social Darwinism and Propaganda

Because of the disappearance of viable alternatives to capitalism, the Darwinian character of the contemporary juncture in the system's development no longer finds

it necessary to pretend that the capitalism's benefit will eventually trickle down to those unable to fend adequately for themselves. The weak are simply losers in a dog-eat-dog world. When it even finds it necessary to justify such exclusion from market largesse, "compassionate" fascism would rationalize it in terms of "tough love."[6] Already in the late '60s Garrett Hardin had shown the way towards this first link of the global economy to Nazism in his famous essay on "Lifeboat Ethics."[7]

Globalized Totalitarianism

Similarly, globalization's totalitarian nature offers another connection to Nazism. Following Hannah Arendt, Hinkelammert defines totalitarianism as the reduction of an essentially rich and multi-faceted human experience to a single relationship with a "perfect institution." Thus Hinkelammert describes a totalitarianism that

> … reduces the subject to a single social relationship and isolates it in order to make the perfect institutionality appear as uniquely necessary. Within the socialist society, Stalinist totalitarianism originated from a concept of perfect planning derived from socialist relations of production. Its perfect institutionality therefore was the planning mechanism. In capitalist society, the first totalitarian movement arose in German Nazism which derived its perfect institutionality from the imagination of a racial purity constituting its totalitarian society as a society of war. In the contemporary totalitarian movement, perfect institutionality comes to be the market projected as total market isolating subjects and reducing them exclusively to market relationships.[8]

On Hinkelammert's analysis, totalitarianism begins from the conviction that there exists an institution to which all human relationships must be subordinated. The institutions in question are considered somehow "perfect" by their proponents. For Stalin, the perfect institution was the planning process represented by the decisions of his socialist apparatchiks. No one was allowed to question their decisions with impunity. Similarly, for Hitler, the perfect institution was a permanent war against evil waged for the advancement of the world's natural rulers, its superior race and its national center. Sacrifice of life and subordination of all else to that institution was required of every good German. In its contemporary form, "market totalitarianism" finds "perfect institutionality" in the free market and its governing laws. On this arrangement, all human relationships, including the most intimate are understood and calculated according to market concepts such as cost and benefit, supply and demand, private ownership, competitiveness, efficiency, and contractual obligations. Nothing else is needed to explain or organize any aspect of human life.

Such ideology has delivered into the hands of international capitalism a propaganda system more complete than any devised by Hitler. It embraces media of all types. In the Third Reich, Joseph Goebbels was propaganda minister. Under his leadership, intellectuals and artists found their work suppressed, or they were forced into emigration.[9] Similarly treated were dissenting school teachers and especially university professors. Dissenting public voices were not to be heard.

In like manner, under the sway of global capitalism, the power of money rather than the common good has become the determinant of what people see and hear. In Third World situations, such control has been more overtly Hitlerian than in countries belonging to "the center." Even at the center, however, media ownership effectively renders judgment about "news fit to print." Just after the first Gulf War Hinkelammert explained

> (N)either are there means of communication capable of criticizing the system. Nor does short wave radio have news from outside, for now there really is no outside. Freedom of opinion in the means of communication has lost its meaning, insofar as the media suppose that we live in a society which has no alternative. Today control of opinion is planetary—something we experienced for the first time with information about the war against Iraq. There was no alternative information in the entire world; all the means of communication repeated the same story.[10]

State Terror Against Scapegoats

A third connection between Nazism and globalization is the employment of state terror against scapegoats. Those who would interfere in the total market of the New World Order are deemed enemies of "freedom." They include humanists, teachers, union organizers, social workers, feminists, racial integrationists, cultural pluralists, environmentalists, and those whose religious convictions give them overriding concern for "the least of the brethren." These are the rough equivalents of the "official enemies" fascism requires in all of its forms to explain the evils of society. When those who are designated "deviants" organize to resist market totalitarianism, they typically are not hired, lose jobs or are otherwise marginalized by the system. When they become truly threatening, they qualify as legitimate targets of death squads every bit as efficient and brutal as the Nazi S.S.

As Chomsky earlier indicated, this is what has happened routinely throughout the Third World under fascist military regimes, which served international capitalism throughout the post-war period. As earlier indicated, a short list of the Nazi types receiving such U.S. support include Diem in Vietnam, Saddam Hussein in Iraq, Resa Palavi in Iran, Manuel Noriega in Panama, three Somozas in Nicaragua,

the Duvaliers in Haiti, the nameless generals of Argentina and Brazil for about twenty years after 1964, Suharto in Indonesia, Marcos in the Philippines, Pinochet in Chile, Mobutu in Zaire, Park in South Korea, Strossner in Paraguay, Botha in South Africa, Smith in Rhodesia, and Batista in Cuba. These lesser Hitlers are together responsible for the deaths of millions, far in excess of the victims attributed to Germany's Holocaust. And these regimes are by no means confined to the Cold War era.

For instance, German Gutierrez has shown in exquisite detail how Colombia's infamous military continues this tradition in the post-Cold War world. Thus critics of globalization in Colombia are treated as subversives, terrorists and enemies of the state. They are imprisoned without trial, tortured and/or assassinated.[11] In Colombia more than 5000 such opponents have lost their lives to the Colombian military and paramilitary forces, which are worthy successors to the fascism's Brown Shirts, Black Shirts and Gestapo.[12] Despite unanimous condemnation of such policy by international human rights organizations, the United States continues to offer unqualified support to the Colombian government, all in the name of its War on Drugs.

In fact, the U.S. has consistently refused to make Colombia's human rights record a factor in determining whether or not the U.S. would continue extending aid to Colombia's military.[13]

Religious Persecution, Anti-Semitism, and Liberation Theology

Similarly, the right to free practice of religion has been routinely denied by globalized capitalism, as it was under Hitler's regime. For Hitler, of course, the objects of religious persecution were preeminently Jews. In today's system, the objects of religious persecution are Muslims (the Arabs among them being Semites too), and practitioners of liberation theology.

On the one hand, the traditional association of Jews with the banking system, usury and capitalism made them ideal scapegoats for the more undeniable, endemic dysfunctions of that system. On the other hand, their tradition's dissent from unadorned capitalism's Spencerian worldview made them especially abhorrent to Hitler's Third Reich. That is, the Jewish tradition showed largely consistent commitment to the very "widows and orphans" whom Spencer was so willing to write off. With this in mind, Hitler never missed a chance to associate Jews with Bolshevism.[14] In fact, Schulze centralizes the defeat "Jewish Bolshevism" with the overriding purpose of World War II.

... the goal was, in Hitler's own words, "initiation of the final stage of battle against the mortal enemy of 'Jewish-Bolshevism'" in the Eurasian dominions of National Socialism.[15]

Hinkelammert elaborates the thought,

> The whole bourgeois world considered the Soviet Union as the embodiment of "Jewish Bolshevism." Previous socialist movements throughout the nineteenth century were denounced as "Jewish." The anti-socialist campaign always was a campaign with strong anti-Semite emphasis. This was true not only in Germany, but also in France, England and the United States. Socialism was considered "Jewish madness".[16]

Hitler's own words reveal the ultimate motivation for his anti-Semitism,

> The Jew believes he must subdue all of humanity in order to achieve for it heaven on earth ... While he imagines that he is elevating humanity, he tortures it to the point of despair, paranoia and perdition. If no one stops him, he will destroy it ... despite the fact that he himself faintly realizes that he is also destroying himself ... He must destroy all power, even though he suspects that doing so inevitably leads to his own destruction; this is the point. If you will, it is the tragedy of Lucifer.[17]

To reiterate, the anti-Semitism of Hitler's Third Reich cannot be understood apart from the context of anti-socialism set by the October, 1917 Revolution and the movements which led up to it. From that point on, if not from the middle of the nineteenth century, socialism was constantly referred to as "Jewish madness," and as "Jewish materialism"—phrases taken from the writings of Luther and Calvin.[18] In this light, Hitler's persecution of the Jews was part of his offensive against communism, and against the capitalist liberalism in the Weimar tradition. As Hinkelammert indicates, the Nazi Holocaust was really an attempt to kill the Jewish God, and as such was Nietzschean.[19]

Hitler turned the full force of his police state against the Jews following the burning down of the Reichstag or Chamber of Deputies in 1933. This, according to the Nazis, was a crime of unprecedented heinousness committed by communists, always, as we have seen, associated with the Jews. It was the equivalent of regicide and deicide combined. From then on, the Nazis said, the usual coordinates of good and evil, legal and illegal no longer pertained.[20] The rules of law could be suspended for the duration of the emergency, which proved to be all but permanent. There followed arrests without warrant, suspension of habeas corpus and rules of evidence, military trials, summary executions, and, of course the rounding up of millions, concentration camps and genocide. Again, it is Spielvogel who paints the picture for our students.

On the day after a fire broke out in the Reichstag building (February 27), supposedly set by the Communists, but possibly by the Nazis themselves. Hitler was also able to convince President Hindenburg to issue a decree that gave the government emergency powers. It suspended all basic rights of citizens for the full duration of the emergency, thus enabling the Nazis to arrest and imprison anyone without redress. Although Hitler promised to return to the "normal order of things" when the Communist danger was past, in reality this decree provided the legal basis for the creation of a police state ... The crowning step of Hitler's 'legal seizure' of power came after the Nazis ... sought the passage of an Enabling Act, which would empower the government to dispense with constitutional forms for four years while it issued laws that would deal with the country's problems ... The Enabling Act provided the legal basis for Hitler's subsequent acts. He no longer needed either the Reichstag or President Hindenburg. In effect, Hitler became a dictator appointed by the parliamentary body itself.[21]

The parallels with the treatment of Muslims and the U.S. Constitution following the attacks of September 11th, 2001 are clear. Islam, of course, is based on the Jewish Testament, as well as on the Holy Koran. However, Islam has been less successfully integrated into the western value system than has Judaism. In fact, its mullahs typically disdain Muslims who have accommodated themselves to western ways. This is especially true when the accommodators in question rule nations such as Saudi Arabia, and enrich themselves by delivering to Westerners treasures rightfully belonging to Muslims first. More specifically, Islam's system of justice, its rejection of consumerism and its interpretation of "woman's place" in society are all largely at odds with Western attitudes and aspirations. Nonetheless, Islam's practitioners remain in control of some of the world's most significant deposits of fossil fuel, the life-blood of western economy. With all of this in mind, it has become incumbent for Neo-Nazi globalization to align itself with suitably obedient and westernized Muslim elite on the one hand, and to demonize less tractable Islamic culture on the other. Both approaches represent attempts, not only to wrest from the Middle East its oil reserves, but to exclude Islamic majorities from the stagnating benefits of globalization earlier described. That is, in the light of the threat to globalization posed by a worldwide recession, the West has adopted a coping strategy of excluding Muslims and the East from the re-division of the world's already existing wealth.[22]

September 11, 2001

As Dierckxsens points out, the broad lines of this sort of ideological repudiation of eastern culture were evident well before the attacks of September 11th. Samuel Huntington made them clear in his highly influential essay, "The Clash of

Civilizations," published in *Foreign Affairs* in 1993. There, Huntington described the Culture War that, he predicted, would replace the recently ended Cold War. The new struggle would pit "the West against the Rest" whose religious foundations were fundamentalist. Muslims' rejection of western values made them particularly menacing. Their threat, Huntington predicted, would have to be met by a clear show of western superiority in the economic, political, military and cultural realms.[23]

The attacks of September 11th provided the occasion for fulfilling Huntington's predictions. In this sense, the attacks were comparable to the burning of the Reichstag. After 9/11, as in 1933, the coordinates of good and evil could be ignored with impunity. In fact, following the attacks the Bush administration initiated a whole series of policies reminiscent of Hitler's after the Reichstag conflagration. These included extending to the CIA authority to kill U.S. enemies on the authorization of the president's judgment alone. The extension removed legal restraints on such power introduced in the 1970s, and raised questions about the implied legalization of death squads.[24]

Policy decisions also included justification of alliances with nations exhibiting little regard for human rights, such as Uzbekistan, Iran, Syria and Sudan.[25] Even support of Afghanistan's Northern Alliance shared this characteristic.[26] Additionally, President Bush decided to classify presidential records indefinitely, reversing in the process the 1978 Presidential Records Act. The decision moved Vanderbilt University historian Hugh Graham to remark, "The executive branch is moving heavily into the nether world of dirty tricks, very likely including directed assassinations overseas and other violations of American norms and the UN Charter. There is going to be so much to hide."[27] On November 12th, President Bush also signed the sweeping anti-terrorist Patriot Act of 2001 that would permit previously forbidden surveillance of U.S. citizens, search and seizure without warrant, and extended detention of terrorist suspects without charges filed. The act would also, for example, classify as "terrorist" the act of throwing a rock through a window during an otherwise peaceful demonstration, or contributing money to groups involved in any kind of armed resistance against governments.[28]

President Bush furthermore proposed the institution of military tribunals that would secretly try terrorist suspects on the presumption of their guilt, rather than their innocence, in clear contravention of key principles of standard U.S. jurisprudence. Referring to those appearing before the tribunals, Vice President Dick Cheney said, "They don't deserve the same guarantees and safeguards we use for an American citizen."[29] It was particularly the military tribunal idea that led even conservative critics like William Safire to accuse the president of establishing a dictatorship. Safire wrote: "(Bush's) kangaroo court can conceal evidence by citing

national security, make up its own rules, find a defendant guilty even if a third of the officers disagree, and execute the alien with no review by any civilian court."[30]

Additionally, directly connecting their decision with September 11th, the U.S. Congress awarded the President "fast track" authority over trade agreements, abdicating in the process its right to debate and amend such bills. All of these measures were seen by critics directed against those protesting corporate globalization, as well as against those supporting armed resistances in Colombia and Chiapas.[31]

Finally, issues of national identity cards, the legalization of torture and the use of tactical nuclear weapons in Afghanistan were all seriously proposed and debated in public. Foreigners could be profiled and rounded up without warrant for indefinite detention. *Habeas Corpus* could be suspended and military tribunals introduced. Bombing could force Afghan refugees, for example, to concentrate their populations at the Pakistan border, where millions would starve in a "kinder and gentler," but equally effective genocide. Under the new emergency situation, that promised to be indefinite, Americans protesting such measures would be looked on as unpatriotic. If their protests involved injury to property, they might be prosecuted and punished for terrorist acts.

All of this is not to say that the anti-Semitic nature of the new Nazism is entirely absent from its globalized form. Instead, it continues in a disguise assumed long before the events of September 11th. The disguise is necessary because in the aftermath of the Holocaust, direct persecution of Jews has become politically impossible in the West. Nonetheless, the same persecution has continued as a repression of liberation theology, itself firmly based on Jewish Testament values.[32]

Here it should be emphasized that as under Hitler's regime, persecution of Christianity at the hands of globalization is not universal, but selective. Versions of Christian faith not emphasizing the prophetic social justice tradition are exempt. Thus it was even possible to claim that the Nazi movement was itself specifically Christian, as it did in the 1920 version of the Nazi Party Program.[33] This enabled Hitler to enlist Germany's mainline churches on his side. Catholics were also initially supportive. Once again, Pope Pius XII called Hitler "an indispensable bastion against Russia."[34] But not all Christians were persuaded; those who were not suffered severe persecution.

> In the Lutheran Church the German Christian movement flourished, which took its orientation from the racist-nationalist ideology and Fuhrer-principle of the Nazis. At the Barmen Synod held in May 1934 their opponents formed the Confessing Church, whose members tirelessly attacked the National Socialists despite government reprisals and arrests. Sympathy for the new regime was not lacking among the Catholic clergy, especially after the concordat signed with the Vatican on July 20, 1933. Yet resistance also increased within the Roman Catholic Church as news spread of the

Nazis' euthanasia plans, reaching its height with issuance of the papal encyclical *Mit brennender Sorge* (With deep anxiety) in 1937.[35]

Once again, not all Christians were welcomed in the Third Reich. Dietrich Bonhoeffer's Confessing Church resisted Nazism in the name of gospel values. Some, like Bonhoeffer himself, even joined a conspiracy intended to assassinate Hitler. They suffered the inevitable consequences. Bonhoeffer was executed in prison in 1945. The Catholic Church was more muted in its "anxiety" about Hitler. Concern was largely based on "pro-life" concerns around the issue of euthanasia, not on the extermination of Jews, which the then reigning pope, Pius XII, still stands accused of ignoring.[36]

In the same way, the contemporary system of globalization professes compatibility with Christianity. In the United States, Republicans who most overtly identify with free enterprise theory, boast of fundamentalist Christians as their single most powerful constituent group. Organizations like the Christian Coalition and Moral Majority stood four-square with globalist practice, apparently approving of its social Darwinism, while wringing hands over the theory's biological counterpart.

Meanwhile, other readings and practices of the Christian Tradition—most notably that of liberation theology—were vilified and persecuted without apology, and without even the least public perception that assassinations, disappearances, or torture sessions against their adherents even constituted "religious persecution." More particularly, in El Salvador, more than 60,000 Catholics could be killed (mostly by government forces and death squads), with the same lack of perception. Theologians espousing liberation theology could be assassinated; so could nuns serving the poor; even an archbishop like Oscar Romero could suffer the same fate—again with almost no one mentioning the phrase "religious persecution" in connection with capitalism or globalization. Those supporting globalization could even circulate handbills emblazoned with the slogan, "Be a patriot and kill a priest" and still receive U.S. aid to the tune of one million dollars a day.[37] One can only imagine what accusations might be formulated if identical occurrences had taken place under a communist regime such as Cuba.

For Discussion

1. Explain why it does or does not make sense to identify Hitler as a capitalist.
2. How does this chapter describe the survival of Hitlerism without Hitler since the end of the Second Inter-Capitalist war?
3. Explain the connections between communism, Judaism, and liberation theology.

Notes

1. Pablo Richard. "Teologia de la solidaridad en el contexto actual de economia neoliberal de libre mercado." *El Huracan de la Globalizacion.* Franz J. Hinkelammert, ed. San Jose, Costa Rica: DEI, 1999. 226–227.
2. Ralph Nader and Lori Wallach. "GATT, NAFTA, and the Subversion of the Democratic Process." The Case against the Global Economy: and for Turn Toward the Local. Jerry Mander and Edward Goldsmith, eds. San Francisco: Sierra Club Books, 1996. 100.
3. D. Michael Rivage-Seul, and Marguerite Rivage-Seul. *A Kinder and Gentler Tyranny: illusions of a new world order.* Connecticut: Greenwood Publishers, 1996. ix.
4. Gary Burtless, Robert Z. Lawrence, Robert E. Litan, Leslie Fulbright, and Robert J. Shapiro. *Globaphobia: Confronting Fears about Open Trade.* Washington, Brookings Institution Press. Burtless et al write:

 Some critics of the postwar consensus in favor of free trade have charged that the United States has received the short end of the stick, having been forced to open its economy to a greater degree than other countries. Clearly, the U.S. economy is more open than many others, and has been so for the past fifty years. But the changes in trade barriers resulting from past trade deals have also tilted strongly in our favor. Under the Uruguay Round agreement, for example, the United States will lower its tariffs by about 2 percentage points, while other nations must chop theirs between 3 and 8 percentage points. Likewise, under the North American Free Trade Agreement (NAFTA) ... Mexico has pledged to eliminate its tariffs on U.S. products, which averaged about 10 percent before the agreement, while the United States agreed to eliminate the 4 percent duties previously levied on Mexican exports (30–31).

5. *Ibid.* 57.
6. Morris Goldstein, a former top official at the International Monetary Fund actually used this paternalistic and patronizing phrase in relation to the IMF's refusal to assist Argentina after the country's economic collapse. Goldstein said, "I think the tough love approach is right. It's not the free market that got Argentina into trouble." Martin Crutsinger. "Argentine Aid Tied to Economic Reform: U.S., IMF want plan in place before talks start." *The Lexington Herald-Leader* 4 January 2002, A5.
7. Garrett Hardin. "The Tragedy of the Commons." *Science,* **1968: 1243**-1248.
8. Franz J. Hinkelammert. *Democracia y totalitarismo.* San Jose, Costa Rica: DEI, 1987. 205.
9. Hagen Schulze. Germany: A New History. Trans. Deborah Lucas Schneider. Cambridge: Harvard University Press, 1998. 250.
10. Franz J. Hinkelammert. "Capitalismo sin alternativas?" *Pasos* 37, (Sept./Oct. 1991). 11–23.
11. German Gutierrez. "Colombia: la estrategia de la sinrazon." *El Huracan de la Globalizacion.* Ed. Franz J. Hinkelammert. San Jose, Costa Rica: DEI, 1999. 193.
12. *Ibid.* 188.
13. *Ibid.* 103–109.

14. Again, Spielvogel suggests this: "In Hitler's view, the Russian Revolution had created the conditions for Germany's acquisition of land to the east. Imperial Russia had only been strong because of its German leadership. The seizure of power by the Bolsheviks (who, in Hitler's mind, were Jewish) had left Russia weak and vulnerable." Jackson J. Spielvogel. *Western Civilization, Vol. 2*. 4th ed. Connecticut: Wadsworth Thomas Learning, 1999. 3 Vols. (816).

15. Schulze. *Op. cit.* 27.

16. Franz J. Hinkelammert. *El grito del sujeto: del teatro-mundo del evangelio de Juan al perro-mundo de la globalizacion*. San Jose, Costa Rica: DEI, 1998. 164.

17. *Ibid.* 165.

18. *Ibid.* 155–162.

19. Although there is no direct evidence that Hitler actually read Nietzsche, it is clear that he was heavily influenced by the Ludendorf Movement which espoused Nietzsche's understanding of war, Super-man, master-race, anti-Semitism and death of God. Schulze. Op. cit. 194-97.

20. Franz J. Hinkelammert. *El grito del sujeto ...* 46.

21. Spielvogel. *Op.cit.* 940.

22. Wim Dierckxsens. *Los limites de un capitalismo sin ciudadania*. San Jose, Costa Rica: DEI, 1998. 35.

23. Samuel Huntington. "The Clash of Civilizations." *Foreign Affairs* Summer 1993: 35.

24. Barton Gellman. "CIA Has Authority to Kill U.S. Enemies." *The Lexington Herald-Leader* 28 October 2001, A8.

25. Jeff Jacoby. "U.S. Trying to Catch One Set of Terrorists by Embracing Others." *The Lexington Herald-Leader* 14 October 2001.

26. William Douglas. "Northern Alliance Has Poor Human Rights Record." *The Lexington Herald-Leader* 16 October 2002, A4.

27. George Lardner Jr. "Bush Curbs Release of Executive Papers." *The Lexington Herald-Leader* 2 November 2001.

28. Jack Chang, and Leslie Fulbright. "Rights Activists Fear U.S. Will Abuse Power under Patriot Act." *The Lexington Herald-Leader* 13 November 2001.

29. Anne Gearan. "Military Trials Would Allow Fewer Rights to Terrorism." *The Lexington Herald-Leader* 15 November 2001.

30. Safire, William. "Seizing Dictatorial Power." *New York Times*. N.p., 15 Nov. 2001. Web. 16 May 2017.

31. This global economic dimension of the September 11th attacks was by no means lost on the U.S. leadership. U.S. Trade Representative, Robert Zoellick, directly linked the terrorist attacks with opposition to U.S. trade policy and globalization. He said:

On September 11, America, its open society and its ideas came under attack by a malevolence that craves our panic, retreat and abdication of global leadership ... This president and this administration will fight for open markets. We will not be intimidated by those who have taken to the streets to blame trade—and America—for the world's ills.

Clearly, then, the September 11th attacks had in no way caused administration officials to take its eyes off the ball of trade globalization as its ultimate priority. Zoellick even used the occasion to call for "trade promotion authority" (i.e. "Fast Track" powers to push through Congress regional trade pacts without debate or amendment). The Trade Representative's words also made it clear that the crisis would be used to discredit opponents of globalization by opportunistically linking them with the September 11th terrorists.

32. Pablo Richard. *Op. cit.* 232.
33. Point #25 of the Program reads, "We demand freedom of religion for all religious denominations within the state so long as they do not endanger its existence or oppose the moral senses of the Germanic race. The party as such advocates the standpoint of a positive Christianity without binding itself confessionally to any one denomination." M. Gregory Kendrick, Loretta O'Hanlon, and Janice Archer. *Documents of Western Civilization, Volume II: 1550 To Present.* Connecticut: Wadsworth Thomas Learning, 1999. 192.
34. Paul Johnson. Johnson, Paul. *A History of Christianity.* New York: Atheneum, 1977. 490.
35. Schulze. *Op. cit.* 253.
36. Johnson. *Op. cit.* 491.
37. Lernoux, Penny. *Cry of the People: The Struggle for Human rights in Latin America*: 61, 76.

Capitalism's Contemporary Crisis and the Rise of Neo-Fascism

What we have seen so far suggests that acquainting oneself with history by a careful and critical study of available sources such as text books, the daily paper and even government documents does indeed reveal the operative values of the U.S. system since the turn of the 19th century. It shows the reasons for the 9/11 "Attack on America" to be much deeper and more systemic than has been allowed, even by most critics. The roots of "Muslim rage" identified in various publications since September 11th are not isolated incidents, missteps or errors on the part of the United States, but exactly what the capitalist system does when subjected to crisis. It routinely endorses a police state, suspends civil rights, and engages in religious persecution, sponsors death squads, kangaroo courts and torture.

For many, that sort of response to capitalism's current crisis is intensifying before our very eyes in this second decade of the 21st century. Critical thinking demands understanding its nature and the alternatives it presents.

The Nature and Origins of the Current Crisis

According to economist, Richard Wolff, capitalism today is in the deepest crisis he has seen in his lifetime of more than 75 years.[1] And if we define fascism as

"capitalism in crisis," it makes sense that we are witnessing today a rebirth of fascism across the planet.

Fascism, recall, is police state capitalism—or rather an economy mixed in favor of the economic and social elite and enforced by police and military forces. Fascism's ideology tends to blame the dysfunctions of its system on the most vulnerable members of society—Jews in the case of Nazi Germany, but also immigrants, people of color, the disabled, the poor, and those whose sexuality does not conform to binary heterosexual patterns. As we've seen in the previous two chapters, that's the type of economy the United States imposed on virtually the entire Third World since the end of the Second Inter-Capitalist War.

The Contemporary Crisis

This brings us to the specifics of the present day and the re-emergence of neo-fascist tendencies in the United States and Western Europe. Again, according to Professor Wolff, it has been brought on by a crisis that has seen profits of capitalists themselves skyrocket, while the wages of workers in the traditional centers of capital have remained flat over the last 40 years or more.

Those phenomena have been produced by five main changes in society and the workplace during that time period, viz. (1) completion of participants' recovery from the destruction of the Second Inter-Capitalist War in the early 1970s, (2) the massive entrance of women into the workforce, (3) the introduction of computers and robots into offices and factories, (4) the offshoring of industrial processes to low wage havens in the Global South, and (5) the emergence of unsustainable national and personal debts. All of these developments taken together have created huge income disparities. They have increased profits for employers and driven down wages for workers. The aforementioned crisis ensued.

To begin with, the destruction of two inter-capitalist wars along with a whole series of 20th century revolutions, most notably in Russia and China, left much of the world in rubble. So it wasn't until the '70s that the afflicted nations got completely back on their feet. For the United States (virtually untouched by the wars' destruction), this recovery meant that markets gradually dried up for many of its products that were subsequently produced locally, for instance, in Europe and Japan.

The whole process affected labor forces everywhere. The war had empowered many women, who while men were off fighting the war, stepped into the productive industrial jobs previously closed to them. This not only gave birth to the women's movement, but exercised downward pressure on wages, since the pool of

available workers had expanded and women's traditionally lower wages were more attractive to employers.

The moon landing of 1969 signaled the dawn of the cybernetic age of computers and robots. These "labor saving" devices increased labor productivity, but at the same time eliminated huge numbers of jobs. However, instead of shortening the work day, capitalists took advantage of the advances to pocket the revenue produced by the more efficient labor force, while labor's wages remained stagnant.

In the wake of the computer and robot revolution, capitalists eventually experienced what Dr. Wolff calls "a eureka moment." It dawned on them that advances in cybernetics, along with strides in communication and transport capabilities by air and sea would afford opportunity to move their factories away from the high wage centers where capitalism was born to low wage countries previously confined to producing raw materials and agricultural products. Computers, surveillance devices, phones, and faxes empowered capitalists to employ workers for less than $1.00 per hour, instead of $20 or more at home. This led to greatly increased profits and a massive outflow of production to places like China, India, Brazil, and Vietnam.

All of this exercised severe downward pressure on wages in the developed world. For workers there now found themselves in direct competition with what they considered virtually slave labor. In efforts to persuade their employers not to abandon them, they proved willing to work longer hours for lowered pay and reduced benefits in health care, pensions, and the other concessions they had won in the post-war period, when labor was in short supply and trade unions were strong.

Meanwhile governments across the world lowered taxes on corporations in developed countries to keep them from moving to tax havens abroad, and in the less developed world, to lure them there. The result was a drying up of funds to provide public services.

Individual households coped with this situation of lowered income by working longer hours, working more than one job, and/or by borrowing money to maintain the living standard to which they had become accustomed. (The credit card industry did not emerge until the 1970s; before that, credit cards were available chiefly for traveling businessmen). At the same time, governments borrowed massively as well to keep voters happy rather than reduce public services or raise taxes on the rich. The result was skyrocketing debt everywhere.

Corporations and banks were happy to extend loans to governments, because the wealthy preferred having public administrations borrow from them at interest rather than being obliged to pay taxes to the government. The banks also found it necessary to loan to consumers, because producers would otherwise have an insufficient pool of consumers for their products. This was especially true in the Global

South, where those working for $1.00 an hour were at best unlikely purchasers of anything but absolute necessities.

Thus the crisis of capitalism is described:

- An expanded workforce including women, immigrants, and workers in the Global South.
- Fewer available jobs as a result of computers and robotizing.
- Stagnant or falling wages in the traditional capitalist centers.
- Increased borrowing by workers to make up for vanishing purchasing power.
- Increased stress for families attempting to maintain their former standard of living by working longer hours or taking on extra work.
- Less money in government coffers as a result of politicians' unwillingness to raise taxes on corporations and the wealthy.
- Resultant skyrocketing public debt.
- Imposition of austerity measures and fewer public services.
- Rising wages for the relatively few in the Global South who have access to employment by foreign firms.
- Insufficiency of such "higher wages" to buy the products the laborers themselves produce.

And, of course, none of this takes account of relatively unregulated capitalism's increasingly evident deleterious effects on the environment in the form of climate chaos, waste disposal problems, and, for example, over-fishing made possible by the trade's computer-based industrialization.

Alternatives to the Failing System

All of this raises the question: Is capitalism the best we can do? Or is there a viable alternative to what socialists have long considered a moribund system? To answer that question, first consider socialism's alternative, its strengths and weaknesses. Then think about ways of overcoming the weaknesses.

Recall, first of all, socialism's critique and resulting strategy. As we saw in Chapter Four, socialist critics like Karl Marx recognized that capitalism's private ownership of the means of production, its market freedom, and lack of earnings' cap all necessarily lead to exploitation of workers and of the environment. The socialist remedy was to make ownership public rather than private, to replace markets with rational planning, and to limit maximum earnings by individuals. That strategy enjoyed unprecedented success on the one hand, but miserable failure on the other.

The successes of socialism are rarely recognized in the Platonic Cave of capitalist propaganda. However, in the case of the Soviet Union, socialism enabled Russia, the most backward country in Europe at the time of the First Inter-Capitalist War, to rise to the status of the planet's second leading super-power in the space of just 50 years. Before that, the country's economy was not only backward and predominantly agrarian, but had also undergone the devastation of two World Wars (the second of which claimed 19 million Russian lives), of a revolution against Czarist feudalism, and of counter revolutionary invasions by allied capitalist forces including the United States, France, and Great Britain. Nevertheless, Russia arose from the ashes to industrialize and become a world power with a swiftness unprecedented in world history, except later by the People's Republic of China. Under state socialism China achieved even greater prosperity in an even shorter period of time. China's economy is currently ranked second only to the United States. Its annual rate of growth far outstrips that of the U.S.

Such successes, however, were achieved at great cost. For the reigning interpretation of socialism gave too much power to government. It shifted the exploitation of workers from the private capitalist class to public bureaucrats. That is, while their countries' economies as a whole prospered, the lot of workers under Soviet and Chinese socialism remained virtually unchanged. One set of masters merely replaced another. This explains the overthrow of the Soviet Union in 1989, and today's increasing labor unrest in China.

Missteps like those should not be surprising. No economic transitions have ever occurred smoothly. The passage from feudalism to capitalism involved horrendous wars. So did the abolition of the slave system. And one has only to read the novels of Charles Dickens and Upton Sinclair to observe the horrors involved in the early stages of industrial capitalism as we know it. Add to this the resource wars closer to our own day along with the environmental disasters spawned by industrialism in general, and it becomes clear that capitalism's alternative to the feudalist and slave systems was neither smooth nor kind.

So, given capitalism's history and its current crisis on the one hand, and socialism's history and its very evident failures on the other, what North Star should critical thinkers adopt as a goal to overcome simple replacement of capitalism's private bureaucratic exploitation of workers with socialism's public bureaucratic exploitation? Richard Wolff suggests that the answer is "democracy at work," i.e. gradual replacement of capitalism's private ownership of productive facilities with worker ownership. Experiencing democracy in the workplace would transform it from merely casting a ballot every two or four years, to an everyday exercise of power in the workplace, where people end up spending most of their lives.

Worker ownership begins by replacing corporate boards of directors with workers' councils composed of all an enterprise's employees (in the case of small firms) or of elected representatives (in the case of larger enterprises). This arrangement overcomes the obvious problems represented by current boards of directors—15 or 20 people who typically meet far removed from the location of the entrepreneurial plants they represent. Nonetheless they make all the decisions about what to produce, where to produce, and what to do with the resulting profits.

It is not surprising that according to this arrangement, the boards often make decisions that negatively affect their distant, nameless employees. For instance, the board's members might decide to produce products in ways that end up polluting neighborhoods where the workers live. If labor saving robots or computers enter the picture, board members might decide to lay off workers and award the resulting profit increases to themselves in the form of higher salaries, rather than increasing employee wages or reducing the length of their work day. Boards might even decide to move an entire factory to Brazil or China, leaving their former workers unemployed and without prospect.

None of these decisions would likely be made if workers collectively owned their factories or places of business. Workers wouldn't vote to pollute their own neighborhoods, nor to give vastly higher wages to fellow workers, nor to lay off themselves or their colleagues rather than increase their own shares in profit or shorten their work days. Above all, they wouldn't likely vote to offshore their jobs leaving themselves without employment or prospect.

Instead (for instance in a restaurant) workers would present themselves Monday through Thursday as usual. But then on Friday, for example, half the workers would spend the day meeting to decide changes in what to produce, how to produce, and what to do with the profits. The following week the other half of the workforce would do the same thing. Periodically, the whole staff would meet as well. If labor-saving tools became available, it would not be surprising if decisions were made to shorten everyone's work day rather than to lay workers off. In this way, the promise of computers and robots would serve workers rather than bureaucrats, either private or public.

Arrangements of this type are not merely utopian (except in the sense described by Franz Hinkelammert and reported earlier here). In 1956, in the Basque region of Spain, the Mondragon Corporation emerged following the cooperative model just described. It grew to become the 10th largest enterprise in Spain, employing more than 74,000 workers in 257 companies in fields as diverse as finance, industry, retail establishments and education. (Mondragon, by the way, was initiated by Jose Maria Arizmendi, a Catholic priest influenced by the long-standing and highly progressive social teaching of the Church, that largely inspired liberation theology.)

In this area too, Cuba is showing the way, especially following the United States change in policy under President Obama. On Cuba's part, the change *does* means that the Island is opening itself to foreign investment. But it is doing so on its own terms—tightly regulated by the Cuban government. At the same time, Cuba is vastly expanding its already strong cooperative sector, while reducing its state-run monopolies. Fostering cooperatives means that workers collectively own the enterprises that employ them. They receive the same, and even broader aid from the Cuban government as that extended to capitalist enterprises in the United States and elsewhere in the free market world. The aid takes the form, for instance, of tax breaks, subsidies, holidays for workers, vacations, etc. The idea is to have co-ops enter into competition not only with other cooperatives, but with private sector concerns on a level playing field to see which arrangement the workers prefer.

Something similar has taken shape in Italy. There, according to the Marcora Law passed in 1985, any company going out of business, must extend to workers the right of first refusal in a subsequent transfer of ownership. Similarly, when a worker loses employment because of a job moving elsewhere, he or she is given a choice. Either the individual may receive unemployment compensation for up to three years, or he or she can find 5 colleagues willing to form a cooperative venture. In that case, the 6 workers in question are given their 3 years of unemployment compensation in a single lump sum. They then pool their resources to start the new cooperative business with suitable low-interest government loans if necessary.

Across the globe, worker cooperatives already employ 250 million people and in 2013 together represented $3 trillion in revenue

Conclusion

The foregoing chapters have examined the example of Hitler, who defended capitalism under siege. He was a "strongman" advocate of an economy protecting private ownership of the means of production, and mixed in favor of the white supremacist capitalist patriarchy. On behalf of industrialists, bankers and large landowners, he imposed that economy by police and military force against socialist opposition not only in Germany, but throughout Western Europe. According to his own statements, his persecution of Jews must be understood in that context. His anti-Semitism, then, was not a personal quirk, but was in keeping with a long-standing tradition that associated Jews and Bolshevism throughout the western world, including the United States. Mainline Christians supported Hitler's program, including his anti-Semitism. Christians, like those in Bonhoeffer's Confessing Church opposing *der Fuhrer's* program received the same treatment as Jews.

Donning our magic glasses has suggested that Hitlerism continued without him following his personal defeat in 1945, this time imposed by the most prominent apparent winner of World War II, the United States. So Hitlerism appeared without disguise in the former colonies, where sometimes uniformed dictators abducted, tortured and killed with abandon those associated with the Great Enemy, socialism. Comparatively little attention was paid to this phenomenon by the general public in the First World, where a comprehensive system of propaganda kept Americans in particular from calling Hitlerism by its true name. As a result, Hitler's system could continue with little opposition to its project of preventing the spread to the Third World of capitalism's desperate perestroika which since the 1940s had so dramatically raised working class living standards in the United States and Western Europe.

But even there, capitalism with a human face gradually removed its mask, as unprecedented economic growth fueled by post-war reconstruction had run its course in the early 1970s. The unmasking continued after 1989 and the practical disappearance of apparent alternatives to capitalism, following the fall of the Soviet Union. With that event, "globalization" became capitalism's watchword. Its social Darwinism was imposed by the World Bank, the International Monetary Fund, and World Trade Organization. Following spectacular protests in Seattle in 1999, grassroots rebellion against such market totalitarianism spread rapidly throughout the world, placing in jeopardy the intensified global aspirations of international capital. The most spectacular protest of all, as recognized immediately by Robert Zoellick, occurred on September 11th, 2001. The attack literally brought down the operational center of globalized Hitlerism.[2] The system, of course, responded vigorously, as key elements of Hitler's police state, long operative in the Third World, came home to the First World.

The question now is how to respond to the Hitlerian juggernaut. The argument here has been that reviewing history is an important element of critical response. The account of Hitler's triumph is there for all to see, embedded in the textbooks our students study and in the newspapers we read with our morning coffee. Unless our children are taught to see history through the lens of Hitler's triumph, later generations might remember 2001 not only for the attacks of September 11th, but as the year the extreme right wing in the United States effected a *coup d'etat*, seized the presidency by fraud and deceit, and introduced a police state to enforce its globalized economy upon the rest of the world, despite protests across the planet.

It is not too late, this chapter has suggested, to recognize that capitalism as we know it has run its course. Advancing cooperatives as expressions of democracy at work represents a fitting conclusion for a book on critical thinking in this age of fake news and alternative fact.

For Discussion

1. Explain why it does or does not make sense to identify Hitler as a capitalist.
2. This chapter claims that since the mid-1970s capitalism has entered an irreversible crisis. Explain the elements of that crisis.
3. Do you see cooperatives as a viable response to the alleged crisis of capitalism?
4. How else might capitalism respond effectively to the crisis elements that have allegedly emerged since the mid-'70s?

Notes

1. For the following section, see Richard Wolff's Democracy at Work website: www.democracyatwork.info/ "D@w." Web. 16 May 2017.
2. All of this raises the slightly anachronistic question of how history might regard an act by Jewish resisters during the Holocaust that involved drawing attention to their plight by commandeering German airliners to fly into the Fuhrer's headquarters, the German parliament the administration buildings of Volkswagen or Bayer, or the headquarters of the SS. Would the resisters be remembered as terrorists against innocent Germans? Or would passengers on board the plane and other German civilians killed in the process be seen as willing collaborators, culpably ignorant of the massacre of Jews?

Rule Nine

Collect Conclusions and Live Critically

Having come this far in the book, you have, no doubt, already drawn some conclusions about central elements of critical thinking, your personal outlook, about structures that have shaped your life, about the stories and theories you've been taught about how the world works. You've even considered your own identity at its most basic level. Maybe in the process, you have realized that you are not essentially American, white or black, male or female, but a citizen of the world—once again, despite all you've been told. Perhaps you have begun to realize that at your deepest core you are one with everyone and everything in the universe; what you do with, for, and to others, you do to yourself.

So what?

At the level of everyday life, possibly you have understood key economic concepts for the first time, and have gained some perspective on ideologies that divide and unite conservatives, liberals and radicals. As you've done so, you might well have realized that such convictions are not merely matters of personal preference. They can be tested using historical pattern analysis as well as the standard criteria that distinguish sound scientific thought from its opposite.

So what?

That is the question: so what?

I mean, it's all well and good to *understand* critically. But such understanding is of little value unless it leads to critical *living*. In other words, if you're truly to

benefit from the study represented in this book, you have to live with it a while, come back to it again and again, and apply its criteria to issue after issue.

In short, you must "collect conclusions" and live as though they were true. Doing so is what distinguishes deep critical thought from merely thinking about "critical thinking." Doing so will deepen and modify your convictions. Your energy will increase. So will your courage for critical living.

You will have irrevocably put on the magic glasses.

Seen Through Magic Glasses, *Citizenfour* Is About Critical Living

Citizenfour[1] won the 2016 Academy Award for best documentary. Directed by Laura Poitras, the film is about a government whistleblower who, at great risk to himself, lived out the implications of truly critical thinking. *Citizenfour* traces the saga of Edward Snowden—the thirty-something CIA employee who in 2014 leaked classified information from the National Security Agency (NSA).

The information revealed America's massive world-wide spy system that Snowden saw as absolutely eviscerating U.S. constitutional protections against "unreasonable search and seizure."

In case you've forgotten, the 4th Amendment of the Constitution reads as follows:

> The right of the people to be secure in their persons, houses, papers, and effects, against unreasonable searches and seizures, shall not be violated, and no warrants shall issue, but upon probable cause, supported by oath or affirmation, and particularly describing the place to be searched, and the persons or things to be seized.

In contradiction to those words, Snowden's revelations show that indeed "Big Brother" is watching us at all times. We are under constant surveillance. None of our e-mails or phone calls is secure. Telephones normally found in hotel rooms are routinely used as listening devices. All of our e-mail searches are monitored and recorded.

This means that citizens expressing disapproval of government policies are easily identified. So are our constitutionally protected efforts to organize against such policies. All of us are subject to blackmail and prosecution based on stories manufactured from "metadata" and texts gathered by our watchers.

Knowing full well that he would be hunted down and prosecuted (and possibly executed) for his leaks, Edward Snowden shared his information with Laura Poitras and with *Guardian* reporter, Glen Greenwald. Snowden fled to

Russia where he was given temporary political asylum. *Citizenfour* and the Academy Award are the upshots.

Of course, Snowden's opponents say his revelations have endangered national security and that he is guilty of treasonous acts of espionage. In response, the former CIA contractor says the whole matter of government secrecy and surveillance needs full debate. So do extra-judicial killings in the world-wide drone assassination program. Security, Snowden implies, is less important than freedom, privacy, and protecting the lives of innocents arbitrarily killed on mere suspicion of possibly one-day harming U.S. citizens. Then there are those disturbing words in the Fourth Amendment ...

In terms of this book, *Citizenfour* is about a young man whose NSA work endowed him with Dick Gregory's "magic glasses." Doing so led him to put the welfare of his nation and world ahead of his own comfort and safety. He is now a man without a country who exemplifies what it means to adopt a world-centric perspective that places ethics above ego-centric and ethnocentric concerns.

Do you agree?

At this point, let me put my cards on the table—just in case I haven't sufficiently tipped my hand. It's only fair, since you already know that neutrality is impossible. Fairness however is attainable. And in the interests of fairness, let me share a few of the conclusions I've reached by applying the rules this book has outlined. Some of the conclusions are general, and some more concrete. I share them not to persuade you that they are true, but to encourage you to articulate your own conclusions, though they may differ wildly from my own. If you're like me, achieving clarity here will help you decide how you might live differently.

My General Conclusions

Here's what I've concluded generally. (As I said, more particular deductions will follow below):

1. **I've been lied to and manipulated throughout my life.** Though I love most of them dearly, and though there were occasional exceptions, parents, teachers, church leaders, government officials, and the media have consistently let me down. Don't misunderstand; I'm not indicting them as bad people. Most of them were not. It's just that they didn't know any better. Often they were simply in denial. But for whatever reason, they

indoctrinated, brainwashed, and manipulated me. As a result, I didn't know any better either. My horizons were narrowed. It became highly unlikely that I would ever really think for myself. Instead, I'd simply adopt the conventional wisdom of Plato's Cave and of the Ruling Group Mind.

2. **The basic falsehood I learned was religious.** Rather than a force for unity, religion became a badge of separation. It distinguished God's special people from those who were not. Precisely like those others who I was taught were *not* God's people, I believed I belonged to the elect. Now I recognize that such belief does not have "explanatory value." It simply doesn't ring true in reference to a God responsible for the creation of everyone. More specifically, as a naturally religious boy, I was early taught a mind-based Christianity. I was made suspicious of those who understood God and spirituality in ways other than those sanctioned by my own (Roman Catholic) denominational teachings. As a result, I ended up embracing something like the beliefs John McMurtry summarized earlier in this book. Few of them, I now realize have anything to do with the teachings of Jesus.

3. **Similarly, the education I received prevented me from truly understanding the systems and structures that shaped my very comfortable life, as well as the lives of the world's impoverished majority.** Capitalism was good. Marxism, socialism, and communism were bad. Fascism was something Hitler dreamed up; it had been defeated once and for all in World War II. That's about all I was made to know. Why think any further? So I didn't.

4. **Politically, I was falsely led to believe that America, my country, was completely exceptional.** Wasn't I fortunate to be born into "the greatest country on earth," "the land of the free and the home of the brave?" Yes, our leaders had made occasional blunders. But basically our policies and history (in contrast to those of other less virtuous peoples) were just, altruistic, and generous. My study of history has given the lie to those unexamined convictions.

5. **The claim of American exceptionalism has led me to accept repeated violations of the principle of universality.** As a result, I had no trouble, for example, endorsing the U.S. right to forbid other nations from possessing nuclear weapons. I could do this even though the United States had the largest nuclear arsenal in the world, and is the only nation ever to have used such weapons. I was like U.S. citizens today who see no contradiction in "America's" criticizing and sometimes punishing other nations for "electoral fraud," even though the U.S. election of 2000 has been widely discredited and decided by Supreme Court decree, rather than democratically. Something similar pertains to torture. The U.S. vilified Cuba, for instance,

for alleged torture, but justified using identical "aggressive interrogation techniques" on its own prisoners—in Cuba! Such examples of incoherence can pass muster because "we" consider ourselves good and have virtuous intentions. Those others are evil. I can no longer think that way.

Those are only a few of the conclusions stemming from my own disciplined critical thinking processes—from the application of the principles outlined in this book. Do any of my conclusions sound familiar to you? If so, then you might be ready to answer that "so what?" question.

My Particular Conclusions

During the fall semester of 2014, I taught a Religion course at Berea College called "Poverty and Social Justice." The course was personally significant because it rounded off 40 years of teaching at Berea, where my first class convened in 1974—exactly 40 years earlier. (I already told how I came to Berea, fresh from leaving the priesthood, on fire from Vatican II, sensing the increasing importance of liberation theology and naively ready to change the world.)

In this 2014 semester, 19 students (mostly juniors and seniors) participated in REL 126. The students were engaged, committed, funny, energetic and smart. They, along with our readings, films and required community activism, taught me a great deal. And that, by the way, has been my consistent experience since 1974—I'm the principal beneficiary of the courses I've taught. (I'm thankful every day for the path Life has so gently led me follow.)

In any case, and in the spirit of this chapter, the course caused me to reflect on my teaching career and what I have learned in the process. So let me share 20 of my own specific learnings here. Of course, none of my students would be able to draw these conclusions. After all, they were exposed to most of the underlying historical events and to the resulting ideas for the first time only during the course. However, for me, as I've indicated, REL 126 represented a kind of capstone to 40 years of teaching and nearly half a century of trying to understand the world from the viewpoint of its disenfranchised majority. Grasping that understanding, I've come to realize, is the only hope of salvation our world has.

But before sharing those conclusions, let me tell you a bit more about the course itself. Doing so may help you understand what the type of critical thinking advanced here looks like in classroom practice.

Like all of my courses over the years, its basic purpose was to stimulate critical thought about poverty, hunger and what the Christian tradition teaches about

social justice. Our readings included Ron Sider's *Just Generosity*,[2] Cynthia Duncan's *Worlds Apart*,[3] and the Bread for the World *2014 Hunger Report*.[4] We also analyzed the (still relevant) 1973 Pastoral Letter by the U.S. Catholic bishops of Appalachia, "This Land Is Home to Me.[5]"

In addition, all of us attended monthly meetings of Kentuckians for the Commonwealth (KFTC) and volunteered for their "Get out the Vote" actions. A KFTC activist spent two of our class periods leading us in a game of "Survive or Thrive," a wonderfully instructive game she had invented to replicate the problems of international "free trade" agreements. The activist wasn't our only class guest. A grass roots entrepreneur from a clothing factory in Nicaragua and a Glenmary priest-activist campaigning against Appalachian mountaintop removal also graced our classroom.

Inspired by Howard Zinn's *A People's History of the United States*, and taking Plato's Allegory of the Cave as our guiding image, the course had us attempting to re-vision U.S. history from the viewpoint of the poor and disenfranchised rather than "the official story" of presidents, generals, the rich and the famous.

So we made sure that our current events source reflected those usually neglected viewpoints. To that end, students watched and reported regularly on "Democracy Now,"[6] Amy Goodman's daily news program. We even spent some class time watching and discussing a number of interviews with street-level newsmakers by Ms. Goodman. Additionally, class participants researched and reported on issues of the day including climate change, police militarization, prison privatization, the philosophy of Ayn Rand, reparations to descendants of African slaves, the campaign for a living wage, the rise of ISIS in the Middle East, and Israel's bombing of Palestinians in Gaza.

In line with our commitment to understanding the experience of the actually poor and disenfranchised, our approach to the Christian tradition in this religion course was that of liberation theology—again, understood as "reflection on the following of Christ from the viewpoint of those working for the liberation of the poor and oppressed." Our readings here were drawn from a series on the topic which I had authored and published on my blog site[7].

A screening of the film *Romero*[8] along with some other shorter documentaries, put flesh on those intentionally brief to-the-point readings. The documentaries emphasized U.S. sponsorship of Third World dictatorships under genocidal U.S. allies like Pinochet (Chile), Saddam Hussein (Iraq), the Duvaliers (Haiti) and Somozas (Nicaragua), Mobutu (Congo), and Diem (Vietnam).

Together our intentionally subversive approaches to history and faith were intended to expose students to the untold history of the United States, and to the untold story of Jesus of Nazareth. From all of this, I drew the twenty conclusions

I mentioned earlier. Remember, my students could *never* reach such conclusions. My hope is that someday (if they continue reading outside the dominant culture) they might:

1. Historically speaking, the United States is the country Adolf Hitler and his backers imagined Germany would be had they triumphed in World War II—the absolute ruler of the capitalist world at the service of corporate interests. In short, (even apart from its present leadership), the U.S. has become the fascist police state Adolf Hitler aspired to lead.

2. As such the principal enemies of the United States are those Hitler (following John Calvin) imagined being the protégés of "Jewish Madness"— viz. the world's poor and disenfranchised.

3. These are (and have been since the end of the Second Inter-Capitalist War) the objects of what CIA whistle-blower, John Stockwell, has termed "The Third World War against the Poor" located throughout the developing world.

4. This war by the United States has made it the principal cause of the world's problems in general and especially throughout the former colonial world, as well as in the Middle East, Ukraine, and in the revived threat of nuclear war, along with the disaster of climate change.

5. Its war against the poor has made the United States a terrorist nation. Compared to its acts of state terrorism (embodied e.g. in its worldwide system of torture centers, it unprovoked war in Iraq, illegal drone executions, the unauthorized bombings in Syria, its preparations for nuclear war), the acts of ISIS and al-Qaeda are miniscule.

6. Far from "the indispensable nation," the United States is more aptly characterized (in the words of Martin Luther King) as "the greatest purveyor of violence in the world today." Without the U.S., the world would be far less violent.

7. At home, "our" country increasingly tracks the path blazed by Nazi Germany. It has become a state where corporate executives and their government servants are excused by one set of laws, whereas U.S. citizens are punished by another. Following this regime, law-breakers go unpunished; those who report them are prosecuted.

8. This type of law is increasingly enforced by a militarized police state in which law enforcement officers represent an occupying force in communities where those they are theoretically committed to "protect and defend" are treated as enemies, especially in African-American and Latino communities.

9. As a result, a new wave of "lynchings" has swept the United States at the hands of "law enforcement" officers who execute young black men

without fear of punishment even if murders by police are recorded on video from beginning to end.

10. In addition, disproportionate numbers of blacks and Latinos have been imprisoned in for-profit gulags that rival in their brutality Nazi concentration camps.

11. The point of the militarized police state and prison culture is to instill fear in citizens—to discourage them from constitutionally sanctioned free speech, protest and rebellion.

12. As in Nazi Germany, the dysfunctions of America's police state (including poverty, sub-standard housing and schools, drug addiction, and broken families) are blamed on the usual suspects: the poor themselves, especially non-white minorities. They are faulted as undeserving welfare dependents and rip-off artists. Systemic and structural causes of poverty are routinely ignored.

13. In reality, welfare and other "government programs" (like food stamps) represent hidden subsidies to corporate employers such as Wal-Mart and McDonalds. These latter pay non-living wages to their workers and expect taxpayers to make up the difference through the programs just mentioned.

14. Such government programs could be drastically shrunk and limited to the unemployed, disabled, children, and the elderly, if all employers were compelled to pay their workers a living wage adjusted for inflation on an annual basis. Currently, that wage must be at least $15.00 an hour.

15. Moreover, since education quality and achievement are the most reliable predictors of students' future poverty levels, the U.S. education system should be nationalized rather than privatized, teachers' salaries should be dramatically increased, and all facilities K through 12 regardless of location should enjoy similar high quality.

16. All of this should be financed by declaring an end to the so-called War on Terror, withdrawing from foreign conflicts and reducing by two-thirds the U.S. military budget.

17. Instead, the current system of corporate domination, state terrorism, war against the world's poor, and lynching of minority men and women is kept in place by rigging the nation's electoral system in favor of right wing extremists. They control the system through practices such as unlimited purchase of government (the Citizens United decision), voter suppression tactics (e.g. voter I.D. laws), redistricting, and rigged voting machines. Corporatists do not want everyone to vote.

18. U.S. citizens are kept unaware of all this by a mainstream media and (increasingly) by a privatized system of education owned and operated by their corporate controllers.

19. As a result, revolution has been rendered inconceivable.

20. The only hope and prayer is for a huge general crisis of some type (like another Great Depressions) that will awaken a slumbering people.

Practical Conclusions

No doubt, in terms of critical living, responses to what I've just shared, as well as to my "so what" question will vary widely. Some will be shocked and appalled by what they have read here and probably have long since laid the book aside. Others newly introduced to critical thinking in the way I've presented it will simply continue living as they have. Still others might be prepared to change some few elements of their lives. A few will want to do a lot more—to change drastically.

In any case, responses might affect where you get your information about the world. They might influence your lifestyle and your politics. To show you what I mean, consider the concrete suggestions that follow. They may prove helpful if your conclusions are similar to the ones I myself have collected and just shared. As you've seen in Chapters Two and Three, I've adopted several of them for myself. Others remain aspirations for me.

Knowledge Responses

1. Internalize any information in this book that might help you make sense of the world where our existential reality in something like Plato's Cave. Especially make your own what you've learned about:
 • Economic systems
 • The 4 Levels of violence
 • And of how the world works in terms of colonialism and neo-colonialism
2. View movies and other cultural expressions through Dick Gregory's "magic glasses," i.e. from a world-centric (or, if possible cosmic-centered) perspective.
3. Become aware of whom you listen to and why.
4. Using what will be explained in Chapter Twenty, complete at least one research project directly testing Chomsky's Propaganda Model. Better yet, do so in conjunction with others similarly testing the model's application to situations other than the one you've chosen.
5. Form a discussion group to share your findings in serious dialog.
6. Sharpen your critical historical perspective by reading the books I've repeatedly cited by:
 • Zinn
 • Galeano
 • Rodney
 • Stone and Kuznick

7. Because of their grassroots nature and their practice of consulting grass-roots expertise, rather than relying exclusively on Washington analysts, think-tank researchers, generals, and representatives of the arms industry, experiment with getting your news from:
 - Democracy Now[9]
 - Information Clearing House[10]
 - OpEdNews[11]
8. Balance your news intake by consciously comparing what you learn from the sources just named with what's presented by:
 - *The New York Times*
 - *The Washington Post*
 - Fox News
 - CNN
 - Rush Limbaugh
9. For all sources, check stories against the criteria of:
 - Internal coherence
 - External coherence
 - Explanatory value
10. Share your knowledge with family and friends.
11. Take courses and/or get a degree in social justice studies.
12. Become a teacher of critical thinking.
13. Write, op-eds, articles, books. (It's easier than you think.)

Lifestyle Responses

1. Travel as much as you can, especially in the Global South. But do so pur-posefully—i.e. to understand the world from the viewpoint of its majority. To that end:
 - Travel, for instance, with Witness for Peace[12] or the Center for Global Justice[13]. They'll make sure you penetrate below the surface and escape the tourist enclave depicted in Figure 14.3.
 - Using the offices of such organizations, stay with local families commit-ted to social justice.
 - Learn at least one Global South language. French will help you, for instance, in Haiti, Portuguese in Brazil, and Spanish throughout Latin America.
2. Keeping the dynamics of colonialism and neo-colonialism in mind, refuse to work for multinational corporations whose business practices are reflected in Figures 14.2 and 14.3.
3. Instead, seek employment in an NGO committed to social justice or spe-cifically in a worker-owned co-op.

4. Or join the Foreign Service and attempt to influence United States policy from within the system.

5. Similarly, if you find yourself subscribing to the "competing version" of U.S. history, question the wisdom of joining the U.S. military, advising anyone else to do so, or of supporting any war without first doing detailed research.

6. Once again, conscious of colonial dynamics, become an aware consumer who:
 • Reads food labels
 • Knows about the labor practices behind products you buy

7. View advertising with a skeptical and critical eye.

8. If (after doing further research) you find yourself subscribing to the "Palestinian Story" outlined in Chapter Eleven, get involved in the Boycott, Divestment, and Sanctions (BDS) movement[14].

9. Regardless of your religious beliefs (or lack thereof), begin the practice of meditation in an attempt to contact your "deepest self." A good place to start is with Eknath Easwaran's *Passage Meditation*. As I mentioned in Chapter Two, it represents the method I have found easiest and most helpful.

10. Make the connection between your spiritual practice and political responsibility.

Political Responses

1. Identify the political issues that mean most to you. They might include voter suppression, immigrant rights, police brutality, Black Lives Matter, public financing of elections, single-payer health care, raising the minimum wage to $15.00 per hour, anti-war resistance, capital punishment, free trade agreements, Native American land rights, water protection from oil Pipelines …

2. Watch Richard Wolff's monthly "Economic Update" on YouTube and/or subscribe to his weekly radio program[15] at www.democracyatwork.info/

3. Try to understand his exposition of worker cooperatives in order to explain them to your friends and relatives as viable alternatives to a form of capitalism that creates the huge wealth disparities depicted in Figure 7.1.

4. Know the voting records of your representatives, and vote accordingly.

5. Declare yourself a citizen of the world.

6. Run for office on a platform of global responsibility and justice.

Questions for Discussion

1. Make a list of your own conclusions. Discuss them with others.
2. This chapter has enumerated 25 conclusions the author has drawn after his own application of rules for critical thinking. What do you think of them? Are they anything like your own? Why or why not?

Activity

Review the practical suggestions offered in this chapter. Code them by placing a check mark (√) beside any action you are already doing and intend to continue, a plus sign (+) beside any new action you intend to add to your repertoire, an exclamation point (!) beside actions you feel especially strong about adding, a minus sign (–) beside actions you would never adopt, and a question mark (?) beside actions you either don't understand or are not sure you want to take. Compare and discuss your answers with those of others.

Notes

1. *Citizenfour.* Dir. Laura Poitras. Participant Media, HBO Films, Praxis Films, 2014.
2. Ron J. Sider. *Just Generosity: a new vision for overcoming poverty in America.* Grand Rapids, MI: Baker Books, 2007.
3. Cynthia M. Duncan, Cynthia. *Worlds Apart: Why poverty persists in rural America.* 2nd ed., New Haven, CT: Yale University Press, 1999.
4. David Beckmann. *Ending Hunger in America: 2014 Hunger report: 24th Annual report on the state of world hunger.* Washington, DC: Bread for the World Institute, 2014.
5. *This Land is Home to Me: a pastoral letter on powerlessness in Appalachia.* Webster Springs, W. V.: Catholic Committee of Appalachia, 1990.
6. www.democracynow.org. Accessed 18 May 2017.
7. mikerivageseul.wordpress.com/
8. *Romero.* Dir. John Duigan. By John Sacret Young. Prod. John Sacret Young. Perf. Raul Julia and Richard Jordan. Paulist Pictures, Warner Bros. Studios, 1989.
9. Democracy Now: www.democracynow.org/
10. Information Clearing House: www.informationclearinghouse.info/
11. OpEdNews: www.opednews.com/index.php
12. Witness for Peace: witnessforpeace.org/delegations/
13. Center for Global Justice: www.globaljusticecenter.org/content/cuba-mexico-tours
14. Boycott, Divest, Sanction (BDS) Movement: en.m.wikipedia.org/wiki/Boycott,_Divestment_and_Sanctions
15. Richard Wolff, Democracy at Work: www.democracyatwork.info/

Rule Ten

Detect Silences (and Fake News)

Some questions ... Before reading this book had your schooling ever exposed you to clear ideas about Marxism, socialism, or communism in ways that were intended to have you consider them fairly and not simply dismiss them out of hand? Had you ever seen a side-by-side presentation of the official and competing stories of U.S. history for serious consideration that led your teachers to have you genuinely discuss whether the United States is on the whole a force for good or evil in the world based on historical facts?

Before reading this book, were you aware of the history of the conflict between Israelis and Palestinians, and of the centrality of that conflict in the eyes of the Arab world? Did you know of the connection routinely made in the Islamic world between the situation in Israel/Palestine and what the West considers terrorism? Did you ever hear the Palestinian defense of suicide bombers compared with their enemies who bomb them with such devastating effect from 30,000 feet? Did you ever entertain the idea that the Founding Fathers of the United States fulfilled the F.B.I. definition of terrorists perhaps every bit as much as the members of ISIS?

Most importantly, has your education so far even attempted to present you with systematic criteria for reaching rational answers to the myriad questions that such considerations raise—while entertaining those questions without egocentric or ethnocentric bias?

If your answer to any of those questions is "no," then you are already aware of the meaning of the truth criterion, "detect silences." If "no" is your answer, your education has been filled with such silences. It has been "partial," "biased," "conservative" (in the sense of keeping the status quo), and arguably propagandistic. Its boundaries have been set by the parameters of generally admissible political opinion—by the Ruling Group Mind.

Now aware of such blinders, you are equipped, should you choose, to put on the magic glasses to re-view the education you have so far received. You are perhaps ready draw conclusions about the deafening silences in public (and educational) discourse that must be overcome by genuinely critical thought.

Among those conclusions you might agree with the following:

- **Academic agendas are typically *partial* and closed to subversive ideas.** In this, classroom discourse tends to mirror the one-sidedness of public discourse. To repeat: when was the last time you read a mainstream opinion piece giving a sympathetic hearing to the viewpoint of insurgents in Afghanistan or Iraq? How about the viewpoint of Palestinians? How many of us are familiar with the reasons enumerated by Osama bin Laden for the 9/11 attacks of 2001? How much discussion of those motives has found its way into your classrooms? Honest answers to such questions indicate the extreme partiality of what too often takes place there.

- **Academic agendas have been shaped by aristocratic and *elite* ideas which marginalize the viewpoint of the dispossessed majority.** The reference here is to the standard classics in most fields which are inherently conservative. This is especially true in crucial fields like economics, history, and political science. It's also true for philosophy, literature and other traditional disciplines. All of them are products of eras when most people couldn't read. So "the classics" were produced by the literate aristocracy who naturally defended the order which guaranteed their privilege and power. When books challenging their perspectives came along (e.g. from Marx and socialists), they were (and remain) routinely vilified by the intellectual elite.

- **Academic agendas are usually *deceptive* and constantly threatened by hijackings endorsed by defenders of the status quo.** Plato saw that as far back as 5th century Athens. Don't forget his "Parable of the Cave?" Those people carrying the statues and projecting the shadows on the wall were defenders of what Plato called Athens' *doxa*—the obvious "of course" statements that support any status quo. They were the Sophists committed to making the weaker argument appear stronger. Plato contrasted their teachings with the liberating education of the subversive Socrates who called the doxa into question.

- **Academic agendas give a great deal of space to *deadly* ideas.** Given our current crises in economy, environment, population, democracy, human rights, religion, and meaning in general, it is difficult not to draw such a conclusion. Think about climate chaos and its connection with the economic growth championed by both wings of the Property Owners' Party. Think about talk radio's criminalization of environmentalists. In a word, conservation of the given order is killing us all and will lead to planetary disaster. For the good of the planet, such suicidal tyranny of deadly ideas must be exposed and named for what it is.
- **All of this is intimately connected with the controversy about alternative fact and fake news that comprises the context of critical thinking today.** As previously suggested, the mainstream media (MSM) can act like those statue-bearers in Plato's Cave. The news they promulgate is routinely shaped by ethnocentric dominator hierarchies. And that's no wonder. Its presenters, through no fault of their own, have been shaped by the biased education just described.

Chomsky's Propaganda Model: A Tool for Critical Thinking

That's the principal message of *Necessary Illusions*, by Noam Chomsky who, in effect not only connects Plato's Allegory of the Cave to our world of alternative fact and fake news, but shows us how to test for suspected fakery.[1] In so doing, he suggests a research project that provides a fitting conclusion for this study of critical thinking. The project will enable skeptics to evaluate Plato's thesis about manipulation by our keepers, who, Chomsky charges, routinely foster silence about our wardens' crimes that are every bit as gruesome as those of their vilified enemies.

In this final chapter, then, consider what Chomsky calls the Propaganda Model of information dissemination that operates through ethnocentric political discourse, education, and especially the mainstream media. For Chomsky, such information sources create for us an unreal shadow world that fails to take seriously the realities of the world's unseen majority whose lives are shaped by U.S. domination.

The model holds that the mainstream media function as vehicles of propaganda intended to "manufacture consent" on the part of our culture's majority—often misrepresented within the cave as "special interests." The majority includes workers, labor unions, the indigenous, family farmers, women, youth, the elderly, the handicapped, ethnic minorities, environmentalists, etc. The MSM and those they represent seek to secure the latter's consent for policies favoring what is

termed "the national interest." This, according to propagandists, is the province of corporations, financial institutions and other business elites. Such interests in turn are served not only by the media, but by elected officials, educational institutions, churches, and so on. These latter often represent resistant grassroots movements as threats, since such movements actually seek greater influence on national life.

To control such tendencies, the media in the United States defines the limits of national debate within boundaries set by a two party system of wealthy government officials, by unquestioned patriotism, support for the free market, vilification of designated enemies (e.g. ISIS, Russia, China, Cuba, Syria, Iraq, Iran, North Korea …) and support for official friends (e.g. Israel, Saudi Arabia, Great Britain …). Support for such "client states" ignores their objectionable actions that often parallel and even surpass similar acts committed by designated enemies.

None of this means that "liberal" criticism is excluded from the national media. On the contrary, such criticism of either government officials (like Donald Trump) or the corporate elite is common. However, the media rarely allows serious criticism of either the free enterprise system as such, or of the American system of government. Accordingly, Chomsky's model predicts:

- More articles will be devoted to the "atrocities" of designated enemies than to similar actions by the U.S. or its clients.
- Less space (column inches) will be similarly allocated for reporting the alleged crimes of the U.S. or its clients.
- In either case, story sources will tend to be American government officials and intellectuals (university professors, think tank experts, conservative churchmen) friendly to U.S. policy.
- The reporting of "enemy" crimes will devote comparatively little space to the "official explanations" of the governments in question.
- It will depend more heavily on U.S. government spokespersons, on opposition groups within the offending countries concerned and on grassroots accounts.
- The crimes and "atrocities" of designated enemies will be explained in terms of exceptionally evil individuals or a corrupt and unworkable system.
- On questionable evidence or with none at all, the crimes and atrocities of "designated enemies" will be attributed to the highest levels of government.
- Meanwhile the crimes of the U.S. or its client states will be denied, rationalized or otherwise excused.
- Incontrovertible proof (a "smoking gun") will be demanded to prove the "crimes" of the U.S. or its friends.
- If admitted, these crimes and atrocities will be explained as exceptional deviations by corrupt individuals (at the lowest level possible).

- The ultimate conclusion drawn from the discovery of "our" crimes along with any resulting trials and convictions will be that "the system works."
- This bias will be revealed not only in the ways noted above, but by differences in language (words, phrases, allusions) employed in writing the articles in question.

Testing the Model

Chomsky doesn't expect readers of *Necessary Illusions* to simply accept his allegations about the media's creation of what amounts to fake news. Instead, he proposes testing the model's predictions. The first step in doing so entails identification of "paired examples." These comprise similar controversial actions, performed by the United States or its client states on the one hand, and by "designated enemies" on the other.

In *Necessary Illusions* many such pairings are provided—all of them, of course, taken from the 1980s, when the book was published. Then U.S. involvement in Central American wars (especially in Nicaragua) dominated the news. While historically dated, the examples still communicate what the author means by paired examples. In addition, even dated case studies can prove useful as student research projects to broaden their historical knowledge, while at the same time testing the model's predictions. (More current examples will be suggested below.) Those given by Chomsky include:

- U.S. celebration of elections in (client state) El Salvador (widely criticized for their meaninglessness in Europe) vs. media adoption of the U.S. official account that the 1984 elections in (designated enemy) Nicaragua either never occurred or were hopelessly rigged, even though the Nicaraguan elections were praised internationally for their freedom and fairness[2]
- The defense and rationalization of the U.S. downing of the Iranian air bus in 1988, vs. the furor over the earlier (1983) Soviet destruction of KAL 007[3]
- The lack of comment on Indochinese injuries and fatalities caused by U.S. mines left behind after the Vietnam war, and on the refusal of the United States to supply minefield maps to civilian mine-deactivation squads, vs. the denunciation of the Soviet Union for the civilian casualties caused by their mines in Afghanistan, where they *did* provide maps to assist mine clearing units[4]
- Media indignation aroused in 1988 over alleged plans to build chemical weapons factories in Libya, vs. the media's lack of concern for the extensive

civilian casualties in Indochina caused by U.S. chemical warfare there through its use of Agent Orange[5]

- The sympathetic support given Israel for its repeated invasions and bombings in Lebanon even in the absence of immediate provocation, vs. the identification of Nicaraguan "hot pursuit" of Contras across its unmarked border with Honduras as an "invasion" of a sovereign state[6]
- The press position that Soviet provision of MIG fighter planes to Nicaragua would legitimate a U.S. invasion of that country, vs. media acceptance of the threat posed to Nicaragua by U.S. shipment of F-5 fighter planes to neighboring Honduras[7]
- Portrayal of the World Court as the culprit, when the United States was condemned for its support of the Nicaraguan Contras in 1986, vs. press dismay over Iran's lawlessness when it refused to recognize the Court's adverse decision during the hostage crisis of 1979[8]
- Portrayal of the World Court as the culprit, when the United States was condemned for its support of the Nicaraguan Contras in 1986, vs. press astonishment over Saddam Hussein's lawlessness when he refused to recognize the Court's jurisdiction, when it ordered him to cease his occupation of Kuwait in 1990
- Press outcry over the genocide of the Pol Pot regime in Cambodia, vs. its silence about the proportionately larger-scale slaughter in East Timor at the hands of U.S.-backed Indonesian invaders[9]
- Criticism of Soviet failure to pay its U.N. dues, vs. silence about U.S. debts in the world body[10]
- The extensive media coverage given the 1984 murder of Fr. Jerzy Popieluszko in Soviet-controlled Poland by policemen who were quickly apprehended, tried, and jailed, vs. the comparatively little space given the murder of 100 prominent Latin American religious martyrs, including the Archbishop of San Salvador and four raped American churchwomen, victims of the U.S.-backed security forces[11]

Contemporary Paired Examples

Paired examples with more contemporary relevance might include:

- The San Bernardino shooting on December 2, 2015 by Muslim, Rizuan Farook and Tashfeen Malik vs. the January 29th, 2017 shooting in a Quebec City mosque by white nationalist and supporter of Donald Trump, Alexandre Bissonette

- The U.S. nuclear weapons modernization program announced by President Obama vs. suspicions that Iran might have initiated a program to acquire nuclear weapons
- Iran's nuclear weapons program vs. Israel's
- Justifications for attempts by the United States to overthrow the Sandinista government of Nicaragua during the 1980s vs. Russian justifications for its invasion of the Ukraine beginning in 2014
- Russian and Syrian atrocities in the Battle for Aleppo in 2016 vs. similar acts by the U.S. and Iraq in the Battle for Mosul that same year
- Stories on Cuban political prisoners vs. stories on U.S. political prisoners
- Portrayal of Islam as an inherently violent religion vs. Christianity as an inherently violent religion
- The Jewish Holocaust at the hands of Germans vs. the Native American Holocaust at the hands of European settlers
- Alexander Putin as a "murderer" vs. Barack Obama as a "murderer" via extra-judicial assassinations by drone.

Through Magic Glasses
September 11: The New Pearl Harbor[12] Demonstrates the Accuracy of Chomsky's Propaganda Model

A vivid film example of Noam Chomsky's propaganda model is provided in *September 11: The New Pearl Harbor*.[13] That's Massimo Mazzucco's documentary that 9/11 scholar, David Ray Griffin, has called "the film we've been waiting for."

The amount of evidence the film offers in its efforts to discredit the official story of 9/11 is overwhelming. It comes from eyewitnesses, government officials, and experts on aviation and explosives. Architects, engineers and others in the scientific community advance evidence throughout the five-hour documentary. It all goes far beyond familiar points about the fact that Building 7 fell without having been struck by any plane, about the melting point of steel girders, and the near impossibility of the aviation maneuvers required to strike the Pentagon.

Observations here are not about advancing "conspiracy theories" in this book about critical thinking. Rather, they are about critical thinking itself—about facing the double standards that Chomsky alleges government and media employ to create fake crises and fake news about designated enemies on the one hand, while observing comparative silence about our government's and military's own crimes on the other.

Consider the following:

- In 2003, the U.S. government insisted on invading Iraq because of its possession of "weapons of mass destruction." When inspectors couldn't find those weapons, their failure was characterized by the Bush administration as evidence of Saddam Hussein's evil genius. Hussein was so insidious, they claimed, that he was able to hide masses of chemical and other weapons from very thorough inspectors. The administration used such non-evidence-as-evidence to justify an invasion and war that has taken more than a million lives of innocent Iraqis.

- In September of 2013, President Obama was on the point of bombing Syria for its use of chemical weapons. The evidence justifying Obama's attack remained secret. Beyond that, when asked for justification, only purely circumstantial proof was offered. The chemical weapons in question, we were told, required launchers available only to the regime of Syrian president Bashar al-Assad. This means that for Mr. Obama, secret evidence and circumstantial proof were sufficient to justify killing hundreds, if not thousands of innocent Syrians.

- In 2017, President Trump, before investigating the incident, actually *did* bomb Syria on alleged, but undisclosed evidence that al-Assad had used sarin to "gas his own people." The U.S. response took place without allowing time for investigation—just two days after the original chemical weapons attack.

- In November of 2013, Senator John McCain of Arizona accused Edward Snowden of sharing U.S. secrets with Russia. "If you believe he didn't, McCain said, "then you believe that pigs fly." McCain's incontrovertible evidence? He didn't say. Was his evidence stronger than that Mazzucco advances to support reopening 9/11 investigations?

That last question is the point here.

Each of these examples demonstrates the applicability of Chomsky's Propaganda Model. When it's a question of attacking enemies, Chomsky says, the flimsiest of reasons, the thinnest of connections, simple implications, logical deductions, illogical conclusions, and circumstantial evidence are enough to justify mass murder of the innocent. But when it's a question of alleged U.S. crimes, even a "smoking gun" can be explained away.

Watch the Mazzucco documentary. Then imagine if the proof against Saddam Hussein or al-Assad had risen to the level of that advanced by 9/11 scientists and other scholars.

> All of this suggests conclusions for critical thinkers striving to transcend simple ethnocentrism: The justification for any war should go beyond the detail offered in *9/11: The New Pearl Harbor*. Moreover, any reasoning legitimizing future wars should evoke critical comparisons with and questions about 9/11, the level of evidence there, and the reasons for ignoring its questions about the official story.
>
> In effect, such demands might well preclude future wars. In fact, no war in recent memory has been based on anything like the evidence and reasoning marshaled in *9/11: The New Pearl Harbor*. See for yourself.

Testing Paired Examples

Testing such paired examples involves

- Locating news reports of both incidents in the mainstream media, e.g. *The New York Times*.
- Counting the number of articles devoted to each incident.
- Measuring the column inches given each
- Comparing the reporting of each incident, noting:
 o The source-bases of the articles in question and whether they conform to Chomsky's predictions as earlier described.
 o Whether there are significant language differences in the reports of the "paired examples."
 o The significance of the differences.
 o How the quality of evidence advanced or demanded in each case differs. (E.g. Is a "smoking gun" required for alleged U.S. crimes, while something less is tolerated as proving the crimes of designated enemies?)
 o Whether conclusions are drawn or implied about evil intent on the part of "designated enemy" leaders, while similar actions by the U.S. or its clients are excused or rationalized.
 o Whether conclusions are drawn or implied about the corruption and unworkability of the "designated enemy's" system, while similar actions by the U.S. or its clients are explained in terms of exceptional crimes by officials at the lowest level possible.
 o Whether arrests, trials or convictions are accepted as indications that the system in question does work or that it doesn't.

Conclusion

To summarize, what's been said here is that genuinely critical thinking must be committed to questioning parameters of perception that define the limits of acceptable discourse. None of this involves shoving anyone's opinions down the throats of partners in dialog. That never works anyway. In fact, genuine critical dialog frequently entails emboldening those partners to find voice for expressing various "unofficial stories" in an atmosphere that's safe and supportive.

The bottom line here is simply this: we shouldn't be afraid of critical thought that questions axioms, *doxa*, or doctrine. Our primary job as students, teachers, and simply as persons is to wake up.

We need to read and discuss books that call our egocentrism and ethnocentrism into question. Then, after exposure to Howard's Zinn's *People's History*, or Eduardo Galeano's *Open Veins of Latin America*, or Walter Rodney's *How Europe Underdeveloped Africa*, or the anti-colonial writings of Mohandas Gandhi, real critical thinking might inspire questions about the thundering silences contained in standard textbook presentations of history, political science, and economics—not to mention what we read in the papers, hear on the radio or see on TV.

To reiterate: both Plato's Allegory of the Cave and Chomsky's propaganda model suggest that the problem of fake news has been with us for a long time. Even more importantly: critiquing it goes much deeper than merely analyzing what appears in the newspapers, on television or online. Instead, critical thinking often challenges its practitioners to break silences and make a 180 degree turn away from accepting what we've been told by beloved parents, teachers, priests, ministers, politicians, other public figures and friends.

No wonder it's so intimidating to exit the cave!

For Discussion

1. What has been the most "thundering" silence in your own educational experience?
2. Think of particular teachers you have had. Which of them were willing to break the silence described in this chapter? How did students, parents, and other teachers respond?
3. What are the dangers of breaking the kind of silences this chapter alleges?
4. Tell of an experience in which you have "broken silence".
5. In your own words, explain the relationship between the Allegory of the Cave and Noam Chomsky's propaganda model.

6. Do you consider Chomsky's theory accurate?
7. What are its strengths and weaknesses?
8. Are you familiar with the 9/11 truth movement? Is its discrediting by official sources an example of propaganda? Discuss.

Activity

Form a research team of three members to test one of the contemporary paired examples noted above. Working together as much as possible, divide the tasks described in this chapter for evaluating Chomsky's propaganda model. Prepare a group report summarizing the findings of your research. Include a provisional evaluation of Chomsky's model, noting difficulties you had in understanding and applying it, along with any questions that have arisen about the model itself and its method.

Notes

1. Noam Chomsky. *Necessary illusions.* Toronto, ON: CBC Enterprises, 1990.
2. *Ibid.* 66–67.
3. *Ibid.* 34.
4. *Ibid.* 35.
5. *Ibid.* 38–39.
6. *Ibid.* 54–55.
7. *Ibid.* 55–56.
8. *Ibid.* 82.
9. *Ibid.* 156.
10. *Ibid.* 222.
11. *Ibid.* 137, 146–147.
12. *September 11th: The New Pearl Harbor.* Producer and Director: Massimo Mazzucco. Turin, Italy, 2013.

Index

G

H

**Narrative, Dialogue
and the Political
Production
of Meaning**

Michael A. Peters
Peter McLaren
Series Editors

To submit a manu-
script or proposal for
editorial considera-
tion, please contact:

Dr. Peter McLaren
UCLA Los Angeles
School of Education &
Information Studies
Moore Hall 3022C
Los Angeles, CA 90095

Dr. Michael Peters
University of Waikato
P.O. Box 3105
Faculty of Education
Hamilton 3240
New Zealand

WE ARE THE STORIES WE TELL. The book series Education and Struggle focuses on conflict as a discursive process where people struggle for legitimacy and the narrative process becomes a political struggle for meaning. But this series will also include the voices of authors and activists who are involved in conflicts over material necessities in their communities, schools, places of worship, and public squares as part of an ongoing search for dignity, self-determination, and autonomy. This series focuses on conflict and struggle within the realm of educational politics based around a series of interrelated themes: indigenous struggles; Western-Islamic conflicts; globalization and the clash of worldviews; neoliberalism as the war within; colonization and neocolonization; the coloniality of power and decolonial pedagogy; war and conflict; and the struggle for liberation. It publishes narrative accounts of specific struggles as well as theorizing "conflict narratives" and the political production of meaning in educational studies. During this time of global conflict and the crisis of capitalism, Education and Struggle promises to be on the cutting edge of social, cultural, educational, and political transformation.

Central to the series is the idea that language is a process of social, cultural, and class conflict. The aim is to focus on key semiotic, literary, and political concepts as a basis for a philosophy of language and culture where the underlying materialist philosophy of language and culture serves as the basis for the larger project that we might call dialogism (after Bakhtin's usage). As the late V.N. Volosinov suggests "Without signs there is no ideology," "Everything ideological possesses semiotic value," and "individual consciousness is a socio-ideological fact." It is a small step to claim, therefore, "consciousness itself can arise and become a viable fact only in the material embodiment of signs." This series is a vehicle for materialist semiotics in the narrative and dialogue of education and struggle.

To order other books in this series, please contact our Customer Service Department:

> (800) 770-LANG (within the U.S.)
> (212) 647-7706 (outside the U.S.)
> (212) 647-7707 FAX

Or browse online by series:

> www.peterlang.com